MEMORIAL ART GALLERY

AN
INTRODUCTION
TO THE
COLLECTION

SUSAN DODGE PETERS, EDITOR

MEMORIAL ART GALLERY OF THE UNIVERSITY OF ROCHESTER
IN ASSOCIATION WITH HUDSON HILLS PRESS, NEW YORK

First Edition

© 1988 by the Memorial Art Gallery of the University of Rochester
Rochester, New York 14607.

Published in the United States of America by the Memorial Art Gallery of the
University of Rochester and distributed in association with Hudson Hills Press,
Inc., Suite 1308, 230 Fifth Avenue, New York, New York 10001-7704.

Distributed in the United States, its territories and possessions, Canada,
Mexico, and Central and South America by Rizzoli International
Publications, Inc.
Distributed in the United Kingdom, Eire, Europe, Israel, and the Middle East
by Phaidon Press Limited.
Distributed in Australia by Bookwise International.
Distributed in Japan by Yohan (Western Publications Distribution Agency).
Distributed in South Korea by Nippon Shuppan Hanbia.

Editor: Susan Dodge Peters
Copy editor: Carol Betsch
Production coordinators: Mark Donovan and Deborah Rothman
Coordinator of manuscript processing: Rhonda Olson
Coordinator of photography: Daniel Knerr
Photographers: James M. Via, David Henry, Richard Margolis, Michael
Hager, Bruce Miller, Museographics

Design by Robert Meyer Design, Inc., Stamford, CT
Typography by Rochester Mono/Headliners
Color and image assembly by Rochester Empire Graphics, Inc.
Paper by Alling and Cory
Printed by Lawyers Co-operative Publishing Company

Hudson Hills Press: Paul Anbinder, editor and publisher

Library of Congress Cataloging-in-Publication Data

University of Rochester. Memorial Art Gallery.
 Memorial Art Gallery.

 1. Art—New York (State)—Rochester—Catalogs.
2. University of Rochester. Memorial Art Gallery—
Catalogs. I. Peters, Susan D. II. Title.
N719.A58 1988 708.147'89 88-42978
ISBN 1-55595-019-1 (alk. paper)

This publication was supported in part by a grant from the National
Endowment for the Arts, a Federal agency.

NOTE TO THE READER:

Memorial Art Gallery: An Introduction to the Collection has been divided into five
sections representing the major areas in which the Memorial Art Gallery has
significant holdings. The five sections are: Ancient art; European art, which is
subdivided by centuries; Asian art; American art, which is also subdivided by
centuries; the art of Africa, Oceania, and the Americas. The works in each
section are first arranged geographically by countries, regions, or, as in the case
of African and Pre-Columbian art, by cultures. These geographical or cultural
subdivisions are ordered alphabetically. Within each country or region, the
works are arranged chronologically by the date of the object. Placed at the
beginning of these geographical subdivisions are the pieces for which only
approximate dates are known.

 Each section begins with essays on individual art works which include infor-
mation on the provenance, exhibition history, and selected bibliographic refer-
ences pertaining to the work itself. Following the essays is a photographic
survey of other objects in the collection, representing the breadth of the
Gallery's holdings from the same culture or period.

CONVENTIONS:

Dimensions are in inches with height preceding width preceding depth or
diameter.

Alternative titles, in parentheses, follow the preferred title.

When additional works in the collection are referred to in the text, these works
are followed with the Gallery's acquisition number.

Full bibliographic citations are given in the literature section; shorter versions
are used in the footnotes.

Titles of exhibitions are cited in italics if a publication was issued in conjunction
with the show. Titles of all other exhibitions are cited in quotation marks.

The pinyin system of romanization has been used when referring to Chinese
art. The Wade-Giles system has been retained, however, when it appears in
bibliographic references and citations.

ABBREVIATIONS:

Gallery Notes:	*Gallery Notes* is a publication of the Memorial Art Gallery.
MAG:	Memorial Art Gallery of the University of Rochester.
Porticus:	*Porticus: The Journal of the Memorial Art Gallery of the University of Rochester.*
Treasures from Rochester:	Wildenstein Galleries, New York, *Treasures from Rochester: Memorial Art Gallery of the University of Rochester,* 1977.

Essays are signed with initials. The authors' full names and corresponding
initials are listed below.

Bernard Barryte	BB	Howard S. Merritt	HSM
Bonnie Apgar Bennett	BAB	Joan B. Morgan	JBM
Marianne Berardi	MB	Pratapaditya Pal	PP
Robert Steven Bianchi	RSB	Susan Dodge Peters	SDP
Diran Kavork Dohanian	DKD	Randall Rhodes	RR
Katherine C. Grier	KCG	Donald Rosenthal	DR
Erica E. Hirshler	EEH	G. Kenneth Sams	GKS
Patricia Junker	PJ	Susan E. Schilling	SES
Donald D. Keyes	DDK	Prescott D. Schutz	PDS
Penny Knowles	PK	Roberta M. Schwartz	RMS
Susan Koslow	SK	Grace Seiberling	GS
Christine Mullen Kreamer	CMK	M. Katherine Smith	MKS
Robert Lodge	RL	David Walsh	DW

CONTENTS

FOREWORD

The Memorial Art Gallery's diverse and notable collection, one of the finest regional collections in the country, is little known outside of Western New York. While many of its outstanding individual works have been researched, reproduced, and exhibited nationally and internationally, few know the encyclopedic breadth of the Gallery's holdings. *Memorial Art Gallery: An Introduction to the Collection*, the first publication of its kind in the Gallery's seventy-five-year history, is intended to remedy this situation. For these pages, over 300 objects, spanning chronologically from 3,000 B.C. to 1987, and ranging geographically from Egypt to the Americas, have been selected to represent the Gallery's extensive collection.

Although this is the Gallery's first comprehensive publication on its collection, several significant publications have preceded it. In 1961, the Memorial Art Gallery, under Gertrude Herdle Moore, director, and Isabel C. Herdle, curator, issued a handbook to the Gallery's collection. Written by Susan E. Schilling and Langdon F. Clay and funded by the Women's Council, the *Handbook* was a photographic survey of the collection, with introductory essays that addressed the historical significance of the art from the different periods and cultures represented. A supplement to the *Handbook,* including new acquisitions from 1962-1968, was published in 1968. While not initially intended as an introduction to the collection, the catalogue for the 1977 exhibition, *Treasures from Rochester: Memorial Art Gallery of the University of Rochester,* held at the Wildenstein Galleries in New York, has served this purpose for the past decade. Since 1980, the Gallery's journal, *Porticus: The Journal of the Memorial Art Gallery of the University of Rochester,* has also proved an important vehicle for dissemination of scholarly research on the collection.

Need for an updated and comprehensive publication on the collection, however, has long been recognized. With a generous grant from the National Endowment for the Arts, work on *Memorial Art Gallery: An Introduction to the Collection* began in 1983 under the directorship of Bret Waller. Essential to the completion of the publication has been the assistance of former Board of Managers President Herbert W. Vanden Brul. From the beginning, he has believed in the significance of this project and has contributed generously to ensure its successful conclusion.

Production of the book was made possible by the generous support of Lawyers Co-Operative Publishing Company, Rochester Empire Graphics, Alling and Cory, and Robert Meyer Design, Inc. At Lawyers Co-Operative, where the book was printed and bound, we wish to thank Thomas Gosnell, Robert Hursh, Michael Peters, and Sherman Lawner. At Rochester Empire Graphics, for their assistance with color and image assembly, we wish to thank Van Buren N. Hansford, Jr., Bill Bachman, Jerry Guisto, Jim Marks, and John Meyer. At Alling and Cory, our supplier of fine quality paper, we wish to thank Gilman Perkins and Donald Williams for their invaluable help. Special thanks are due to the designer of the book, Robert Meyer of Stamford, Connecticut; to his associate Brenda Mason; and to Nancy DeNatale who assisted her. We also wish to acknowledge the assistance of Paul Anbinder at Hudson Hills Press for distributing this publication.

At the Gallery, several individuals steered the project over its five-year course. Donald Rosenthal, then the Gallery's Chief Curator, was the publication's first coordinator; he was assisted by Randall Rhodes. In 1986, Penny Knowles assumed the coordination of the project and formed an advisory committee that included Isabel Herdle, Patricia Junker, Susan E. Schilling, and David Walsh. Susan

Dodge Peters was appointed the publication's editor in 1986. Through her superb direction and guidance, this monumental project has been brought to a successful conclusion.

Over the past five years, almost everyone on the Gallery's staff has been involved in this publication. Bernard Barryte, as Curator of European Art, and Patricia Junker, as Chief Curator and Curator of American Art, were involved in every aspect of the publication, particularly overseeing work on the objects in their fields. Daniel Knerr coordinated the publication's photography. He was assisted by Karin Harriman, Sandra Markham, and Marie Via. Sandra Markham was also responsible for measuring all of the works of art, and Marie Via for compiling all the information for the photographic captions. Librarians Stephanie Frontz and Janet Clarke-Hazlett offered research assistance to the Gallery's staff as well as to many of the other writers. Mark Donovan and Deborah Rothman worked closely with Robert Meyer, the designer, throughout the publication and managed the details of the production. Patricia Eldridge, Christine Garland, Margaret Hubbard, and Christine Hyer helped to write the grants and to raise funds for this project, and Kim Hallatt, Edmund Pease, and Marcia Vogel handled the publication's many financial details.

First Elecia Almekinder, and then Rhonda Olson, who saw the project to completion, were responsible for coordinating the word processing of the manuscript. Assisting them in the typing were Brian Aranowski, Karin Harriman, Jean Kraley, Sara Lemmon, and Kathleen May. They also helped with the project's correspondence as did Patricia Marcus. Members of the Gallery's docent program generously assisted with the proofreading of the publication. We are most grateful for the efforts of Maureen Basil, Nancy Curme, Catherine Geary, Susan Hyde, Bonnie Nolen, Hélène Robinson, Diane Tichell, Anne Vilas, Helen Williams, and, particularly, Joan Yanni. Two Education Department interns were also helpful: Siobhan LeGros with organizational assistance, and Nancy Malone with expert proofreading.

Many in addition to the Gallery's staff assisted with this publication. Early in the project Aimée Ergas and Margaret Bond offered editorial advice. Carol Betsch's contributions as the publication's copy editor were invaluable. Michael Hager, David Henry, and James M. Via were the publication's principal photographers. Also included are photographs by Richard Margolis, Bruce Miller, and Museographics. For expert typesetting services, we wish to thank the staff of Rochester Mono/Headliners, especially Gregory Smith and Anthony Wildy. For help ranging from research assistance to the identification of writers, thanks to Armanda Balduzzi, Rochester; Robert Baldwin, Connecticut College; McCrea Hazlett, Rochester; Professor Emeritus Erik Larsen, University of Kansas; Paul Lauf, Rochester; Michael Padgett, Museum of Fine Arts, Boston; The Provenance Index, The Getty Art History Information Program, Santa Monica; Patricia Cain Rodewald, Rochester; Franklin W. Robinson, Museum of Art, Rhode Island School of Design; Professor Emeritus Alan Sawyer, University of British Columbia; Cornelius C. Vermeule, Museum of Fine Arts, Boston; Robert M. Borstman, Rijksmuseum "Nederlands Scheepvaart Museum," Amsterdam; and Martie Young, Cornell University.

Finally, and most importantly, we are grateful to the publication's authors, to whom belongs the credit for the informative and scholarly substance of this publication. The splendid "History of the Collection" was written by Isabel Herdle and Gertrude Herdle Moore. Writers on the staff of the Memorial Art Gallery—past and present—are Bernard Barryte, Patricia Junker, Penny Knowles, Susan Dodge Peters, Randall Rhodes, Donald Rosenthal, Susan E. Schilling, and M. Katherine Smith. Bonnie Apgar Bennett, Diran Kavork Dohanian, Professor Emeritus Howard S. Merritt, Grace Seiberling, and David Walsh are all faculty members in the Department of Art and Art History of the University of Rochester. Special thanks are due to Professor Dohanian for granting permission to reprint several articles that appeared originally in the Gallery's journal, Porticus. Also from the Rochester community are Katherine C. Grier, historian at the Margaret Woodbury Strong Museum; Joan B. Morgan; and Roberta M. Schwartz (City University of New York). Other distinguished contributions were made by Marianne Berardi (University of Pittsburgh); Robert Steven Bianchi, the Brooklyn Museum; Erica E. Hirshler, Museum of Fine Arts, Boston; Donald D. Keyes, Georgia Museum of Art; Christine Mullen Kreamer, National Museum of Natural History, Smithsonian Institution; Susan Koslow, Brooklyn College of the City University of New York; Robert Lodge, Intermuseum Laboratory, Oberlin; Pratapaditya Pal, Los Angeles County Museum of Art; G. Kenneth Sams, University of North Carolina at Chapel Hill; and Prescott D. Schutz, Schutz and Company, New York.

To the many individuals who contributed to Memorial Art Gallery: An Introduction to the Collection, we offer our sincerest thanks. In his 1987 dedication of the Gallery's Vanden Brul Pavilion, University of Rochester President Dennis O'Brien said, "At the Memorial Art Gallery, we touch the glory and fragility of humanity." Those affiliated with the Memorial Art Gallery take pride in the scope and quality of the collection and are delighted now to share with others a few of its many treasures.

Grant Holcomb
Director

HISTORY OF THE COLLECTION

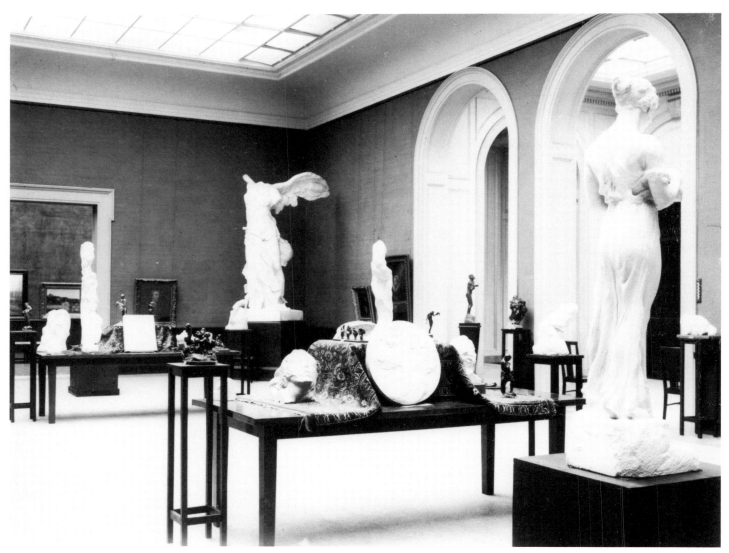

Hall of Casts, 1914.

The story of the Memorial Art Gallery's permanent collection begins even before the Gallery's impressive bronze doors formally opened to the public on October 9, 1913. Among its first acquisitions were a lappet of old Burano lace, four plaster casts of Greek sculpture, and a group of contemporary American paintings, soon to be included in the inaugural exhibition. None was of world-shaking importance or great historical or creative value, but they played a vital role in the development of the permanent collection.

The Gallery's acceptance of that gift of Italian lace settled two early and important issues: first, whether the new gallery was to have a permanent collection at all or to depend rather on a changing program of exhibitions; and, second, if there was to be a collection, what its scope and purpose should be. Should it, for example, be limited primarily to the so-called fine arts of painting and sculpture, the preference of the Gallery's initial donor, Mrs. James Sibley Watson, who was brought up in the glamorous traditions of the princely collections of Europe? Or should it be a teaching museum and reflect all phases of human creativity from paintings to ceramic pots, from Maya stelae to modern mobiles—the all-encompassing view that George L. Herdle, the Gallery's first director, was urging? Fortunately, the lace and Mr. Herdle won!

The four large-scale reproductions of classic Greek sculpture, the gift of the University of Rochester Class of 1880, are now symbols of what was to become a close and essential relationship between the Gallery and the University. Transferred from Sibley Library, they formed a "Hall of Casts" at the Gallery—a typical and traditional feature of many American museums of that period. Later, as the permanent collection grew, they presented an increasingly difficult installation problem. The wings of the two Nikes, for example, cast disturbing and alien shadows across many a twentieth-century landscape! In 1939 the casts were given to the city schools and their going marked the end of reproductions in the permanent collection, save for a few later replaced architectural and sculptural elements in the 1926 building addition.

Like the four plaster casts, the group of American paintings which came to the Gallery that first year—among them works by Jonas Lie, Horatio Walker, and Willard Metcalf—are also symbolic, anticipating the Gallery's later emphasis on American nineteenth- and early twentieth-century art. They manifested, too, the munificent generosity of the Watson-Sibley families, which happily has continued through three generations. Mr. and Mrs. James Sibley Watson, Mr. Hiram Sibley (Mrs. Watson's brother), Mrs. John Gade and Mrs. Ernest R. Willard (Mrs. Watson's nieces), and Mrs. Granger A. Hollister (Mr. Watson's sister) were among those early donors. James G. Averell, Mrs. Watson's architect son, in whose memory the Gallery was created, was also represented in that first year by an excellent collection of old master prints he had purchased in Europe, which his mother presented in 1913, thereby founding the Gallery's outstanding print department.

Unfortunately, at the time of the Gallery's founding, there were no extensive or significant private art collections in Rochester of the sort that had so often led to the forming of an art museum in other American cities. The city's early private collections had long since disappeared: the Hiram Sibley "Rochester Academy of Art" paintings either sold to Daniel Powers or divided among Sibley relatives; the Powers Gallery and the William Kimball collections auctioned in New York; and the Charles W. Green collection of nineteenth- and early twentieth-century American paintings later dispersed in Chicago. There were, however, important paintings owned in the city, as frequent summer loan exhibitions in the Gallery revealed. Many of these, such as Hiram Sibley's Gérôme, George Eastman's Inness, Fletcher Steele's Vuillard and Rouault, and the Watsons' Monets later found permanent places on the Gallery walls through gifts and bequests.

For more than a quarter of a century, the Gallery had no acquisition funds with which to realize its cherished dream of presenting a general survey of the vast span of art from prehistoric to contemporary times. It was soon discovered that no consistent accession plan could be achieved solely through gifts, for a donor's special interests and tastes had always to be considered. Happily, the subtle (and, perhaps, at times, not so subtle!) urgings on the part of the curatorial staff often resulted in the acquisition of a much needed and wanted treasure. From such sources have come Dancers by Edgar Degas, a thirteenth-century French stone sculpture of St. Mary Magdalene, and a Tang Dynasty Guan-yin from the cave temples of Long-Men, gifts of Mrs. Charles H. Babcock; and a group of figures from Han, Tang, and Song tombs given by James Sibley Watson.

But on the whole, the growth and scope of the Gallery's collections during the first thirty years depended primarily on individuals' gifts and bequests. Fortunately, Gallery donors were generous, knowledgeable, and numerous; unhappily, they are all too numerous to be recorded here. Among the major donors in recent years are Dr. and Mrs. James T. Adams, Dr. Ralph Alexander, Mrs. Charlotte Whitney Allen, Dr. and Mrs. James Aquavella, Dr. James B. Austin, Miss Helen Ellwanger, Dr. and Mrs. George Ford, Dr. and Mrs. Fred Geib, Mr. and Mrs. Edward Harris, Mr. and Mrs. Thomas Hawks, Mr. and Mrs. Julius G. Kayser, Dr. and Mrs. Frank Lovejoy, Jr., Professor and Mrs. Howard Merritt, Mr. Charles Rand Penney, Dr. and Mrs. Bernard Schilling, Mr. and Mrs. Daniel C. Schuman, Mr. and Mrs. Arthur Stern, Mrs. Richard Turner, Mr. and Mrs. Herbert W. Vanden Brul, Judge and Mrs. John Van Voorhis, Dr. and Mrs. Michael Watson, the Norry family of Rochester, and the Iselin family of New York. Outstanding among a group of anonymous donors is the discriminating and most generous patron whose continuing gifts of

prints and drawings have added the work of such major masters as Rembrandt, Cézanne, Mantegna, Gauguin, Toulouse-Lautrec, Schongauer, Goya, and Winslow Homer.

In 1939 the Marion Stratton Gould Fund, bequeathed by Mrs. Samuel Gould in memory of her young daughter, made it possible for the Gallery, for the first time in its history, to carry out the long-planned development of its collection. The first purchase from the Gould Fund was El Greco's *Vision of St. Hyacinth,* which was first seen in the Gallery as part of the special loan exhibition "Precursors of Modern Art." The succeeding Gould Fund accessions, spanning a wide range of periods and schools, reflect the same high quality and historic importance of that first purchase. The Gould Fund is still the Gallery's ranking accession fund.

A series of exhibitions, featuring room interiors that reflected the patterns and objects of life in eighteenth- and nineteenth-century

Memorial Art Gallery, ca. 1913.

Rochester and the Genesee country, first attracted to the Gallery Mr. R.T. Miller, Jr., publisher, educator, successful business entrepreneur, and gentleman farmer from nearby Scottsville. Beginning in 1940 and continuing until his death in 1958, Mr. Miller gave recurring funds that made possible the purchase of a treasure trove of art objects. They range widely in period and provenance—from the impressive marble figure of St. Catherine by the Sicilian Renaissance sculptor Antonello Gagini, formerly in the Cathedral of Palermo, to a rare pair of nineteenth-century heron decoys from Long Island or the New Jersey shore; from an Assyrian alabaster relief panel of the ninth-century B.C. palace of Ashur-nasir-apal II to the bronze *Ile de France* by twentieth-century sculptor Maillol; and from a first-century Roman sarcophagus

to a collection of American Colonial, Federal, and early Empire furniture. Resources of the fund were used to develop widely representative coverage of American folk art and collections of pre-Columbian and African art.

In 1949, with moneys from both the Gould and the Miller funds, a collection of sculpture, paintings, and decorative objects were acquired at auctions from the famed sale of the Joseph Brummer collection in New York. Practically every part of the Gallery's collection, from Babylonian to Baroque, was enriched. A thirteenth-century polychromed and carved console depicting *Doubting Thomas,* from the church of Saint-Martin-de-Candes, France, was possibly the most significant addition of all.

Special funds for the purchase of art objects have played—and continue to play—a vital role in the growth of the collection. Beginning with the Hollister Fund for prints and drawings established in 1938, the Chester Dewey Fund, and the Marie Devine Fund for medieval art, they have assured not only the steady growth of the collection, but also its high quality. More recently, the Joseph C. Wilson Memorial Fund, established in 1971 and contributed to by over two hundred associates and friends of the late head of the Xerox Corporation and long-time member of the Gallery's Board of Managers, made possible the acquisition of a monumental and dramatic bronze, *Working Model for Three Piece No. 3: Vertebrae,* by Henry Moore. Nine drawings in ink, watercolor, and gouache, spanning the years 1923 to 1972 and selected by the sculptor himself, were also acquired with the Wilson Fund.

The most recent and second-largest purchase fund in the Gallery's history was announced in 1980: the Clara and Edwin Strasenburgh Fund. Its first acquisition was an important and summarizing work of the eighteenth-century Venetian painter Francesco Guardi, *San Giorgio Maggiore, Venice,* a luminous and lively view of that impressive Palladian church seen across the sparkling waters of the Giudecca.

Although the Gallery was woefully slow in acquiring purchase funds to add to its collections, it was fortunate, on the other hand, in the number and quality of the many private collections that came its way, beginning in 1928 with the Herbert C. Ocumpaugh collection of Egyptian, Near Eastern, and classical material from Predynastic to Roman times. The Gallery also acquired the Oothout collection of

Delftware of the seventeenth to nineteenth centuries; the Mrs. Henry Strong collection of Northwest Indian baskets and artifacts; the Ida Lynch and Edith A. Babcock collections of European and American prints of the seventeenth to twentieth centuries; the Antoinette P. Granger bequest of American nineteenth-century furniture, paintings, sculpture, and decorative objects; and the Edith H. Woodward collection of American, English, and European silver of the seventeenth to nineteenth centuries. A dramatic chapter in the Gallery's history was added in 1951 when the Frederic P. Morgan collection, with its excellent surveys of Roman and Near Eastern glass, a rare pair of early Mycenaean kraters, Egyptian and Classical sculpture, and Persian ceramics, was "rediscovered" on a hot summer's day in the upstate Finger Lakes home of the Morgan family, after more than a half century of near oblivion. The collection had been assembled by Frederic P. Morgan, during his tenure as American consul in Egypt, with the

Isabel Herdle and building superintendent Raymond Pike install the George Eastman Collection at the Gallery in October of 1948.

help of his good friend G. C. C. Maspero, the famed Egyptologist.

Finally, ranking next in size to the 1928 Ocumpaugh collection, the Charles Rand Penney collection of contemporary prints, drawings, sculptures, and watercolors, which came to the Gallery in 1975, added over three hundred major works by the leading artists of this century. Selected with the donor's discrimination and connoisseurship, the Penney gift at once impressively raised the Gallery's holdings of twentieth-century art.

The University of Rochester, too, played an important role in the story of the collection. Very early in the Gallery's history, the University presented the excellent collection of old master prints assembled by its first president and fine arts lecturer Martin Brewer Anderson. Later, and of greater importance, was the bestowal of the George Eastman collection. Seventeenth- and eighteenth-century Dutch, Flemish, and English paintings, bequeathed to the University by Mr. Eastman, represent such masters as Rembrandt, Hals, van de

Cappelle, Van Dyck, and Reynolds. The University's legacy from the Bertha Buswell-Ralph Hochstetter estate filled many gaps in the Gallery's holdings with Dutch paintings and European decorative arts of the seventeenth to the nineteenth century.

In 1950 the close personal friendship of Alan Valentine, late president of the University, with former Senator William Benton, then chairman of the Encyclopaedia Brittanica, resulted in the purchase through the Marion Stratton Gould Fund of selections from the Encyclopaedia Brittanica collection of twentieth-century American paintings. Among them were works by Stuart Davis, Arthur Dove, Georgia O'Keeffe, Thomas Hart Benton, Walt Kuhn, John Marin, Ralston Crawford, and John Sloan.

Finally, a new and especially welcome source for acquisitions is the generous gift of purchase funds from the Gallery's lively and vitally supportive Women's Council. Long a power behind the annual membership campaigns, docent program, Creative Workshop budgets, and countless fund-raising galas and travel tours, the Women's Council now has become an art donor as well. Beginning in 1970 with a pair of wall hangings designed by Fernand Léger and Alexander Calder, presented to the Gallery for the very unartistic purpose of deadening sound vibrations in the Conference Room, the Women's Council has since made possible the acquisition of significant work by such diverse artists as Asher Durand, Angelica Kauffmann, Hyacinthe Rigaud, Rachel Ruysch, Helen Frankenthaler, and Lilly Martin Spencer.

There is a final group of Gallery "treasures" that, perhaps, should have begun this story of the collections. These—totally unaccessioned but gold labeled!—are the devoted people who as staff, Gallery Board of Managers and volunteers, University of Rochester art and art history faculty, have shared in the forming of the permanent collection and its interpretation through the years. The Gallery has been fortunate indeed to have had their expertise and scholarship, their uncounted hours of service, and their enthusiastic support.

May the Gallery's next seventy-five years bring an equally rich harvest of treasures and people!

Gertrude Herdle Moore, Director Emeritus
Isabel C. Herdle, Curator Emeritus

CONTENTS

ANCIENT ART

EGYPTIAN, NEW KINGDOM,
18TH DYNASTY

Standing Figure of the Finance Minister Maya, ca. 1300 B.C.
Limestone, h. 33½", w. 10¼"
R. T. Miller Fund, 42.55

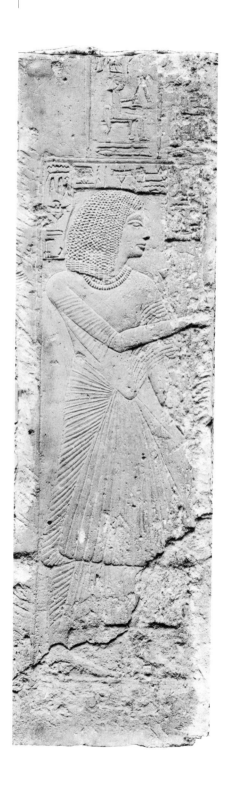

Ancient Egyptian art is often described as hieroglyphic because the tenets that governed the forms of the individual hieroglyphic signs also governed the outlines of two-, and by extension, three-dimensional representations. According to these principles, the scribes and the artists were required to represent objects from their most characteristic point of view. A turtle, for example, would be shown from a bird's-eye view so that its shell and fully extended head, tail, and feet would be completely visible. On the other hand, most fish were shown in profile because that view contained all of the visual information necessary for its identification.

This relief is an extremely fine demonstration of that fundamental principle of Egyptian art. Looking directly over the head of Maya, the name of the man in this relief, to the one vertical column of signs, the viewer sees a hieroglyph that represents a seated male figure holding a flail. The most characteristic view of a human face is the profile (as found on coins of all nations). The human eye, however, is most recognizable in the frontal view, so that image is incorporated into the design of the profile face. The system was followed for the depiction of the entire human body, the torso represented from the front view, the feet in profile. With this system in mind, we can compare the hieroglyph and the figure of Maya and understand that the conception of both is identical.

Throughout the nearly four thousand years of Egyptian civilization, scribes and artists, while adhering to the principles of this system of representation, nevertheless altered or modified certain details in such a way that distinct artistic styles, associated with specific chronological epochs, developed. Here Maya is shown wearing an elaborate wig, the individual curls of which are tied at their ends. His facial features are distinctive, particularly his aquiline nose and strong chin. His accessories include two collars of disk beads, representing the "gold of honor," with which pharaohs of the period rewarded distinguished administrators. His fashionable costume includes bolero sleeves and an elaborately pleated kilt and apron. The delicacy of the sculpting is evident in the emergence of the forearms from beneath the gossamer material of the shirt and in the contour of the body at the hips.

This relief once decorated the Tomb of Maya at Saqqara and was recorded in the nineteenth century by Richard Lepsius, the renowned German Egyptologist, who with his team studied the tomb. Their published drawings of the exterior south side of the entrance to the so-called antechamber of the tomb show this relief in place.[1] It subsequently entered the possession of Lord Amherst, who amassed one of the finest collections of Egyptian antiquities in the nineteenth century. One suspects that Giovanni Anastasi, a wealthy merchant who ran a collateral business in antiquities, was originally responsible for its removal because other parts of this tomb can be traced to him. The sands of the desert eventually engulfed the tomb and its exact location was lost until 1986 when the tomb was rediscovered by the joint team of the Rijksmuseum van Oudheden in Leiden, Holland, and the British Egypt Exploration Society.[2]

The results of future planned excavations of this tomb will reveal more about Maya, the son of Iwy and Werit, who rose successively through the administrative ranks of Egypt until he became the Overseer of the Royal Treasury, serving the pharaohs Tutankhamun, Ay, and Horemhab and supervising the preparation of the tombs of Tutankhamun and Ay in the Valley of the Kings. An inscription, today in Liverpool, tells us that Tutankhamun himself commanded Maya to journey from Aswan in the south to the shores of the Mediterranean to levy taxes to establish offerings for all the gods of Egypt.[3]

RSB

1. Erhart Graefe reproduced drawings from Richard Lepsius's study in "Das Grab des Schatzhausvorstehers und Bauleiters Maya in Saqqara," *Mitteilungen des Deutschen Archaeologischen Instituts, Abteilung Kairo* 31, no. 2 (1975), pp. 187-220.

2. M. J. Raven, "De herontdekking van het graf van Maya," *PHOENIX—Bulletin uitgegeven door het Vooraziatisch-Egyptisch Genootschap Ex Oriente Lux* 32, 2 (1986), pp. 47-57; and pp. 63-64.

3. Amin A. M. A. Amer, "Tutankhamun's Decree for the Chief Treasurer Maya," *Revue d'Egyptologie* 36 (1985), pp. 17-20.

PROVENANCE:
Saqqara, Egypt, from the Tomb of Maya; (possibly Giovanni Anastasi?); Lord Amherst; Sotheby's, London, June 13–17, 1921, no. 193, pl. 5; acquired from Professor Vladimir Simkhovitch.

LITERATURE:
W. Helck, *Urkunden der 18. Dynastie,* vol. 21, Berlin, 1958, p. 428, no. 849; W. Helck, *Urkunden der 18. Dynastie—Uebersetzung zu den Heften* 17-22, Berlin, 1961, no. 2170-2171; E. Graefe, "Das Grab des Schatzhausvorstehers und Bauleiters Maya in Saqqara," *Mitteilungen des Deutschen Archaeologischen Instituts,* Abteilung Kairo 31, no. 2 (1975), pp. 187-220; E. Graefe, "Ein wiederaufgetauchtes Relieffragment aus dem Grabe des Maya in Saqqara," *Mitteilungen des Deutschen Archaeologischen Instituts, Abteilung Kairo* 33 (1977), pp. 31-33, fig. 6; B. Porter and R.L.B. Moss, *Topographical Bibliography of Ancient Egyptian Hieroglyphic Texts, Reliefs, and Paintings,* Vol. 3, 2nd ed., revised by J. Málek, Oxford, 1979, pp. 661-663; E. Graefe, "A Relief Fragment from an Egyptian Tomb of the Late Eighteenth Dynasty," *Porticus* 4 (1981), pp. 1-8; Amin A. M. A. Amer, "Tutankhamun's Decree for the Chief Treasurer Maya," *Revue d'Egyptologie* 36 (1985), pp. 17-20; M. J. Raven, "De herontdekking van het graf van Maya," *PHOENIX—Bulletin uitgegeven door het Vooraziatisch-Egyptisch Genootschap Ex Oriente Lux* 32, no. 2 (1986), pp. 47-54, 63-64.

Kraters with Chariot Motif, ca. 1300–1225 B.C.
Terracotta, 51.203: h. 18½″, d. 15½″ (left)
 51.204: h. 17¼″, d. 14⅛″ (right)
R. T. Miller Fund, 51.203 and 51.204

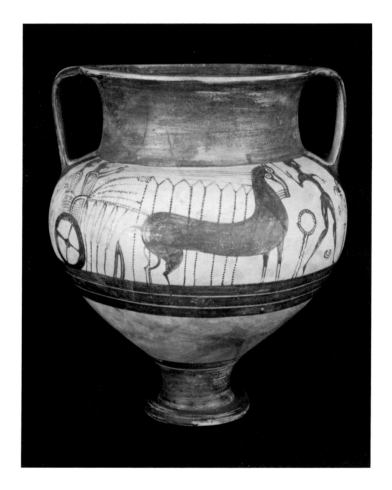

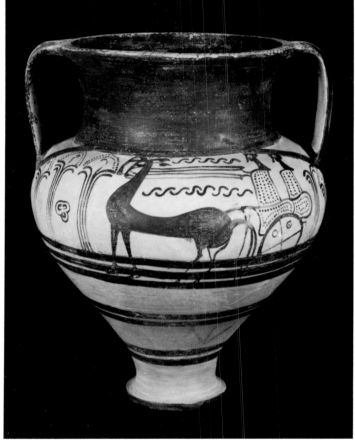

These two ceramic vessels, which were excavated by the British in 1896 on Cyprus, have been labeled at various times Mycenaean, Levanto-Mycenaean, and Cypro-Mycenaean, indicating the problematic interpretation of their origins. Their shape and decoration suggest that they were made by artists from the mainland Greek Mycenaean culture, but where these artists studied and worked—in the Levant, on the Peloponnesus, or on Mycenaean Cyprus itself—is still being debated. The question remains whether these vessels were part of an export trade, or whether the artists established workshops at the newly settled Mycenaean trading posts.

The Mycenaeans were the dominant power in the eastern Mediterranean by the thirteenth century B.C. Obsessed with war and fortifications, their fortresslike architecture is characterized by stone blocks and walls of massive proportions. They decorated their homes, palaces, and objects with battle and hunting scenes. Depictions of soldiers dressed in armor were common in wall and ceramic paintings. These preoccupations parallel the development of new types of bronze weapons, such as swords, daggers, knives, and spearheads. This age of war and heroism, when rulers lived in sumptuous stone palaces surrounded by luxurious objects of ivory, gold, and other precious materials, may have been the period of the Trojan war celebrated in Homer's *Iliad* and *Odyssey*.

These kraters, or vessels used for the mixing of wine and water, are decorated with images of the chariots that were driven in chase, war, or ceremonial processions. The chariot's body was probably made of wicker and placed on a fixed axle with four-spoked wheels; it was usually pulled by two horses. In these painted examples, two men stand in the driving compartments. In the larger krater (51.203), a wasp-waisted man walks in front of the horses brandishing a stick. A pair of horses pulls each chariot, but only one body is shown for each pair. Each body, however, has two tails and two thin, elongated heads with two large eyes. The humans are drawn within a double outline filled with dots, and their silhouetted heads are also dominated by a single eye each. The friezelike processional is repeated on both sides of the krater.

The simplification and stylization of realistic details in these kraters are formal characteristics typical of the late thirteenth century B.C. The calligraphic flow of the brush demonstrates the ease with which the ceramists decorated both pieces. Similar though these kraters are, there are subtle stylistic differences, suggesting that they may have been made several decades apart. The krater decorated with long-stemmed flowers and palms and the horses with long tufted manes (51.204) may be the older of the two. The increased abstraction of the horses' manes and summarily indicated landscape details suggest a later date for the other vessel (51.203).[1]

RR

1. Karageorghis and Masson, "Two Mycenaean Chariot Craters," pp. 168, 172.

PROVENANCE:
Excavated in 1896 on Cyprus; Joseph Clark Hoppin, 1896?; Frederic Morgan, Cairo, Egypt, and Aurora, NY.

LITERATURE:
V. Karageorghis and O. Masson, "Two Mycenaean Chariot Craters at Rochester, U.S.A.," *Bulletin de correspondance helléninque* 93, no. 1 (1969), pp. 162-173, figs. 1-9; S. A. Immerwahr, "Three Mycenaean Vases from Cyprus in the Metropolitan Museum of Art," *American Journal of Archaeology* 49 (October/December 1945), pp. 534-556.

EXHIBITIONS:
MAG, "Frederic Morgan Collection," 1952; Baltimore, Walters Art Gallery, "Minoan and Mycenaean Art," 1964 (51.203 only).

Herzfeld Pyxis
Porphyry (?), h. 2 $\frac{3}{16}$″, diam. 3 $\frac{3}{8}$″
R. T. Miller Fund, 49.14

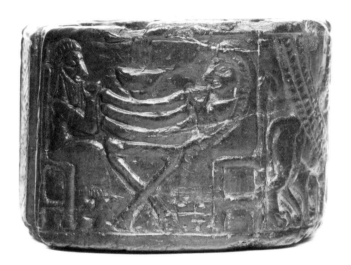

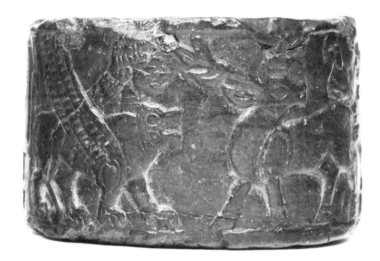

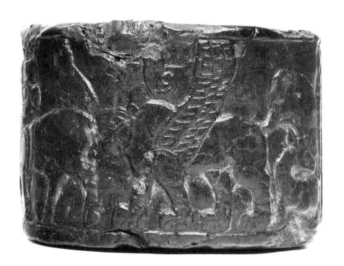

The *Herzfeld Pyxis,* named for its first owner, is the best preserved of a small group of similar stone relief carvings. Two excavated examples are known from Carchemish in North Syria; in addition the Cleveland Museum of Art and the Museum of Fine Arts, Boston, each have one. On the basis of style and iconography, all appear to have been North Syrian or "Syro-Hittite" in origin, and to date generally to the ninth and eighth centuries B.C. The Gallery's example, like the others, reflects monumental carving in stone, as found in the architectural sculpture at Carchemish, Zincirli, and Tell Halaf.

Carved from a single piece of stone, the pyxis is cylindrical, with four roughly triangular compartments inside. The circular borings on the top edge and upper wall opposite (the latter still containing the remnant of a metal pin) were for the attachment of a lid.

On the body of the vessel, and aligned with the hole in the top, is a narrow, vertical strip incised with a basket-weave design and flanked by channels. The remaining circumference of the pyxis bears two figural scenes of unequal width, carved in low, flat relief. At the left, two diners sit at a cross-legged table laden with stylized loaves of bread held down by a bowl. The diner at the right, a woman holding a cup to her mouth, wears an undergarment and a fringed veil extending from head to ankles. Her partner, whose upper body is restored in tinted wax, is dressed in a long, fringed robe. (The figure has no doubt been correctly restored as a man.) Both wear shoes with upturned toes.

In the wider scene at the right, two sphinxes approach a stag from either side. The stag proceeds to the left, his head turned to view a plump bird perched on his back. A small antelope lies in the far right corner. The sphinxes have the leonine bodies and wings that are common for the type in Near Eastern art, but each also has, in addition to the customary human head, a lion's head, which makes them hybridized versions of an already fabulous creature. The sphinx at the right, and perhaps its partner, bears a third head, that of a bird of prey, at the end of its tail. The different hairstyles of the two mythical animals might indicate that they are male and female.

Although the latter scene lacks real action because of the quiet, mannered poses, it is possible that the sphinxes are moving in for a kill, and that the bird perched on the stag, if a vulture or buzzard, is a gloomy portent to its host. The antelope at the left may be no more than a device for filling space, if the carver worked from left to right and found himself with excess at the end.

The significance of the scenes on the *Herzfeld Pyxis,* as well as the purpose or function of this type of object, is not clear. The banqueters, found also on other pyxides and monumental sculpture, could be either human or divine, while the encounter between sphinxes and stag is surely connected somehow with the otherworldly. Both scenes convey messages of nourishment, as do those on other examples of the type, and it is possible that the special shape, with its inner compartments for substances in small portions, played some role in ritual dining or provided sustenance for the deceased in the afterlife. (A plain, ivory example was found in a grave at Tell Halaf in North Syria.)

Whatever its purpose or significance, the *Herzfeld Pyxis* is a minor treasure of the Gallery, serving well to illustrate the style and iconography of an artistically prolific and singular ancient society, one whose products are generally not well represented in North American museums.

GKS

PROVENANCE:
Purchased by the Orientalist Ernst Herzfeld in Baghdad in the late 1920s; Joseph Brummer, New York, 1944; Brummer sale, Parke-Bernet Galleries, New York, part 1, April 20–23, 1949, lot 56.

LITERATURE:
Ernst Herzfeld, "Hettitica," *Archäologische Mitteilungen aus Iran* 2 (1930), pp. 132-135; Margarete Riemschneider, *Die Welt der Hethiter,* Stuttgart, ca. 1954, pl. 104; Oscar White Muscarella, "Near Eastern Bronzes in the West: The Question of Origin," *Art and Technology: A Symposium on Classical Bronzes,* ed. S. Doeringer et al, Cambridge, MA, 1970, p. 120, fig. 11; Winfried Orthmann, *Untersuchungen zur Späthethitische Kunst,* Bonn, 1971, p. 553 and pl. 70, c-f; Arielle P. Kozloff, "Three Ancient Near Eastern Celebrations and a Guest of Honor," *Bulletin of the Cleveland Museum of Art* 61, no. 1 (January 1974), pp. 14-18, figs. 7-10; G. Kenneth Sams, "The Herzfeld Pyxis: North Syrian Sculpture in Miniature," *Porticus* 3 (1980), pp. 1-12.

ROMAN, 2ND CENTURY A.D.

Togatus (*Consul*)
Marble, h. 68¼″ with plinth, max. w. 30⅜″, d. 22½″
Marion Stratton Gould Fund, 73.146

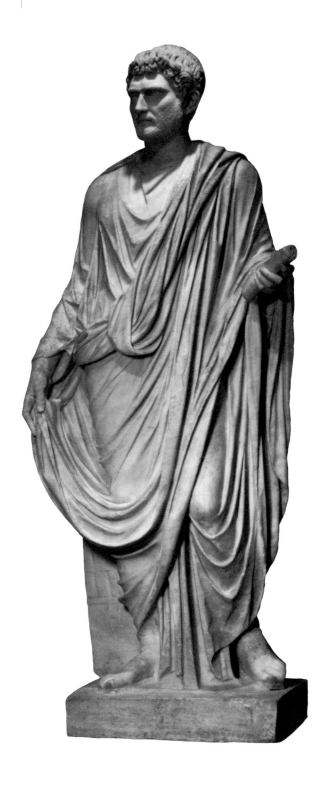

This white marble toga-clad figure, called a togatus, which was buried for centuries in Rome, was described in a nineteenth-century text, *Ancient Marbles in Great Britain,* as "a Roman Consul in the act of speaking."[1] In his left hand, he holds a scroll; a box of scrolls behind the right leg partially supports him. He holds in his right hand an edge of the toga that sweeps down in deep folds to the knee before rising to the left shoulder.

Over time the *Togatus* suffered a number of injuries. The statue's head broke off in a fall but was repaired in antiquity with a metal dowel set in a lead-filled socket. The line of breakage and the ancient repairs prove that head and body were carved from a single piece of marble. The nose, an oval at the back of the head, and the left knee were also repaired with metal dowels. The left knee was broken into three parts but is now restored, along with the fragile overlapping folds of thin marble of the toga.[2]

The style of the toga and its carving are similar to the style of first-century togate figures in the Virginia Museum of Fine Arts in Richmond and the Walters Art Gallery in Baltimore. The stylistic handling of the head, however, does not date from the first century; the drillwork technique evident in the hair does not appear until the Antonine period in the second century. It is possible that the statue is an early Antonine work (ca. A.D. 140) and that the head was reworked later in the century or perhaps in the Severan age (third century).[3]

The collecting of ancient sculpture was begun in England in the early seventeenth century by the Earl of Arundel, who was the first to bring a significant collection of antique marbles back to England from Italy. After the discoveries of Herculaneum in 1738 and Pompeii in 1748, Englishmen on the grand tour began acquiring ancient marbles, mosaics, vases, and terracottas. To display their collections, many built sculpture galleries in their great country houses.

This statue was purchased in 1829 by the Duke of Buckingham in Italy and was probably shown in the oval "saloon" of his country estate, Stowe. When the Stowe collections were sold in 1848, the Duke of Hamilton acquired this *Togatus* for his palace in Lanarkshire, Scotland.

SES

1. Michaelis, *Ancient Marbles,* pp. 157-158, pp. 300-301.

2. Joseph Ternbach, "Summary of the Restoration of Roman Marble Togatus," January 25, 1975 (conservator's report in MAG archives).

3. Letter to author from C. C. Vermeule and M. Padgett, July 30, 1986.

PROVENANCE:
Purchased in Italy by the Duke of Buckingham in 1829 for Stowe House; acquired at Stowe sale in 1848 by the Duke of Hamilton for Hamilton Palace, Lanarkshire, Scotland; Spink and Son, Ltd., London, 1927; Joseph Brummer sale, Parke-Bernet Galleries, New York, May 11–14, 1949, lot 208A; Mr. and Mrs. Norman Armitage, 1949–1973.

LITERATURE:
Adolf Theodor Friedrich Michaelis, *Ancient Marbles in Great Britain,* Cambridge, 1882, pp. 157-158, pp. 300-301; H. R. Forster, *The Stowe Catalogue,* London, 1848, p. 265; *Antiquarian Quarterly,* 1925, p. 100, pl. 10; *Burlington Magazine,* January 1927, p. 34; C. C. Vermeule, "Notes on a New Edition of Michaelis, *Ancient Marbles in Great Britain,*" *American Journal of Archaeology* 59, no. 1 (January 1955), p. 135; Betsy Brayer, "Consulus Togatus Prevenit," *Scene* 5 (summer 1974).

Head of Tethys, 3rd century A.D.
Marble, stone, and glass, 49 ⅞ x 82 ⅞ ″
University of Rochester Appropriation, 42.2

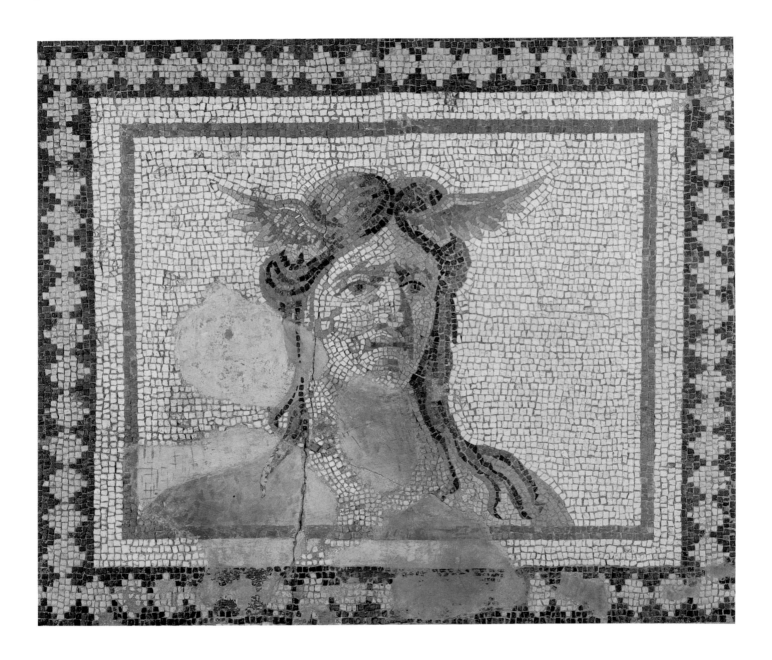

This mosaic was found during 1939 in excavations at Daphne, a suburb of Antioch, formerly Syria, today part of Turkey. Antioch, capital of the Roman province of Syria, was one of the most important cities of the ancient world. During the third century A.D., the residences of the wealthy were decorated with floor mosaics of high quality, which were sometimes geometric, sometimes figural, in design. Most of the figural mosaics excavated at Antioch were placed in front of doorways, while geometric panels were spread like carpets through corridors. Similar mosaics found in fully excavated buildings indicate that this mosaic lay in a corridor with the head of Tethys probably facing the doorway of a room.

Tethys was the wife of Oceanus, the god whose waters encircled the world; she may have been regarded as a fertility goddess. The features, highlights, and shadows of her face are all created illusionistically from small stone tesserae in a limited range of colors. Her monumental, sober features depart from the relative lightness of many decorative mosaics from Antioch. The head is flanked by two panels of geometric design; all are surrounded by a step-pyramid framing motif, which is typical of the region, and a border of broad red bands.

The *Head of Tethys* and a smaller companion panel in the collection, *Birds and Flowers* (42.3), are evidence of the luxurious decoration of villas at Antioch during the late antique period. The structure in which the pieces were found has been extensively modified and damaged. Determination of the precise original location of the mosaic in the building is, therefore, now impossible. Despite some losses of tiles, which have been filled in, the *Head of Tethys* is a well-preserved example from the greatest period of Roman mosaic art.
DR

PROVENANCE:
Excavated in 1939 by a combined archaeological team from Princeton University, the Worcester Art Museum, Wellesley College, the Baltimore Museum of Art, Dumbarton Oaks Research Library and Collection, and the Musées Nationaux de France.

LITERATURE:
W. A. Campbell, *Antioch-on-the-Orontes,* vol. 3, ed. Richard Stillwell, Princeton, 1941, p. 203, no. 161A, pl. 77; Dorio Levi, "Two Mosaic Pavements from Antioch," *Antioch Mosaic Pavements,* Princeton, 1947, p. 222; Frances F. Jones, "Antioch Mosaics in Princeton," *Record of the Art Museum, Princeton University* 40, no. 2, 1981, ill. p. 22; John J. Dobbins, "Mosaics from Antioch," *Porticus* 5 (1982), pp. 8-14, figs. 2, 2a, 4.

EGYPTIAN, SAQQARA, OLD KINGDOM,
FIFTH DYNASTY, CA. 2450–2350 B.C.

Relief from the Tomb of Metetu
Stone, 10⅜ x 25½ x 1⅞"
Gift of a Friend of the Gallery, 73.64

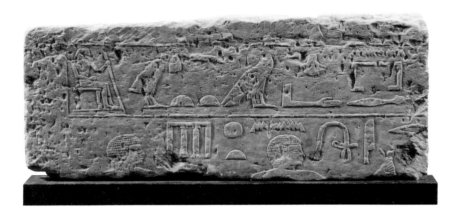

EGYPTIAN, COPTIC, 5TH–6TH CENTURY A.D.

Textile Ornamented with Fish and Flying Figures Bearing Gifts
Wool and linen, 12 x 11¾"
R. T. Miller Fund, 49.32

ETRUSCAN, 5TH CENTURY B.C.

Warrior
Bronze, 5⁵⁄₁₆ x 2⅜ x 1¾"
R. T. Miller Fund, 53.41

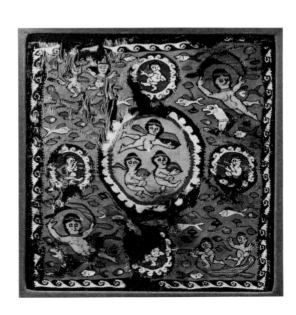

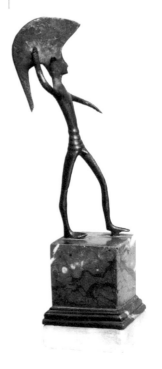

EGYPTIAN, MEMPHIS (EXCAVATED AT KARNAK),
OLD KINGDOM, 5TH DYNASTY, CA. 2450–2350 B.C.

Portrait of King Ny-user-ra (ruled 2370–2360 B.C.)
Red granite, 11⅜ x 9¼ x 6⅜″ (top); 32⅛ x 9⅜ x 15⅜″ (whole: lower portion is a cast of the fragment in Museum of Egyptian Antiquities, Cairo)
R. T. Miller Fund, 42.54

GREEK, GEOMETRIC PERIOD, 8TH CENTURY B.C.

Horse
Bronze, 3⅛ x 3¼ x 1¼″
R. T. Miller Fund, 53.43

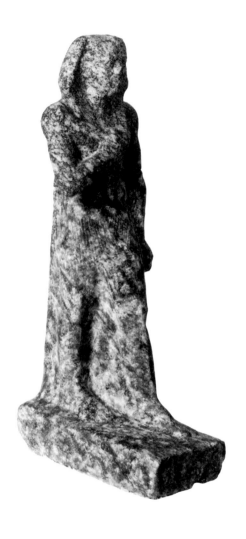

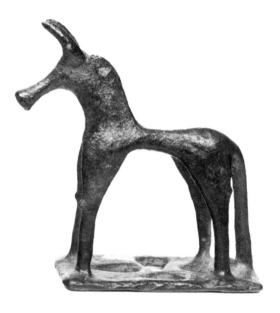

GREEK, ATTICA, LATE 6TH CENTURY B.C.

Lekythoi
Terracotta with paint, each 4¾ x (diam.) 2″
University of Rochester Appropriation, 29.87.1 (left) and 29.87.2 (right)

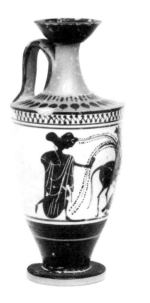
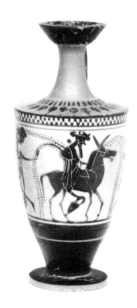

GREEK, BOEOTIA?

Protome, ca. 450–425 B.C.
Terracotta with polychrome, 14¼ x 11⅝ x 3⅝"
June Alexander Memorial Fund and Tribute Fund, 88.5

GREEK, EARLY 6TH CENTURY B.C.

GREEK, EARLY 6TH CENTURY B.C.

Black-Figure Kylix with Dionysian Revelers
Terracotta with paint, 3 x 8 (diam.) x 10⅜" (with handles)
University of Rochester Appropriation for the
C. Herbert Ocumpaugh Collection, 29.90
(Bottom: detail of exterior)

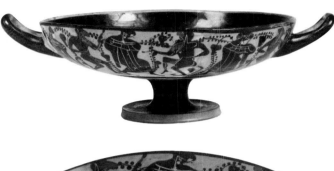

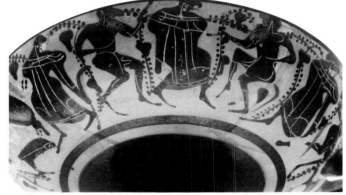

GREEK, 2ND–1ST CENTURY B.C.

Tyche
Marble, 11⅜ x 8½ x 10¼"
R. T. Miller Fund, 49.73

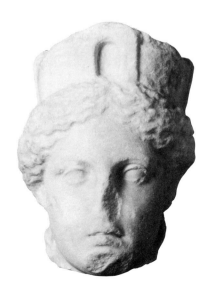

ASSYRIAN, NIMRUD (KAHLU, IRAQ)
(EXCAVATED AT NORTHWEST PALACE OF
ASHUR-NASIR-APAL II
[RULED 883–859 B.C.], ROOM I)

Kneeling Figure of a Winged Genius, ca. 865–860 B.C.
Alabaster, 30 x 25⅝"
R. T. Miller Fund, 44.10

GREEK, ATTICA (EXCAVATED AT SALAMIS)

Grave Stela, 400–375 B.C.
Marble, 28 x 18¾ x 4½"
Helen Barrett Montgomery Bequest, 36.54

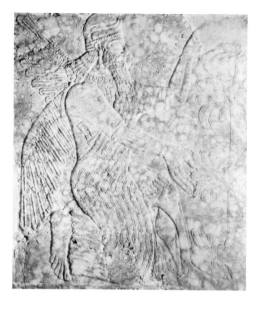

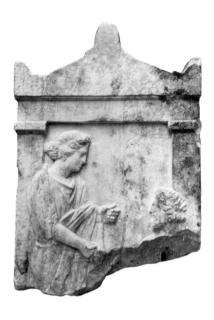

MESOPOTAMIAN, TELLO?, CA. 1900–1800 B.C.

Bearded Male Figure Holding a Goat
Terracotta, 3 x 2½ x 1"
R. T. Miller Fund, 45.60

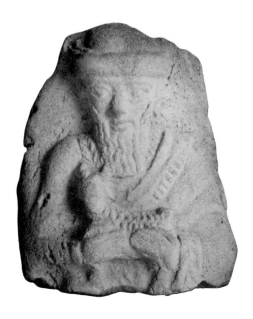

ROMAN, THIRD QUARTER OF 2ND CENTURY A.D.

Male Head
Marble, 11⅜ x 7⅞ x 8¹¹⁄₁₆"
R. T. Miller Fund, 46.39

ROMAN, POMPEII

Cupid Holding a Mask, ca. A.D. 63–79
Fresco, 8 x 5¼
Gift of Herbert C. Ocumpaugh, 28.75

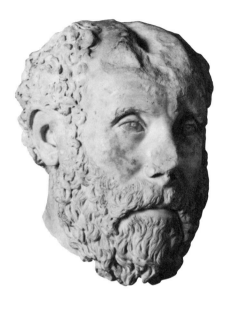

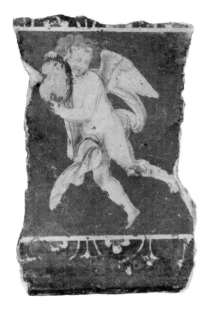

PERSIAN, ACHAEMENID PERIOD, 650–330 B.C.

Tribute Bearer, ca. 518–465 B.C.
Stone, 22½ x 13"
R. T. Miller Fund, 44.1

ROMAN, LATE 1ST CENTURY B.C.

Torso of a Young Man
Marble, 25 x 13⅝ x 9¹⁄₁₆"
Ocumpaugh, Babcock, Dewey, and Montgomery funds, 36.53

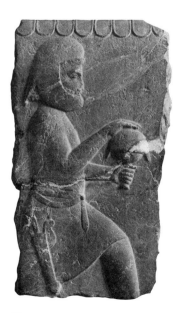

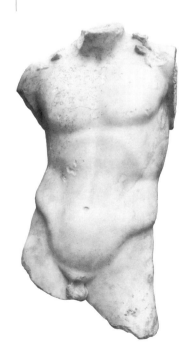

ROMAN, THIRD QUARTER OF 3RD CENTURY A.D.

Sarcophagus with Portrait Medallion, Orpheus, and Two Lion Heads
Marble, 19½ x 71 x 19½"
R. T. Miller Fund, 49.72

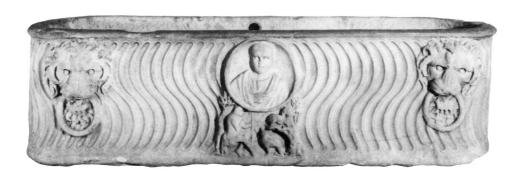

ROMAN, ROME, LATE 3RD TO 4TH CENTURY A.D.

Sarcophagus with Fisherman, Good Shepherd, and Two Griffins
Marble, 18½ x 74¼ x 22"
R. T. Miller Fund, 43.34

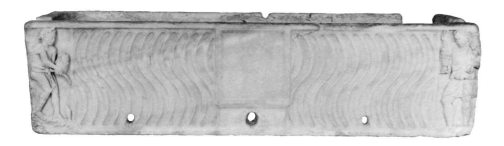

CONTENTS

EUROPEAN ART

EUROPEAN ART 1100–1400

Angel
Limestone, 34 ½ x 18 ⅞ ″
R. T. Miller Fund, 43.35
(Left)

Apostle
Limestone, 33 x 13 ¾ ″
R. T. Miller Fund, 49.6
(Right)

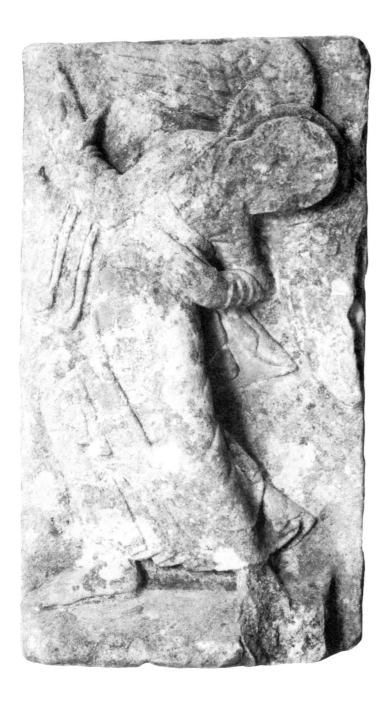

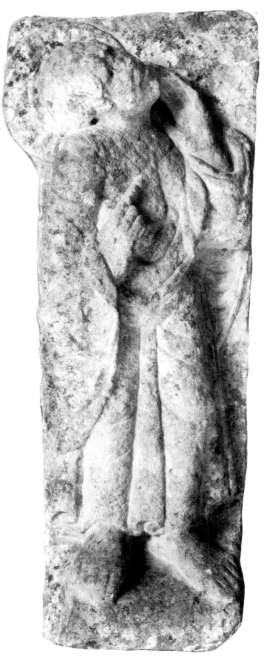

These impressive Romanesque sculptures, carved in high relief from rectangular limestone slabs, appear to be from a single program of architectural decoration. The slabs bear full-length figures identified as an Apostle and an angel. The Apostle is standing and turning to the right, with his head sharply inclined to the left and looking up. He raises his left hand to his chin, seemingly in a gesture of wonder, while he points up to the right with his right hand. The angel strides to the left, but bends sharply to the right with head looking downward over the shoulder; both hands point to the upper left.

The angel and the Apostle have been associated with seven other sculptures, all Apostles, in collections at Duke University, Rhode Island School of Design, and Smith College. Although there are significant differences in style between the Gallery's two works and the other Apostles, recent research into their provenance and scientific analysis of their stone indicate that the works should be viewed as a group and that the stone from which they were carved was from a quarry in the area of Sarlat in the Dordogne. The formats and subjects of the sculptures indicate that they were parts of a monumental portal ensemble representing the Ascension of Christ. In some portal compositions of this subject, such as that at Collonges (Corrèze), the semi-circular tympanum over the door is dominated by the central image of the ascending Christ surrounded by figures in a heavenly realm. In such a configuration, the Gallery's angel would be positioned to the right of Christ; there would be another angel in a reversed pose on the left. Both angels would look down to the row of Apostles and, usually, the Virgin, who together witness Christ's bodily ascent into heaven. The Apostles now at the Gallery, Duke, Smith and Rhode Island are from this group; of them only Peter, with his attribute of keys, is identifiable. Because these figures are carved from separate blocks, they cannot themselves have formed the lintel of the door. They were probably positioned just above this architectural member, constituting the lowest range of the figure composition.

Although it has been suggested that the sculptures are related to the work at the church of St. Martin at Brive (Corrèze), their style has not been convincingly identified. As yet, no other fragments from this composition have been recognized and no credible proposal has been made for their association with a known site.

DW

PROVENANCE:
Joseph Brummer, Brummer Gallery, New York, 1943 (43.35) and 1949 (49.6).

LITERATURE:
R. C. Moeller III, *Sculpture and the Decorative Arts,* Raleigh, NC, 1967, pp. 8-17; R. C. Moeller and W. Heckscher, "The Brummer Collection at Duke University," *Art Journal* 27, no. 2 (winter 1967–1968), pp. 182-184; W. Cahn, "Romanesque Sculpture in American Collections, Part 2: Providence and Worchester," *Gesta* 7, (1968), pp. 53-54; W. Cahn, "Romanesque Sculpture in American Collections, Part 3: New England University Museums," *Gesta* 8, no. 1 (1969), p. 56; L. Pressouyre, "Chronique: Sculptures romanes des collections américaines: Providence et Worcester," *Bulletin Monumental* 127 (1969), pp. 50-57; S. K. Scher, *The Renaissance of the Twelfth Century,* Providence, RI, 1969, pp. 50-57, ill.; L. Pressouyre, "La renaissance du XIIe siècle," *Revue de l'art* 7 (1970), pp. 98-99; W. Cahn, "Romanesque Sculpture in American Collections, Part 7: New York and New Jersey," *Gesta* 10, no. 1 (1971), p. 51, ill.; W. Cahn, "Romanesque Sculpture in American Collections, Part 14, The South," *Gesta* 14, no. 2 (1975), J. French, E. Sayre, L. van Zelst, "Nine Medieval French Limestone Reliefs: The Search for a Provenance," *Application of Science in Examination of Works of Art,* Boston, 1985, pp. 132–141.

Doubting Thomas
Saint-Martin-de-Candes, Indre-et-Loire, France
Limestone, polychrome, h. 24″, w. 17½″, d. 17″
R. T. Miller Fund, 49.76

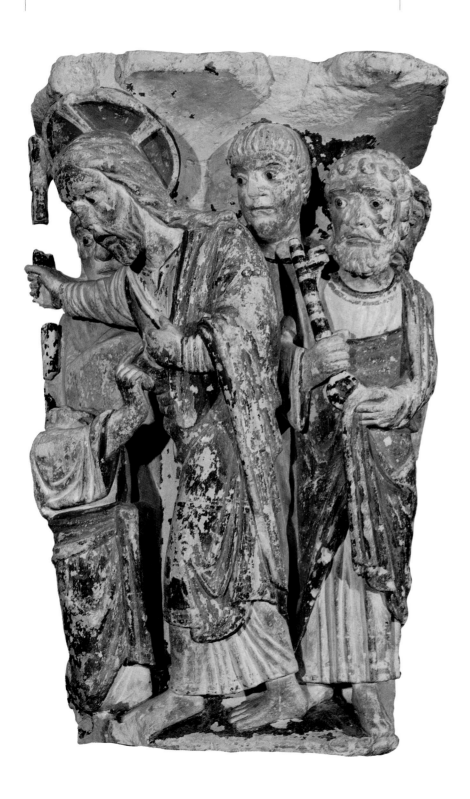

The carved console of the *Doubting Thomas* was originally placed at the base of a short shaft that descended from a vaulting rib in the sacristy of the small church of Saint-Martin-de-Candes in France. Its position in the church is certain, for there are stucco *moulages* (molded copies) of this and another sculpture now in situ. The original material was removed and the replacement made during a late nineteenth-century restoration.

In this representation, based on the text of St. John's Gospel (John 20:25-27), Christ strides to the left, exposing the wound in his side to a kneeling Thomas. In his right hand, Christ holds a cross-staff, an emblem of his victory over death. Four of the disciples witness the event. St. Peter can be identified among them by the key he carries; he occupies a prominent position at Christ's left side.

The *Doubting Thomas* and a console representing Christ's post-Resurrection appearance to Mary Magdalene (John 20:16-17) form pendants on either side of the window of the apsidiole on the eastern wall of the sacristy. Two other sculptures in the sacristy continue the series of New Testament scenes of the appearances of Christ on earth after the Crucifixion and Resurrection: an Ascension occupies the southeast corner and a Pentecost, the south wall.

The events depicted in all these consoles represent the common theme of Christ resurrected before witnesses, events confirming the reality of the Resurrection. This physical reality is stylistically conveyed by the near independence of the figures from the block of the console and by the lively movement of the principals of the narrative, who have natural expressions and gestures. These elements and the simply treated, form-defining drapery are characteristic of emerging Gothic figural style in the opening years of the thirteenth century.

SES

PROVENANCE:
Sacristy of Saint-Martin-de-Candes; Bacri Frères, Paris; Joseph Brummer, New York; Brummer sale, Parke-Bernet Galleries, New York, June 8–9, 1949, lot 567.

LITERATURE:
Ludwig Schreiner, *Die Frühgothische Plastik Südwestfrankreichs*, Cologne, 1963, pp. 85, 157, 180-181, fig. 64, pl. 19; A. Mussat, "Candes," *Congrès archéologique de France* 122, Anjou, 1964, p. 502; Léon Pressouyre, "La Renaissance du XIIe siècle," *Revue de l'art* 7, 1970, p. 98, fig. 3; Susan E. Schilling and David A. Walsh, "An Early Gothic Sculpture of the *Doubting Thomas*," *Porticus* 8 (1985), pp. 1-6, ill.

EXHIBITIONS:
Metropolitan Museum of Art, New York, *The Year 1200*, 1970, no. 20, p. 16, ill.; Wildenstein Galleries, New York, *Treasures from Rochester*, 1977, p. 5.

FRENCH, CLERMONT-FERRAND

Feast Scene, ca. 1255–1265
Potmetal and glass, 22¼ x 22½"
Gift of Mr. James Sibley Watson, 29.68
(Left)

Two Servants, ca. 1255–1265
Potmetal and glass, 22 ⁹⁄₁₆ x 23¼"
Gift of Mr. James Sibley Watson, 29.69
(Right)

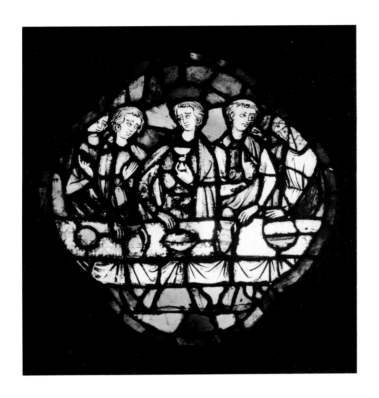

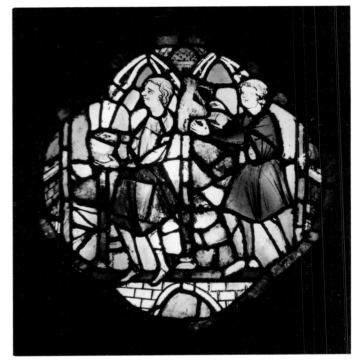

These two thirteenth-century stained-glass medallions come from the Cathedral of Notre Dame, Clermont-Ferrand, Puis de Dômes, France, and are identifiable by photographs taken during restoration work early in this century. The two medallions, which were displaced by several restoration projects, were originally components in lancet windows located in a bay of the axial chapel, dedicated to St. John the Baptist. These lancets consist of medallions placed one on top of the other, the ground being filled in with a geometric design. (The lancets now include panels of twentieth-century glass.) The glazing in the St. John the Baptist chapel was probably completed by the mid-1260s.

The first medallion, *Feast Scene,* shows five figures seated at a table covered by a white cloth and holding bowls and urns. The whole is bordered by a red fillet. The second, *Two Servants,* depicts two figures, presumably servants, one carrying a bowl and the other, a fawn. They walk before a double-pointed arch and over a masonry archway. The colors of both medallions are rich and intense; the ground of each is of cobalt blue, which contrasts vividly with the red, green, and gold of the figures.

These medallions are related by style and iconography to those still in place in the chapel at Clermont-Ferrand. The left-hand lancet in the bay of the chapel depicts the story of the Prodigal Son, and includes a medallion that is similar to the Gallery's medallion of the two servants. Again, two servants are featured; one leads a calf, the other carries an ax. The figures walk over the same masonry arch found in the Gallery's medallion and are executed in the same style and character. It is, therefore, extremely probable that the Gallery's medallion was originally part of this lancet. The medallion that depicts the seated figures may also have been part of this lancet or of the one adjacent, the subject of which is the life of St. John the Baptist and includes a feasting scene.

The Gallery's medallions are further related to those at Clermont-Ferrand by color. All of the medallions in the St. John the Baptist chapel have blue grounds and figures clothed in deep, rich colors. The effect created by these intense colors is similar to that produced by the windows at Sainte Chapelle in Paris, constructed between 1240 and 1248. The term "Court Style Glass" has been used to distinguish the remarkable concept of extensive glazing in deeply saturated, jewellike colors initiated by the work at Sainte Chapelle. The program of glazing at Sainte Chapelle used the same device of medallions-within-lancet used later at Clermont-Ferrand, and the iconographical programs found at Sainte Chapelle are similar, sometimes identical, to those at Clermont-Ferrand.

The suggestion has been made that the artisans who executed the glazing at Sainte Chapelle were also responsible for that at Clermont-Ferrand. While there is currently no evidence to support this hypothesis, it is clear that the program at Clermont-Ferrand is heavily influenced by Sainte Chapelle, if not directly connected with it. Therefore, these stained-glass medallions represent excellent examples of a major aesthetic component of thirteenth-century French art and architecture.

MKS

PROVENANCE:
Cathedral of Notre Dame, Clermont-Ferrand; Michel Acézat, Paris; Arnold Seligmann, Rey and Co., New York.

LITERATURE:
"Stained Glass at Rochester," *The American Magazine of Art* 20, 1929, pp. 652-654; "A Gift of Thirteenth-Century Stained Glass," *Bulletin of the Memorial Art Gallery* 1, no. 6 (1929), pp. 2-4, ill.; Susan Schilling, *The Middle Ages: A Modern Legacy,* Rochester, 1974, p. 19; Helen Jackson Zakin, "Three Stained-Glass Panels from Clermont-Ferrand," *Porticus* 5 (1982), pp. 23-30, ill.; Richard Marks, "Recent Discoveries in Medieval Art," *Scottish Art Review* 16 (1984), pp. 14-15; Helen Jackson Zakin with Meredith Parsons Lillich, *Stained Glass before 1700 in American Collections: New England and New York,* Studies in the History of Art Monograph Series 1, vol. 15, Washington, DC, [1984], p. 198.

Madonna and Child
Limestone, polychromed and gilded, h. 54″, w. 18¼″, d. 11″
Gift of Emily Sibley Watson (Mrs. James Sibley Watson), 28.466

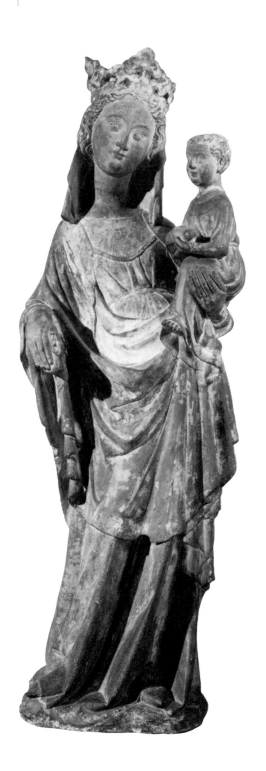

In this *Madonna and Child,* a delicate balance is achieved between courtly elegance and approachability which is typical of the compelling images of this popular subject developed in the Ile-de-France in the first half of the fourteenth century. The Virgin's pose is both active and relaxed, characterized by a graceful S curve running through the figure in a continuous, sweeping movement. The Virgin's stance serves ostensibly to support the Christ Child, whom she holds in her left arm at hip level. We can sense some appreciation of the mechanics of weight, but the essence of this figure is conveyed largely by its voluminous drapery. The mantle's lower hem sweeps across the body at knee level; folds on its front surface form a series of arcs that become more widely spaced and pointed toward the lower hem. There is deep undercutting in the drapery around the legs, though the folds over most of the garment are themselves relatively shallow. The general pose and the drapery conventions may be compared with the fourteenth-century polychromed *Madonna and Child* in the Cloisters of the Metropolitan Museum, New York (formerly in the Kaiser Friedrich Museum, Berlin). The proportions of the Virgin's figure and the angular, sweeping twist of her stance recall the famous *Virgin and Child* from St. Aignan, now in the Cathedral of Notre Dame in Paris, and comparison should also be made with an ivory of the same subject in the Gallery's collection (45.38, p. 52).

The formal equilibrium complements and, to some extent, reinforces the meaning of the work. The elegant quality of the dress and pose imply the Virgin's elevation and nobility, while the Child's pose and the manner in which he is supported impart an informal, tender mood. The Virgin's crown alludes to her role as Queen of Heaven, but this crown rests on the veil over her head, a symbol of her humility. Although only a fragment of it now remains, the Virgin apparently held a flower in her right hand, likely a lily or a rose, while with her left she supports the Christ Child, who holds a bird, probably a dove or a goldfinch. The bird and the flower are pendants drawn together visually by the bold sway of mantle drapery. The lily is a symbol frequently used in scenes of the Annunciation, and its presence here would refer to the moment of the Incarnation. If the bird is a goldfinch, as is so frequently the case, the Child presents us a symbol of his Passion, and we are shown a contrast between Christ's first appearance on earth and the last events of his life. The whole image, then, embodies the essence of God's plan of salvation.
DW

PROVENANCE:
Haussaire Collection, Rhiems; with Arnold Seligmann, Rey and Co., New York.

LITERATURE:
Bulletin of the Memorial Art Gallery 1, no. 3, 1929, pp. 1-3, 11; *American Magazine of Art* 20 (February 1929), pp. 106-107, ill.

EXHIBITIONS:
Detroit Institute of Arts, "A Loan Exhibition of French Gothic Art," 1928, no. 39.

Holy Trinity
Alabaster, traces of polychrome, h. 21³⁄₁₆", w. 11", d. 2"
Gift of Mr. and Mrs. Walter G. Oakman and
Mrs. James Hammond MacVeagh, 37.3

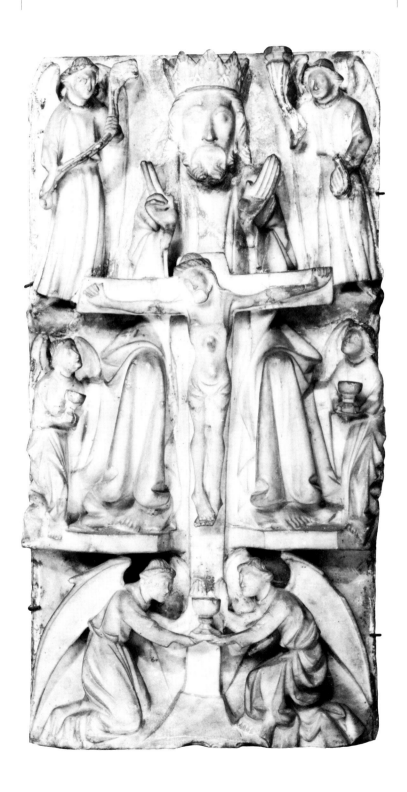

English sculpture of this kind has been associated with an extensive alabaster industry, chiefly in the Nottingham area during the late Middle Ages. In this work, the figures are symmetrically organized within a vertical rectangular format. The elements of the composition fall into gridlike compartments, and the field is separated into three equal horizontal zones. Making a gesture of benediction, God the Father dominates the upper part of the composition as he presents a smaller figure of Christ on the cross between his knees. Censing angels fill the corners of the upper zone; pairs of angels with chalices occupy the sides of the middle and lower registers. The forms are carved in deep relief with the individual figures varying widely in scale. The rigid frontal bodies of God and Christ define the major axes of the composition, while the angels form more curvilinear patterns with their contours and drapery and have freer movement.

Characteristics of format, composition, figure style, and especially the rather schematic rendering of detail suggest a date in the second half of the fifteenth century. All the characteristics of this piece can be found in numerous extant examples of the subject produced by the alabaster industry. An original context of this work is suggested by an altarpiece in the Victoria and Albert Museum in London which has its polychrome intact and its panels still within the original wooden frame with explanatory inscriptions. The subject, size, and shape of the Gallery's alabaster suggest that it was the central scene in such an altarpiece. In the London example, a similar central panel is flanked by scenes that glorify the Virgin, including the Annunciation, Assumption, and Coronation.

The subject of this panel is usually identified as the Holy Trinity, although, unlike many other images of this type, it does not contain the usual dove of the Holy Spirit with the Father and the crucified Son. In some cases, the dove was painted or separately attached, but there is no evidence of this here and its presence cannot be assumed. In this subject, however, which is usually central in an altarpiece assembly, the sacrificial nature of the Crucifixion is clearly emphasized by the action of the angels collecting in chalices blood that flows from Christ's wounds. The ceremonial or ritual aspect is also underlined by the hieratic composition and by the angels dispensing incense. Such a configuration is entirely appropriate to the Eucharistic Sacrifice of the Mass that took place on the altar directly below the altarpiece.

DW

PROVENANCE:
Mrs. Walter Oakman and Mrs. James Hammond MacVeagh, Cazenovia, NY, 1937.

LITERATURE:
Augusta S. Tavender, "Medieval English Alabasters in American Museums," *Speculum* 30, no. 1 (January 1955), p. 69, no. 51, pl. 7; David A. Walsh, "An English Alabaster of the Trinity," *Porticus* 4 (1981), pp. 14-23.

MASTER OF
THE URBINO CORONATION

Italian, Riminese, second half of 14th century
Annunciation to Zacharias
Fresco transferred to canvas, 69 $\frac{5}{16}$ x 53 ½ "
Marion Stratton Gould Fund, 43.3

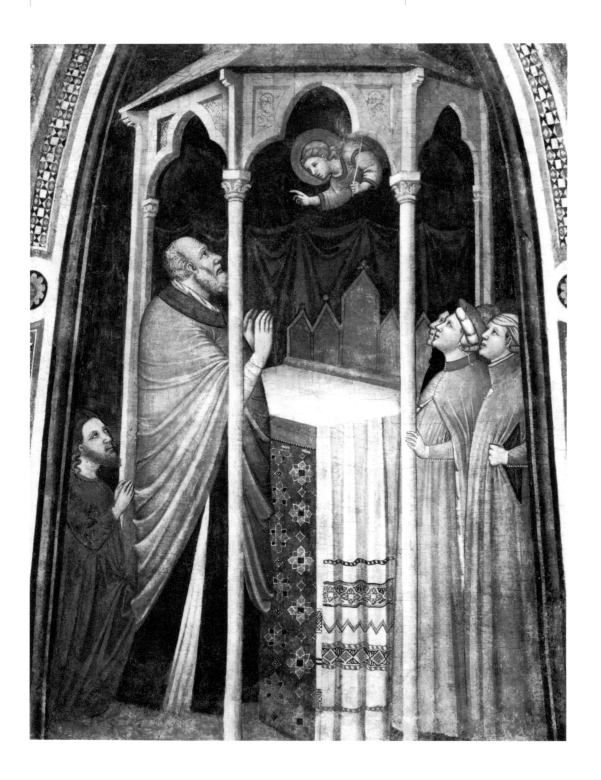

This detached fresco is said to come from the church of S. Lucia in Fabriano and would probably have been part of the original fresco decoration since the church was built in the second half of the fourteenth century. Its original placement in a Gothic ceiling vault is obvious from the shape of its decorative borders, which would have met and enframed the now truncated roof of the hexagonal temple. A more subtle indication of its position on a high and curving surface is the artist's attenuation of the figures, making them appear more correctly proportioned when seen at an angle from below.[1]

The Annunciation to Zacharias is the usual beginning for a Life of John the Baptist; its primary textual source is the beginning of the Gospel of St. Luke, although various medieval sources for the Lives of the Saints elaborated on St. Luke's account. As the people waited anxiously outside the temple, Zacharias, the aged high priest, was performing his duties for the evening oblation and burning incense over the altar. Gabriel appeared to him to announce that his barren wife, Elizabeth, also advanced in years, was to conceive a son. Overcome with fear, Zacharias questioned the possibility of the miracle and was struck dumb by the angel for his lack of faith. The Gallery's fresco deviates from the narrative, and from most other depictions of the event, by showing a witness to the annunciation and Zacharias not with the censer but with his hands raised in the ritual. It is unusual that Zacharias does not have a halo, particularly given that he has a conspicuous incised one in the *Birth of John the Baptist* in Rome. The kneeling figure to the left is assumed to be a witness, his long hair and untailored robe in keeping with Biblical costume. The men to the right, dressed in contemporary fourteenth-century clothes, their hair neatly cut and contained, are presumably citizens of Fabriano and perhaps the donors.

The Master of the Urbino Coronation is a distinct, if unknown, artistic personality identified by this work's stylistic affinity to the *Coronation of the Virgin with SS. Catherine and Agnes,* a three-part panel in the Galleria Nazionale delle Marche in Urbino.[2] He worked extensively in Fabriano and seems to have been trained in the Riminese school. One of the most easily identifiable characteristics of his style is the lack of a single facial type or even a consistent set of proportions for the human figure; this stylistic distinction can easily be seen in the differences among the figures of Zacharias, the witness, and the donors.

BAB

1. Two other frescoes have also been connected with S. Lucia and this artist: a *Crucifixion* in the Museum of Fine Arts, Boston, and a *Birth of John the Baptist* in the Galleria Nazionale, Palazzo Barberini, Rome.

2. Mario Salmi was the first to assemble this artist's work; he published it in "La Scuola di Rimini," *Revista del R. Instituto di Archeologia e Storia dell'Arte* 3, no. 3 (1932).

PROVENANCE:
(?) Prince Bardini, Florence, to 1922; Segredakis, New York, ca. 1930; G. J. Demotte, New York; Brummer Gallery, New York, in 1943.

LITERATURE:
Federico Zeri, "Un affresco del Maestro dell'Incoronazione d'Urbino," *Proporzioni,* 1950, no. 3, pp. 36-40, figs. 20, 22; Carlo Volpe, *La pittura riminese del trecento,* Milan, 1965, pp. 50, 88, fig. 296; Burton B. Fredericksen and Federico Zeri, *Census of Pre-Nineteenth-Century Italian Paintings in North American Public Collections,* Cambridge, MA, 1972, pp. 137, 418, 629; Fabio Bisogni, *Index of Italian Art, Conducted at Harvard University Center for Renaissance Studies at I Tatti* [1976], p. 95.

Italian, second half of 14th century
Madonna and Child with SS. Francis of Assisi, John the Baptist, Peter, and Dominic
Tempera on panel, h. 30″, w. 86½″, d. 6¼″
Marion Stratton Gould Fund, 57.4

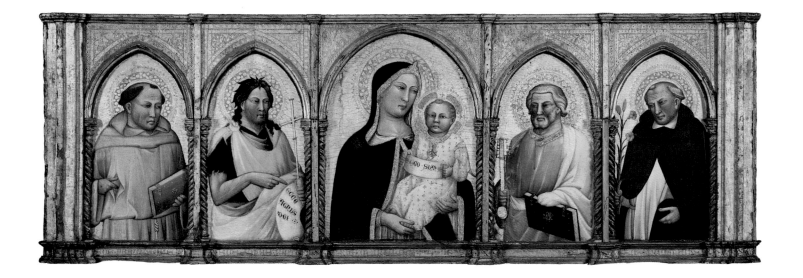

This altarpiece, although missing the painted gables and superstructure of its frame, is an interesting example of the polyptych form popular in Tuscany during the fourteenth century. Parts of the frame have been added or restored, but many are original, including sections of the inscribed fascia below. Nothing is known of the commission or intended placement of the work, but its subject and emphasis are certainly the established Church.

The central panel contains a rather stern image of the Madonna and Child, with the beginning of the inscription, "I am the light of the world." On the left, John the Baptist, first of the New Testament prophets, points toward the central devotional panel, as well as to his scroll, "Behold the Lamb of God." On the right, St. Peter covers his hand to hold the Book of the Word, and prominently displays the key to Christ's earthly kingdom, given to him as the first church leader. On either end of the polyptych are St. Francis and St. Dominic, founders of the most important mendicant orders. These saints represent not only the authority of the Church but also its multifaceted role in daily life: the Dominicans were known for their preaching, the Franciscans for their work among the poor and sick. The mood created by the severity of expression and the lack of a welcoming glance to the viewer indicate a date in the years following the Black Death of 1348.

The artist of this work is unknown. His idiosyncratic style belongs to the school of Nardo di Cione, but it is far from the extremely subtle modeling and color sense of the master himself. On the basis of the punches used in the gold background, Mojmír Frinta has associated this polyptych with workshops in Pisa and suggests the name of Bernard Nello di Giovanni Falconi, whom Vasari, the sixteenth-century historian, mentions as a follower of Orcagna, Nardo's brother, and as working in Pisa. The figures of the saints are stock images found in any number of Nardoesque works, and the provincial quality of the work is revealed most clearly in the two-dimensionality of the figures squeezed into their frames.
BAB

PROVENANCE:
(?) Kleinberger, Paris; Marczell von Nemes, Munich; Marczell von Nemes sale, Munich, June 16, 1931, lot 2; Paul Drey Gallery, New York, by 1931.

LITERATURE:
Burton B. Fredericksen and Federico Zeri, *Census of Pre-Nineteenth-Century Italian Paintings in North American Public Collections,* Cambridge, MA, 1972, pp. 146, 629; Mojmír S. Frinta, "A Seemingly Florentine Yet Not Really Florentine Altarpiece," *Burlington Magazine* 117, no. 869 (August 1975), pp. 527-535, fig. 22; Wildenstein Galleries, New York, *Treasures from Rochester,* 1977, p. 13.

EXHIBITIONS:
Detroit Institute of Arts, *The Sixteenth Loan Exhibition of Old Masters: Italian Paintings of the 14th to 16th Century,* 1933, no. 7, ill.

Italian, Florentine, (active 1356–d. 1398)
Crucifixion with God the Father
Tempera on panel, h. 68 ³/₁₆″, w. 25 ⅞″, d. 4 ⅜″
Marion Stratton Gould Fund, 51.26

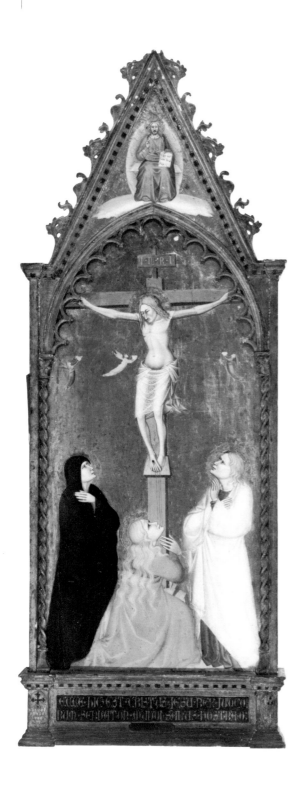

Giovanni del Biondo, one of the best and most productive of the painters working in Florence after the Black Death of 1348, belongs to the school of Orcanga. His early work reflects the influence of Nardo di Cione; his later, the influence of Jacopo di Cione. *Crucifixion with God the Father* is usually accepted as a later work, which Miklós Boskovits has dated between 1375 and 1380. The Crucifixion is presented as a devotional, not a narrative, subject. The three grieving angels are collecting the blood of the sacrament and the three traditional mourning figures—the Virgin Mary, Mary Magdalene, and John the Evangelist—intensify the holiness, but not the drama, of the image. In the gable above, God the Father gives his blessing.[1]

The earliest known owner of the work, Signore Enrico Testa, recorded in 1927 that the two lateral panels of this triptych were sold separately in Milan. The frame, the columns, and the base with its inscription and coats-of-arms are modern and were probably added for the first New York sale of the American Art Association. Testa's early photograph shows the panel in a different, more fragmentary frame, which also seems to have been modern or in large part reconstructed. These additions do not detract from the high quality of the painting, whose figures are particularly well preserved. The gold ground has been uniformly worn away, revealing the red bole undercoat and clearly showing the size and shape of the original square pieces of gold leaf that were applied to the panel.

BAB

1. The inscription on the book is modern.

PROVENANCE:
Enrico Testa, Florence; Achillito Chiesa (about 1927), Milan; Achillito Chiesa sale, American Art Association, Anderson Galleries, April 24, 1930, p. 30, no. 59, ill.; William S. Hawk, Kingston, NY, 1930, sale, American Art Association, Anderson Galleries, New York, February 4-5, 1931, p. 70, no. 163, ill.; Julius Weitzner, New York (dealer), by 1933 through 1949; Caesar R. Diorio, New York (dealer), in 1949.

LITERATURE:
Richard Offner, "A Ray of Light on Giovanni del Biondo and Niccolo di Tommaso," *Mitteilungen des Kunsthistorischen Institut in Florenz* 7, 1956, p. 189; Richard Offner and Klara Steinweg, *A Critical and Historical Corpus of Florentine Painting,* New York, sec. 4, vol. 5, 1969, pp. 73-75, ill.; Burton B. Fredericksen and Federico Zeri, *Census of Pre-Nineteenth-Century Italian Paintings in North American Public Collections,* Cambridge, MA, 1972, pp. 88, 629; Miklós Boskovits, *Pittura fiorentina alla vigilia del Rinascimento 1370–1400,* Florence, 1975, p. 313.

EXHIBITIONS:
Smith College Museum of Art, Northampton, MA, "Italian Primitives," 1932, no. 8; Detroit Institute of Arts, *The Sixteenth Loan Exhibition of Old Masters: Italian Paintings of the 14th to 16th Century,* 1933, no. 10.

Christ and St. John, ca. 1140–1170
Limestone, h. 11⅜″, w. 8″, d. 2½″
Marie Adelaide Devine Fund, 84.41

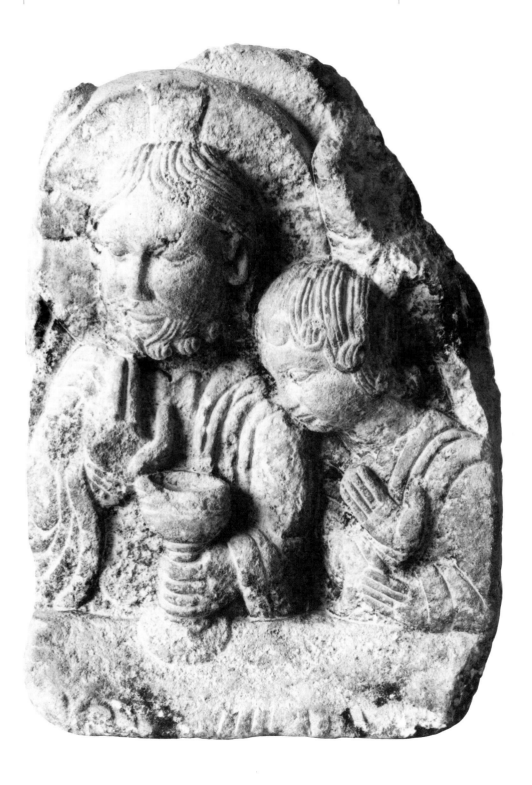

This small limestone relief appears to be a fragment of a representation of the Last Supper. The bearded figure with a cruciform halo, who holds a chalice and is gesturing in benediction, and the other, who also has a halo and leans against the first, are surely Christ and the young St. John the Disciple from the center of such a composition. The relief is clearly broken on the sides, but traces of figures flanking the central pair still remain. The bottom may also be incomplete; the relief probably extended below the tablecloth to include the figures' legs and feet. The depiction of Christ holding the chalice and giving the blessing represents the words he spoke in anticipation of his sacrifice (Matthew 26:26-29), which are considered to be the basis of Christian Communion. It is interesting that most contemporary representations of the Last Supper do not illustrate this scene, but rather, show Christ giving the sop to Judas in recognition of Judas's future betrayal (Luke 22:21).

The distinctive style of this relief relates it to a number of twelfth-century monuments in the northeast Spanish province of Catalonia, where important ensembles of sculpture are located in such centers as Ripoll, Gerona, San Cugat, and Vich. Here we find parallels to the compact figures of this relief, with heads rendered as clearly defined and rounded volumes, drapery with flat, sharp-edged folds that hook over the shoulder, and other conventions of anatomy. Judging from fragments excavated by Eduardo Junyent on the site, sculpture from the now largely destroyed Romanesque cathedral at Vich seems to have particular affinities with the Gallery's piece. These fragments, found in collections in the vicinity and in museums elsewhere, vary in subject, format, and scale, but they have been recognized as belonging to the monumental portal of the church, which was of the type exemplified by Santa Maria at Ripoll. Among these Vich fragments are narrative cycles similar in scale to the Gallery's relief. Moreover, in the documents relating to the portal, Junyent located a reference to a Last Supper of which this relief might be the central part. DW

PROVENANCE:
Dealer, Barcelona, 1960–1961; Edward R. Lubin, New York (dealer); Thomas F. Flannery, Jr., Collection, Chicago; Sale of Flannery Collection, Sotheby's, London, December 1, 1983, no. 82; Edward R. Lubin, New York (dealer), 1984.

LITERATURE:
Marilyn Stokstad, "Three Apostles from Vich," *The Bulletin of the Nelson Gallery and Atkins Museum* 4, no. 11 (1970), pp. 2-24; Xavier Barral i Altet, *La Catedral de Vic,* Barcelona, 1979, p. 21; Sotheby's, London, *Thomas F. Flannery, Jr., Collection Sale,* 1983, no. 82, p. 97, ill.; Edward R. Lubin, New York, *Catalogue* [1984], no. 1, ill.

FRENCH, LIMOGES, 13TH CENTURY

Pyx
Champlevé enamel on gilded copper, 3 x 2¾ ″
R. T. Miller Fund, 49.21

GRIGOR OF TARSOS

Armenian, active 1215–1255
The Gospels, 1216, with subsequent additions
Ink, tempera, and gold on parchment, 9¼ x 6½ ″
Marion Stratton Gould Fund, 50.8

FRENCH, LIMOGES

Châsse with Scenes from the Life of St. Stephen, 1220–1230
Champlevé enamel on gilded copper, 3¾ x 4⅛ x 2¾ ″
R. T. Miller Fund, 49.20

FRENCH (MEUSE RIVER VALLEY: VALENCIENNES?)

Psalter-Hours (Office of Liège), 1260–1275
Ink, tempera, and gold on parchment, 6½ x 5¾ ″
Marion Stratton Gould Fund, 53.68

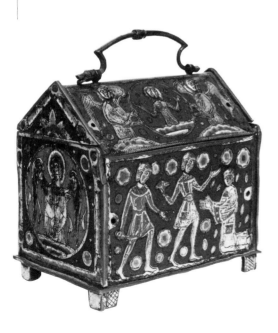

FRENCH, LE MANS, 13TH CENTURY

St. Mary Magdalene
Limestone, polychromed, 58¼ x 18¾ x 9⅝″
Gift of Mrs. Charles H. Babcock, 30.2

FRENCH (FROM THE CATHEDRAL OF NOTRE DAME, CLERMONT-FERRAND)

Lancet Window with Scenes from the Life of St. Privat (bottom) and recomposed panels (top), ca. 1265–1270
Stained glass, 62½ x 30⅛″
Gift of James Sibley Watson, 29.70

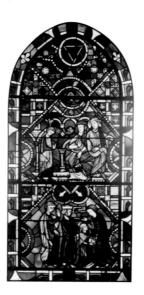

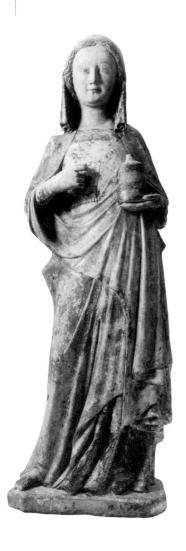

FRENCH, 14TH CENTURY

The Annunciation
Red sandstone, 13⅞ x 14 x 3⅝″
R. T. Miller Fund, 49.70

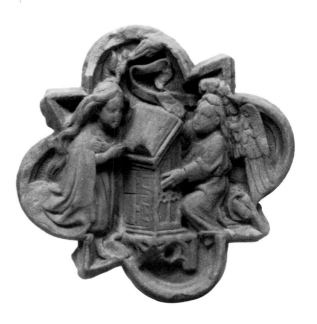

FRENCH, ILE-DE-FRANCE, 14TH CENTURY

Madonna and Child
Ivory, 8¼ x 2¼ x 1¾"
R. T. Miller Fund, 45.38

FRENCH, 14TH CENTURY

Leaf of a Diptych: Crucifixion and Nativity
Ivory, 6⅜ x 3¼ x ⅜"
R. T. Miller Fund, 49.19

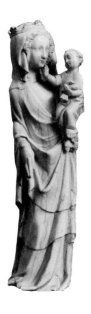

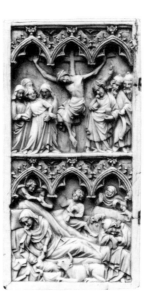

GERMAN (RHENISH)

Crucifixion Figure of Christ, ca. 1200
Gilded copper, 5¾ x 5½"
R. T. Miller Fund, 49.43

NORTH ITALIAN, GENOA?,
LATE 12TH-EARLY 13TH CENTURY

Capital: Crouching Lion
Marble, 11⅛ x 21¼ x 5¼"
R. T. Miller Fund, 49.10

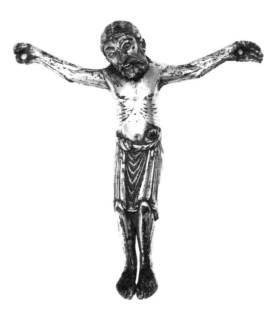

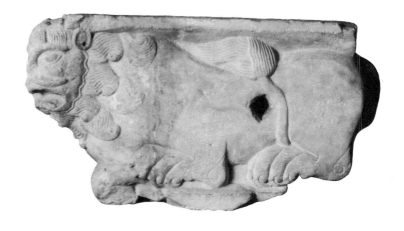

ITALIAN, TORCELLO

Head of an Angel, ca. 1150–1200, with later (19th century?) additions
Glass, stone, and glazed ceramic, 15½ x 11½ "
Marion Stratton Gould Fund, 42.52

NORTH ITALIAN

Baptismal Font with Symbols of the Four Evangelists and Four Angels, ca. 1200
Limestone, 26¾ x 31½ " (diam.)
R. T. Miller Fund, 49.5

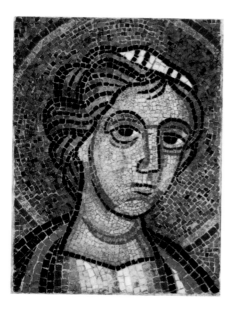

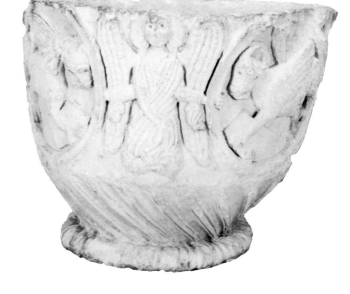

ITALIAN, RIMINI, 14TH CENTURY

Madonna and Child Enthroned between Six Saints and Angels
Tempera on panel, 26⅛ x 22¼ x 2¾ " (with frame)
Gift of Mrs. Charles Wright Dodge and Mrs. Adrian Devine in memory of
Bertha Hooker, 27.1

SPANISH, EARLY 13TH CENTURY

Crucifix
Wood with traces of polychrome, 82 x 54⅛ x 15½"
R. T. Miller Fund, 52.34

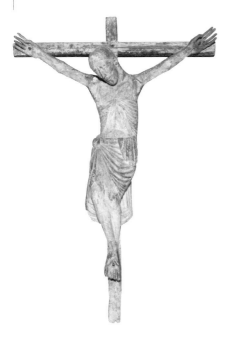

SPANISH, LATE 13TH CENTURY

Mourning Virgin
Wood, polychromed, 58 x 14½ x 11¾"
R. T. Miller Fund, 52.33.1

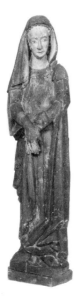

SPANISH, LATE 13TH CENTURY

St. John the Evangelist
Wood, polychromed, 62 x 16⁵⁄₁₆ x 11¼"
R. T. Miller Fund, 52.33.2

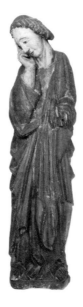

EUROPEAN ART 1400–1600

French (b. Netherlands), ca. 1500–1575
Portrait of Charles 1ᵉʳ de Cossé, Comte de Brissac, ca. 1530s
Oil on panel, 6¼ x 5″ (oval)
Marion Stratton Gould Fund, 47.1

Many artists were attracted to Lyons, France, in the middle of the sixteenth century. Situated at an international trading crossroads that served France, Italy, Germany, and the Netherlands, Lyons was a thriving commercial center. Corneille de Lyon was among the artists who settled there, and he became one of the most successful and influential painters of the period. The first record of Corneille's activities in the city is recorded in 1534; the exact date of his arrival from The Hague, however, remains unknown. By 1541 he is mentioned as a painter in the court of the dauphin—soon to become Henry II of France—and in 1547 Corneille was naturalized by the new king.

Corneille, who called himself "Peintre du Roi," the king's painter, was favored with royal portrait commissions as well as commissions from the aristocracy and bourgeoisie. In a record of Catherine de Medici's visit to his studios in 1564, portraits of the "great lords, princes, cavaliers, princesses, dames, and daughter of the Court of France"[1] were said to have been seen.

Corneille is thought to have introduced to France a format that became the hallmark of his style—the small, half-length portrait, which possibly stemmed from the Netherlandish tradition of painting portraits in illuminated books. This size was appealing both economically—as it was affordable—and stylistically. At the time, the fashionable French portrait technique was to make a preliminary sketch in chalk which was later enlarged as a painting. Corneille's small portraits, in contrast, could be painted directly from life onto the wooden panels, a method that lent his work an immediacy and liveliness the larger portraits often lacked.

Identification of Corneille's work has been made difficult over time because of the large output of his workshop (in which a son, who also signed his work "Corneille," and a daughter worked) and the international influence Corneille had on painters of the period. The strength of the attribution of this work to Corneille de Lyon rests on the exceptional quality of the painting itself, distinguished by the fineness of detail, and the blue background color, which is found in paintings firmly attributed to him.

More complicated, however, is the identification of the sitter. Early in the 1530s, the first identifiable period of Corneille's career, he painted several known portraits of Charles 1er de Cossé, count, later duke of Brissac, maréchal de France (Metropolitan Museum of Art, New York; Louvre, Paris). Although there are similarities between the facial characteristics of the young man in this painting and others known to be Charles 1er de Cossé, scholars have warned that there is often a marked "family likeness" among Corneille's portraits. There is also a tendency to identify any attractive young man of this period as Charles 1er de Cossé, who was a soldier and a gallant, known popularly as "le beau Brissac."[2]

SDP

1. Quoted in Walters Art Gallery, *Taste of Maryland,* p. 2.

2. From correspondence in MAG archives from Charles Sterling (1947) and Dana Bentley-Cranch (1965).

PROVENANCE:
Adolph-Ulrich Wertmüller sale, Philadelphia, May 18, 1812, no. 16, listed as "French Noblesse"; to P. Flandrin, New York (dealer); Robert Gilmor, Jr., Baltimore (acquired as by Hans Holbein from Flandrin in 1821); Robert Lebel, Paris, acquired from collateral descendant of Robert Gilmor, Jr.; Caesar R. Diorio, New York (dealer).

LITERATURE:
Robert Gilmor, Jr., manuscript catalogue of collection, 1823; Michel Benisovich, "The Sale of the Studio of Adolph-Ulrich Wertmüller," *Art Quarterly* 16, no. 1 (spring 1953), pp. 20-29, fig. 2; William Dunlap, *A History of the Rise and Progress of the Arts of Design in the United States,* 1834, reprint, Boston, 1918, vol. 3, p. 274; Anna Wells Rutledge, "Robert Gilmor, Jr., Baltimore Collector," *Journal of the Walters Art Gallery* 12 (1949), pp. 18-39, fig. 11.

EXHIBITIONS:
Maryland Historical Society, Baltimore, 1848 (exhibited as by Hans Holbein); Maryland Institute, Baltimore, 1856 (exhibited as by Hans Holbein); Walters Art Gallery, Baltimore, "Robert Gilmor II of Baltimore, 1774–1848, the City's First Connoisseur and Collector," 1949; Carnegie Institute, Pittsburgh, PA, *French Painting: 1100–1900,* 1951 pl. 47; Cummer Gallery of Art, Jacksonville, FL, *French Art of the Sixteenth Century,* 1964 no. 7, ill.; Munson-Williams-Proctor Institute, Museum of Art, Utica, NY, "European Paintings from the Rochester Memorial Art Gallery," 1967; Wildenstein Galleries, New York, *Treasures from Rochester,* 1977, p. 31; Walters Art Gallery, Baltimore, *The Taste of Maryland: Art Collecting in Maryland 1800–1934,* 1984, pp. 2-3, ill.

Italian, Florentine, ca. 1439–1497/8
Madonna and Child
Marble, h. 36¼″, w. 28″, d. 5⅜″
Gift of the Honorable and Mrs. John Van Voorhis, 69.1

PROVENANCE:
(?) Countess Sala; Sala Collection sale, Paris, May 19, 1933, no. 43; William Randolph Hearst, New York; William Randolph Hearst Collection sale, Gimble Brothers/Hammer Galleries, 1941, no. 1044-1, p. 60, ill.; Van Voorhis Collection to 1969.

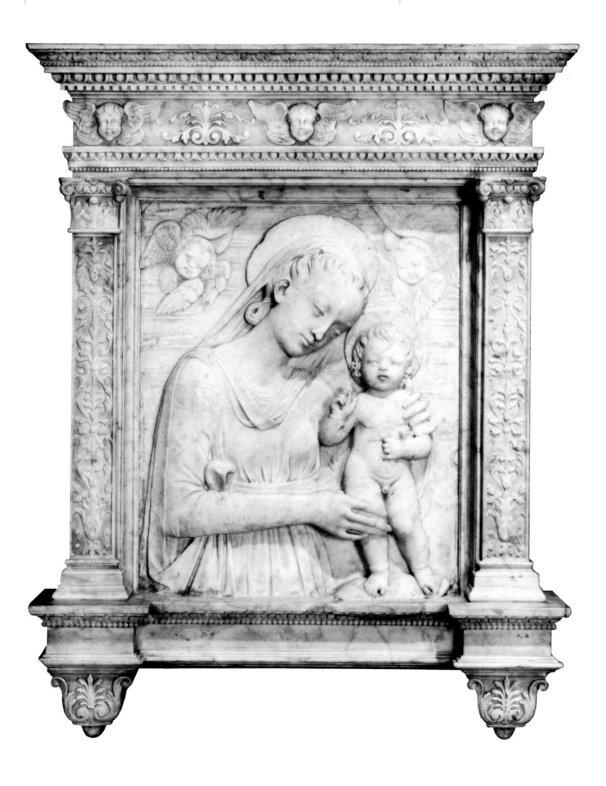

WORKSHOP OF BENEDETTO DA MAIANO

Italian, 1442–1497
Madonna and Child with Saint John the Baptist and Cherubim
Stucco and polychrome, h. 27 7/16", w. 18 3/4", d. 2"
R. T. Miller Fund, 49.71

PROVENANCE:
Dr. J. F. Stillwell, New York, to 1927; William Randolph Hearst, New York, to 1941; William Randolph Hearst Collection sale, Gimbel Brothers/Hammer Galleries, New York, 1941, no. 506-2, p. 51, ill.; Joseph Brummer, New York; Joseph Brummer sale, Parke-Bernet, part 3, June 8-9, 1949, no. 409, p. 84.

EXHIBITIONS:
Munson-Williams-Proctor Institute, Museum of Art, Utica, NY, "Art Masterpieces of New York State Museums," 1950.

SCHOOL OF LORENZO GHIBERTI
Italian, Florentine, 1378–1455
or
SCHOOL OF JACOPO DELLA QUERCIA
Italian, Tuscan, 1374/5–1438

Madonna and Child
Terracotta, h. 36½″, w. 23″, d. 6⁹⁄₁₆″
Gift of Mr. and Mrs. James Sibley Watson, 31.1

PROVENANCE:
Joseph Brummer, New York (dealer).

LITERATURE:
Ludwig Goldscheider, *Ghiberti,* London, 1949, p. 148, fig. 39; John
Pope-Hennessy, *Italian Gothic Sculpture,* London, 1955, p. 216, fig. 94; John
Pope-Hennessy, *Luca della Robbia,* Ithaca, NY, 1980, p. 61.

EXHIBITIONS:
MAG, Rochester, NY, "Arts of the Italian Renaissance," 1931.

These three relief sculptures of the Madonna and Child are representative of a form of Renaissance sculpture intended for reproduction. Such sculptures began to appear in the 1420s, primarily in Florence, and continued to be produced, probably in great numbers, for several decades. The surviving examples exhibit a wide variety in size and medium but, as with these three, all share a rather tender and intimate image of the Mother and Child: sometimes the Child sleeps or plays, often the Madonna cuddles or adores him with serene melancholy. The reliefs are in stucco, terracotta, marble, or bronze, and were meant for private patrons. Some were placed in family chapels in parish churches, others decorated burial sites; but most seem to have been intended for more private places, bedrooms, gardens, or even the facades of houses. Evidence on the side of the Domenico Rosselli relief (69.1; p. 58) indicates that it was once set into a wall. The most three-dimensional of these works, a very high quality relief from the school of Ghiberti or Jacopo della Quercia (31.1; p. 59), was probably meant to stand free on a large piece of furniture; the frame and background are later additions.

Virtually all of the Madonna and Child reliefs are without documentation that establishes their authorship by a specific sculptor, but they can be categorized by type and by the stylistic peculiarities of the best sculptural shops of the fifteenth century: those of Lorenzo Ghiberti, Donatello, Benedetto da Maiano, Desiderio da Settignano, the Rossellini, and the della Robbia. Chance survival and nineteenth-century reproduction of these works make it extremely difficult to draw reliable conclusions, but it seems that a design originated with a well-known master, who might execute it in marble to be reproduced in many media by his shop, or he might make a mold to be cast in terracotta or stucco. Evidence suggests that some marble reliefs were never copied and others are themselves copies after higher quality terracotta or stucco examples that, in turn, might or might not reflect an unknown marble original. In any case, terracotta and stucco were not merely cheap materials used primarily to reproduce marble images but were important Renaissance media that allowed the sculptor to model, instead of carve, yet not incur the enormous expenses of bronze casting.

In the Renaissance such relief sculpture ranked in artistic importance with decorated furniture, chests, boxes for various kinds of valuables, and fine pottery and metal objects. The reliefs were accessible to a much larger market than a few rich patrons, and this availability, plus the lack of intrinsic value of their materials, made them vulnerable to changes of taste and simple redecorating. These three works display the great diversity in this fifteenth-century mass market. Although the Domenico Rosselli relief is marble, it is from a less prestigious stylistic tradition and workshop, and seems not to have generated copies. The terracotta *Madonna and Child* (31.1), sculpted in an inexpensive medium, is of a higher quality but it, too, seems to be a unique piece. Although there are others similar to it in conception, there are no known copies or prototypes, and this example was probably modeled rather than cast from a mold. Evidence suggests, however, that a well-known Madonna and Child, or one from a major master, might be reproduced many times. Such is the case with the stucco associated with Benedetto de Maiano (49.71; p. 60), which exists in a number of variations.[1] Several other examples differ in size from the Gallery's, revealing the frequent dependence of minor sculptors on another artist's original composition but not on a single mold. It is quite likely that more than one of these terracotta and stucco examples were cast more recently than the Renaissance. The nine-teenth century in particular shared with the fifteenth a love of these reliefs, whose value was not diminished by their reproduction.

The difficulty of identifying specific artists for each of these reliefs is not problematical. The little that is known of the fifteenth-century art market suggests that the sculptors themselves were unconcerned about the use of their designs: the notion of an original versus a reproduction was irrelevant to them. For example, the *Ricordanze* or workshop diary of the fifteenth-century Florentine painter Neri di Bicci (which offers a rare glimpse into the bustling world of an artist/artisan),[2] documents that Neri received, apparently from several sculptors, numerous framed reliefs for his shop to paint and gild. Sometimes Neri himself had frames custom-made on consignment, but other than a reference to reliefs by Desiderio da Settignano, there is no mention in his account books of the sculptors of the original works. This one Florentine painting workshop sold as many as fifty-five polychromed stucco reliefs of the same half-length *Madonna and Child* for which Neri had purchased the original mold. By the 1470s he was having stucco reliefs molded to his own order by woodworkers who also made the frames, and thus the original sculptor was one more step removed from the final product. It is easy, therefore, to understand why we find such a wide variation in quality and form in the reliefs that survive. It is also clear why these three reliefs are significant, not as works by individual artists, but as representative examples of vernacular Renaissance art.

BAB

1. An exact but badly weathered duplicate, with the same integral frame and putto head below, is in a niche in the facade of the first house on the left outside the Porta Fontebranda in Siena. Various photoarchives in Florence have noted other replicas, in stucco or terracotta, in the following collections: Max von Busch and Museo Bandini, Fiesole; S. Bartolo in Testo, Scandicci; Bargello, Florence; ex-Kaiser Friedrich Museen and private collection, Berlin; National Museum, Stockholm; and several private collections in Florence. A painted stucco in the Museé Jacquemart-André, Paris, is an exact copy except for additions of a bracelet, necklace, and designs on the Madonna's robe and the haloes. Another, in a private collection in Florence, has the sole addition of beads. One other copy, also in a Florentine collection, is painted with a landscape background; John the Baptist has a larger cross and scroll; and the whole composition is enclosed in an extra frame molding widened at the bottom to allow for an inscription. An example noted in the Hearst Collection, New York, is set in the center of a crude wooden triptych, or three-part altarpiece, with standing saints painted on the side panels. Even more indicative of the aesthetic importance and popularity of the original design are those copies that do not exactly duplicate the Gallery's relief. The terracotta version in the Cleveland Museum of Art abbreviates the composition to the Madonna and Child and the book below, and encloses them in an elaborate painted frame.

2. Neri di Bicci, *La Ricordanze, 10 Marzo 1453—24 Aprile 1475,* ed. Bruno Santi, Pisa, 1976.

FRANCESCO BENAGLIO

Italian, Veronese, ca. 1432–before 1492
Madonna and Child
Oil on panel, 26⅜ x 16⅜″
Signed lower right on column: *Francesco Benaglio Pinx*
Marion Stratton Gould Fund, 64.21

This poignant *Madonna and Child* is one of the few known signed works by Benaglio, and is a fine example of Veronese painting in the second half of the fifteenth century. In its general composition the work derives from a type of Madonna and Child made popular by Andrea Mantegna and Giovanni Bellini, and continues the theme of the Incarnation of Christ, obvious in the child's nudity and playfulness as well as in the helplessness of his pose. But Benaglio also emphasizes Christ as humanity's salvation, and enriches his subject with several specific symbolic images. The Virgin, with her hands clasped in prayer, adores the Child in a distant, detached and self-absorbed way. The body of Christ is offered on a cushion placed on a stone parapet, reminiscent of the altar as well as the tomb. In front of him is a pear, which in connection with the Incarnate Christ is an allusion to his love for humanity. Behind them is a dead tree, a symbol of rebirth and of the Resurrection. At its base are two rabbits, symbols of fecundity and of those who put their hope of salvation in Christ and his Passion. The celebratory nature of this theme of salvation is emphasized by the festive garland hanging above.

When this panel was cleaned in 1965, Francesco Benaglio's signature on the lower right was discovered. He is the best-known member of the productive Benaglio family of painters in Verona. Francesco, whose work was generally influenced by the Paduan school, was also very impressed by Andrea Mantegna's style, and in 1462 he imitated Mantegna's famous altarpiece *Madonna and Child with Saints,* painted for the church of San Zeno in Verona from 1457 to 1459.[1] Benaglio was not interested in making an exact copy but rather in reproducing Mantegna's extraordinary spatial conception, using the frame pilasters as architectural elements in the painted space of the scene. In the Gallery's panel, Benaglio seems to have been influenced again by Mantegna's use of space and his heavy, classically inspired architecture.

BAB

1. Benaglio's triptych is in the chancel of S. Bernardino, Verona.

PROVENANCE:
Georges Chalandon, Paris and Lyons; M. Knoedler and Co., New York.

LITERATURE:
Bernard Berenson, *Northern Italian Painters of the Renaissance,* 1907, p. 267 (as by Domenico Morone); Bernard Berenson, "Nove Quadri in cerca di un'attribuzione, Part 3," *Dedalo,* May 1925, p. 751 (as by Morone), reprinted in Bernard Berenson, *Three Essays in Method,* 1927, pp. 55-59, p. 69, fig. 58; Raffaello Brenzoni, *Allgemeines Lexikon der Bildenden Künstler,* vol. 25, Leipzig, 1931, p. 164 (as by Morone); Evelyn Sandberg-Vavalá, "Francesco Benaglio," *Art in America* 21 (March 1933), pp. 57, 63, fig. 9; Robert Longhi, "Una Madonna della Cerchia di Piero della Francesca per il Veneto," *Arte Veneta,* no. 2 (April/June 1947), p. 88, fig. 82; Bernard Berenson, *Italian Painters of the Renaissance,* rev. ed. 1968, London, vol. 1, pp. 38, 511; Burton B. Fredericksen and Federico Zeri, *Census of Pre-Nineteenth-Century Italian Paintings in North American Public Collections,* Cambridge, MA, 1972, pp. 25, 629.

EXHIBITIONS:
Munson-Williams-Proctor Institute, Museum of Art, Utica, NY, "European Paintings from the Rochester Memorial Art Gallery," 1967; MAG, "Harris K. Prior Memorial Exhibition," 1976; Wildenstein Galleries, New York, *Treasures from Rochester,* 1977, p. 19, ill.

Italian, Florentine, 1466–1524
Madonna and Child with Angel
Tempera on panel, diam. 37 ¼ ″
Marion Stratton Gould Fund, 47.30

By the end of the fifteenth century, Florentine painters enjoyed an active popular market, created as much by the accessibility of their images as by the economic prosperity of their patrons. This *Madonna and Child with Angel* is a fine example of the intimate and decorative panels that were produced. Its religious subject is the purity and virginity of the Madonna as Mother of the Incarnate Christ, and the Child's exposed body emphasizes the idea of God made flesh. To its original viewers, this subject was undoubtedly also expanded to a reverence for motherhood and the family. The tondo form may derive from the round *desco da parto,* the often lavishly decorated tray on which a mother was brought food after giving birth. Whether or not this was the source, the tondo shape was certainly a striking addition to the Renaissance interior and echoed the ubiquitous roundel in Renaissance architecture. It also served, as here, to focus the intimate subject and to bring it closer to the viewer with a minimum of distraction or contrivance.

Raffaellino del Garbo, master of Andrea del Sarto and Bronzino, was a prolific painter whose style changed a great deal over the course of his career. This diversity, plus the fact that he is referred to variously as del Garbo, Carlo, and Capponi in documents, has led to confusion concerning his works. It is now generally agreed, however, that all the different names and styles belong to the same Raffaellino, who took the name del Garbo from the street where he had his workshop (now Via Condotta in Florence). Raffaellino began his career in the style of Filippino Lippi, and ultimately of Botticelli. Their decorativeness and lyrical use of line is evident in the porcelain skin against rich reds and greens, the translucency of the haloes, and the complicated and lushly varied drapery with its precise and vibrant highlights. Among the large number of tondi by Raffaellino, this panel, whose composition is carefully planned for its shape, is one of the finest. Raffaellino shows himself to be an able pupil of the Florentine School at the end of the fifteenth century, an artist with the promise for a distinctive mature style.

BAB

LITERATURE:
Bernard Berenson, *Florentine Painters of the Renaissance,* 3rd ed., rev. and enlarged, New York, 1909, p. 136; *The Holford Collection, Dorchester House,* Oxford, 1927, vol. 1, p. 26, no. 42, pl. 39; I. Vavasour-Elder, "Two Florentine Panel Paintings," *Art in America* 18, no. 6 (October 1930), pp. 294-299, fig. 4; Raymond van Marle, *Italian Schools of Painting,* The Hague, 1931, vol. 12, p. 371; Burton B. Fredericksen and Federico Zeri, *Census of Pre-Nineteenth-Century Italian Paintings in North American Public Collections,* Cambridge, MA, 1972, pp. 171, 629.

Italian, Florentine, 1494?–1557
The Conversion of St. Paul
Oil on panel, 38 x 31″
Marion Stratton Gould Fund, 54.2

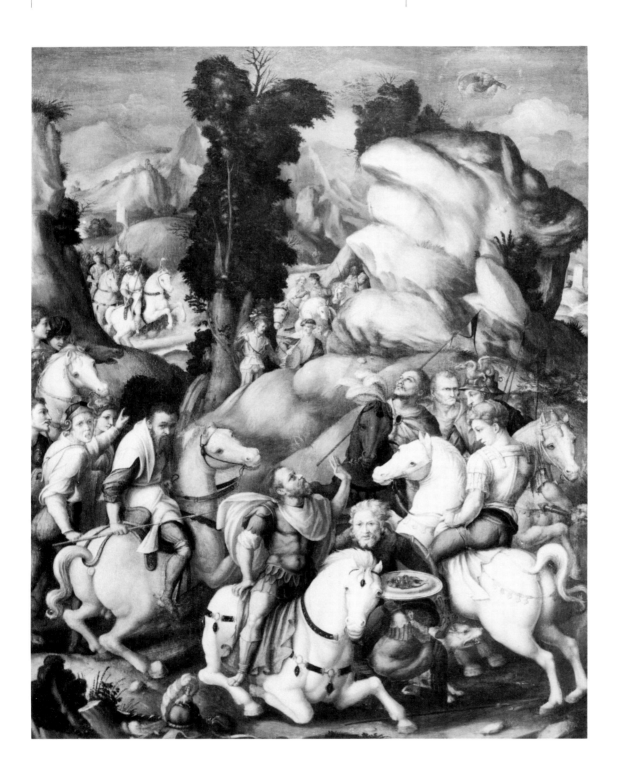

This is a complex painting by an artist attempting to reconcile two very different styles. Bacchiacca, who was both a pupil and an assistant of Perugino, returned from Perugia to his native Florence probably late in 1513. There he became a friend of Andrea del Sarto, with whom—as well as with Granacci, Franciabigio, Pontormo, and Bronzino—he was associated in important commissions. The artist and historian Vasari, Bacchiacca's contemporary and friend, noted that Bacchiacca was considered a diligent painter, especially of small figures, and that he was a skilled painter of animals, plants, and grotesques. He was, in addition, an excellent designer of tapestries and was several times employed on festival decorations in Florence. Known also are signed decorations and a painted *studiolo,* or small study, in the Palazzo Vecchio, done in Bacchiacca's late years when he is recorded on the Medici payroll.[1]

Bacchiacca's problem, shared by numerous contemporaries, was the reconciliation of the quattrocento style, in which he was trained, with the new High Renaissance style of Leonardo, Andrea del Sarto, Fra Bartolommeo, and increasingly the hegemony of Raphael and Michelangelo. Bacchiacca solved it by developing a systematic eclecticism, a selective and absorptive process of imitation, a borrowing of motives, attitudes, and technical procedures. Almost invariably his figures are derived from Raphael (whose work he studied largely through reproductive prints) or Michelangelo. These are ingeniously arranged in or before landscape settings that he also derived from prints by northern European artists, especially those by Albrecht Dürer and Lucas van Leyden.

Immediately apparent in the *Conversion of St. Paul* is the curious, yet typical, blending of modern and archaic features. The additive and generally symmetrical, rigorously diagrammatic composition reveals the quattrocento characteristics that proclaim the artist a pupil of Perugino. The tendency to restrict, somewhat, recession in depth, with concomitant emphasis on vertical elements, is a partial adoption of one of the new structural and expressive means of Tuscan Mannerism.

Of the numerous figures, six are derived from Michelangelo: five from the *Battle of Cascina,* one from the Sistine Chapel ceiling. Two are taken from Agostino Veneziano's engraving after Raphael's *Spasimo* (Prado, Madrid). At least one depends on Leonardo, one on Perugino, and one is taken from Lucas van Leyden's engraving of the *Conversion of St. Paul.*[2] This last, the drummer in center middle distance, is in symbolic encounter with the drummer based on Michelangelo's *Cascina*. For the mountainous background, Bacchiacca used Dürer's woodcut *Visitation* (B. 84) and engraving *Madonna with the Pear* (B.41)[3] as well as Lucas's *Conversion.*

Iconographically, Bacchiacca's treatment of the subject, so important in the history of the Christian faith, is of unusual interest. The Conversion had been treated as an equestrian scene in both the North and the South since the mid-twelfth century. The customary Italian rendering showed Paul having fallen or in the act of falling from his horse. In the Northern tradition Paul remains firmly astride the horse and raises a hand to shield the light streaming down from God, but the shock of the conversion forces the horse to the ground. Bacchiacca or his patron seems to be consciously rejecting the normal Italian rendering. Vasari tells us that the artist did numerous paintings that were sent to France and England. It is possible that, if works like the *Conversion of St. Paul* were, in fact, designed for the export trade, their iconography was deliberately modified in accordance with Northern taste.

Evident in this important work are the variety and allusive juggling of forms characteristic of much later cinquecento production. Bacchiacca foreshadows here a sort of "mannered Mannerism," and in his methods anticipates not only those of Vasari's generation but also those of a supposed later systematic, eclectic program. This painting also demonstrates, as do Bacchiacca's other works, the close and fruitful interrelationship between prints and paintings which is one of the most pervasive, essential and, indeed, causative features of Mannerism.

HSM

1. Giorgio Vasari, *The Lives of the Painters, Sculptors, and Architects,* trans. A. B. Hinds, 4 vol., London, 1963, vol. 2, p. 134, vol. 3, pp. 54, 297, 303-304.

2. Ellen S. Jacobowitz and Stephanie L. Stepanek, *The Prints of Lucas Van Leyden,* Washington, DC, 1983, no. 19.

3. "B" numbers refer to the cataloguing of Adam Bartsch. See *The Illustrated Bartsch: Dürer,* ed. Walter L. Strauss, vol. 10, 1-2, New York, 1980, part 1, pp. 97, 356-357.

PROVENANCE:
Private collection, England; Julius Weitzner, New York (dealer); Caesar R. Diorio, New York (dealer).

LITERATURE:
Howard S. Merritt, "A New Accession," *Gallery Notes* 20, no. 3 (January 1955), ill., n.p.; Howard S. Merritt, "Bacchiacca Studies; The Uses of Imitation," Ph.D. diss., Princeton University, 1958; George Marlier, "Pourquoi ces rochers à visages humains?" *Connaissance des arts,* no. 124 (June 1962), pp. 82-91, fig. 6; Lada Nikolenko, *Francesco Ubertini, Called Il Bacchiacca,* New York, 1966, pp. 23, 60, fig. 74; Burton B. Fredericksen and Federico Zeri, *Census of Pre-Nineteenth-Century Italian Paintings in North American Public Collections,* Cambridge, MA, 1972, p. 629.

EXHIBITIONS:
Art Association of Indianapolis (IN), John Herron Art Museum, "Pontormo to Greco," 1954, no. 5, ill.; University of Kansas Museum of Art, Lawrence, *Masterworks from University and College Art Collections,* 1958, no. 70, ill.; Baltimore Museum of Art, *Bacchiacca and His Friends,* 1961, no. 17, fig. 15; Wildenstein Galleries, New York, *Treasures from Rochester,* 1977, p. 26, ill.

NICOLÒ DELL'ABATE

Italian, 1509/1512?–1571
Portrait of a Boy of the Bracciforte Family, ca. 1550
Oil on canvas, 63¾ x 34¼ "
Marion Stratton Gould Fund, 76.13

Nicolò dell'Abate fashioned his own courtly, elegant style from the influences of Correggio, Dosso Dossi, Parmigianino, Giulio Romano, and Flemish landscapists. Noted for his frescoes, he began early in 1537 in his native Modena to decorate with Alberto Fontana, the *Beccherie,* of which only a few fragments remain. At the Boiardo family's castle at Scandiano, he painted scenes from the *Aeneid* and a ceiling octagon of musicians, *Concert,* some of which, mounted on canvas, are now in the Galleria Estense in Modena. There, too, in the Palazzo Comunale, Nicolò painted a series of Roman history scenes in 1546.[1] Landscape backgrounds in all these frescoes are both realistic and fanciful.

Nicolò moved to Bologna in 1548, where he continued to paint literary themes. Animated scenes from Ariosto's *Orlando Furioso,* done for the Palazzo Torfanini (now in the Pinacoteca Nazionale, Bologna), are depicted in airy, imaginative settings. The frescoes that Nicolò painted in the Palazzo Poggi, today part of the University of Bologna, are masterpieces of aristocratic elegance. Card games, concerts, festive banquets, landscapes, and more scenes from the *Aeneid* demonstrate the artist's gifts in composition, brilliant execution, and use of color.

Nicolò dell'Abate was called to France by Henry II, and with Primaticcio, a Bolognese artist, and Rosso Fiorentino became one of the three great artists of the School of Fontainebleau. Though Nicolò carried out designs of Primaticcio in the ballroom and the Ulysses gallery, he was able to establish his own stylistic originality. Two important canvases of the French period, *The Rape of Proserpine* (Louvre, Paris) and *Aristaeus and Eurydice* (National Gallery, London) continue the expansive, magical landscapes seen in two Bolognese paintings, *Landscape with the Stag Hunt* (Borghese Gallery, Rome) and *Landscape with Wild Boar Hunt* (Spada Gallery, Rome) of about 1550–1552. Their sparkling vistas enhance the imaginative concept of landscape developed in the sixteenth century.

Portrait of a Boy of the Bracciforte Family shows a full-length figure clad in ivory-colored silk, embroidered in gold, with a sword at his side, a costume that identifies him as a young nobleman.[2] The boy's cultivated taste and future destiny are alluded to by the allegorical winged figure *Fame,* holding two long thin trumpets, and the book and the flute on the table. In his right hand is a medal said to represent, though the letters are indistinct, the arms of the Bracciforte family.[3]

Although there are no portraits documented among the works from Nicolò's Italian period, a number are nonetheless attributed to him.[4] In this portrait the face, painted with particular delicacy and sensitivity, and the hands can be compared to the lute player in the Scandiano *Concert,* and certainly to the Palazzo Poggi figures, which would date this painting about 1550.

In all of his work—the fresco cycles, oil paintings, drawings, designs for architectural decorations, and the portraits that are ascribed to him—Nicolò dell'Abate displayed versatility, imagination, fine draftsmanship, and poetic invention.

SES

1. Sylvie Béguin, *Mostra di Nicolò dell'Abate,* Bologna, 1969; Erika Langmuir, "Arma Virumque—Nicolò dell'Abate's Aeneid Gabinetto for Scandiano," *Journal of the Warburg and Courtauld Institutes* 39 (1976), pp. 151-170; "*The Triumvirate of Brutus and Cassius:* Nicolò dell'Abate's Appian Cycle in the Palazzo Comunale, Modena," *Art Bulletin* 59, no. 2 (June 1977), pp. 188-196.

2. Attributed to Nicolò dell'Abate, Bolognese period, ca. 1550, by Federico Zeri in a letter of May 20, 1976, to Mr. Louis Goldenberg, Wildenstein and Co., New York.

3. According to Zeri (see note 2), "the medal in the boy's hand is not included in the specialized works on Italian Renaissance medals; it must have been struck in very few examples for the Bracciforte Family, whose arms it shows very clearly." According to Vittorio Spretti, *Enciclopedia storico-nobiliare italiana,* Bologna, 1928–1935, the Bracciforti were connected with Piacenza, Milano, Parma, Colorno, and Fiorenzuola in the sixteenth century.

4. Sylvie Béguin, *The Age of Correggio and the Carracci,* Washington, DC, 1986, p. 48.

PROVENANCE:
Alessandro Contini-Buonacossi Collection, Italy; Myron C. Taylor, New York; Wildenstein Galleries, New York.

LITERATURE:
Helen Comstock, *One Hundred Most Beautiful Rooms in America,* 1958, p. 98, ill.; Feruccia Cappi Bentivegna, *Abbigliamento e costume nella pittura italiana,* Rome, 1962, pl. 344; Susan E. Schilling, *"Portrait of a Boy of the Bracciforte Family,"* MAG, *Annual Report 1975–1976,* pp. 10-11, ill.

EXHIBITIONS:
Wildenstein Galleries, New York, *Treasures from Rochester,* 1977, p. 29; Philbrook Art Center, Tulsa, OK, *Gloria dell'Arte, A Renaissance Perspective,* 1979–1980, no. 147, pp. 74-75, ill; Pinacoteca Nazionale, Bologna, and National Gallery, Washington, DC, *The Age of Correggio and the Carracci,* 1986–1987, no. 2, pp. 48-50, ill. p. 49.

DOMENIKOS THEOTOCOPOULOS,
CALLED EL GRECO

Spanish (b. Greece), 1541?–1614
The Apparition of the Virgin to St. Hyacinth, ca. 1605–1610
Oil on canvas, 39⅜ x 24⅜"
Marion Stratton Gould Fund, 38.28

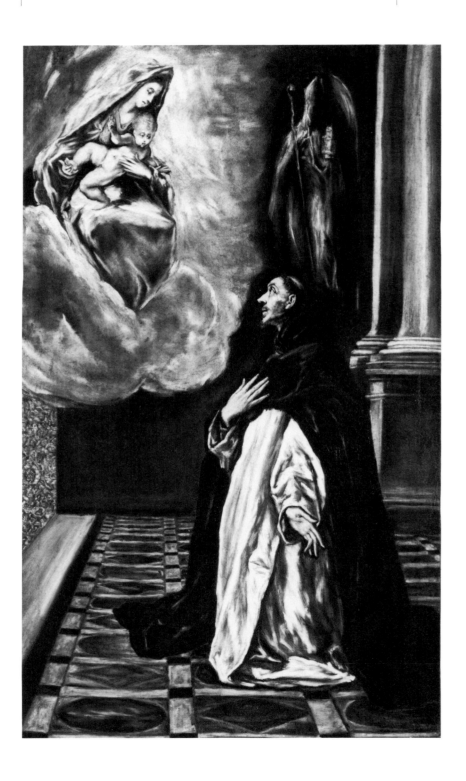

During the early decades of the twentieth century, El Greco was "rediscovered." His significance as a painter was re-evaluated according to standards of the art of this century, and he has been hailed as one of the great precursors of modern painting. The roots of modernism are seen in the intensity of El Greco's personal vision and in the dramatic attenuation, even distortion, of his forms for expressive ends.

El Greco is the popular name of Domenikos Theotocopoulos, an artist born in Crete, who lived and studied in Venice and Rome, and made Toledo, Spain, his home during the second half of his life. Although the history of his early life is not known in detail, his painting bears evidence of the Byzantine traditions of his native Crete as well as exposure to masters of the High Renaissance, particularly Titian and Tintoretto in Venice and Raphael and Michelangelo in Rome.

The Apparition of the Virgin to St. Hyacinth was painted in the last decade of El Greco's life. It belongs among the large number of devotional paintings of saints in his oeuvre. The identification of the saint as Hyacinth is based on hagiographical details and from similarities to a contemporary painting of this same subject.

Hyacinth (1185–1257) was a Polish Dominican priest who, according to legend, had a vision of the Virgin on the feast day of her Assumption. Although a relatively little-known saint, he had been recently canonized when El Greco painted this work. In the year of Hyacinth's canonization, 1594, Ludovico Carracci, one of the leading Italian painters of the period, commemorated the event with *The Vision of St. Hyacinth* (Louvre, Paris).[1] The poses and positions of the Virgin and the saint in the Carracci painting are remarkably close to those El Greco chose a decade later. Although Carracci's *Vision* itself was probably unknown to El Greco, who had been living in Spain since the late 1570s, he may well have learned of the painting through an engraving by either of the Flemish printmakers Johannes Sadeler or Raphael Sadeler.[2]

El Greco painted two very similar versions of St. Hyacinth kneeling in devotion before a vision of the Virgin and Child. The other version (Barnes Foundation Collection, Merion, PA) is larger and more detailed, and in it the image of the bishop in the niche behind St. Hyacinth, which is vaporous here, is more defined. Scholars vary in their opinion about the relation between these two paintings. The Gallery's version has been considered both a sketch for the larger version and a replica El Greco painted after the larger work was completed.[3] It has also been suggested that El Greco may have worked on this painting with an assistant. In his authoritative study *El Greco and His School*, Harold E. Wethey attributes this painting to "El Greco and assistant," citing distinctions between the "more skillful brushwork in the figures" and the "rather summarily painted" pavement tiles and columns as evidence of two hands.[4]
SDP

1. H. Bodmer, *Ludovico Carracci,* Magdeburg, 1939, p. 49, no. 80, fig. 43.

2. Martin S. Soria, "Some Flemish Sources of Baroque Painting in Spain," *Art Bulletin* 30, no. 4 (December 1948), p. 250. The image by Johannes Sadeler (1550–ca. 1600) is reproduced in F. W. H. Hollstein, *Dutch and Flemish Etchings, Engravings, and Woodcuts, ca. 1450–1700,* thirty vols., ed. Dieuwke de Hoop Scheffer, Amsterdam, 1949, vol. 21-22, p. 145, no. 367, as "after A. Carracci?." An engraving by Raphael Sadeler (1560–1628/32) reproduces this image in reverse and includes the inscription, "A. Carazo Inventor" (Hollstein, ibid., p. 236, no. 104).

3. Halldor Soehner refers to the Gallery's painting as a replica in his "Greco in Spanien," p. 179.

4. Wethey, *El Greco,* p. 127.

MASTER I. C.
(JEHAN COURTEYS, FRENCH, DIED 1586, OR
JEAN DE COURT, FRENCH, CA. 1508–1584)

Covered Tazza with Scenes from Genesis, ca. 1555–1585
Limoges enamel, 11 x 7⅜ "
Buswell-Hochstetter Bequest, 55.136

SCHOOL OF VEIT STOSS

German (Franconia), 1447–1542
St. John the Evangelist
Lindenwood, 31½ x 10⅜ x 7½ "
Bertha Buswell Bequest, 55.111

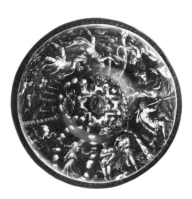

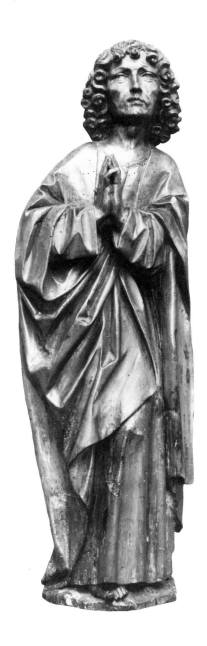

GERMAN, 16TH CENTURY

St. Peter
Wood, 32¾ x 22¼ x 6¼"
Bertha Buswell Bequest, 55.80

MARTIN SCHONGAUER

German, ca. 1450–1491
Virgin and Child with Apple, ca. 1475
Engraving, 6 ¹³⁄₁₆ x 4 ⅞"
Anonymous gift, 82.39

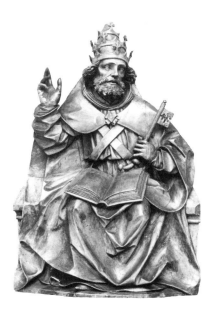

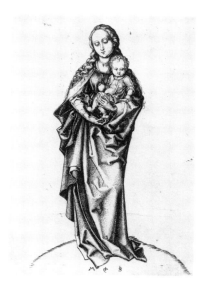

SCHOOL OF DONATELLO

Italian, 1386–1466
Madonna and Child
Stucco, 11⅛ x 8¾"
Gift of Emily Sibley Watson (Mrs. James Sibley Watson), 28.467

ALBRECHT DÜRER

German, 1471–1528
The Sea Monster, ca. 1498
Engraving, 9 ¹⁵⁄₁₆ x 7 ⁷⁄₁₆"
Gift of Emily Sibley Watson (Mrs. James Sibley Watson), 13.19

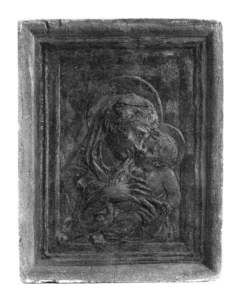

ANTONELLO GAGINI

Italian, 1478–1536
St. Catherine, 1525
Marble, 63 x 26 x 17½"
R. T. Miller Fund, 49.75

VINCENZO CATENA

Italian, 1470–1531
Portrait of a Man, ca. 1508
Oil on panel, 12⅝ x 10¼"
Marion Stratton Gould Fund, 49.64

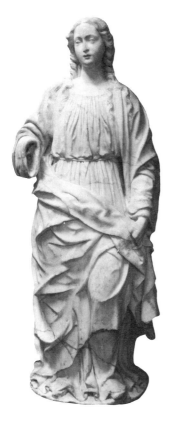

ATTRIBUTED TO MATTEO DE' PASTI

Italian, 1420–1467/68
Portrait of a Member of the Corsini Family
Marble with polychromed and gilded wood, 17¾ x 12"
Given in memory of Inez D'Amanda Barnell by her friends, 65.8

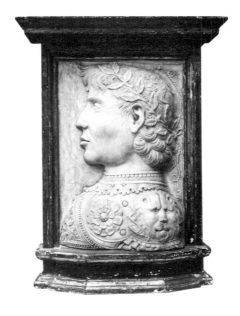

JACOPO ROBUSTI TINTORETTO
Italian, 1518–1594
or
DOMENICO TINTORETTO
Italian, 1560–1635

Portrait of a Venetian Patrician
Oil on canvas, 44¾ x 35″
George Eastman Collection of the University of Rochester, 68.97

VRANCK VAN DER STOCKT

Low Countries (Flemish), 1424–1495
St. Margaret with Donor
Oil on panel, 18⅛ x 7⅞″
Marion Stratton Gould Fund, 44.15

FRANCO-FLEMISH

Judgment of Emperor Otto III of Saxony, ca. 1495
Wool and silk, 168½ x 134″
Gift of James Sibley Watson, 30.1

MASTER OF ST. SANG

Low Countries (Flemish), active ca. 1515–1530
Adoration of the Magi, ca. 1515
Oil on panel, 38⅝ x 21¾″
Marion Stratton Gould Fund, 80.43

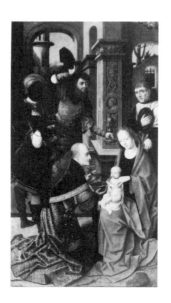

HENDRIK GOLTZIUS

Low Countries (Dutch), 1558–1616
The Sorcerer, or *Allegory of Time and Nature,* ca. 1588
Chiaroscuro woodcut, 13¾ x 10⅜"
Anonymous gift, 79.66

LOW COUNTRIES (SOUTHERN NETHERLANDS)

Elisha Multiplying the Widow's Oil, ca. 1570–1575
Oil on panel, 38¾ x 56"
Gift of James O. Belden, 77.187

WORKSHOP OF WILHELM DE PANNEMAKER

Low Countries (Belgian), active 1548–1561
Tapestry with Trellised Garden with Animals
Wool and silk, 147 x 182"
Gift of Mrs. Granger A. Hollister, 31.15

Low Countries (Flemish), 1544–1607
Wooded Landscape with Town in a Valley, before ca. 1590
Pen and ink with wash on paper, 8 ¾ x 12 ⁷⁄₁₆"
Anonymous gift, 81.38

Chalice
Gilded electrum, 9 ⅛ x 6 ⅜"
R. T. Miller Fund, 49.52

SCHOOL OF NOVGOROD

Russian
St. George Slaying the Dragon, ca. 1300–1350
Tempera on panel, 30 ¾ x 23 ¹⁄₁₆"
Gift of Professor George Ford and his wife, Patricia, 82.18

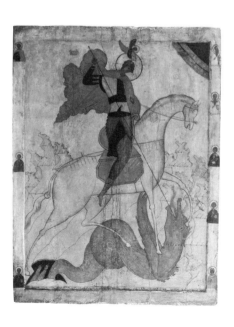

Contents

EUROPEAN ART 1600–1800

ANTHONY VAN DYCK

Flemish, 1599–1641
Portrait of an Italian Nobleman, 1622–1625
Oil on canvas, 40 x 32½"
George Eastman Collection of the University of Rochester, 68.100

Temperamental, pious, and vain, Van Dyck was also supremely talented. His religious and mythological pictures and especially his portraits are among the outstanding masterpieces of Baroque painting. The great success that he enjoyed during his lifetime is further suggested by the numerous imitators and followers he inspired in Flanders, Italy, and England.

Van Dyck learned his craft as an apprentice to Hendrick van Balen, but he was functioning as an independent artist perhaps as early as 1616 and was accepted as a master in Antwerp's Guild of St. Luke in 1618. That same year he began his fruitful collaboration with Peter Paul Rubens, whose graphic style and compositional innovations exerted a most profound influence on the younger artist. After a brief visit to England, Van Dyck left for Italy, where he particularly admired the work of Titian. In 1627 he returned to Antwerp and remained there until 1632. In that year he emigrated to England, where he came to enjoy immense prestige as the favorite painter of Charles I.[1]

During his stay in Italy, Van Dyck established himself in Genoa, using the home of the printmakers and painters Lucas and Cornelis de Wael as a base. His success in the maritime republic is suggested by a guide book published in 1780 which claimed ninety-nine paintings by Van Dyck for the city, of which seventy-two were portraits.[2] Although the formulas he used had their prototypes in the works of Titian and Rubens, Van Dyck's success as a portrait painter was the result of more than simple imitative virtuosity. All of his portraits reflect an acute sensitivity to his individual sitters and his innate appreciation of the aristocratic image they sought to project.

The Gallery's canvas has suffered over time, but the liveliness of expression, feeling of truth, and sense of nobility which the seventeenth-century biographer Raffaello Soprani praised in Van Dyck's Genoese portraits remain evident in *Portrait of an Italian Nobleman*.[3] The three-quarter length, life-size figure stands before the substantial masonry of a doorway in a pose that Van Dyck repeated in his 1630 portrait of Nicholas Lanier (Kunsthistorisches Museum, Vienna). His head is turned to face the viewer in a gesture that vivifies the three-quarter view of his armored torso.[4] His right arm is akimbo; his left hand, with characteristic tapering fingers, rests confidently on the pommel of the sword that symbolizes both his noble status and his military calling. His face is set off by a discreet filigree collar which, though considerably restored, is apparently of the same *punto in aria* lace that ornaments his cuffs. The various textures are rendered with luscious precision: the sleek, cool surface of the black armor glistens with reflected light; the flesh of the carefully modeled face and elegant hand has an almost palpable softness and warmth; the eyes glitter with life. Although the subject's name has been lost, his social identity is very clear: we know this man to be a gentleman-warrior, alert, proud, and self-confident.

BB

1. Van Dyck's career is lucidly surveyed by Christopher Brown, *Van Dyck,* Ithaca, NY, 1983.

2. Ibid., p. 86.

3. *Vite de' pittori, scultori, ed architetti genovese . . .,* ed. C. G. Ratti, Genoa, 1768 (reprint, Bologna, 1969), vol. 1, p. 447.

4. Dr. Helmut Nickel, curator of arms and armor at the Metropolitan Museum of Art, New York, has identified the armor as of North Italian, possibly Brescian, origin and contemporaneous with the date of the portrait (Vergara, "Armor and Lace," p. 12, note 1).

PROVENANCE:
Private collection, Venice; Jean-Baptiste-Pierre Le Brun, Paris (by 1807/8; his sale, 1810?); Henry Danby Seymour, Manor House, Trent; Miss Jane Margaret Seymour, Knoyle House, Salisbury, Wilts.; M. Knoedler and Co., New York; George Eastman, Rochester in 1913.

LITERATURE:
Jean-Baptiste-Pierre Le Brun, *Recueil de gravures a l'eau forte, et ombrées . . . recueillis dan un voyage fait en Espagne, au midi de la France et en Italie, dans les années 1807 et 1808,* 2 vols., Paris, 1809, vol. 2, p. 43, no. 146 (engraved in reverse); John Smith, *A Catalogue Raisonné of the Works of the Most Eminent Dutch, Flemish, and French Painters,* 8 vols., London, 1829–1837, vol. 3, pp. 175-176, no. 606; Gustav Waagen, *Treasures of Art in Great Britain,* 3 vols., London, 1854, vol. 2, pp. 241-242; Jules Guiffrey, *Antoine Van Dyck: Sa vie et son oeuvre,* Paris, 1882, p. 283, no. 973; Gustav Glück, *Van Dyck,* Stuttgart, 1931, p. 538, no. 164; Erik Larsen, *L'opera completa di Van Dyck,* 2 vols., Milan, 1980, vol. 1, no. 348; Lisa Vergara, "Armor and Lace: Anthony Van Dyck's *Portrait of an Italian Nobleman,*" *Porticus* 8 (1985), pp. 7-12; Erik Larsen, *Anthonis Van Dyck: Die Gemälde,* Freren, 1987 (forthcoming).

EXHIBITIONS:
British Institution, London, 1861, no. 49; MAG, "Loan Exhibition of Paintings Owned by Residents of Rochester," 1914, no. 79; MAG, "The George Eastman Collection of Paintings," 1948–1949; Wildenstein Galleries, New York, *Treasures from Rochester,* 1977, p. 40; MAG, *The George Eastman Collection,* 1979–1980, pp. 20, 33, ill.

DAVID TENIERS THE YOUNGER

Flemish, 1610–1690
Tavern Scene
Oil on canvas, 18⅜ x 11⅞"
Signed lower left: *D. Teniers, Fec*; dated, on drawing attached to wall: *1680*
Buswell-Hochstetter Bequest, 55.70

David Teniers the Younger was received as a master in the Antwerp painters' guild in 1632. After his marriage to the daughter of the prominent painter Jan "Velvet" Brueghel, Teniers's career advanced rapidly. He became intimately acquainted with Rubens and his family and some years later was elected dean of the guild. For two decades he exercised his craft in his native city but moved permanently to Brussels in 1651 after being appointed court painter to the archduke Leopold Wilhem, a position he retained under Don Juan of Austria. Despite his removal from Antwerp, Teniers maintained an interest in the city's artistic affairs. At his instigation, an academy was founded there in 1665. This act was in keeping with his ambition to elevate the social status of artists, a concern also revealed by his application for a patent of nobility. Favored by the Hapsburgs in The Netherlands and Spain, his work was eagerly sought by other European rulers, among them Charles I of England, William of Nassau, and Christina of Sweden.

Teniers was the outstanding "little master" of the Spanish Netherlands. His paintings were renowned for their attractive silvery brown tonality and unusually rapid execution; it was said that he could produce a work in only an afternoon. For the archduke he painted views of the royal art collection as well as close to 250 small-scale copies of Italian paintings in the possession of the duke. In addition to portraits in small format, Teniers painted a wide range of figure subjects. Especially popular themes were scholars, alchemists, witches and demons, monkeys aping human manners, myths and Scriptural episodes. But the greatest demand was for paintings of rural life and tavern scenes, of which the Gallery's piece is a typical example.

In a rustic country tavern, boon companions relax, smoke, drink, and gab. Their leisure, however, is not deserved. Shunning the light of day and its call to labor, these merry fellows carouse while others toil. Coarse-featured and attired in the rude dress of country folk, they engage our attention by their uninhibited behavior. At the extreme left, a man overcome by his excesses relieves himself in a wooden tub. Propriety and temperance are unknown here. The figures in the foreground, all of whom are smoking (which was thought at the time to inebriate), are showing signs of intoxication.

Tavern Scene is unusual in that it is one of the few pictures produced near the conclusion of Teniers's career which are dated. Painted when the artist was seventy, it is a finely crafted piece that shows no diminution of his artistic power. Particularly noteworthy for its tonal unity, the painting's range of browns effectively conveys the dusky atmosphere of this rural inn. Except for the smoker lighting his pipe, who is attired in blue and sports a red cap, the other men wear garments that do not differ in hue from their surroundings.

Genre scenes painted in The Netherlands during the Baroque era, whether produced by Dutch or Flemish artists, appear to be faithful records of quotidian experience. But this verism is fictitious, as Teniers's *Tavern Scene* illustrates. The components in this work are actually conventions derived in the main from Adriaen Brouwer's paintings. But whereas the peasants in Brouwer's compositions are often violent and vulgar, the actions of Teniers's characters are less provocative, evoking our amusement rather than sharp condemnation.

Teniers, though, does not condone their behavior, a fact that is evident from the presence of the owl drawn on the sheet of paper tacked to the wall directly in the painting's center. A popular iconographic handbook of the day identified the owl as an attribute of vulgar, common persons and proverbs referring to drunkenness often mention the bird, for example, "He is as drunk as an owl." Owls also signified folly, a point underscored in the drawing by the spectacles and candlestick that flank the bird. These motifs point to its irremediable behavior. Even with the aid of light and occular correction, the creature remains blind to its own ignoble actions.[1]

Teniers was not the only artist influenced by the emblem. Ten years before Teniers painted *Tavern Scene,* the Dutch artist Jan Steen used the very same picture of the owl, eyeglasses, and candlestick in *The Drunken Couple* (Rijksmuseum, Amsterdam). A legend beneath the owl explains: "What use candle and spectacles if the owl cannot and will not see?" As an heir to the Erasmian tradition, Teniers accepted folly as an inherent aspect of human nature but, like Erasmus, he believed that man, being a rational being, could temper his sensual impulses through education. Teniers's *Tavern Scene,* diverting as it is, is nevertheless an instrument of moral instruction.

SK

1. An emblem (95) first published in Gabriel Rollenhagen's *Selectorum emblematum centuria secunda* (Utrecht, 1613) expressed this idea with identical symbols: "Light is utterly useless to the blind" ("*Coecus nil luce iuvatur*").

PROVENANCE:
Lord Huntingfield, England; Bertha Hochstetter Buswell (Mrs. Henry Buswell), Buffalo, NY; Mr. Ralph Hochstetter, Buffalo, NY, 1941–1955.

EXHIBITIONS:
Wiener Secession, Vienna, "Drei Jahrhunderte Vlämische Kunst, 1400–1700," 1930, no. 113; MAG, "The Buswell-Hochstetter Collections," 1955; Munson-Williams-Proctor Institute, Museum of Art, Utica, NY, "European Paintings from the Rochester Memorial Art Gallery," 1967; MAG, "Through the Looking Glass," 1981; Center for the Fine Arts, Miami, FL, *In Quest of Excellence,* 1984, no. 58, pp. 190, 240, ill. p. 196.

HYACINTHE RIGAUD

French, 1659–1743
Portrait of Charles Gaspard Guillaume de Vintimille du Luc, Archbishop of Paris, 1731
Oil on canvas, 61 ⅞ x 52 ¾ "
Gift of the Women's Council of the Memorial Art Gallery, 68.1

Rigaud was the leading portraitist to the royal court at Versailles and the high aristocracy in Paris at the beginning of the eighteenth century. His most famous work is an ornate state portrait of Louis XIV. There were many influences on the formation of his style, but in this large-scale clerical portrait he follows the formula of the Flemish Baroque painter Anthony Van Dyck's *Cardinal Guido Bentivoglio* (ca. 1623, Palazzo Pitti, Florence), seating the subject in full regalia in an elegant armchair before a dramatically billowing curtain. A desk with writing materials and a rich library in the background also allude to the sitter's administrative and scholarly attainments. Rigaud's colors, however, are cooler and more silvery than those of Van Dyck.

The archbishop (1656–1746) came from a rich and distinguished Marseilles family that had produced numerous generals and ambassadors. Named bishop of his native city at the age of twenty-eight, Msgr. de Vintimille du Luc was subsequently archbishop of Aix-en-Provence from 1708 to 1729 and of Paris from 1729 until his death. He was less known for theological learning than for his administrative and diplomatic skills; his mild, conciliatory nature is evident in Rigaud's portrait.

Rigaud's account book indicates that the portrait was executed in 1731 for 3,000 *livres,* the artist's highest price for all except royal commissions. The origin and destination of the commission is not known, since the painting was not included in the inventory of the archbishop's possessions at his death. An unfinished strip along the bottom, continuous with the rest of the canvas, may have been intended for an inscription identifying the subject. The work may, therefore, have been painted for donation to a church or other public institution. Its imposing scale illustrates late Baroque portraiture at its most grandiose.

DR

PROVENANCE:
Comte Allard du Chollet, Paris, 1919; Heim Gallery, London.

LITERATURE:
L. Dussieux, E. Soulié, Ph. de Chennevières, P. Mantz, and A. de Montaiglon, *Mémoires inédits sur la vie et les ouvrages des membres de l'Académie Royale de peinture et de sculpture,* Paris, 1854, vol. 2, pp. 125, 198; J. Roman, *Le Livre de raison du peintre Hyacinthe Rigaud,* Paris, 1919, pp. 207, 261, 277; Donald A. Rosenthal, "An Archbishop's Portrait by Hyacinthe Rigaud," *Porticus* 7 (1984), pp. 17-22.

EXHIBITIONS:
Schloss Charlottenburg, Berlin, *Höfische Bildnisse des Spätbarock,* 1966, no. 54; Heim Gallery, London, *French Paintings and Sculpture of the Eighteenth Century,* 1968, no. 3; MAG, "Harris K. Prior Memorial Exhibition," 1976; Wildenstein Galleries, New York, *Treasures from Rochester,* 1977, p. 44, ill.

JEAN-BAPTISTE LEPRINCE

French, 1734–1781
The Visit, 1779
Oil on canvas, 34¾ x 50¾"
Signed and dated lower left: *Le Prince / 1779*
Marion Stratton Gould Fund; and Mr. and Mrs. E. Lewis Burnham, Edith
Holden Babcock bequest and Bertha Buswell bequest, by exchange, 77.102

In order to pursue his artistic ambitions, Leprince secured the patronage of the maréchal de Belle-Isle, governor of the painter's native city of Metz. With his support, Leprince moved to Paris, where he entered the atelier of the influential painter François Boucher and adopted the master's decorative manner and fanciful treatment of pastoral subjects. After his marriage failed, Leprince traveled for two years in Italy but was evidently uninspired by the antique scenery. In 1758 he passed through Holland on his way to Russia. In Russia he sketched continuously, recording the costumes and customs he observed during his travels. Leprince used this exotic material to establish his reputation after returning to Paris in 1763.[1] The famous connoisseur Pierre Jean Mariette observed a considerable improvement in the artist's technique over what it had been before his departure,[2] and this opinion was echoed by the Académie into which Leprince was inducted in 1764. His paintings of Russian subjects (*russeries*) were initially praised, and his related prints, some produced by the aquatint method that he claimed to have invented, enjoyed wide popularity.[3] In 1773 Leprince delivered a lecture on landscape to the Académie. Published as *Principles du dessin,* this treatise marked a new focus in the artist's work. The landscapes to which Leprince devoted his final years are well represented by the Gallery's painting, *The Visit.*

Although Leprince's Russian subject matter was novel, the images tend to have a fantasylike quality because the artist largely retained the pastel hues and delicate technique of the older Rococo style he had assimilated in Boucher's studio. Later works similar to *The Visit,* such as *Figures Outside a Country Inn* (1781)[4] and the 1776 canvas *Landscape with Figures* (Museum of Art, Baltimore), possess a more solid naturalism, reflecting one trend in French landscape painting as it evolved during the second half of the eighteenth century.[5] At the same time that Jean-Jacques Rousseau was promoting a new sensibility toward nature, French connoisseurs were collecting the naturalistic masterpieces of the Dutch Golden Age and the academician Charles-Joseph Natoire, as director of the French Académie in Rome (1751–1774), was encouraging young artists to sketch out-of-doors. The importance of the direct study of nature was emphasized by Leprince, who advised young artists first to study individual parts of trees, then to portray specific species, and finally to depict the appearance of trees at varying distances at specific times of day. The benefits of such careful observation are evident in *The Visit.*

Eschewing the conventions of classical landscape which had been the legacy of Nicholas Poussin and Claude Lorrain, Leprince created a canvas reminiscent in style and subject matter of the works of the seventeenth-century Dutch masters. Like Jacob van Ruisdael, Jan Wijnants, or Nicholaes Berchem, for example, Leprince combined genre with landscape to suggest a moment glimpsed in everyday life.[6] The figures and their costumes are individualized and meticulously painted; the textures throughout are carefully differentiated. The billowing clouds and subtle modulations of light and shade enliven the surface, while the old tree, which functions as the central axis of the composition, is rendered with appropriate grandeur. Filled with domestic animals, a variety of subsidiary figures, a château, and a farmhouse, the extensive vista offers a view of nature tamed in which humankind is a fundamental element. The genre episode complements the integrated view of nature suggested by this panorama. With its implication of class roles that were typical of the ancien régime and well understood by those who patronized the arts, the depiction of nobles visiting a peasant family to congratulate them on the birth of a child would have appealed to the sense of humanity cultivated during the Enlightenment.

BB

1. See Louis Réau, "L'Exotisme russe en l'oeuvre de Leprince," *Gazette des beaux-arts,* March 1921, pp. 145-165, and Kimberly Rorschach, *Drawings by Jean Baptist Leprince for the "Voyage en Sibérie,"* Philadelphia, 1986.

2. Pierre Jean Mariette, *Abecedario,* ed. P. de Chennevieres and A. de Montaiglon, 6 vols., Paris, 1851–1856, vol. 3, pp. 192-193.

3. For example, the enthusiasm expressed by Denis Diderot in his review of the 1765 Salon was considerably diminished by the display of similar subjects in 1767. See *Salons,* ed. J. Seznec and J. Adhémar, Oxford, 1960, vol. 2, pp. 171-180, and vol. 3, pp. 206-220.

4. Sotheby's (Geneva), June 28, 1979, lot 162.

5. Philip Conisbee, *Painting in Eighteenth-Century France,* Ithaca, NY, 1981, pp. 171-200.

6. On the influence of Dutch precedents and the taste for genre painting in eighteenth-century France, see Heather McPherson, "Some Aspects of Genre Painting and Its Popularity in Eighteenth-Century France," Ph.D. diss., University of Washington, 1982.

PROVENANCE:
Comte de Seuilhade de Chavin, France; Newhouse Galleries, New York.

LITERATURE:
R. Saisselin, "A Leprince Landscape," *Porticus* 2 (1979), pp. 26-33.

EXHIBITIONS:
Wildenstein Galleries, New York, *Romance and Reality Aspects of Landscape Painting,* 1978, no. 41; MAG, "Masterpieces for Rochester: Acquisitions since 1975," 1979; High Museum of Art, Atlanta, GA, *The Rococo Age: French Masterpieces of the Eighteenth Century,* no. 69, p. 140; Dixon Gallery and Gardens, Memphis, TN, *From Arcadia to Barbizon: A Journey in French Landscape Painting,* 1987, no. 4, p. 33.

JOHANNES BERDARDUS DUVIVIER,
CALLED BERNARD DUVIVIER

French (b. Flanders), 1762–1837
Cleopatra Captured by Roman Soldiers after the Death of Mark Antony, 1789
Oil on canvas, 45 x 58″
Signed and dated lower right: *B Duvivier 1789*
Marion Stratton Gould Fund, 84.40

Johannes Berdardus (called Bernard) Duvivier first studied at the Academy of Bruges in his native Flemish city. His early works included genre scenes, seascapes, and allegorical portraits. By 1783 he was studying at the Paris Académie with his countryman Joseph-Benoît Suvée, whose dramatic manner and severe archaeological settings had a marked influence on Duvivier's historical compositions. In 1785 he received the second prize in the Académie's annual Prix de Rome competition for *The Death of Camilla* (Musée Tessé, Le Mans), a picture that revealed the artist's great promise.

Although Duvivier failed to win the Prix de Rome, he nevertheless was able to travel to Italy in 1790 with the assistance of a benefactor and to remain there for six years. Duvivier exhibited at the Salon in Paris from 1793 to 1827, though few of these paintings can be located today. In addition to historical and mythological works, he exhibited landscapes and portraits. Duvivier's contemporary reputation as a history painter is indicated by the numerous engravings and lithographs after his compositions, a few of which may have been executed by the painter himself.

The subject of this painting is a rarely depicted moment in the story of Antony and Cleopatra. In Plutarch's *Life of Mark Antony*, Antony dies of a self-inflicted wound in Cleopatra's "monument," a fortified tomb in which the Egyptian queen had barricaded herself. Shortly thereafter, several of Octavian Caesar's men, seeking to capture Cleopatra alive, enter the monument just as she is about to stab herself. The soldier Proculeius forestalls Cleopatra's suicide by seizing and then admonishing her: "For shame Cleopatra, you wrong yourself and Caesar much, who would rob him of so fair an occasion for showing his clemency, and would make the world believe the most gentle of commanders to be a faithless and implacable enemy."[1] Although Caesar's motive in ordering his soldiers to save Cleopatra was indeed questionable, it would seem, nonetheless, that the theme of this painting is the noble virtue of clemency.[2]

The scene of Cleopatra comforting the dying Antony was often represented in the late eighteenth century.[3] Depictions of Cleopatra's attempted suicide, however, are so rare that one suspects this one was an assignment, perhaps for one of the preliminary rounds of the Prix de Rome competition.[4] Not only the format but also the simple frame that was acquired with this picture are characteristic of Prix de Rome entries of the period.[5] That Duvivier's *Death of Camilla*, which won the second prize in 1785, is virtually identical in size to the *Cleopatra* supports this idea.

Cleopatra is the work of a young artist whose training in the academic tradition is reflected in the numerous figural quotations found throughout the canvas. The figure on the right is derived from the Farnese *Captive* (Museo Nazionale, Naples); the striding figure of Proculeius is derived from the third-century statue known as "Pasquino," which survives in three versions, one in Rome and two in Florence; the pose of Cleopatra herself is indebted to the *Laocoön*.[6] The recumbent figure of Antony presumably has a more recent source in Jacques-Louis David's *Dead Hector* (Ecole des Beaux-Arts, Paris), which itself derives from Nicolas Poussin's *Death of Germanicus* (Institute of Arts, Minneapolis).

Duvivier has gracefully synthesized these diverse sources, and the *Cleopatra* demonstrates a considerable gain in dramatic power over his *Death of Camilla* painted four years earlier. Though the subsequent evolution of Duvivier's style is not well documented, this early painting already embodies many of the qualities that the critic T. C. Bruun-Neergaard praised in the artist's later work: effective composition, careful study of the individual figures, and strong yet attractive color.[7] The meticulous technique and precise attention to detail also suggest Duvivier's occasional work as a miniaturist.

DR / BB

1. Plutarch, 78.2-3. The translation is from *The Lives of the Noble Grecians and Romans*, trans. John Dryden, rev. A. H. Clough, New York, n.d., pp. 1148-1149.

2. This interpretation offered by Bernard Barryte.

3. A. Pigler, *Barockthemen*, Budapest, 1956, vol. 2, pp. 382-386; for other depictions of the story of Antony and Cleopatra, see also pp. 351 and 379-381.

4. The final subject in the Prix de Rome competition for 1789 was *Joseph Recognized by His Brothers*.

5. See International Exhibitions Foundation, Washington, DC, *The Grand Prix de Rome: Paintings from the Ecole des Beaux-Arts, 1797–1863*, 1984. Due to condition, this presumably original frame has been replaced.

6. On the fame of these statues and their use as models, see F. Haskell and N. Penny, *Taste and the Antique*, 2nd ed., New Haven, 1982, pp. 169-172, 291-296, and 243-247.

7. T. C. Bruun-Neergaard, *Sur la situation des beaux-arts en France*, Paris, 1801, pp. 144-148.

PROVENANCE:
Private collection, France, 1984; Patrick Weiller, Paris (dealer).

LITERATURE:
D. Rosenthal, "A *Cleopatra* by Bernard Duvivier," *Porticus* 8 (1985), pp. 13-25, ill.

EXHIBITIONS:
MAG (circulated), *La Grande Manière, Historical and Religious Painting in France, 1700–1800*, 1987, no. 18, pp. 90-91, ill.

JAN DAVIDSZ. DE HEEM

Dutch-Flemish, 1606–1683/84
Still Life
Oil on panel, 14⅜ x 18⅜ "
Signed upper right: *Jan de Heem*
Marion Stratton Gould Fund, 49.63

J an de Heem was born in Utrecht, trained by his father, and as a young man lived in Leyden as well as in his native city. De Heem then moved to Antwerp, where he is documented as a member of the guild in 1636. For more than two decades he resided in the Flemish city, but after 1658 he was frequently absent from it. The young de Heem began his career as a fruit painter in the manner of Balthasar van der Ast and produced several *vanitas* still lifes. He was later influenced by the tonal painting of the Haarlem artists Pieter Claesz. and Willem Claesz. Heda. In Antwerp, liberated from the smaller formats and more restricted motifs favored in the Dutch Republic, the artist produced large scale, virtuosic banquet pieces that brought him great fame and were enthusiastically collected by nobility and wealthy merchants. Unique among seventeenth-century still-life painters, de Heem realized a successful amalgamation of the northern and southern Netherlandish traditions of this genre.

Assembled on the marble table in this painting is a choice collation, a roemer of sweet wine to wash down oysters and bread, and grapes and oranges to lend flavorful piquancy to the meal. Pepper, too, has been set out in a silver shaker for the diner, whose presence is indicated by a glowing wick and sulphur sticks. The seemingly casual disposition of the objects belies a calculated balance between stability and motion, which is revealed by closer examination. The composition is structured on an isosceles triangle, with its apex at the lip of the wine glass and its base formed by the bread and orange. Curvilinear contours throughout the painting disguise this strict geometry as well as move our eye around the composition. Reinforcing the intimacy of the design is the painting's warm tonality. Browns, golden hues, and orange predominate, heightened by cool whites and blue. Notes of red and green further enliven the orchestration of hues. The various objects are descriptively painted, their material presence is almost illu-sionistically recreated. As if to make a point of his amazing skill (as well as to demonstrate the adage that "art is a mirror of reality"), de Heem seems to have painted his self-portrait in a reflection on the roemer's cup. He is seated at his easel, a large studio window behind him.

Still lifes were often intended as objects of meditation. Rarely, however, did a work promote only one train of thought, as motifs were usually open to a variety of interpretations. Thus painters could appeal to a broad audience, unrestricted by religious persuasion, nationality, or education. Among the many readings that can be discerned in this panel is an allegory of human conduct. The orange (the fruit consumed by Adam and Eve) and the wick (a reference to human mortality, our punishment for the first sin) symbolize the Fall. The Eucharistic grapes and bread signify the Redemption. And between the Fall and the Redemption is carnal appetite, embodied in the aphrodisiac oyster.

Though inherent in the human condition, carnal appetite can be tamed by moderation. De Heem indicates this salvation through two symbols: a knife, which represents measure as well as the capacity to distinguish between good and evil; and a peeled citrus, which also signifies measure since, as is shown in this painting, it was used to temper wine. The laurel branch points to the anticipated victory over the desires of the flesh. The pansy entwined on the branch symbolizes two things: meditation, for right action; and the Trinity's spiritual guidance.[1]

SK

1. A note from the dealer Caesar R. Diorio in 1949 indicates that a pendant to this painting is said to have been acquired by the Eugene Slatter Gallery, London, about 1949. MAG archives.

PROVENANCE:
Private collection, Munich; Major Casedemont; Julius Weitzner, New York (dealer); Caesar R. Diorio, New York (dealer).

EXHIBITIONS:
MAG, "In Focus: A Look at Realism in Art," 1964, no. 20; Munson-Williams-Proctor Institute, Museum of Art, Utica, NY, "European Paintings from the Rochester Memorial Art Gallery," 1967; Wildenstein Galleries, New York, *Treasures from Rochester,* 1977, p. 42, ill.

JAN VAN DE CAPPELLE

Dutch, 1624/26–1679
View off the Dutch Coast, after ca. 1652
Oil on canvas, 30½ x 39⅛"
Inscribed lower left: *J V Cappelle*
George Eastman Collection of the University of Rochester, 68.99

The prominence of seascapes among the pictorial genres culti-
vated during the Golden Age of Dutch painting reflected
the wealth and power engendered by Holland's naval superi-
ority.[1] Van de Cappelle is acclaimed as one of the most accomplished
and innovative artists to specialize in marine subjects, but he was not a
professional painter.[2] Rather, he was a merchant, managing the family
dyeing business and accumulating considerable wealth. He also
amassed an impressive art collection that included about two hundred
paintings and six thousand drawings.[3]

Van de Cappelle's collection was devoted primarily to the
landscape and marine painters who had contributed to the devel-
opment of Dutch naturalism from the beginning of the century.
According to his friend the artist Gerbrandt van den Eeckhout
(1621–1674), van de Cappelle "taught himself to paint out of his own
desire."[4] He presumably developed his style from the work of the
artists represented in his collection. According to the inventory taken
at his death, van de Cappelle owned about 400 drawings by Jan van
Goyen, 900 by Avercamp, and 1,350 by Simon de Vlieger, the artist
whose seascapes exerted the greatest influence on van de Cappelle.
Van de Cappelle himself introduced a new form of calm seascape. His
interest in reflections and the vaporous luminosity of the Dutch atmo-
sphere was demonstrated in the limpid tranquility of the scenes he
painted.

Van de Cappelle's seascapes are characterized by their meticu-
lous formal construction, subtle color harmonies, and a sense of
motionless quiet. A geometric structure supports the rhythmical
grouping of the compositional elements, which are carefully balanced
within the frame, and complements the mellow beauty of the
restrained palette. His delicate brushwork creates fluid transitions
between land, sky, and water, emphasizing the reflections on the
water's surface. Van de Cappelle's surviving work is characterized by
a consistent refinement, although the silvery tones of his earliest
canvases assume a more golden cast in later paintings.

Dated after 1652 on the basis of the signature, *View off the
Dutch Coast* is an excellent example of van de Cappelle's unique accom-
plishment.[5] The *roei-jacht* (or *chaloup*) with its passengers serves as the
compositional focus of this painting. Paralleling the spits of land in the
foreground and middle distance, it floats diagonally toward a large
ship, which almost disappears in the light that radiates from the
distant horizon. The individualized staffage figures add a human pres-
ence to the natural environment. Their brightly colored costumes
enliven the harmonious gray and gold tonalities of the surface. Van de
Cappelle uses the disorder of the billowing clouds, the asymmetry of
the row of piers in the foreground, and the fluttering sail of the *kaag* on
the right to animate the serene beauty of the scene and emphasize its
fundamental order.

BB

1. I use the term *seascape* in the broad sense, to encompass all paintings in which boats are
the predominant motif, as suggested by Wolfgang Stechow, *Dutch Landscape Painting of the
Seventeenth Century,* London, 1966, p. 110.

2. Seascapes (including harbor scenes, beachscapes, and estuary scenes) comprise about
three-quarters of van de Cappelle's approximately two hundred surviving paintings.
The remaining works are primarily winter scenes, of which many depict frozen rivers.

3. The inventory is printed in Russell, *Jan van de Cappelle,* pp. 49-57.

4. "Album Amicorum Jacobus Heyblocq" (1654; MS in the Royal Library, The Hague),
p. 283; cited in Russell, *Jan van de Cappelle,* pp. 10, 48-49.

5. Russell suggests that "the signature with two p's was not used before 1652" (ibid.,
pp. 20-21).

PROVENANCE:
Sir Joseph B. Robinson, Dudley House, Park Lane, London (his sale:
Christie's, London, July 6, 1923, lot 49); M. Knoedler and Co., New York,
George Eastman, Rochester, NY (after 1925).

LITERATURE:
A. Scharf, "The Robinson Collection," *Burlington Magazine* 100 (September
1958), p. 300, fig. 49; Margarita Russell, *Jan van de Cappelle, 1624/26–1679,*
Leigh-on-Sea, 1975, p. 89 (Addenda, no. 7, fig. 91 [incorrectly printed as 93]);
Peter Sutton, *A Guide to Dutch Art in America,* Grand Rapids, MI, 1986, p. 257.

EXHIBITIONS:
M. Knoedler and Co., New York: *Loan Exhibition of Dutch Masters of the
Seventeenth Century,* 1925, no. 18; MAG, "The George Eastman Collection,"
1948–1949; Wildenstein Galleries, New York, *Treasures from Rochester,* 1977,
p. 43; MAG, *The George Eastman Collection,* 1979–1980, p. 34.

RACHEL RUYSCH

Dutch, 1664–1750
Floral Still Life, 1686
Oil on canvas, 45 x 34¼ ″
Signed lower left on rock: *R Ruysch/1686*
Acquired with contributions made in memory of Brenda Rowntree by her friends, through the Acquisition Fund of the Women's Council, and the Marion Stratton Gould Fund, 82.9

Rachel Ruysch, one of Holland's greatest flower painters, was also one of the first Dutch women artists to gain international recognition during her lifetime. She served as court painter to the elector palatine in Düsseldorf, and her fame spread to Italy when the elector sent two of her pendant still lifes as a royal gift to the grand duke of Tuscany. After the elector died in 1716, Ruysch returned to Amsterdam, where she continued to paint until the age of eighty-three, two years before her death.

During the first decade of her extraordinary sixty-five-year career, Ruysch produced approximately a dozen still lifes that she staged in marshy woodland environments.[1] *Floral Still Life* is the largest of these, and the only example of Ruysch's work in this genre in an American collection.[2]

When Rachel Ruysch was fifteen, her parents recognized her considerable artistic gifts and apprenticed her to Willem van Aelst (1627–1682), one of the finest flower painters at mid-century. This was an unusual arrangement for the time; a talented young woman was seldom permitted to study with a male master who was not a family member.[3] Van Aelst introduced Ruysch to the genre of the woodland still life as well as to the asymmetrical floral composition with sweeping S-curves that would later become the hallmark of her mature paintings.

In *Floral Still Life* and many later paintings, Ruysch juxtaposed the beauties of the natural world with its fierce, unsettling side. Snakes prey upon birds' eggs, hideous flies and beetles crawl on otherwise magnificent flowers, lizards and butterflies battle alongside lilies beginning to open.

This tradition, of combining a spotlighted floral motif and an insect/reptile drama in the foreground with a sinister backdrop (murky pools, toadstools, gnarled tree trunks, and rocky outcroppings), was developed by the Dutchman Otto Marseus van Schrieck in the mid-seventeenth century. Van Schrieck was a passionate naturalist, who kept, at his cottage near Amsterdam, a vivarium of toads, snakes, frogs, lizards, and other creatures—moving models for his paintings.

Many artists and scholars of the time shared a similar enthusiasm for collecting natural specimens; van Schrieck thus had a large and international group of students, imitators, and patrons. His followers continued to paint these moody nature scenes well into the eighteenth century, when an emphasis on exotic opulence and theatricality replaced an earlier taste for simple elegance in Dutch painting. Rachel Ruysch's sensitivity to plant and animal life stems from a profound understanding of science; her father was a distinguished surgeon and botanist, Professor Frederik Ruysch of the University of Amsterdam, who possessed a world-renowned collection of anatomical specimens and natural curiosities.

In *Floral Still Life,* an early student work, Ruysch repeats the right half of a woodland still life by Abraham Mignon, a painter inspired by van Schrieck.[4] Ruysch selectively copied the elements in Mignon's painting which most interested her—the dead trunk, the wide variety of cultivated flowers, which seem to sprout miraculously from it, the boulder anchoring the foot of the tree, and the wildlife encounters. The combination of naturalism and artificiality which Ruysch drew from Mignon's work in these years was a characteristic she maintained in her painting throughout her career.[5]

In the woodland still-life paintings by van Schrieck and many of his followers, the preying creatures, given unmistakable prominence through lighting and scale, are meant to be seen symbolically. As *vanitas* pieces, the paintings contain symbolic references to the transience of life, the inevitability of death, and the lifelong struggle against evil. In Ruysch's work, however, the "symbolic" elements are subordinated to a concern for a unified design so that they become occasional or secondary. The lack of focus on these individual components in both Ruysch's woodland still lifes and her more traditional flowerpieces discourages definite symbolic readings.[6]

Although many of Ruysch's canvases date well into the eighteenth century, they epitomize the best qualities of seventeenth-century fruit and flower painting in their sensitive modeling of form, attention to minuscule details, invisible brushwork, high degree of finish, and exploitation of chiaroscuro for dramatic effect.

MB

1. Ruysch's earliest known dated work of 1682 (National Gallery, Prague) marks the beginning of her career. Two small pendants in the Musée des Beaux-Arts, Lille, from 1747, are her last dated paintings.

2. This still life is one of the largest in her oeuvre, which numbers approximately 130 paintings. Peter Sutton lists Ruysch's paintings in American public collections in *Dutch Art in America,* Grand Rapids, MI, 1986, p. 346.

3. Ann Sutherland Harris and Linda Nochlin, *Women Artists: 1550–1950,* Los Angeles, 1976, pp. 35, 40.

4. This painting by Mignon (formerly attributed to Jan Davidsz. de Heem) is in the collection of the Prince of Liechtenstein, Vaduz. Ruysch painted two other variations on the Vaduz picture. One, dated 1685, is in the Boymans-van Beuningen Museum, Rotterdam (museum no. 1751); the other, which is signed but undated, hangs in the Staatliche Kunstsammlungen, Kassel (museum no. 450).

5. It seems unlikely that Ruysch studied directly with Mignon as has sometimes been suggested, for he died when she was only fifteen. She probably had access to his work, however, through several channels. One of these was probably van Aelst; another may have been her future husband, Juriaen Pool II, who was the adopted son of Mignon. The precise location of the Vaduz painting during the 1680s, when Ruysch would have seen it, is unknown.

6. Because Rachel Ruysch did not compose these early woodland still lifes but derived their elements secondhand, the extent to which she intended the juxtaposition of motifs to carry symbolic or narrative meanings remains unclear.

PROVENANCE:
F. F. Ittenbach collection; Heberle sale, Cologne (Anonymous sale, probably Ittenbach), November 8, 1898, no. 100, ill.; Kellner collection, Vienna; Lepke sale, Berlin (Anonymous sale, probably Kellner), December 3, 1929, no. 31, ill.; Van Marle and Bignell sale, The Hague, March 1974, no. 367A, ill.; Lempertz sale, Cologne, June 27, 1974, no. 202, ill.; Christie's sale, London (properties of the trustees of the Sir A. C. S. Abdy Will Trust), December 1, 1978, no. 81, ill. in color; acquired from Gallery P. de Boer, Amsterdam, 1982.

LITERATURE:
M. H. Grant, *Rachel Ruysch, 1664–1750,* Leigh-on-Sea, 1956, no. 9, p. 25 (date given as 1680); Marianne Berardi, "The Early Masterpieces of Rachel Ruysch," *Porticus* 10/11 (1988).

EXHIBITIONS:
Gallery P. de Boer, Amsterdam, 1982; 'S-Hertogenbosch, Noordbrabants Museum, *A Flowery Past: A Survey of Dutch and Flemish Flower Painting from 1600 until the Present,* 1982, no. 60, p. 103.

Italian, 1581–1644
Two Musicians (The Concert), 1630–1635
Oil on canvas, 40½ x 47¾ "
Marion Stratton Gould Fund, 53.8

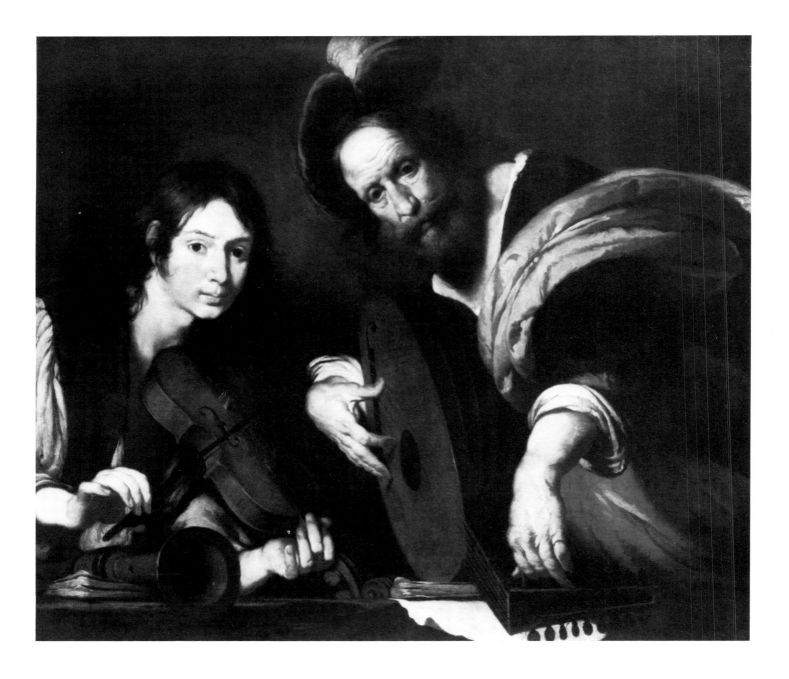

Strozzi's career is described by his earliest biographer, Raffaello Soprani, who justly praised the artist's bold and brilliant colors as well as his command of chiaroscuro.[1] Shortly after his father's death (1596/97), Strozzi began his artistic training under Pietro Sorri, a Sienese painter resident in Genoa. In 1598 Strozzi entered the Capucine monastery of S. Barnaba, where he continued to paint devotional subjects. When he left the monastery ten years later in order to support his mother and his sister by his art, Strozzi became a prelate. On the death of his mother in 1630, the artist became embroiled in a serious controversy over his refusal to reenter the monastery. Jailed briefly, Strozzi escaped to Venice by 1631. There he became a monsignor in 1635 and enjoyed continuous success as a painter for the remainder of his life.

Throughout his career Strozzi was stimulated by the accomplishments of his contemporaries. Most notably, the nervous brushwork and luminous colors of the Tuscan master Federico Barocci had a formative impact on Strozzi's style. Strozzi became familiar with the dramatic naturalism of Caravaggio, evident in *Two Musicians,* primarily through the works of Orazio Gentileschi and the Utrecht master Hendrick Terbrugghen, who worked in Italy from 1604 to 1614.[2] The bravura elegance of the Flemish painters Peter Paul Rubens and Anthony Van Dyck, who both worked in Genoa, is reflected particularly in Strozzi's portrait style. His later work shows the influence of the Venetian Paolo Veronese, whom Strozzi admired greatly. Strozzi assimilated these diverse forces and transmuted them into a personal idiom that significantly influenced the evolution of the Baroque style both in his native Genoa and in Venice.

The dating of Strozzi's extensive oeuvre is complicated by the artist's habit of producing multiple replicas of his most successful compositions. In addition, Strozzi reused models who, like repertory actors, are assigned new roles in other compositions. The middle-aged lute player and young violinist reappear in numerous paintings and were perhaps members of Strozzi's studio. Both musicians look directly out from the canvas, establishing eye contact with their audience. The psychological relationship thus formed is enhanced by perspective and pictorial devices. Although the musicians are separated from their audience by a parapet, the foreshortened shawm on the ledge links the fictive space with actual space. Similarly, the neck of the lute and the lutenist's arm are foreshortened and appear to extend into the audience's space. The vivacious expressions, dramatic highlighting, illusionistic devices, naturalistic rendering of details, plus Strozzi's liberal use of richly saturated colors combine to encourage an empathetic response from the viewer.

The intended meaning of the painting remains uncertain. Beginning in the Renaissance, secular concert scenes were popular and frequently symbolized Musica with its associated ideas of harmony and love. By the seventeenth century this allegorical content had diminished, and concert scenes were most frequently included as an element in larger programs representing the Five Senses or the Four Temperaments.[3] This composition survives in several independent versions and no evidence suggests that any canvas belonged to a larger program. Beyond satisfying a need for pictorial variety, a contrast between ingenuous youth and experienced age may be suggested by the figures. Such an interpretation, however, is not supported by the musical instruments, which might function as symbolic attributes. Within the context of humanist conventions, the violin and the lute both allude to ideas of balance and harmony and, therefore, do not provide the necessary contrast. Furthermore, although a string and a woodwind instrument are held as attributes of Poesia in Cesare Ripa's *Iconologia* (1618), an interpretation of the image as "Poetry," based on the inclusion of the Apollonian violin and lute together with the Bacchic shawm, seems somewhat strained.[4]

However the painting was meant to be interpreted, the popularity of Strozzi's *Two Musicians* is attested by the survival of sixteen other versions, some of which vary in the depiction of the violinist, and some of which are studio productions.[5] The Gallery's version is closest to the Hampton Court type, and it has been suggested that the Gallery's canvas may be the prototype for these paintings.[6] Although it repeats a composition probably invented in Genoa, the Gallery's painting has been dated on stylistic grounds to the first phase of Strozzi's Venetian career.

BB

1. *Le Vite dei pittori, scultori, ed architetti genovese e di forestieri che in Genova operano* (Genoa, 1674), cited here in the second edition, annotated and expanded by Giuseppe Ratti, 2 vol. (Genoa, 1768), reprint Bologna, 1969, vol. 1, p. 185.

2. For example, the version of *Two Musicians* in the Queen's collection at Hampton Court was formerly attributed to Caravaggio (see Michael Levey, *The Later Italian Pictures in the Collection of Her Majesty the Queen,* London, 1964, pp. 101-102, cat. no. 656); the version belonging to the Duke of Devonshire, Chatsworth, has been attributed to Caravaggio as well as to his followers Valentine de Boulogne and Mattia Preti (see S. C. Cavendish, Duke of Devonshire, *Masterpieces in the Duke of Devonshire's Collection,* London, 1901, p. 12).

3. Patricia Egan, "'Concert' Scenes in Musical Paintings of the Italian Renaissance," *Journal of the American Musicological Society* 14, no. 2 (summer 1961), pp. 184-195.

4. Reproduced in Emanuel Winternitz, "The *Lira da Braccio,*" in *Musical Instruments and Their Symbolism in Western Art,* New Haven, 1979, fig. 13. In relation to values associated with Platonic humanism, the shawm, with its wild and piercing sound, might share with the flute its associations with Dionysian sensuousness, in contrast to the virtues of harmony and balance associated with Apollo's lyre and related stringed instruments. See Plato, *Republic,* 3.199; Winternitz, "The *Lira da Braccio,*" pp. 96-98, and his "The Curse of Pallas Athena," in the same volume, pp. 150-165.

5. Luisa Mortari, *Bernardo Strozzi,* Rome, 1966, identifies other versions of *The Concert,* not all autograph, in the following collections: Bergamo, Galleria Lorenzelli (p. 92); Dresden, Gemäldegalerie (p. 103); Hampton Court Palace (p. 137, and see note 2, above); Legnano, Collection Maggioni (p. 141; now U.S.A.); Milan, Collection Cicogna (p. 148; now New York, private collection); Munich, Leuchtenberg collection (p. 152); Moscow, Museum of Fine Arts (p. 152, as by Workshop); New York, private collection (p. 156, formerly Stanley Wulc collection, Rydal, PA [Michael Milkovich, *Bernardo Strozzi, Paintings and Drawings,* Binghamton, NY, 1967, p. 100]; sale Christie's, London, June 29, 1973, lot 52, to Russell); Rome, Collection Mameli (p. 166); Rome, Collection Rocchetti (p. 169); Tarbes, Musée Massey (p. 178, as by Workshop); Treviso, Raccolta Binaro (p. 180); Venice, Professor Carrer collection (p. 184); formerly Madrid, private collection (p. 210). There is in addition the version belonging to the Duke of Devonshire, Chatsworth (see note 3 above). See also A. M. Matteucci, "L'attività Venezia di Bernardo Strozzi," *Arte Veneta* (1955), p. 146, n. 2.

6. Letter from Bertina Suida Manning to Nicholas M. Acquavella, January 3, 1952 (MAG archives).

PROVENANCE:
(?)Conte Giacomo Carrara, Bergamo (by 1796); (?)Accademia Carrara, Bergamo (sold 1835); private collection, Genoa; Pietro Acorsi, Turin; Nicholas M. Acquavella Gallery, New York, 1953.

Note: Traditionally associated with Conte Giacomo Carrara as among the works deaccessioned by the Accademia Carrara in 1835, the painting is not, however, identified in Angelo Pinetti, *Il Conte Giacomo Carrara e la sua galleria secondo il catalogo del 1796,* Bergamo, 1922.

LITERATURE:
Burton B. Fredericksen and Federico Zeri, *Census of Pre-Nineteenth-Century Italian Painting in North American Public Collections,* Cambridge, MA, 1972, p. 629.

EXHIBITIONS:
Hopkins Center Art Galleries, Dartmouth College, Hanover, NH, *The World of Shakespeare,* 1964; University Art Gallery, State University of New York at Binghamton, *Bernardo Strozzi, Paintings and Drawings,* 1967, no. 23; Portland (OR) Art Museum, *Seventy-five Masterworks,* 1967–1968; Denver Art Museum, *Baroque Art: Era of Elegance,* 1971, p. 52.

FRANCESCO SOLIMENA

Italian, 1657–1747
The Triumph of Judith, ca. 1725–1730
Oil on canvas, 38¾ x 49¼"
Gift of Dr. and Mrs. James V. Aquavella, 77.109

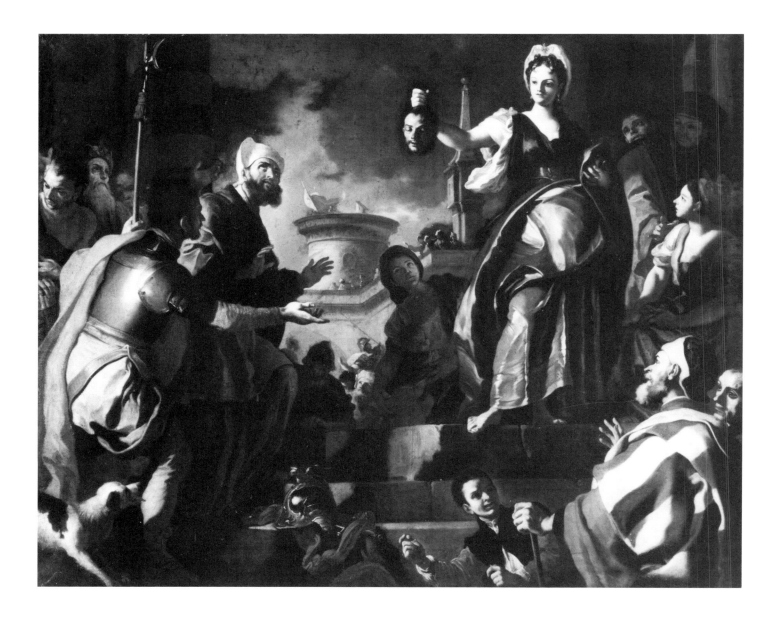

A painter, poet, designer of sculpture and architecture, and reputedly a brilliant conversationalist, Solimena maintained a large workshop and was responsible for an enormous body of work, covering acres of canvas and frescoed walls. His sheer artistic stamina during a prolific ninety years ensured his international fame and influence. After Luca Giordano's death in 1705, Solimena succeeded this influential painter as the leading master of the Neapolitan Baroque style. Recognized as the preeminent decorator of the period, his works were sought by patrons from places as distant as France, Austria, and England.[1]

After receiving his initial training from his father, Angelo, Solimena moved to Naples in 1674 where his style matured under a variety of influences. From Mattia Preti he absorbed the dramatic chiaroscuro technique that derived ultimately from Caravaggio. Giovanni Lanfranco acquainted him with the intensity of Venetian color and the decorous classicism of the Emilian school founded by the Caracci. From Carlo Maratta and others he assimilated the nobility and power of Roman classicism, while the grandeur of Giordano's magnificent compositions exerted an especially profound influence. From these sources Solimena synthesized a personal style that answered the demands for elaborate religious and secular images necessary to fill the walls of churches and palaces during a period of extensive building activity.

The Gallery's *Triumph of Judith* is one of four renditions of this subject by Solimena. In his monograph on the artist, Ferdinando Bologna asserts that Solimena's first painting of this subject, commissioned about 1704 by Marchese Durazzo of Genoa, is today in the Villa Bombrini, Cornigliano. This composition is essentially repeated in the canvas dated about 1730 now in the Gemäldegalerie of the Kunsthistorisches Museum, Vienna. During the years 1725 to 1730, Solimena developed the variation represented in the Gallery's canvas, which has a more focused composition and fewer figures. Another example of this alternative composition belongs to The Guildhall, Abingdon.[2]

Solimena's bold and fluent Baroque style is clearly illustrated in *The Triumph of Judith*. The composition is characteristically balanced and cohesive. Voluminous draperies give each figure a classical monumentality of form. The dramatic chiaroscuro unifies the composition, intensifies the effect of the gestures and expressions, emphasizes the tangible reality of varying textures, and strengthens the illusion of relief and volume. The compositional format and Judith's pose reflect Solimena's admiration for Giordano's treatment of this theme in the fresco dedicated to biblical heroines which he painted between 1702 and 1704 in the Chapel of the Treasury in the Certosa di S. Martino, Naples.[3] As in Giordano's fresco, Solimena's canvas is dominated by the heroic figure of Judith, who proudly displays the head of Holofernes. Her grisly trophy is highlighted against the crepuscular sky, filling the dramatic void at the center of the composition. Towering over the subsidiary figures, Judith's elevated position enhances her heroic grandeur. She is surrounded by a dynamic spiral of figures who represent all classes of society. Each face is individualized, including one on the extreme right that may be a self-portrait. The gestures and expressions of these people communicate gratitude, awe, admiration, astonishment, and other emotions appropriate to the situation.

The subject is taken from the apocryphal book of Judith (13:15-17), which tells how the heroine went to the camp of Holofernes, the Assyrian general who was besieging the town of Bethulia,

dazzled him with her beauty, and, after pretending to accept his advances, beheaded him with his own sword while he was in a drunken stupor. The painting illustrates the moment when Judith displays the trophy of her victory to the citizens she has rescued: "Then she took the head out of the bag and showed it, and she said to them, 'Here is the head of Holofernes, the commander of the army of Assyria. . . . For the Lord has struck him down by a woman's hand. . . .' All the people were greatly astonished." In a Christian context, the story of the Jewish heroine generally signified the triumph of virtue over vice. It also acquired a more specific function as a powerful symbol of the triumph of the Church over heresy. Working in the devout atmosphere of Counter-Reformation Naples, Solimena has portrayed Judith as confident that she has served God's will. The pictorial devices the artist employs dramatically appeal to the emotions of the audience and are intended to inspire a fervor matching the faith that motivated Judith.

BB

1. Bernardo de Dominici, *Vite dei pittori, scultori, ed architetti napoletani,* 4 vols. in 3, Naples, 1742–1745, reprint, 1840–1846, vol. 4, pp. 453-454. Solimena's biography, first recorded by de Dominici (pp. 405-493), is now conveniently summarized by Carmen Bambach Cappel, "Francesco Solimena, 1657–1747," in *A Taste for Angels: Neapolitan Painting in North America, 1650–1750,* New Haven, 1987, pp. 163-183.

2. Ferdinando Bologna, *Francesco Solimena,* Naples, 1958, pp. 89-90, 247, 250-251, 283. On the Durazzo commission, see de Dominici, *Vite,* vol. 4, pp. 428-429, and Piero Torriti, "Due Solimena ritrovati a Genova," *Emporium* 127, no. 760 (April 1958), pp. 157-164, who dates this commission 1715–1728.

3. According to de Dominici (vol. 3, p. 430), Solimena praised the fresco, remarking that "no great painter could imitate the fury, fire, and knowledge with which he painted that battle, because it seems to have been painted all in one breath, and with a single stroke of the brush." On Giordano's fresco, see Oreste Ferrari and Giuseppe Scavizzi, *Luca Giordano,* 3 vols., Naples, 1966, vol. 1, pp. 175-186, and vol. 2, pp. 230-231.

ALESSANDRO MAGNASCO

Italian, 1662–1749
The Exorcism of the Waves, after 1735
Oil on canvas, 33 x 51″
Marion Stratton Gould Fund, 52.2

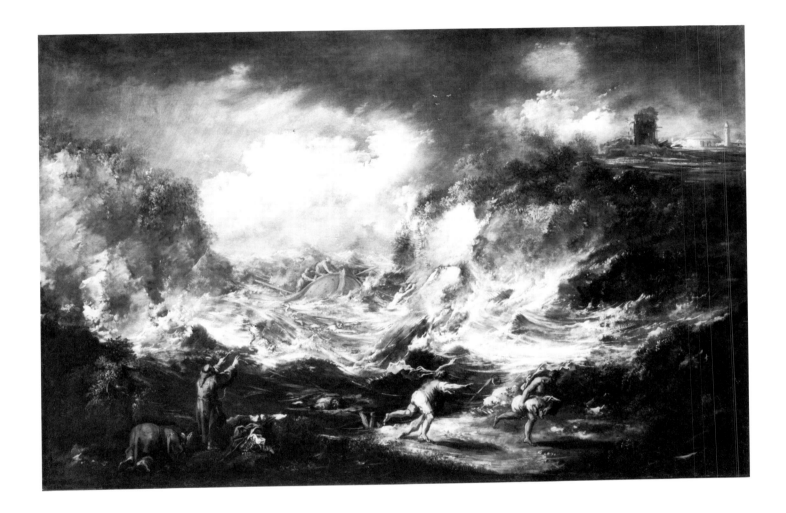

According to his first biographer, Magnasco began his training with his father, Stephano, a follower of the influential Genovese painter Valerio Castello.[1] On his father's death, Alessandro moved to Milan, where a wealthy patron apprenticed him to the Venetian painter Filippo Abbiati. There also he befriended another Venetian, Sebastiano Ricci, a slightly older contemporary who was influential in the formation and dissemination of the Rococo style. Magnasco began his career as a portrait painter but quickly abandoned this genre in favor of landscapes. He developed a highly personal style, "composed of swift, but very artful dabs, tossed off with a certain bravado," appropriate to his idiosyncratic subjects, which are "delightful, and furnished with a chiaroscuro more beautiful than can be seen elsewhere."[2] His work appealed to the eccentric tastes of Grand Duke Gian Gastone de' Medici, and his brother Ferdinando, who encouraged Magnasco's production of "melodramatic canvases, where Jewish synagogues, crazed ascetics, sorcerers, gypsies, beggars, and scenes of monastic life were delineated with quivering staccato restlessness."[3] After his sojourn in Florence (ca. 1710–1713), Magnasco traveled to Venice and then returned to Milan, where he remained until 1735 when he moved back to his native Genoa at the behest of his only daughter.

Magnasco's fame declined rapidly after his death, and his work was rediscovered only in the early twentieth century. Considerable effort has since been devoted to uncovering the formal and iconographic sources of Magnasco's work. Antecedents have been identified, for example, in the technique of Castello and the imagery of Salvator Rosa and Jacques Callot.[4] Nevertheless, Magnasco's intellectual orientation remains obscure, and his disquieting art remains an isolated phenomenon. His genre scenes frequently feature thieves, craftsmen, or soldiers. His hallucinatory landscapes seem to revel in the uneven struggle between man and nature, while his crepuscular interiors are either claustrophobic or cavernous. Throughout his work there is a fascination with torture, necromancy, mystical excess, and the penitential practices of monks.[5] While Magnasco was a notable draftsman, his canvases are extremely painterly, depending upon tonal variations and the juxtaposition of colors, rather than line, to suggest depth and volume. His brushwork is delicate and exciting, revealing both his virtuosity and a technical affinity with the Rococo style favored by his contemporaries throughout Europe. His unique staccato technique is particularly evident in his masterful rendering of the small, attenuated, and frenetic figures who populate his pictures. Although he collaborated with painter Clemente Spera, Magnasco left no immediate followers; his spiritual heirs are Giovanni Battista Piranesi and Francisco Goya.

The Exorcism of the Waves is an excellent example of the artist's late style after he returned to Genoa in 1735.[6] The storm-wracked scene appears to be illuminated by the sudden, lurid glare of lightning. The jagged edges of rocks, leaves, waves, and clouds are crisply delineated by scintillating white highlights, which emphasize the effect of violent motion. Dominating the center of the canvas, tumultuous waves threaten to capsize and crush a small boat and its helpless passengers, who struggle to escape sea monsters and reach safety in a rock-bound cove. The foreground figures are dwarfed by the awesome forces they confront. Two survivors flee with their belongings, while on the left, one Franciscan monk genuflects.[7] His more stalwart companion raises a crucifix and gesticulates in a desperate effort to quell the tempest. While this painting might be read as an ironic statement on the efficacy of prayer, the precise meaning of this and related compositions remains uncertain.

BB

1. Carlo Giuseppe Ratti, *Delle vite de' pittori, scultori, ed architetti genovese . . .* , 2 vols., 1768; reprint Bologna, 1969, vol. 2, pp. 155-162.

2. Ibid., pp. 157-158. Ratti discusses Magnasco's style in greater detail in the first draft of his biography, on which see Fausta Franchini Guelfi, "Magnasco Inedito: contributo allo studio delle fonti e aggiunte al catalogo," *Studi di Storia delle arti,* vol. 5, 1983–1985, pp. 294-295, 299-300, and 323-324.

3. Harold Acton, *The Last Medici,* 2nd. ed., New York, 1958, p. 286.

4. Rudolf Wittkower, *Painting and Architecture in Italy, 1600–1750,* 3rd rev. ed., Harmondsworth, 1973, p. 478, with additional bibliography. Also see Fausta Franchini Guelfi, *Alessandro Magnasco,* Genoa, 1977.

5. On the relationship between Magnasco's imagery and contemporary efforts to reform monastic life, see Guelfi, "Magnasco Inedito," pp. 303-308.

6. Geiger, *Alessandro Magnasco,* 1949, pp. 41-42, ill. 443-492 passim. According to Geiger, the pendant to the Gallery's painting, *Pirates on the Seashore,* is in the Gaetano Speranti collection, Milan (ibid., p. 150, ill. no. 469). On the other hand, Pospisil (*Magnasco,* pp. 19-20) dates the Gallery's canvas and related marine subjects to Magnasco's first Milanese period, ca. 1695. See also Ratti, *Delle vite,* p. 159. Magnasco repeated the theme of the Gallery's painting several times. Variants include a canvas in a private collection in Genoa, reproduced in Guelfi, *Alessandro Magnasco,* p. 132, fig. 135, and *A Tempest with Two Franciscan Monks* (Currier Gallery of Art, Manchester, NH).

7. Alternatively, the fleeing figures may be scavengers absconding with booty cast upon the shore.

PROVENANCE:
Montovani-Orsetti collection, Bologna (as by Pieter Mulier the Younger, called Cavalier Pietro Tempesta); sale Sambon, Milan, May 29–30, 1898, lot 113-114 (?); Benno Geiger, Venice; Leuchtag collection, Vienna; Julius Weitzner, New York (dealer).

LITERATURE:
Benno Geiger, *Alessandro Magnasco,* Berlin, 1914, no. 66; Benno Geiger, *Alessandro Magnasco,* Vienna, 1923, p. 57, no. 256; Giuseppe Delogu, *Pittori minori liguri lombardi piemontesi del 600 e del 700,* Venice, 1931, p. 129; Maria Pospisil, *Magnasco,* Florence, 1944, pp. 19-20; Benno Geiger, *Alessandro Magnasco,* Bergamo, 1949, pp. 150, 159, ill. no. 468; Burton Fredericksen and Federico Zeri, *Census of Pre-Nineteenth-Century Italian Paintings in North American Public Collections,* Cambridge, MA, 1972, p. 629.

EXHIBITIONS:
Paul Cassirer, Berlin, (circulated 1914: Kunstverein, Cologne; Schneider, Frankfort-am-Main; Galerie Levesque, Paris; Thannhauser, Munich; and Flechtheim, Düsseldorf, 1920), *Alessandro Magnasco,* no. 66; Munson-Williams-Proctor Institute, Museum of Art, Utica, NY, and MAG, *Masters of Landscape: East and West,* 1963, p. 40; Vassar College Art Gallery, Poughkeepsie, NY, "Nature and Natural Phenomenon in the Art of the Eighteenth Century," 1964, no. 11.

JOOS DE MOMPER
Flemish, 1564–1635

and

(?) JAN BREUGHEL THE ELDER
Flemish, 1568–1625

Landscape with Figures, ca. 1620(?)
Oil on panel, 18⅜ x 26⅞"
Marion Stratton Gould Fund, 46.36

PETER PAUL RUBENS

Flemish, 1577–1640
The Reconciliation of King Henry III and Henry of Navarre, 1628
Oil on panel, 8⅞ x 7¼"
Marion Stratton Gould Fund, 44.24

GERHARD VAN OPSTAL

Flemish, 1597–1668
Female Satyr, Bacchus, and Putti (right) and
Pan, Nymph, and Putto (left)
Ivory, 8½ x 6¼ x 1" and 8½ x 5¾ x ⅞"
Bertha Buswell Bequest, 55.49.1-.2

PIERRE MIGNARD

French, 1612–1695
Head of St. Cecilia, ca. 1663
Black, red, and white chalk on paper, 12⅜ x 9⅜"
Marion Stratton Gould Fund, 78.53

ATTRIBUTED TO FRANÇOIS BOUCHER

French, 1703–1770
Venus and Cupid, ca. 1732
Oil on canvas, 15⅞ x 12⅝"
Marion Stratton Gould Fund, 50.4

STUDIO OF FRANS SNYDERS

Flemish, 1579–1657
The Fable of the Fox and the Stork
Oil on canvas, 47⅛ x 61¼"
Gift of Dr. and Mrs. James V. Aquavella, 72.75

ATTRIBUTED TO JOSEPH-MARIE VIEN

French, 1716–1806
Lot and His Daughters
Black and white chalk on paper, 11 $^{15}/_{16}$ x 15 $^{9}/_{16}$ "
Marion Stratton Gould Fund, 78.55

ATTRIBUTED TO AUGUSTIN PAJOU

French, 1703–1809
Bust of a Man
Terracotta, 16 ½ x 14 ⅝ x 12 ⅝ "
Marion Stratton Gould Fund, 68.3

CLAUDE MICHEL CLODION

French, 1738–1814
Bacchante and Female Satyr
Terracotta, 15 ¾ x 16 ½ x 14"
Gift of Dr. and Mrs. James V. Aquavella, 69.28

THOMAS GAINSBOROUGH

English, 1727–1788
Man with Book Seated in a Landscape, 1753
Oil on canvas, 24 x 20"
Gift of Dr. and Mrs. Fred W. Geib, 75.115

HUBERT ROBERT

French, 1733–1808
Figures amidst Ruins
Oil on canvas, 25¾ x 32⅛"
Marion Stratton Gould Fund, 63.14

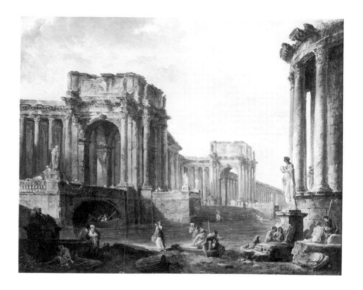

SIR JOSHUA REYNOLDS

English, 1723–1792
Portrait of Miss Hoare, 1782
Oil on canvas, 36 ³/₁₆ x 28"
George Eastman Collection of the University of Rochester, 77.1

GEORGE ROMNEY

English, 1734–1802
Colonel James Clitherow, 1784
Oil on canvas, 30 x 25"
George Eastman Collection of the University of Rochester, 76.24

FRANCIS WHEATLEY

English, 1747–1801
The Death of King Richard II, ca. 1792–1793
Oil on canvas, 78 x 60"
Marion Stratton Gould Fund, 87.1

FRANS HALS

Dutch, 1580–1666
Portrait of a Man
Oil on canvas, 30½ x 25½"
George Eastman Collection of the University of Rochester, 68.101

JAN STEEN

Dutch, 1626–1679
The Cake Baker, ca. 1661–1669
Oil on canvas, 26¼ x 20⁷⁄₁₆″
Buswell-Hochstetter Bequest, 55.71

GOVAERT FLINCK

Dutch, 1615–1660
Vertumnus and Pomona
Oil on canvas, 38¼ x 45¼″
Gift of Dr. and Mrs. Frank W. Lovejoy, Jr., 83.10

REMBRANDT VAN RIJN

Dutch, 1606–1669
Christ Preaching (*La Petite Tombe*), ca. 1652
Etching, burin and drypoint, 6¼ x 8¼″
Anonymous gift, 77.149

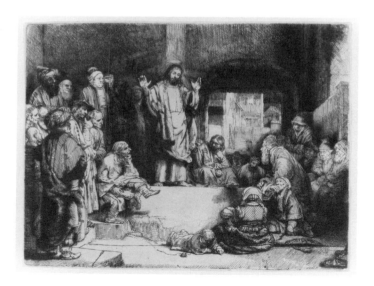

REMBRANDT VAN RIJN

Dutch, 1606–1669
Seated Woman
Black chalk on paper, 4⅞ x 3⅜ ″
Anonymous gift, 81.39

REMBRANDT VAN RIJN

Dutch, 1606–1669
Portrait of a Young Man in an Armchair, ca. 1660
Oil on canvas, 41 x 33½ ″
George Eastman Collection of the University of Rochester, 68.98

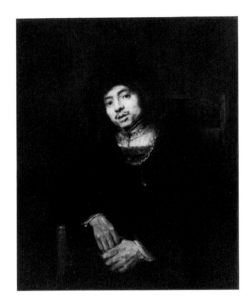

JAN GLAUBER
Dutch, 1646–1726

and

GÉRARD DE LAIRESSE
Flemish, 1641–1711

Tobias and the Angel
Oil on canvas, 38¾ x 52½ ″
Given in memory of Irene Comfort Jones by her husband,
Robcliff V. Jones, 70.43

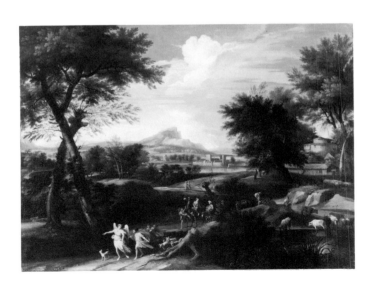

PIETRO PAOLINI

Italian, 1603–1681
Portrait of a Man Holding Dürer's "Small Passion," ca. 1637
Oil on canvas, 49¾ x 40¾"
Marion Stratton Gould Fund, 77.103

BERNARDINO POCCETTI,
CALLED BERNARDINO DELLE GROTTESCHE

Italian, ca. 1548–1612
Christ Carrying the Cross, ca. 1610
Engraving, 12⅞ x 7¹³⁄₁₆"
Anonymous gift, 86.112

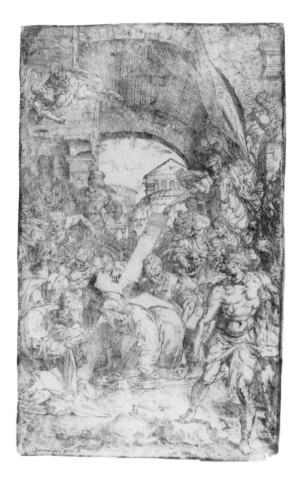

CORRADO GIAQUINTO

Italian, 1703–1766
The Trinity, ca. 1743
Oil on canvas, diam. 30″
Marion Stratton Gould Fund, 81.2

Swiss, 1741–1807
Portrait of John Monck, 1764
Oil on canvas, 39 x 29″
Gift of the Women's Council on the occasion of
the Council's 40th anniversary, 80.56

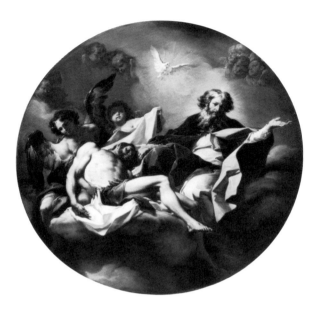

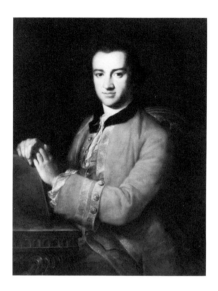

FRANCESCO GUARDI

Italian, 1712–1793
San Giorgio Maggiore, Venice
Oil on canvas, 17⅛ x 24½″
Clara and Edwin Strasenburgh Fund, 82.6

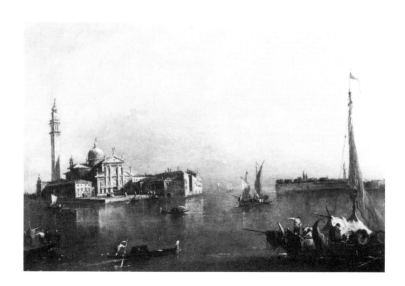

EUROPEAN ART
1800–1900

JEAN-AUGUSTE-DOMINIQUE INGRES

French, 1780–1867
Portrait of Pierre-François Bernier, 1800
Oil on paper mounted on canvas, 18¼ x 15″
Marion Stratton Gould Fund, 55.176

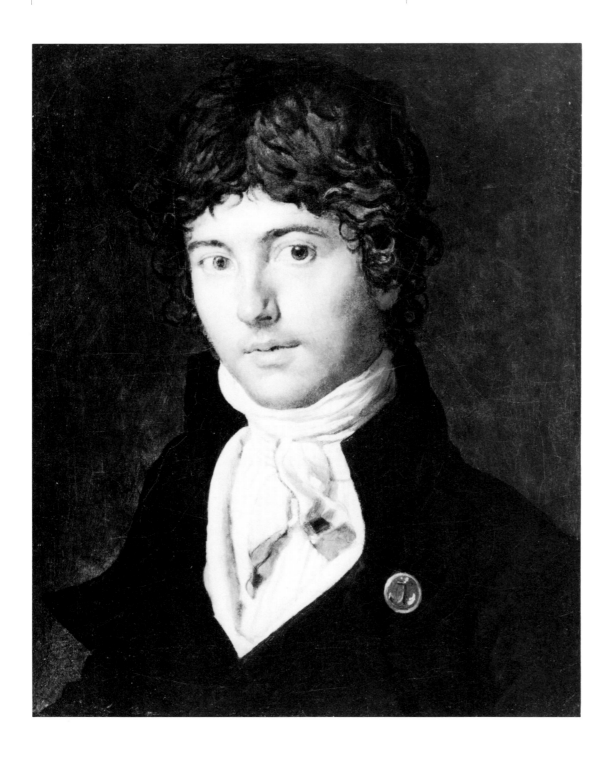

Ingres was the most gifted pupil of Jacques-Louis David and was widely regarded as the chief heir of the Neoclassical school. In his youth the artist's taste for flat, linear complexity in his paintings was considered eccentric, and Ingres, who aspired to be a history painter, was forced to earn his living for years drawing pencil portraits in Rome. Finally recognized in middle age, Ingres became the self-appointed, conservative pillar of the "School": the values he defended were precise drawing, learned composition, and elevated subject matter. Ironically, Ingres is probably admired today less for his paintings of Greek and Roman history than for his portraits, particularly his late pictures of Parisian society women wearing dresses with complicated patterns. The virtuoso treatment of the surface in these works gives evidence of Ingres's exceptional abilities as a draftsman.

The portrait of Bernier belongs to a different group of small works painted throughout the artist's youth (ca. 1800–1820); the subjects are male family members, friends, and fellow students. Among the works closest to the Gallery's painting in composition and technique are *The Artist's Father* and a *Portrait of a Young Man* (both 1804, Musée Ingres, Montauban). As late as 1819, Ingres, in his *Portrait of Paul Lemoyne* (Nelson-Atkins Museum of Art, Kansas City), continued this format for the portrait of a friend, though using then a more open sketchy manner. Compared with his larger and more finished society portraits the painting of Bernier is very informal, particularly in the alert, fleeting expression and in the treatment of the unruly hair, a device also used by others who studied with David at this time.

Pierre-François Bernier (1779–1803), an astronomer from Ingres's native Montauban, is described by the artist in his notebooks as a childhood friend. The portrait formerly bore a label, now lost, that identified the subject and indicated the date, 1800. Bernier arrived in Paris on January 31 of that year to take an academic position and left on September 28 for a scientific expedition to the South Seas, from which he never returned. The anchor button on Bernier's lapel is a clear reference to this naval expedition, to which the astronomer was appointed on August 5, 1800. The painting, therefore, unless executed later as a memorial, must have been completed during a brief period of time in August and September 1800. Ingres's brilliant achievements as a portraitist are already prefigured in this early work, one of a series of paintings that are surprisingly close to the Romantic portraiture of Géricault and Delacroix.

DR

PROVENANCE:
Haro Sr. and Jr., sale, Paris, May 30–31, 1892, no. 120; Haro Sr. sale, April 2–3, 1897, no. 168; M. Fauchier Magnan; H. Haro sale, December 12–13, 1911, no. 218; Henry Lapauze, sale, June 21, 1929, no. 60; H. Southam, Ottawa; Private collection; M. Knoedler and Co., New York.

LITERATURE:
Henri Delaborde, *Ingres, sa vie, ses travaux, sa doctrine,* Paris, 1870, pp. 261-262, no. 158 (as "Vernier"); Henry Lapauze, *Les Dessins de J.-A.-D. Ingres du Musée de Montauban,* Paris, 1901, vol. 1, pp. 234, 247 (as "Bornier"; Cahiers 9 and 10); Henry Lapauze, *Ingres, sa vie et son oeuvre,* Paris, 1911, pp. 36-37, ill.; Georges Wildenstein, *Ingres,* rev. ed., 1956, p. 159, no. 3, ill.; Donald A. Rosenthal, "The *Portrait of Pierre-François Bernier* by Ingres," *Porticus* 7 (1984), pp. 24-29.

EXHIBITIONS:
Wildenstein Galleries, New York, *Treasures from Rochester,* 1977, p. 51, ill.

French, 1814–1875
The End of the Day, 1867–1869
Pastel and black crayon on paper, 29 x 36¾″
Signed lower right: *J. F. Millet*
George Eastman Collection of the University of Rochester, 36.74

Millet, the son of a peasant farmer from the community of Gruchy, remained devoted to the French countryside throughout his life. Millet drew the subjects of his mature work, from 1849 until his death in 1875, from the rural life he had known since childhood. In 1849 Millet settled in the village of Barbizon, and largely because of him Barbizon became a major center of artistic activity beginning in the 1850s. Artists from America as well as France devoted themselves there to the study of the peasant and the land.

Millet studied in Paris under the successful history painter Paul Delaroche, but he always objected to the theatrical, exaggerated style of his teacher's large-scale academic paintings. In a letter to his friend and biographer Alfred Sensier, Millet denounced Delaroche's pictures as having "no genuine emotion, nothing but posing and stage scenes."[1] Renouncing the grandiose historical and mythological subjects popularized by French academic artists such as Gérôme, Cabanel, and Delaroche, Millet preferred what for him were more honest and natural scenes, such as the scruffy and fatigued laborer preparing to leave the field in *The End of the Day.*

In this very large pastel, the laborer stands in the center of the composition, almost the only vertical element in the landscape. As he reaches one arm above his head to put on a jacket, a gesture that accentuates his verticality, he innocently assumes a heroic pose. Towering above the earth, his tools and his horse in the distance, he is the prince of the soil.

The laborer's open-mouthed expression, the coarseness of his hair and clothing recall the primitive features of peasants in paintings by the elder Brueghel and other Northern artists of the sixteenth and seventeenth centuries whom Millet admired. The peasant's earth-tone clothing, ruddy complexion, and potato-shaped nose ally him with the clumps of soil beneath him. Millet balances these coarse characteristics with the softened strokes of pastel, the rosy twilight, and the quivering halolike lines around the figure. The mood is benevolent and spiritual, the figure and his toil dignified. But the twilight that dignifies this laborer also obscures him, suggesting the anonymity of the toiler's life and work.

RMS

1. Quoted in Julia Cartwright, *Jean-François Millet: His Life and Letters,* London, 1910, p. 50.

PROVENANCE:
Emile Gavet, Paris, sale, Hôtel Drouot, June 11–12, 1875, lot 4; E. May, Paris, sale, Galerie Georges Petit, June 4, 1890, lot 80, ill.; T. A. Waggaman, sale American Artists Association, Anderson Galleries, January 25–February 3, 1905, lot 38, ill.; Felix Isman, Philadelphia, acquired 1905; M. Knoedler and Co., New York, 1909; George Eastman, Rochester, NY, 1910.

LITERATURE:
L. Soullie, *Les Grands Peintres aux ventes publiques, Jean-François Millet,* Paris, 1900, p. 105; W. Gensel, *Millet und Rousseau,* Bielefeld, 1902, pp. 50-51, ill.; H. Marcel, *J.-F. Millet* (1903) Paris, 1927, pp. 101-102; A. Hoeber, *The Barbizon Painters,* New York, 1915, ill. facing p. 31; E. Moreau-Nélaton, *Millet raconté par lui-même,* Paris, 1921, vol. 2, p. 80, fig. 153; T. Reff, "Cézanne's Bather with Outstretched Arms," *Gazette des beaux-arts,* series 6, vol. 59, 1962, pp. 173-190; R. L. Herbert, R. Bacou, M. Laclotte, *Jean-François Millet,* London, 1976, pp. 163-164; André Fermigier, *Jean-François Millet,* Geneva, 1977, p. 52, 144, no. 79, ill.; Lucienne Desnoues, *Toute la pomme de terre,* Paris, 1978.

EXHIBITIONS:
Exposition Gavet, Paris, *Dessins de Millet provenant de la collection de M.G. [Gavet],* 1875, no. 5; Ecole des Beaux-Arts, Paris, 1887, no. 90; *Exposition centennale de l'art français,* Paris, 1889, no. 430; Grand Palais, Paris, *Jean-François Millet,* 1975, no. 181, pp. 224-225, ill.; Hayward Gallery, London, *Jean-François Millet,* 1976, no. 104, p. 163, ill.; Wildenstein Galleries, New York, *Treasures from Rochester,* 1977, p. 54, ill.

JEAN-LÉON GÉRÔME

French, 1824–1904
Interior of a Mosque, 1870s
Oil on canvas, 23⅜ x 35⅜ ″
Signed at base of central column: *J.L. Gérôme.*
Gift of Mr. and Mrs. F. Harper Sibley, 57.18

Throughout the nineteenth century, Europeans traveled to the Middle and Near East in search of exotic adventure. Artists and writers, and by mid-century, photographers, were among the adventurers, and their paintings, writings, and photographs of these foreign lands fanned European fascination with the Orient.

Jean-Léon Gérôme was among the most popular and powerful French academic painters of the nineteenth century and a leader among the Orientalists. He made numerous trips to North Africa and the Near East between 1856 and 1881, during which he sketched. Back in his studio in Paris, these drawings served as the basis of his paintings. Gérôme may also have consulted photographs, perhaps taken himself or acquired through commercial sources.

The precision of execution and the attention to detail in *Interior of a Mosque* are, in fact, strikingly photographic. The specificity of the architectural features, the mottled coloration on the columns, and the rendering of the cast shadows suggest photographic sources. Although the particular mosque depicted in this painting has not been identified, study of a nineteenth-century photograph of a medieval mosque in Cairo with similar arches and wooden structural beams suggests that Gérôme may have based this painting, at least in part, on an Egyptian mosque.[1]

Gérôme was not, however, interested in the architecture alone. He also recorded with great accuracy the gestures and position of the Moslems' prayer cycle. Gérôme has painted these men in the midst of their individual prayers and has noted all the stages of their devotions from the initial upright recitation of vows to the final prostration before God. Even the precise placement of their hands and feet during prayer has been carefully observed.

Beyond the details of ritual and architecture, Gérôme's composition itself conveys the stillness and spirit of worship. Balance is everything. The drama of the massive vertical columns, one of which, daringly, almost divides the painting in half, is counteracted by the horizontal shape of the canvas. The light-bathed interior courtyard, which illuminates the foreground, plays against a backdrop of darkness. The near invisibility of Gérôme's brushstrokes all but eliminates a sense of the artist's presence.

SDP

1. See anonymous photograph of the Mosque of Ibn Tulun, Cairo, reproduced in D. B. and D. Lorimer, *Up the Nile,* New York, 1979, in *Orientalism,* fig. 115, p. 120.

PROVENANCE:
Bought by Hiram Sibley in the 1870s; descended through family.

LITERATURE:
Gerald Ackerman, *The Life and Work of Jean-Léon Gérôme,* New York, 1986, p. 294, no. 514.

EXHIBITIONS:
Dayton (OH) Art Institute, *Jean-Léon Gérôme (1824–1904),* 1972, no. 26, p. 72, ill; MAG and Neuberger Museum, State University of New York at Purchase, *Orientalism: The Near East in French Painting, 1800–1880,* 1982, no. 43, pp. 120-121, fig. 114, ill. on cover.

PAUL CÉZANNE

French, 1839–1906
View of Mt. Marseilleveyre and the Isle of Marie (L'Estaque), ca. 1878–1882
Oil on canvas, 21¼ x 25⅝"
Anonymous gift in tribute to Edward Harris and in memory of H. R. Stirlin
of Switzerland, 69.45

Paul Cézanne's paintings are frequently cited as a source for twentieth-century art, and his interest in construction was an important inspiration for the Cubists. In many ways, however, Cézanne's goals remained the Impressionist ones he had absorbed in contact with other artists of this group, especially while working with Camille Pissarro in the 1870s. Cézanne was not interested in seizing a particular moment, but he remained committed to rendering his perceptions of nature. He wrote to the novelist Emile Zola, a boyhood friend, about the same time he was working on this painting, "I want to ask you if your opinion on painting as the means of expressing sensation, is not the same as mine."[1] In his later letters, he would refer many times to the goal of realizing his sensations.

The town of L'Estaque is thirty kilometers from Aix, where Cézanne was born and his parents lived. Cézanne lived and worked there intermittently between 1870 and 1885, where he could be in the unchanging Provençal countryside he loved but not too near his parents' home. His mother had a small house in L'Estaque, but Cézanne seems to have lived in lodgings most of the time, because, until 1878, he was concealing from his father, on whom he still depended for financial support, the fact that he had a mistress and a young son.

This painting is one of a number of views of L'Estaque and the Gulf of Marseilles done between about 1876 and 1885.[2] In 1876 Cézanne wrote to Pissarro about work he was doing for his first important patron. "I have started two little motifs with a view of the sea.... It is like a playing card,—red roofs over the blue sea.... The sun is so terrific here that it seems to me as if the objects are silhouetted not only in black and white, but in blue, red, brown and violet. I may be mistaken, but this seems to me to be the opposite of modelling."[3] The trapezoidal red roofs in this painting, as in the painting he wrote about, suggest the flat, patterned quality of pips on a playing card. The volumes here are not built up by conventional modeling. The entire painting is a series of related and interlocking shapes, representing the hill, mountains, and area of water, which repeat and reverse one another. Diagonal brushwork, which Cézanne began to use in the late 1870s, conveys some illusion of foliage. These concentrated areas of brushwork vary in size and direction in different parts of the picture according to the nature of the represented object, but they also serve to unify the composition.

In contrast to his colleagues, whose closeup views with their casual croppings and obvious brushstrokes suggested rapid and spontaneous execution, Cézanne enjoyed working in the south of France because the motifs did not change and paintings of them could be worked on for several months. He chose his point of view carefully and thought about the construction of the picture and the interrelation of parts as he worked on it. But he was also interested in rendering the sensation of this particular place, and his choice of bright colors conveys a feeling of the strong light and still atmosphere of the Midi.
GS

1. Cited in *Paul Cézanne: Correspondance*, ed. John Rewald, Paris, 1937, pp. 153-154.

2. Very few of Cézanne's works can be dated precisely. Although Venturi, the author of the catalogue raisonné, dates this painting 1882-1885, its varied brushwork seems to belong to the end of the 1870s. Cézanne was absent from L'Estaque between April 1879 and November 1881. The Gallery's painting is also related to the drawing *La Baie de L'Estaque,* dated 1883-1885 in Venturi (no. 915) and 1878-1882 in John Rewald, *Paul Cézanne: The Watercolors,* Boston, 1983, p. 113, no. 117.

3. John Rewald, *Paul Cézanne,* trans. Margaret H. Leibman, London [1956], p. 118.

PROVENANCE:
Egisto Fabbri, Florence; Paul Rosenberg, Paris; H. R. Stirlin, Zurich, purchased in 1936.

LITERATURE:
Lionello Venturi, *Cézanne, son art, son oeuvre,* Paris, 1936, vol. 1, no. 408, p. 153, vol. 2, pl. 113; Bernard Dorival, *Cézanne,* New York, pl. 72; P. Portman, *Cézanne,* 1957, p. 18, ill.; André Alauzen, *La Peinture en Provence du XIVe siècle à nos jours,* Marseille, 1962, p. 116, pl. 51; L. Brion-Guerry, *Cézanne et l'expression de l'espace,* Paris, 1966, pp. 107-108; Keith Roberts, *Cézanne,* New York, [1967], p. 34; Charles F. Ramuz, *Cézanne,* Lausanne, 1968, p. 13; Gaëton Picon and Sandra Orienti, trans. Simone Darses, *Tout l'oeuvre peint de Cézanne,* Paris, 1975, no. 419; Gilles Plazy, *Cézanne ou le triomphe de la peinture,* Paris, 1988.

EXHIBITIONS:
Venice, *Biennale,* 1920, no. 17; Kunsthalle, Basel, *Cézanne,* 1936, no. 32, ill.; Paul Rosenberg, Paris, *Le Grand Siècle en Suisse,* 1936, no. 2; Palais National des Arts, Exposition internationale, Paris, *Cent trente chefs d'oeuvre de l'art français du moyen âge au XXe siècle,* 1937, no. 251, p. 127; Galerie de la Gazette des Beaux-Arts, Paris, *La Peinture française du XIXe siècle en Suisse,* 1938, no. 7; Paul Rosenberg, Paris, *Cézanne,* 1939, no. 15, ill; Musée de Lyons, *Centenaire de Paul Cézanne,* 1939, no. 28, pl. 10; Palazzo delle Esposizioni, Rome; Florence, *Mostra di capolavori della pittura francese dell'Ottocento,* 1955, no. 7, pl. 84; Kunsthaus, Zurich, *Cézanne,* 1956, no. 45; Musée du Petit Palais, Paris, *De Géricault à Matisse: Chefs d'oeuvre français des collections suisse,* 1959, no. 19; Musée cantonal des beaux-arts, Lausanne, *Chefs d'oeuvre des collections suisse de Manet à Picasso,* 1964, no. 90, ill.; Orangerie des Tuileries, Paris, *Chefs d'oeuvres des collections suisse de Manet à Picasso,* 1967, no. 89, ill.; The National Gallery of Western Art, Tokyo (circulated), *Exposition Cézanne,* 1974, no. 21, ill.; MAG, "Harris K. Prior Memorial Exhibition," 1976; Wildenstein Galleries, New York, *Treasures from Rochester,* 1977, p. 63, ill.; Musée Saint-Georges, Liège, *Cézanne,* 1982, no. 11, p. 74, ill.

EDOUARD VUILLARD

French, 1868–1940
Portrait of Lugné-Poë, 1891
Oil on paper mounted on panel, 8 ⅞ x 10 ½ "
Initialed and dated lower left: *ev 91*
Gift of Fletcher Steele, 72.18

Vuillard met Aurélien Marie Lugné-Poë in 1884 when they were both students at the prestigious Lycée Condorcet. Soon they were sharing a studio at 28, rue Pigalle in Montmartre with the painters Pierre Bonnard and Maurice Denis. Lugné, who added the American-sounding Poë to his name when he began his career as an actor, was thus in the center of the avant-garde artistic ferment of the period. By 1890 he had helped Vuillard obtain the painter's first commission to design a theatrical program in color for the Théâtre Antoine. Later, as the most original theatrical producer of this time, Lugné-Poë asked Vuillard to design eleven programs for his Théâtre de l'Oeuvre.

Vuillard painted his friend's portrait twice: in this painting, at the beginning of their careers, and again in 1912 (Comédie des Champs-Elysées, Paris). Vuillard's intimate yet intense style is already fully developed in this small, early work. The actor-director reads intently by a lamp that dramatically illuminates his face. The cool colors—grays, browns, pale blue, and yellow—are subdued yet modern. This private interior view is characteristic of the themes of the Nabis, a group of painters whose intimate subject matter replaced the more public, colorful outdoor subjects that had been favored by the Impressionists and Post-Impressionists during the previous decades.

DR

PROVENANCE:
H. S., Paris; Mabel Choate, New York, and Stockbridge, MA; Fletcher Steele, Pittsford, NY.

LITERATURE:
John Rewald, *Post-Impressionism from Van Gogh to Gauguin,* New York, 1956, pp. 450, 470, ill. p. 488, 3rd rev. ed., 1978, p. 454, ill.; John Russell, *Vuillard,* Greenwich, CT, 1971, p. 228, no. 6, ill.; Stuart Preston, *Edouard Vuillard,* New York, 1974, p. 66, ill. in color; George L. Mauner, *The Nabis, Their History and Their Art, 1888–1896,* New York, 1978, p. 130, fig. 91.

EXHIBITIONS:
Le Barc, Paris, "Portraits du Vingtième siècle," 1893; M. Knoedler and Co., New York, *A Century of French Painting,* 1928, no. 52; Wildenstein Galleries, New York, *Vuillard,* 1964, no. 3, ill.; Art Gallery of Ontario, Toronto, *Edouard Vuillard 1868–1940,* 1971, no. 6, ill.; Wildenstein Galleries, New York, *Treasures from Rochester,* 1977, p. 78, ill.; Royal Academy of Arts, London, *Post-Impressionism: Cross-Currents in European Painting,* 1979–1980, no. 234, p. 147; National Gallery of Art, Washington, DC, *Post-Impressionism: Cross-Currents in European and American Painting, 1880–1906,* 1979–1980, no. 148, p. 120, ill.; Wildenstein Galleries, New York, *La Revue Blanche,* 1983, ill. p. 44; MAG, *Artists of La Revue Blanche,* 1984, no. 74, ill.; Jane Voorhees Zimmerli Art Museum, New Brunswick, NJ, *The Circle of Toulouse-Lautrec,* 1986, no. 173, pp. 180-181, ill.

PAUL GAUGUIN

French, 1848–1903
The Creation of the Universe, 1893–1894
White line woodcut on Japan paper, second state printed by Louis Roy,
8 x 14″
Signed in block lower right: *PGO*
Inscribed lower left: *L'Univers est créé*
Anonymous gift, 77.147.1

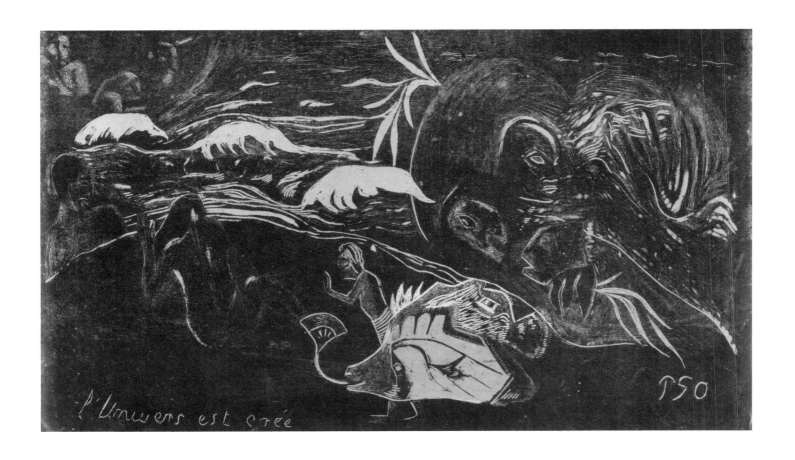

Paul Gauguin began as a Sunday painter but turned seriously to art when he lost his stock-exchange job during the economic crash of 1883. He worked first in the Impressionist style but soon became interested in communicating aspects of the imagination rather than recording perceptions. His simplification of style and interest in the way forms and colors communicated in their own right, like music, was very influential for younger artists. After a period of working in the most primitive parts of France, Gauguin sought to go farther from the pernicious effects of Western civilization. In 1891 he went to Tahiti, where, with the exception of a period in 1893 and 1894 when he returned to France, he spent the rest of his life. Although his existence in this "island paradise" was often difficult and far from idyllic, Gauguin produced many radiant pictures that project the image of a strange and exotic way of life.

The Creation of the Universe was made during Gauguin's return trip to France and is one of a series of ten woodcuts done to accompany Noa Noa, his idealized narrative of his life in Tahiti. Although Gauguin never refers specifically to a creation myth in Noa Noa, he does allude to Polynesian generative deities, such as Tefatou, a male god, and Hina, a goddess whose manifestations include woman, matter, birth, and death. Such myths spurred Gauguin's imagination, and he frequently combined them with Christian references, especially to the Fall of Man. This image was probably not intended to be deciphered in detail, but the crouching woman is undoubtedly Eve, as well as any other first woman, and the universe coalescing out of the vague clouds is paradise. Gauguin wrote that he learned Polynesian myths from his friends and native women. Missionaries and Western civilization, however, had already diluted the native culture; it appears that Gauguin's principal source was Voyages aux îles du grand océan (1837) by Jacques Moerenhout.[1]

The actual block from which this print was pulled is in the Gallery's collection. It is a conventional wood block of the type used for wood engravings, made of six pieces of boxwood endgrain glued together. Gauguin, however, was not interested in achieving conventional effects in his prints. Instead of cutting away from lines drawn on the block to produce a print that looks like a drawing, Gauguin worked with a dark ground, cutting away the lines and shapes he wanted to print white. With a sharply pointed burin, or engraver's tool, he first scratched fine networks of lines to create mysterious tonal effects. He later reworked the woodblock with a gouge and deepened some lines and cutout areas.[2] Gauguin is known to have made rubbings of both his own carvings and Marquesan reliefs, and these may have inspired his approach to his prints.

This print is from a set of about thirty printed in 1894 by Louis Roy, an artist friend of Gauguin. It is not known whether the additional colors were added by other blocks or by stencils.
GS

1. See Charles F. Stuckey, "The First Tahitian Years," in The Art of Paul Gauguin, Washington, DC, 1988, p. 216, with additional bibliography; on the prints for Noa Noa, see pp. 317–329.

2. Harold Joachim called these prints "white line woodcuts" in Gauguin: Paintings, Drawings, Prints, Sculpture, Chicago, 1959, p. 77.

PROVENANCE:
Private collection, NY.

LITERATURE:
Marcel Guerin, L'Oeuvre gravé de Gauguin, Paris, 1927, no. 26, ill.; Gordon Bailey Washburn and Robert McDonald, "The James Lockhart Collection of Prints and Drawings," Carnegie Magazine 32, no. 2 (February 1958), pp. 41-47; Dolores Mayer, "Gauguin's L'Univers est crée: A Creative Vision," Porticus 1 (1978), pp. 40-45, ill.

EXHIBITIONS:
Carnegie Institute, Pittsburgh, PA, From the Lockhart Collection, 1958; MAG, Drawings and Prints from the James H. Lockhart Collection, 1959; MAG, Masterpieces for Rochester: Acquisitions since 1975, 1979; Roberson Center for the Arts and Sciences, Binghamton, NY, 1979; New York State Museum, Albany, Treasure House: Museums of the Empire State, 1980, no. 118; MAG, Art from the Woodblock, 1981; MAG, Prints from the Permanent Collection, 1982; University of Michigan Museum of Art, Ann Arbor (circulated), Artistic Revival of the Woodcut in France, 1985, no. 64c, ill.; Los Angeles County Museum of Art, The Spirtual in Art: Abstract Painting, 1890–1985, 1986–1987, p. 327.

English, 1828–1882
La Bionda del Balcone, 1868
Watercolor on board, 13 ¾ x 14 ⅞ "
Signed and dated lower left: *D.G.R.* [monogram] *1868*
Marion Stratton Gould Fund, 66.17

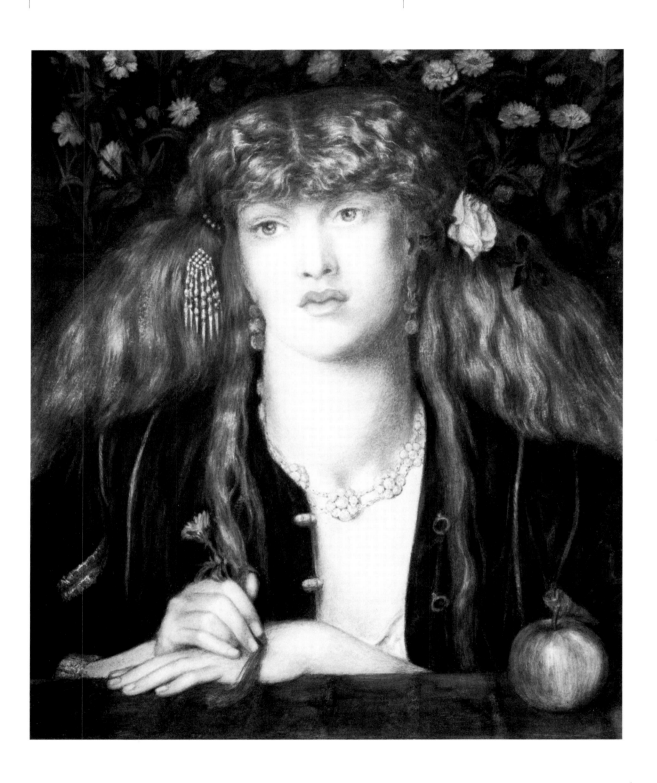

A poet and painter of Italian ancestry born in London, Rossetti became a leading figure in the Pre-Raphaelite movement of young painters in the 1850s. Though the early aim of the movement was to focus on the truth of modern life, its later tendency, emphasized in the works of Rossetti and Edward Burne-Jones, was toward dreamy, escapist Renaissance and medieval romance.

At the end of the 1850s, Rossetti began to move away from narrative scenes and depict single figures of women, often portrayed with symbolic attributes. One such work, *Bocca Baciata,* painted in oil in 1859, was a picture of Rossetti's model and mistress Fanny Cornforth.[1] In 1868 Rossetti painted this larger watercolor version, which originally was probably identical to the 1859 composition. Rossetti's physician, Dr. William Bowman, who had acquired the painting as payment for medical services, consulted Rossetti in 1877 concerning physical changes that had occurred in the work. At that time, the artist completely repainted the face. The features are now more loosely painted and less specific, or portraitlike, than in the 1859 picture.

Rossetti's inspiration for the frontal pose, exotic costume, and sensual appearance of this figure came from Italian Renaissance portraits, as did the foreground parapet and symbolic floral background. The model's flowing reddish hair particularly recalls women depicted by such Venetian artists as Titian. The symbolic meaning of the flowers and other accessories in this painting is especially revealing. The marigolds that fill the background represent cruelty, pain, and grief, and the apple and the serpentlike armband suggest the temptation of Eve. The white rose in the model's hair, however, symbolizes both purity and perfection of beauty.

Rossetti regarded his portraits of women as physical manifestations of his soul. When he replaced Fanny Cornforth's portrait with generalized features, he reduced the sensuality of the image and heightened its spirituality.

DR

1. There are two known versions of *Bocca Baciata*: one in the Museum of Fine Arts, Boston; the other, in the collection of Mrs. Eugene A. Davidson, Santa Barbara, CA. Letter to author from Helen Hall, Museum of Fine Arts, Boston, on September 26, 1984 (MAG archives).

PROVENANCE:
Sir William Bowman, Baronet, ca. 1868; descended in family; sale, London, Sotheby's, June 10, 1953, no. 126; William Alwyn, sale, London, Sotheby's, Nov. 14, 1962, no. 102; Leger Galleries, London; Coats Gallery, New York, 1965.

LITERATURE:
W. M. Rossetti, *Dante Gabriel Rossetti as a Designer and Writer,* London, 1889, p. 100; H. C. Marillier, *Dante Gabriel Rossetti,* London, 1904, pp. 68, 104; Virginia Surtees, *The Paintings and Drawings of Dante Gabriel Rossetti (1828–1882),* Oxford, 1971, vol. 1, no. 114.R.1, pp. 69-70; Stephanie Spencer, "*La Bionda del Balcone* by D. G. Rossetti," *Porticus* 1 (1978), pp. 37-39, ill.

EXHIBITIONS:
Burlington Fine Arts Club, London, *Rossetti,* 1883, no. 144; Art Association of Indianapolis (IN), John Herron Art Institute, and Gallery of Modern Art, New York, *The Pre-Raphaelites: A Loan Exhibition of Paintings and Drawings by Members of the Pre-Raphaelite Brotherhood and Their Associates,* 1964, no. 67; MAG, "The Pre-Raphaelite Movement and Its Influence on American Decorative Arts," 1965; Wildenstein Galleries, New York, *Treasures from Rochester,* 1977, p. 59, ill.; Yale Center for British Art, New Haven, CT, *The Substance or the Shadow: Images of Victorian Womanhood,* 1982, no. 78, ill. pl. 41.

THOMAS COUTURE

French, 1815–1879
Self-Portrait
Oil on canvas, 18¼ x 14⅞ "
Marion Stratton Gould Fund, 47.17

EUGÈNE DELACROIX

French, 1798–1863
Moroccan Chief with Two Warriors, 1854
Watercolor and pencil on paper, 10⅛ x 7 1/16"
Anonymous gift, 87.64

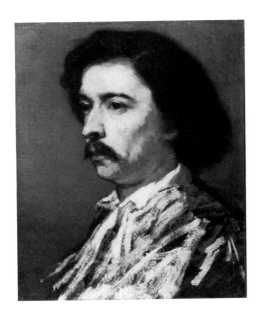

JEAN BAPTISTE CARPEAUX

French, 1827–1875
The Breton Poet with a Cigarette (*The Smoker*), 1863
Bronze, 17 13/16 x 12⅜ x 10 1/16"
Marion Stratton Gould Fund, 69.34

CHARLES FRANÇOIS DAUBIGNY

French, 1817–1878
The Washerwomen of Auvers, 1870
Oil on panel, 11¾ x 20⅜ "
George Eastman Collection of the University of Rochester, 36.59

LÉON AUGUSTIN LHERMITTE

French, 1844–1925
The Washerwomen, ca. 1866
Oil on canvas, 30⅜ x 37¾ "
Gift of Mr. and Mrs. Edmund Lyon, 37.2

GUSTAVE COURBET

French, 1819–1877
The Stonebreaker, ca. 1872
Oil on canvas, 18 x 22"
Marion Stratton Gould Fund, 43.11

French, 1855–1904
Rural Landscape
Oil on panel, 24 x 17½"
Gift of Elizabeth Weiss, 71.24

CLAUDE MONET

French, 1840–1926
The Rocks at Pourville, Low Tide, 1882
Oil on canvas, 25⁵⁄₁₆ x 31"
Gift of Emily Sibley Watson (Mrs. James Sibley Watson), 39.22

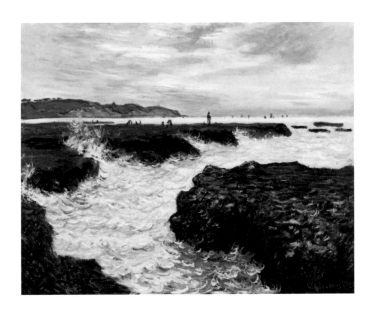

HENRI DE TOULOUSE-LAUTREC

French, 1864–1901
The Englishman at the Moulin Rouge, 1892
Color lithograph, 24¾ x 19¼"
Anonymous gift, 81.41

EUGÈNE BOUDIN

French, 1824–1898
The Seine at Paris—The Alexandre III Bridge, 1889
Oil on canvas, 15 x 21¼"
Marion Stratton Gould Fund, 57.11

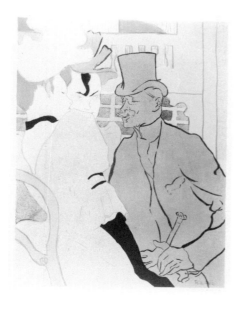

AUGUSTE RENOIR

French, 1841–1919
Near Cagnes
Oil on canvas, 18⅜ x 22"
Marion Stratton Gould Fund, 51.27

JACOB MARIS

Dutch, 1838–1899
Harbor Town, 1875
Oil on canvas, 14 ¼ x 23 ½ "
George Eastman Collection of the University of Rochester, 78.5

SIR HENRY RAEBURN

British, 1756–1823
Portrait of General Hay MacDowell, 1805
Oil on canvas, 93 ¾ x 59 ¾ "
George Eastman Collection of the University of Rochester, 68.102

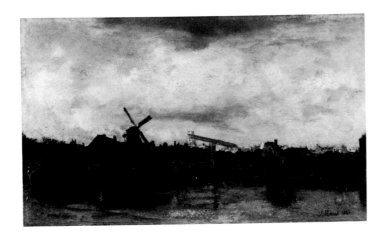

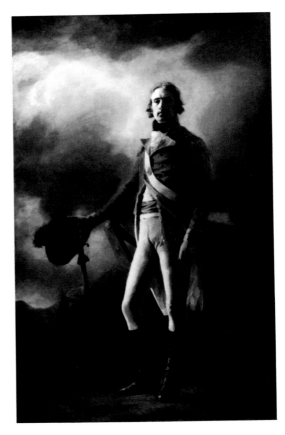

GEORGE FREDERICK WATTS

British, 1817–1904
Youth in the Toils of Love, ca. 1860–1865
Oil on panel, 21 ¾ x 9 ¾ "
Gift of the estate of Robert F. Metzdorf, 77.36

VINCENT VAN GOGH

Dutch, 1853–1890
Man with a Pipe (*Portrait of Dr. Gachet*), 1890
Etching, 7 ⅛ x 5 ⅞ "
Anonymous gift, 77.151

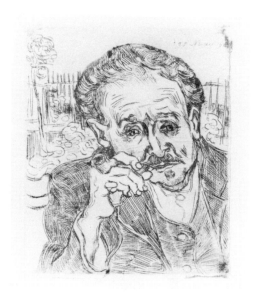

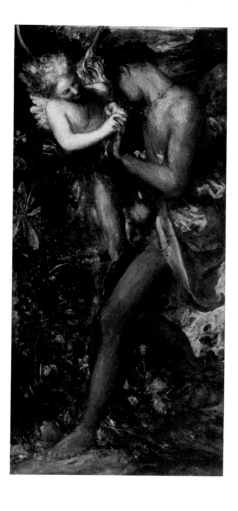

JOHAN FREDERICK (FRITS) THAULOW

Norwegian, 1847–1906
The Stream
Oil on canvas, 23 ¾ x 28 ¾ "
George Eastman Collection of the University of Rochester, 73.151

EMILIO SANCHEZ-PERRIER

Spanish, 1855–1907
Landscape
Oil on panel, 8¾ x 13¾"
Marion Stratton Gould Fund, 74.109

FRANCISCO JOSÉ DE GOYA Y LUCIENTES

Spanish, 1746–1828
Artemisia
Ink on paper, 10⁷⁄₁₆ x 16¹³⁄₁₆"
Anonymous gift, 78.77

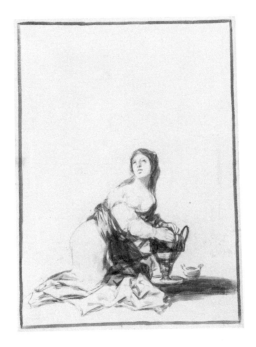

ANTOINE BOURDELLE

French, 1861–1929
Nude Warrior with Sword, 1889
Bronze, 13 x 9⅞ x 4¼"
R. T. Miller Fund, 57.16

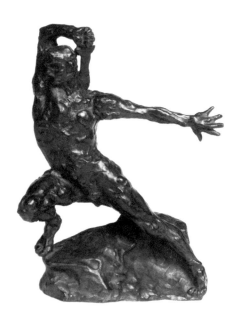

Contents

133

EUROPEAN ART 1900–

EDGAR-HILAIRE-GERMAIN DEGAS

French, 1834–1917
Dancers, ca. 1900
Pastel and charcoal on tracing paper mounted on wove paper mounted on board, 37 ⅝ x 26 ¾ "
Stamped lower left: *Degas* (vente stamp)
Gift of Mrs. Charles H. Babcock, 31.21

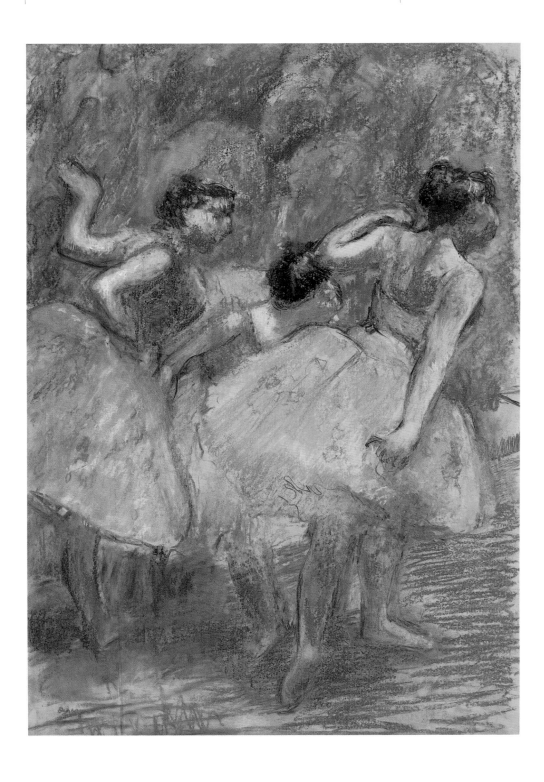

In keeping with Degas's preference for scenes of modern life, he began painting and drawing the ballet regularly by the early 1870s. He portrayed both actual performances and more informal rehearsal scenes like this one, delighting in capturing the dancers in odd, off-balance poses. But when asked by Mrs. Horace Havemeyer, an American collector, why he concentrated on the ballet, he replied seriously, "Because I find there, Madame, the combined movements of the Greeks."

This is one of a series of large, late pastels of dancers (Museum of Modern Art, New York; Riché collection, Paris). Characteristically, the figures are cut off by the frame (here on the left side), and all look toward something that has attracted their attention outside the picture space on the right. The pastel is layered in jagged strokes of brilliant colors, which fancifully reproduce the momentary, unpredictable effects of theatrical lighting. The artist then pressed the pigment down firmly to affix the image more permanently to the paper. While the picture is thus more stable than most pastels, this technique also artificially flattens the pictorial space.

Possibly as a result of Degas's declining eyesight in his later years, the figures are surrounded by heavy, anti-illusionistic contours, and their facial features are only suggested. Degas's perfectionism is revealed in his obsessive repetition of such themes and his subordination of subject matter to achieve purely formal artistic goals. In late works such as this one, Degas seems to prefigure not only abstract art but also the colorism of the Fauves and of the French and German Expressionists.

DR

PROVENANCE:
Degas studio sale, Paris, 1918, first sale, no. 296, ill.; Durand-Ruel Gallery, New York, stock no. N.Y. 4352; Durand-Ruel, Paris, stock no. N.Y. 4658.

LITERATURE:
Bulletin of the Memorial Art Gallery, October 1931; P. A. Lemoisne, *Degas,* vol. 3, Paris, 1946–1949, no. 1430, ill. (as ca. 1903); Alfred Werner, *The Degas Pastels,* New York, 1968, p. 50, pl. 16; Linda Muehlig, "The Rochester *Dancers*: A Late Masterpiece," *Porticus* 9 (1986), pp. 2-9, ill.

EXHIBITIONS:
Cleveland (OH) Museum of Art, *Works by Edgar Degas,* 1947, p. 52, pl. 44; Munson-Williams-Proctor Institute, Museum of Art, Utica, NY, "European Paintings from the Rochester Memorial Art Gallery," 1967; Wildenstein Galleries, New York, *Treasures from Rochester,* 1977, p. 61, ill.; Jean Sutherland Boggs, et al, *Degas,* New York and Ottawa, 1988, no. 366, p. 580 (as ca. 1895-1900).

CLAUDE MONET

French, 1840–1926
Waterloo Bridge: Veiled Sun, 1903
Signed and dated lower left: *Claude Monet 1903*
Oil on canvas, 25½ x 39¼"
Gift of the Estate of Emily and James Sibley Watson, 53.6

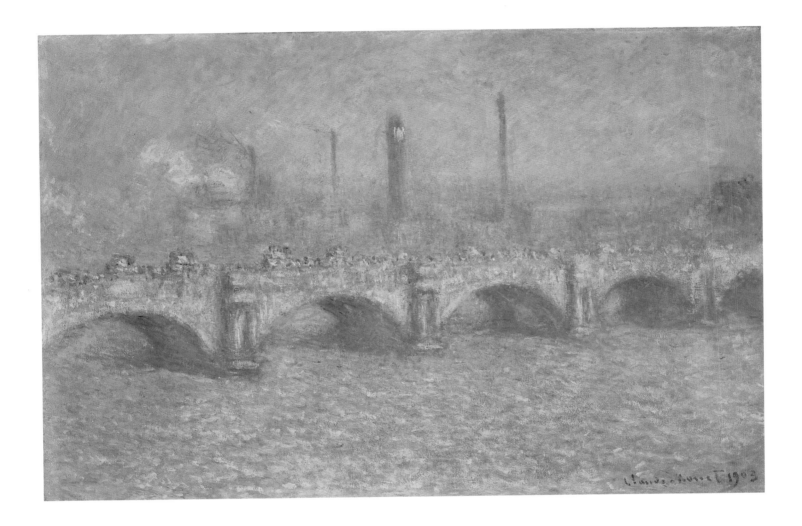

Claude Monet's vivid evocations of effects of light and atmosphere have earned him the reputation of archetypal Impressionist. He remained true to his goal of capturing fugitive effects on the canvas to the end of his life. In his later career, dissatisfied with painting whatever subject happened to attract him, Monet began to work in series, devoting sustained attention to a single motif or a group of related motifs. This view of Waterloo Bridge is one of about a hundred paintings that Monet began in London between 1899 and 1901. Looking left and right from the window of a hotel, he painted Waterloo and Charing Cross bridges in their myriad appearances. He also painted serially the Houses of Parliament from another location.

Monet chose to go to London in the fall and winter, when its famous fogs, exacerbated by the pollution of the Industrial Revolution, were most spectacular. He later said, "I adore London, it's a mass, and ensemble, and it's so simple. When in London, above all what I love is the fog."[1] He was less interested in the details of the scene before him than in the almost palpable atmosphere, its colors, and its changes.

This painting shows the bridge as the sun gleams through the fog, creating shimmering violet and pink reflections on the water which contrast with the blue-green shadows. Carriages and other traffic on the bridge are suggested by yellow and orange dabs. Buildings and smokestacks appear vaguely in the background; the fog has dissolved their outlines and volumes. By his relatively smooth handling of the paint surface and blending of one color into another, Monet suggests the fusion of objects and atmosphere.

For all its vividness and immediacy, this painting was the result of multiple periods of work, on the spot and in the studio. A critic who visited Monet when the painter was at work in London described Monet's ability to see changes so subtle and so swift that they escaped normal perception. Attempting to record these elusive visions, Monet worked on several paintings at once and constantly scrambled to find the canvas in-process that most closely corresponded to the effect before his eyes and to note the colors and atmospheric nuances before they changed. Paradoxically, the more fleeting and delicate the effects he perceived, the less possible it became for him to note them while they lasted. He could not finish most of his canvases on the spot. When Monet returned to Giverny from London in 1901, this canvas and the others, some quite sketchy, were lined up in his studio and worked on in relation to one another. He did not feel ready to exhibit them until 1904 because he wanted the group to work as an ensemble. The effect in this painting is based not only on his response to the scene and his memory of the light, but also on its relation to others in the series.

GS

1. René Gimpel, *Journal d'un collectionneur, marchand de tableaux,* Paris, 1963, p. 88.

PROVENANCE:
Bought from Monet by Durand-Ruel in October 1905; Durbin Horne, February 1906; Durand-Ruel, New York, 1906; Emily and James Sibley Watson, February 1907.

LITERATURE:
L. Venturi, *Les Archives de l'impressionnisme,* vol. 1, pp. 404-405 (W. nos. 1784 and 1787); G. Seiberling, *Monet's Series,* New York, 1981, pp. 203-204, 372, fig. 25; G. Seiberling, "Veiled Sun: Monet's *Waterloo Bridge*," *Porticus* 4 (1981), pp. 35-43; D. Wildenstein, *Claude Monet: Biographie et catalogue raisonné,* Lausanne, 1985, vol. 4, no. 1590.

EXHIBITIONS:
Durand-Ruel, New York, "Monet," 1907, no. 27; Museum of Modern Art, New York, and Los Angeles County Museum of Art, *Claude Monet: Seasons and Moments,* 1960, no. 83; Munson-Williams-Proctor Institute, Museum of Art, Utica, NY, and MAG, *Masters of Landscape: East and West,* 1963, no. 53; Munson-Williams-Proctor Institute, Museum of Art, Utica, NY, "European Paintings from the Rochester Memorial Art Gallery," 1967; Somerset House, London, *London and the Thames,* 1977, no. 92; Wildenstein Galleries, New York, *Treasures from Rochester,* 1977, p. 65.

AUGUSTE RODIN

French, 1840–1917
Torso of a Young Woman, 1909
Bronze, h. 33¼″, w. 18⅛″, d. 14″
Signed on thigh, proper left: *A. Rodin.*
Inscribed on base below signature: © *by Musée Rodin 1961*
Inscribed on base in back: *Georges Rudier / Fondeur. Paris*
Marion Stratton Gould Fund, 62.58

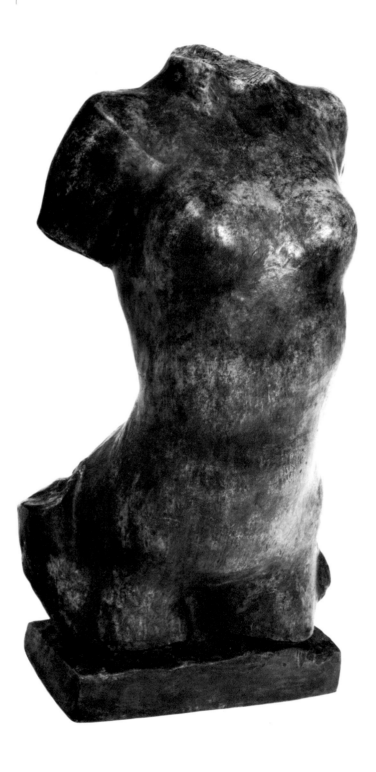

When Rodin died in 1917, the creator of *The Thinker* (1879–1889) and *The Kiss* (1886–1898) was considered internationally to be the world's greatest sculptor. Rodin's career, however, began inauspiciously. Unable to pass the entrance examinations to the prestigious state art school, the Ecole des Beaux-Arts, Rodin studied in a small school for the decorative arts. There he was trained to make architectural ornaments, an occupation that was his livelihood until he was in his mid-thirties.

Rodin's formative background as a decorative artist and the broad popular appeal of his art seem at odds with his current reputation as one of the precursors of modern sculpture. He does, however, rightly belong among both the academics and the revolutionaries. He yearned for acceptance by the Académie and, from the mid-1870s on, exhibited regularly at the official Salon. His traditional portrait heads and nudes thoroughly satisfied the Académie's requirements for subject matter and technical polish. But there were also many pieces that riled the establishment. Rodin's quest in his work to "express all the feelings of the human soul in the face of nature" often lead him far beyond his contemporaries.[1]

Controversy particularly surrounded the pieces that evolved from Rodin's lifelong study of fragments of ancient art.[2] In 1889 he began exhibiting headless torsos, which often were also armless and legless. Though they challenged the academic notion of "finish" in a work of art, to Rodin they were absolutely complete. In the 1880s he asserted that "a well-made torso contains all of life. One doesn't add anything by joining arms and legs to it."[3]

Torso of a Young Woman is a relatively late work, which was derived from a smaller plaster version (h. 13$^{9}/_{10}$", w. 8$^{1}/_{10}$") that was exhibited in the Salon of 1910.[4] From the front, it has beautiful, classical proportions. The figure is full and the skin taut; the chest swells with tremendous confidence. From the back, the source of this thrust is dramatically visible. The back is deeply arched and the musculature is as raw and expressive as it is modulated and realistic in front. Standing directly before the work, the viewer is very subtly led to the back around the left side by following the left shoulder and the left side of the breast, which are ever so slightly raised and pulled back. Preparing the eye for the surface agitation of the back, the ribs on the left side and the hollow beside the breast are forcefully articulated. On the figure's thighs are two amorphous lumps that may be remnants of arms and hands that Rodin eliminated during the course of his work. Rodin scholar Albert E. Elsen has observed that during the enlargement process, Rodin often squared off the rough ends of these stumps, as he appears to have done here.[5]

Torso of a Young Woman is a dynamic example of Rodin's belief in the expressive power of the body. In 1911 he explained, "So the forms and the poses of the human being necessarily reveal the feelings of his soul. The body always expresses the spirit for which it is the shell.... A simple torso—calm, well-balanced, radiant with strength and grace—can make him [a great artist] think of all the powerful reason that governs the world."[6]

Torso of a Young Woman was not cast in bronze during Rodin's lifetime. A total of twelve casts were authorized, however, at the founding of the Musée Rodin in 1918. This piece is number five of an edition of ten done in 1961 by Georges Rudier, a member of the family that has been the exclusive founders of Rodin's work since the turn of the century.

SDP

1. Auguste Rodin quoted in G. H. Hamilton, *Painting and Sculpture in Europe, 1880–1940,* Harmondsworth, 1967, 1974 ed., p. 63.

2. Albert E. Elsen describes the partial figure as "part of Rodin's intent to harmonize the outer world with his inner life and also to connect past with present;" see "When the Sculptures Were White," in *Rodin Rediscovered,* Washington, DC, 1982, pp. 140-141.

3. Auguste Rodin quoted in Albert E. Elsen, *In Rodin's Studio,* Ithaca, NY, 1980, p. 187.

4. Ibid., p. 129.

5. Ibid., p. 187.

6. Auguste Rodin, *Art: Conversations with Paul Gsell,* Berkeley, CA, 1984, pp. 75-76.

PROVENANCE:
Alan Gallery, New York, 1963.

EXHIBITIONS:
Flint (MI) Institute of Arts, "Auguste Rodin," 1980.

French, 1882–1963
Still Life with Pipe, 1913
Oil on canvas, 16¼ x 13" (oval)
Signed on reverse: *G Braque*
Marion Stratton Gould Fund, 54.12

Braque's *Still Life with Pipe* is a mature and elegant product of the intensive early development of Cubism. The Cubist pictorial method was undeniably the most influential early twentieth-century advance beyond direct representation of natural appearances. Braque was among the inventors and developers of Cubism, along with Pablo Picasso and Juan Gris.

This painting is from the extremely critical and brief early phase of Cubism. During the years preceding this picture, 1909 to 1912, Georges Braque and Pablo Picasso applied themselves to the task of building the intellectual and perceptual foundation for this new style of painting. Shortly after completing this painting, Braque's artistic development was interrupted when, in 1914, he was called to the front in World War I. Between 1908 and 1914, Braque painted about 175 pictures, most of which were developed from still-life compositions, the favored springboard for the Cubists' visual analysis and synthesis. Of Braque's work during this period, his oval compositions such as *Still Life with Pipe* are considered his most eloquent pictorial statements.

The intent and importance of Cubism extended beyond simple fragmentation of normal spatial relationships that are readily observable in this and other Cubist paintings. These paintings are not to be viewed as windows into which one gazes at the illusion created by an artist. Braque felt strongly that he was creating something completely independent, apart from nature, an aesthetic *surface* to be approached as such. The surface is the key: *Still Life with Pipe* is an art object that one looks *at*.

Braque invented the medium of collage. By pasting newspaper and other materials to the canvas, he clearly directed the viewer to the work's frontality, to its surface, to a visual sense of touch. Even in pictures made entirely of paint such as *Still Life with Pipe,* Braque emphasized the surface by painting typographic shapes, flat planes, and by applying the paint in dabs that remained paint rather than dissolving into image. He intentionally painted some areas glossy and others mat. Later, Braque would enrich the tactile quality of his surfaces by mixing sand and other materials into the paint as well as by texturing the paint with a comb.

Unfortunately, the critical role of the surface in Cubism was not always understood by later viewers, and over time some of these works were altered by the materials and methods of restorers.[1] *Still Life with Pipe* is one such case. Because the canvas was delicate, conservators feared its condition might deteriorate with age and had it infused with a wax adhesive to prevent paint loss, the usual method of restorers at the time. However, the color of the wax darkened the unpainted areas of the picture where Braque had intended the natural color of the canvas to be visible. As a result, the work was changed, for even in a painting with such muted colors as *Still Life with Pipe,* Braque's strength and subtlety as a colorist are evident. Moreover, the textural variations so important to the work were distorted by a protective coating of varnish.

In 1987 the Gallery's conservation laboratory removed these early restoration materials, so once again the paint can be seen and appreciated much as Braque left it.

RL

1. The proper appearance of Cubist pictures and appropriate conservation methods have been a controversial topic recently brought to the public's attention through an article by John Richardson, "Crimes against the Cubists," in the *New York Review of Books,* June 16, 1983, pp. 32-34. Reader responses were published several months later in " 'Crimes against the Cubists': An Exchange," *New York Review of Books,* October 13, 1983, pp. 41-43.

PROVENANCE:
Galerie Kahnweiler, Paris, before 1914; private collection, Alsace; after World War II sold to Perls Galleries, New York; Stanley Barbee, Los Angeles; Perls Galleries, New York.

EXHIBITIONS:
Perls Galleries, New York, *Picasso-Braque-Gris: Cubism to 1918,* 1954, no. 15, ill.; Saidenberg Gallery, *Braque: An American Tribute,* 1964, p. 30, ill.; Arizona State College Art Gallery, Flagstaff, "Inaugural Exhibition," 1966; Munson-Williams-Proctor Institute, Museum of Art, Utica, NY, "European Paintings from the Rochester Memorial Art Gallery," 1967; Wildenstein Galleries, New York, *Treasures from Rochester,* 1977, p. 88, ill.; Kunsthalle, Cologne, *Kubismus: Kunstler, Themen, Werke, 1907–1920,* 1982, no. 12; Center for the Fine Arts, Miami, FL, *In Quest of Excellence,* 1984, no. 137, p. 190, ill. p. 191.

HENRI MATISSE

French, 1869–1954
Girl with a Tricorne (*Vénitienne*), 1922–1923
Oil on canvas, 24⅜ x 20″
Signed lower right: *Henri Matisse*
Gift of Emily Sibley Watson (Mrs. James Sibley Watson), 24.38

When *Girl with a Tricorne* was exhibited in New York at the Fearon Galleries in 1924, Henri Matisse's work was already well known in this country and his position in the vanguard of contemporary art well established. By 1924 critics had come to expect daring and perennially groundbreaking work from this pioneer of modernism. What they saw instead in this and other paintings of the period were pleasing, decorative canvases. Writing about the Fearon exhibition, an anonymous critic in the *New York Times* described Matisse's choice of work for the show as "circumspect . . . two at the most would awaken adverse criticism. . . . "[1] Another critic observed that "a new Matisse" was on exhibition.[2]

Matisse painted *Girl with a Tricorne* in the winter of 1922–1923 in Nice. By then in his early fifties, Matisse sought in the south of France (where he spent winters from 1916 to 1939) a refuge from the pace of Parisian life and from the demands of his reputation.[3] This painting is typical of the work Matisse produced during that season, which has been characterized as "a series of single-figure frontal portraits . . . set—almost wedged—against decorative backgrounds."[4] It is likely, given the period in which it was done, that the model for the painting was Henriette Darricarrère, a talented young woman trained in both music and dance, who easily entered into the theatrical atmosphere Matisse wanted to create in his paintings.[5]

Girl with a Tricorne delights at first with its decorative qualities. The painting is rich in surface design and color—almost a full spectrum—and the young woman's face has a pretty, doll-like sweetness. Binding these elements, however, is a very tightly controlled space. Although it is not immediately apparent, *Girl with a Tricorne* is set on a very narrow stage: the young woman is pressed between the decorative back panel and the front of the canvas. The break of the back panel at the far right, which shows the actual wall of the room, reveals how Matisse arranged the scene to enhance this flatness.

The composition is based on a simple underlying geometry. The shape of the canvas itself, the screen behind the young woman, the narrow band at the far right, and the floor area are all rectangles. And from her tricorne hat down the cascading yellow veil to the bell-shaped dress, the young woman forms a massive triangle.

Despite all of his obvious attention to decorative details in this and other paintings of the period, Matisse never neglected composition. In his important theoretical essay "Notes of a Painter" (1908), he stated: "Expression, for me, does not reside in passions glowing in a human face or manifested by violent movement. The entire arrangement of my picture is expressive: the place occupied by the figures, the empty spaces around them, the proportions, everything has its share. Composition is the art of arranging, in a decorative manner the diverse elements at the painter's command to express his feelings."[6]

For years, critics and historians were unable to see beyond the immediate sensual delights in Matisse's work of the late teens through the thirties. Its underlying structure and motivation eluded them. *Girl with a Tricorne* almost passes as simply a decorative painting. Gradually, however, the work reveals itself structurally as a decorative expression of balance and harmony.

SDP

1. "The World of Art: Past and Present," *New York Times*, November 23, 1924.

2. "Latest Paintings by Matisse," *The Arts*, November 15, 1924.

3. Pierre Schneider, *Matisse*, New York, 1984, p. 496.

4. Jack Cowart and Dominique Fourcade, *Henri Matisse: The Early Years in Nice, 1916-1932*, Washington, DC, 1986, p. 32.

5. Ibid., p. 27.

6. Henri Matisse, "Notes of a Painter," 1908, reprinted in *Matisse on Art*, ed. Jack Flam, London, 1979, p. 36.

PROVENANCE:
Fearon Galleries, New York; purchased by Emily Sibley Watson (Mrs. James Sibley Watson) for the Gallery.

LITERATURE:
Elie Faure et al, *Henri Matisse*, [Paris, 1923], no. 42; Roger Fry, *Henri Matisse*, Paris, 1935, pl. 42; Alfred H. Barr, Jr., *Matisse: His Art and His Public*, New York, 1951, p. 559.

EXHIBITIONS:
Fearon Galleries, New York, "Fearon Galleries, Inc., under the Auspices of Matisse: Exhibition of Oil Paintings Selected by the Master," 1924, no. 13; Acquavella Galleries, New York, *Henri Matisse*, 1973, no. 26, ill. in color.

HENRY MOORE

British, 1898–1986
Working Model for Three Piece No. 3: Vertebrae, 1968
Bronze, no. 8 of an edition of 8, h. 86¾", w. 92¹⁵/₁₆"
Signed on base, proper right: *Moore 8/8*
Inscribed on side of base: *H. Noack Berlin*
Given in memory of Joseph C. Wilson by a group of his friends, 72.51

Sculpture, Henry Moore said, is distinguished from painting because "it can be seen from innumerable points of view."[1] Indeed, to see a piece of sculpture completely, the viewer must consider it in the round. Looking at sculpture is a cumulative, conceptual experience: the dimensions of time and space are integrated into the work through the actual process of walking around it.

Working Model for Three Piece No. 3: Vertebrae is a complex and mature work that incorporates several recurring themes in Moore's oeuvre: found shapes from nature, such as bones and flint stones; representations of a reclining figure; and interlocking forms. This piece is composed of three organic forms, which, like vertebrae, look as if they were meant to fit together. Separating these three shapes are precisely choreographed spaces that are as essential to the work as the solid elements. These three segments, though distinct, are only seen as parts of the larger whole and the relation of the parts to each other— the degree of separation and union—appears to change as the viewer approaches and moves around the piece. From some vantage points— looking at it from either end, for example—the work fuses into a single mass. But when the piece is approached laterally, the individuality of the parts and the separations become clear.

The subtle references to the human body—bones and appendages—in the three elements suggest that *Working Model for Three Piece No. 3: Vertebrae* may be an abstraction of another abiding concern in Moore's work: relationships between people, their intimacies and distinctions and how these evolve over time. Moore suggests the elusive quality of changing relationships using an essential principle of sculpture: that the relationships among the parts change as we walk around a piece.

Early in his career Moore made preliminary drawings as studies for his sculpture. Later, however, as Moore explained in a letter written to the Gallery after it had acquired the piece, his procedure changed: "I don't think I made any drawings directly connected with the vertebrae sculpture. In my recent sculptures I no longer work from drawings, but from small plaster maquettes."[2] Elsewhere Moore explained about drawing, "Once you draw a view, it tends to become dominant. And that won't do if you are thinking of inventing a sculpture that is to be seen from many vantage points."[3]

Once Moore's maquettes, plaster models that are small enough to be held, are completed, they are enlarged, and the final bronzes are cast. *Working Model for Three Piece No. 3: Vertebrae* is based on a smaller version, *Maquette for Three Piece No. 3: Vertebrae,* 1968. A much larger version—twenty-four and a half feet in length—was cast in 1968–1969.[4]

SDP

1. Henry Moore quoted in Henry J. Seldis, *Henry Moore in America,* New York, 1973, p. 198.

2. Henry Moore to Harris K. Prior, December 7, 1972.

3. Moore quoted in Seldis, *Henry Moore in America,* p. 199.

4. Wilkinson, *Moore Collection,* 1979, p. 202.

PROVENANCE:
Purchased from the artist, 1972.

LITERATURE:
Alan G. Wilkinson, *The Moore Collection in the Art Gallery of Ontario,* Toronto, 1979, p. 202, no. 180.

GIORGIO DE CHIRICO

Italian, 1888–1978
Florentine Still Life (*Balcone a Fierenze*; *Balcone a Venezia*; *Natura morta*;
Natura morta a Venezia), ca. 1923
Oil on canvas, 18¾ x 25″
Signed lower right: *G. de Chirico*
Gift of Helen C. Ellwanger in memory of Gertrude Newell, 64.47

Giorgio de Chirico's mysterious cityscape and still-life paintings of 1911 to 1919 were critically important in the development of early twentieth-century European art. In less than a decade, de Chirico created an oeuvre that directly influenced other artists working in both Paris and Italy before, during, and immediately after World War I, and eventually influenced the Surrealist movement.

De Chirico's first important paintings were made during the years he lived in Paris, from 1911 to 1915. In 1915 he was recalled to Italy to serve in the military during the war. There he continued at first to work in the enigmatic Metaphysical style for which he was already known. At the end of the war, however, about 1918–1919, de Chirico's focus changed. The great historical traditions in art, which he had previously parodied, became important to him as models for his own paintings. Living in Rome and Florence during the early 1920s, he consciously studied, at times even copied, the work of earlier artists, particularly those of the Renaissance.

Florentine Still Life, painted ca. 1923, is among the most striking and successful works of this period. Apples, bananas, scattered leaves and a glass of wine, all arranged on a rumpled cloth, are set in front of a window that looks onto the upper facades of nearby buildings. The light outside is sparkling, and the sky, as if just washed clean by a storm, is brilliant blue and filled with white clouds. The scene is framed on the left by the swag of a curtain and on the right by the corner of an adjacent building. It is a study of classical balance and volume. Gone is the mystery of the early work, and in its place is a painterly celebration of light and space.

But beneath the simple and immediate beauty of this painting is a complex weaving of influences. First, the composition may be seen as a reference to the early Renaissance portrait tradition of placing a sitter in front of a window with a distant landscape background.[1] In both subject matter and painting style itself, *Florentine Still Life* is also closely related to the work of Gustave Courbet, particularly the still-life paintings of 1871, which Courbet executed while he was imprisoned for political activism. Repeatedly in these still lifes, Courbet painted fruits and other objects in the foreground of landscape settings.[2] Courbet's political involvements ultimately prompted him to leave France in 1873, exiling himself to Switzerland where he died in 1877.

De Chirico's admiration for Courbet in well known. In 1925 he published a very personal statement on Courbet as a romantic painter-poet. Particularly revealing in connection with the Gallery's painting is a passage in this publication concerning Courbet's romanticism: "Courbet placed the reality of a figure or an object in the foreground and bathed it in warm summer twilight to which he could impart such pathos—whether it was a fruit or a human form, a nude or a tree, a rock or the foaming wave of a tempestuous sea. But behind the fruit and leaves bent back by the wind we see a distant sky with fleeting clouds."[3]

The connections between de Chirico's *Florentine Still Life* and this written description of Courbet's paintings in general (and the prison still lifes in particular) are striking and suggestive. During the 1920s, when de Chirico veered dramatically from the style that had won him a place in the vanguard of contemporary art, he was seen by critics and his fellow artists as having lost his way.[4] Feeling abandoned, even maligned, de Chirico grew bitter during this period. His admiration and obvious debt to Courbet, underscored by the 1925 state-

ment, may have developed out of a sense that he was then suffering as Courbet had five decades before. As such, *Florentine Still Life* may possibly be seen not only as a stylistic tribute to Courbet, but also as an intense statement of emotional kinship.

SDP

1. Consider de Chirico's use of this Renaissance tradition in *Self Portrait,* 1911–1912 (Metropolitan Museum of Art, New York), and *Self Portrait,* 1920 (Bayerische Staatsgemäldesammlungen, Munich).

2. See particularly Courbet's *Pommes St. Pélagie* (Bayerische Staatsgemäldesammlungen, Munich), which is reproduced in Robert Fernier, *La Vie et l'oeuvre de Gustave Courbet, catalogue raisonné,* Lausanne, 1978, vol. 1, p. 126, no. 771.

3. Giorgio de Chirico, *Gustave Courbet,* Rome 1925 (reprinted in translation in *The Painter's Object,* Myfanwy Evans, ed., London, 1937, p. 127).

4. De Chirico wrote to André Breton in 1922: "I know that in France (and even here) there are people who say that I am making museum art, that I have lost my road, etc." Quoted in James Thrall Soby, *Giorgio de Chirico,* New York, 1955, p. 158.

PROVENANCE:
Balzac Galleries, New York; Gertrude Newell, "Planterrose," Moumour (Basse-Pyrénées), France; Helen C. Ellwanger, Rochester.

LITERATURE:
A. Lancellotti, *La seconda biennale romana d'arte,* Rome, 1923, pp. 23-26; Giuseppi Marchiori, *Le Arti,* Milan, vol. 20., nos. 5-6 (June 1970), pp. 92-97; Claudio Bruni, *Catalogo generale Giorgio de Chirico,* Milan, 1971, vol. 1, no. 53; R. Barilli, "De Chirico e il recupero del museo," *Tra presenza e assenza,* Milan, 1974, p. 290; Isabella Far, et al, *Conoscere de Chirico,* Milan, 1979, no. 105, p. 198, p. 290; *De Chirico,* ed. William Rubin, New York, 1982, p. 193, pl. 86.

EXHIBITIONS:
"Biennale Romana" (exhibited as *Natura morta*), Rome, 1923, no. 16; Balzac Galleries, New York, "Paintings by Giorgio de Chirico," 1930; Palozzo Reale, Milan, *Giorgio de Chirico,* 1970, no. 58, ill.; Kestner-Gesellschaft, Hannover, 1970, no. 57; Galleria Nazionale d'Arte Moderna, Rome, *Giorgio de Chirico, 1888–1978,* 1981-1982, no. 43, p. 112, ill.

WILLIAM-ADOLPHE BOUGUEREAU

French, 1825–1905
Young Priestess, 1902
Oil on canvas, 71¼ x 32"
Gift of Paul T. White in memory of Josephine Kryl White, 73.1

MAURICE DE VLAMINCK

French, 1876–1958
Landscape with Houses and Trees
Oil on canvas, 31⅞ x 39½"
Charles A. Dewey Fund, 30.11

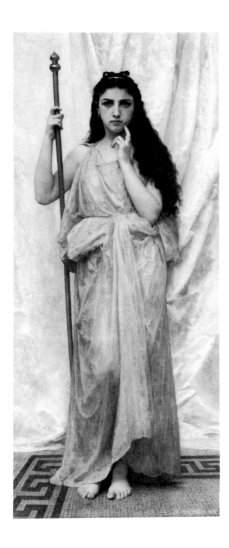

GEORGES ROUAULT

French, 1871–1958
The Abandoned, ca. 1935–1939
Oil over intaglio print on paper, 25⁵⁄₁₆ x 19⅜"
Marion Stratton Gould Fund, 53.30

ARISTIDE MAILLOL

French, 1861–1944
Torso, Ile de France, 1921
Bronze, 47⅛ x 13⅜ x 20⅛"
R. T. Miller Fund, 60.16

MAX KLINGER

German, 1857–1920
Plague (from *On Death, Part II*), 1903
Etching and engraving, 16¾ x 13¼"
Marion Stratton Gould Fund, 76.144.6

KARL SCHMIDT-ROTTLUFF

German, 1884–1976
The Red Bridge, 1921
Watercolor on paper, 18¾ x 23¾"
Marion Stratton Gould Fund, 49.82

MAX PECHSTEIN

German, 1881–1955
Ripe Wheat Fields, 1922
Oil on canvas, 31⅞ x 39⅜"
Gift of Mrs. Rudolph Hofheinz in memory of her son, 49.80

GEORG KOLBE

German, 1877–1947
Kneeling Figure, ca. 1928
Bronze, 21¼ x 9⅝ x 7¾"
Marion Stratton Gould Fund, 62.53

KEES VAN DONGEN

Dutch, 1877–1968
Portrait of a Woman, ca. 1903
Oil on canvas, 39⅜ x 27¾"
Gift of Mr. and Mrs. Irving S. Norry, 66.27

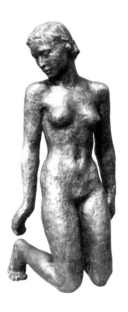

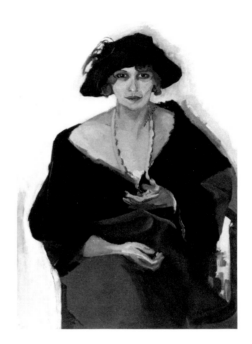

MARINO MARINI

Italian, 1901–1980
Cavalier, 1957
Bronze, 19¼ x 17¼ x 8"
R. T. Miller Fund, 58.1

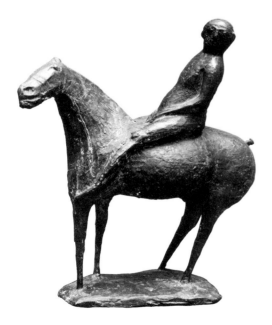

150

PABLO PICASSO

Spanish, 1881–1973
Frugal Repast, 1904 (printed 1913)
Etching (second state, after steelfacing), 18 3/16 x 14 7/8 "
Anonymous gift, 83.120

VASILY KANDINSKY

Russian, 1866–1944
Pentagon, 1927
Watercolor and ink on paper, 11 1/16 x 9 11/16 "
Marion Stratton Gould Fund, 76.145

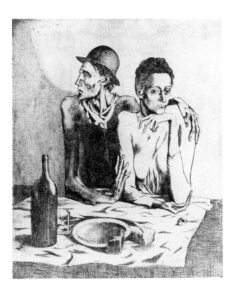

JOAQUÍN SOROLLA Y BASTIDA

Spanish, 1863–1923
Oxen on the Beach, 1910
Oil on canvas, 39 1/2 x 43 1/4 "
Gift of Emily Sibley Watson (Mrs. James Sibley Watson), 14.8

PAUL KLEE

Swiss, 1879–1940
Fairy Tales, 1920
Watercolor and gouache on paper, 8 3/16 x 10 1/4 "
Marion Stratton Gould Fund, 57.37

Contents

Asian Art

The Bodhisattva Guan-yin on Mount Potala, early 13th century
Wood with polychrome and gold, h. 45½″, w. 26⅜″, d. 20½″
R. T. Miller Fund, 42.21

The Bodhisattva, according to Buddhist belief, represents a state of perfection that is both absolute and comprehensive. He represents, as well, the penultimate stage in the evolutionary process that culminates in final liberation, Nirvana. From an historical vantage point, these assumptions are comprehended in the career and experience of a young Indian prince, Siddhartha, who became the Buddha. From the point of view of a developed theology, the Bodhisattva is the evolution of the ineffably Real into the intelligible term of Being, who has attained perfection, yet eschews Nirvana in order to work heroically against the sufferings of all classes of beings until, after all others, he becomes a buddha in the end. By this mighty act of self-denial, extended through all Time, the Bodhisattva is, in effect, an inexhaustible reservoir of Grace.

On the practical level and for the Buddhist faithful, the Bodhisattva is the great example, the archetypal Hero who comprehends, personally, the supreme virtues: wisdom and compassion. He is the helper-in-need who brings together, gracefully, the eternal immutability of the Divine and the absolute transitoriness of the phenomenal world. He is the leader of the caravan to the "Other Shore"; he carries, by his everlasting example and trust in it, the believer There. For the Bodhisattva *personifies* the high doctrines of faith and renders them compatible with popular belief. He is known by many names and is imagined in many forms and appearances.

Preeminent among these names and appearances of the Bodhisattva is that of Kuan-yin (Avalokiteshvara) who is regarded as the embodiment of karuna (saving grace), the active agent of the Dharma's power to transform. His sanskrit name, Avalokita, may be read as "visible" and may be understood to imply that he is the perceived evidence of the Buddha's power. The early standard translation of this name into Chinese is "Kuan-shih-yin" (see-world-sound)[1] which suggests that perception through sight and sound is both reciprocal and universally operative. For the myth of Kuan-yin (Avalokiteshvara) shows him refusing Nirvana in sympathetic response to the collective wailing of all creatures who projected with despair an unbearable future without his active presence. The *Lotus Sūtra* presents him as everywhere-present and efficacious against all possible troubles;[2] it declares that the very sound of his name will bring deliverance from peril. It is little wonder, then, that the cult of the Bodhisattva of Compassion developed an immense popularity in the Buddhist world.

With the wide dissemination of the *Lotus Sūtra* in China, devotion to the saving Bodhisattva became a prominent feature of Buddhist experience there, often eclipsing devotion to the Buddhas themselves. Among the surviving images of the twelfth and thirteenth centuries,[3] icons of Kuan-yin, often very large in scale and in various iconographical forms, outnumber all other types. One of the most popular forms of Kuan-yin, during this period in China, is illustrated by a splendid and moving example in the collection of the Art Gallery. It is a large image, carved from wood and originally embellished with rich colors and gold, that shows the Bodhisattva seated in the position of Royal Relaxation (rājalila), with the right knee drawn up and the foot placed flat upon the base plane. The left leg is pendant, the right arm is extended and rests lightly on the raised knee, and the left arm, straight and rigid with the hand pressing, palm down, upon the base plane, supports the body. The figure is simply dressed in a cloth that is wrapped around the hips and kept in place by a cord or sash. An overlap of the upper edge of the cloth makes a kind of peplum that is fixed by a binding sash, wrapped around the hips and tied at the front in an elegant bow, its ends depending like streamers to the lower edge of the skirt. The upper torso is bare. A broad scarf, knotted at the left armpit, hangs from the left shoulder to the right hip, yajñopavīta-style, and returns, up the back. Another broad scarf, spread over the shoulders like a shawl, falls to the base plane, along the straight left arm, in a slight arc. The other end of this scarf loops elegantly from the right shoulder to right forearm and falls in a long sweep to the base. These simple components of costume were shown as composed of sumptuous materials, as the patterns in applied color and gold originally made clear. The princely ornaments the Bodhisattva wears are also simple but sumptuous. A single necklace of floriform and foliate shapes describes a broad arc on the chest and he wears plain, banded armlets and bracelets. The hair is gathered up into a jatāmakuta, an ultimately Indian mode, composed of five groups of hairstrands fixed in grand loops at the crown of the head, with long loose strands falling to each shoulder, then knotted and trailing along the shoulders. A graceful coronet, made up of floriform and foliate shapes, encircles the jatāmakuta at its base. The front portion of the coronet, now broken off, may have held, originally, a small figure of the Buddha Amitabha, one of the identifying signs of Kuan-yin. The pupils of the eyes are formed by spheres of dark glass, inset, and the cavity just above the meeting of the brows was once filled with a real or simulated gem. The earlobes are elongated but they carry no ornaments; this feature, together with the pronounced creases on the neck and the gem-set urna on the forehead, is a carry-over from Indian convention. These symbolic forms were understood, separately and together, as evidence of the perfection that characterizes the appearance of super-normal beings and distinguishes it from that of ordinary creatures.

In its present state, apart from the loss of its original rich color and gold and some damage to the surface, the image gives a clear idea of its initial elegance which, though diminished, is not obscured. The fingers of the right hand, the thumb of the left hand, the loop of hair from the head to the knot on the left shoulder and bits of drapery are

all replacements; the back of the image has been blackened and scorched by fire, at some time, and a large cavity has been burned into the base near the right buttock.

The irregularly shaped base upon which the figure sits offers the most significant clue to its specific identity. Its sides are grooved, in random patterns, to create a rustic effect. It is the rocky ledge of the Bodhisattva's mountain abode, Potala, from which place he beholds, with sublime compassion, the sufferings of all sentient beings. Various scriptures describe this mountain paradise, originally thought to have been located on an island south of India and later identified with certain sites in South India, China and Japan. The Chinese pilgrim Hsüan-ts'ang (ca. A.D. 596–664) located Potala in South India and described it as a land of "dangerous mountain paths and precipitous cliffs hanging over craggy gorges."[4] Other accounts cite the glorious palaces and lakes at the summit where water flows from many springs and rivulets and the heavy perfume of flowers and trees, growing in abundance, fills the air. The Gandavyūha section of the *Avatamsaka (Hua Yen) Sūtra* relates the visit of the boy-pilgrim Sudhana to Potala, where he wandered in search of perfect truth and heard the sūtra expounded, on the western slope of the mountain, by the Great Bodhisattva himself.[5]

Devotion to Kuan-yin, enthroned on his mountain paradise, was especially widespread in China during the twelfth and thirteenth centuries and it was this aspect of Kuan-yin that was most favored by donors of images and, therefore, by image-makers at that time. Originally, public temple images, like the Gallery's example, were installed on elaborate bases the intricate carving of which defined the rocky topography of the locale. The rockeries often extended beside and over the image forming a kind of grotto. The wall behind the carving was usually covered with brightly colored painting representing the landscape of Potala with its flowing rivulets and lush vegetation. The overall effect was one of an intense and affecting naturalism. The descriptive detail and elaboration of form in the setting provided an effective foil for the broad planes and soft rounded modeling of the figure itself, and enhanced, on the one hand, the effect of dignity and poise in the person of the Bodhisattva and generated, on the other, the clear impression of the Bodhisattva's imminent movement into action. The stunning combination, in the entire ensemble, of specific naturalistic effect with an abstract reduction of form, bonded to symbolic reference, realizes, in measured terms, the essential ideal of the Bodhisattva as the perfect Being who brings together the immutability of the Divine and the transitory nature of the world. The image and its setting recall, as well, the experience of Sudhana at the climax of his search for truth, and transform each worshipper into a pilgrim at the high point of his pilgrimage.

The image in the Gallery's collection, with its gentle harmonies of form in the treatment of anatomy, physiognomy, finely detailed garments and ornamentation belongs to a group of wood sculptures, mostly monumental and illustrating the same theme, produced during the Southern Sung Period (A.D. 1127–1279) or in the northern parts of China under the roughly contemporary rule of the Chin (A.D. 1115–1234).[6] The style derives ultimately from the prototypes of T'ang date (A.D. 618–906) and in many respects the classic formulae are conventionally repeated. But the classic conventions are subsumed within an animation of detail, sometimes mannered, that imparts to the form an effect of pent-up energy and arrested motion. These images share specific form qualities as well: the head is oversize and the face is oval with squared jaws; the hair falling to the shoulders is fixed in a knot before it divides into three separate strands trailing over the shoulder; details of garment, scarves and jewelry are defined, in most of these examples, by long easy sweeps of contour and the surfaces are plastically modulated; descriptive details are deeply carved and undercut at the edges of their shapes and the intermediary planes are simplified; ornamental data is reduced, in most instances, to an elegant minimum.

The sculptures of this group are variously dated "Sung" or "Chin" but definitive criteria for the dating have never been established. An important key to the chronology of these sculptures is provided by a wooden image of Kuan-yin, standing, in the collection of the Metropolitan Museum of Art.[7] It carries all of the style characteristics cited above and is inscribed, on the inside of a removable back panel, with a date corresponding to May 28, 1282, at the very beginning of rule of the Yüan Dynasty (A.D. 1279–1368). But a fragment of a large wooden Kuan-yin on Mt. Potala, in the Nelson Gallery of Art,[8] has the more rounded, even oval, face and long torso of the Rochester example; it shares, as well, the pronounced definition of the contours of neck, pectorals and belly, in deeply carved arcs. The Nelson Gallery fragment may be dated around A.D. 1200 and the Art Gallery's image should be placed somewhere in the three or four decades that follow.

The polychromed wood image of Kuan-yin on Mt. Potala in the Art Gallery's collection, through its technical perfection, pervasive beauty and engaging nobility, offers ample and persuasive proof that the manufacture of extraordinary Buddhist sculpture in wood was still flourishing in the later decades of Sung rule in China.

1. The name is later shortened to "Kuan-yin," which A. C. Soper renders as the "Heeded Voice"; A. C. Soper, *Literary Evidence for Early Buddhist Art in China,* Artibus Asiae Supplementum XIX, Ascona, 1959, p. 158.

2. H. Kern (tr.), *The Saddharma-Pundarika (Sacred Books of the East)* XXI, Oxford, 1884, chapter 24.

3. The images that have survived provide a small sample when one considers the enormous production of Buddhist imagery, of all types, that has been obliterated by persecution, official suppression, fire, and the ravages of nature and time. Still, this small sample provides an important clue to the principal foci of religious devotion in the period represented by it.

4. S. Beal (tr.), *Siyuki: Buddhist Records of the Western World,* New York, 1968, vol. 2, p. 233.

5. J. Fontein, *The Pilgrimage of Sudhana: A Study of the Gandavyūha Illustration in China, Japan and Java,* The Hague, 1967, p. 10.

6. O. Sirén, *Chinese Sculpture from the Fifth to the Fourteenth Century,* New York, 1925, vol. 4, plates 588, 590, 591; J. Fontein and P. Pal, *Museum of Fine Arts, Boston: Oriental Art,* Greenwich, 1969, fig. 64, p. 178; L. Sickman and A. C. Soper, *The Art and Architecture of China,* Baltimore, 1960, plates 79, 80A; A. Priest, *Chinese Sculpture in the Metropolitan Museum of Art,* New York, 1944, no. 66.

7. S. Lee and W-K. Ho, *Chinese Art under the Mongols,* Cleveland, 1968, no. 3.

8. D. Jenkins, *Masterworks in Wood: China and Japan,* Portland, 1976, pp. 44, 45, no. 13.

PROVENANCE:
Ralph M. Chait, New York (dealer).

LITERATURE:
Diran Kavork Dohanian, "The Bodhisattva Kuan-Yin on Mt. Potala," *Porticus* 5 (1982), pp. 31-35, ill.
Editor's note: Reprinted here with author's permission. This article was published when the Gallery used the Wade-Giles system of romanization. All references now use the pinyin system which accounts for the discrepancies in spelling.

The Sun God with Attendants, ca. A.D. 600
Buff sandstone, h. 45¾", w. 23", d. 7⅞"
Marion Stratton Gould Fund, 82.48

This impressive sculpture represents the Hindu solar deity Sūrya and his two attendants, Daṇḍi and Piṅgala. As is usually the case in such images, the principal figure is proportionately much larger than the acolytes. The divinity of all three figures, however, is emphasized by the halo behind each. The sculpture may have graced the main shrine of a temple of the sun god, or it may have once adorned a subsidiary niche of a temple dedicated to some other deity.

Although Sūrya was worshiped in India as an abstract deity by the Indo-Europeans (known as Aryans) at least by 1500 B.C. if not earlier, the earliest surviving images of the god date only from the second century B.C. The triad represented in this composition is of an even later date and rarely appears before the fourth century A.D. The figure of Sūrya, however, dressed characteristically in a long tunic or coat of mail, loose trousers or pajamas, and boots, made its appearance in the northwestern region of the country by the second century of the Christian era. Because he is dressed in the Scythian or Central Asian attire, the image is considered to reflect Iranian influence. Subsequently, when he was given two companions, they, too, were clad in the Scythian mode like their master. In this instance, while Sūrya wears a cylindrical crown, the attendants, in fact, wear Phrygian caps.

As is customary in such compositions, Sūrya invariably stands firm and erect whereas the attendants are animated figures as they stand in strong contrapposto postures. The slightly corpulent figure of Piṅgala on Sūrya's right is busy with an inkpot and pen, thereby making him a bookkeeper, while Daṇḍi, with unsheathed sword, is obviously the divine guardian. Sūrya himself holds two bunches of lotus flowers. A ubiquitous symbol in Indian civilization, the lotus was considered to be particularly appropriate for the sun god as it blossoms daily with the rising sun and closes its petals each evening as the sun sets.

Although the sculpture was probably created in the seventh century, it still exhibits the simplicity and elegance that are characteristics of sculpture of the Gupta period (ca. A.D. 320–600). The hieratic frontality of the image notwithstanding, the figures appear to be modeled in the round. Unlike most such compositions, the backslab has been almost completely cut away except for a shallow support behind the feet. This surrounding space allows the viewer to appreciate better the subtle modeling of the forms as well as the smooth, flowing contours. The ornaments and articles of clothing are not allowed to interfere with the forms. In addition to the naturalistically rendered flowers in Sūrya's hands and the lively postures of the acolytes, the stylish delineation of Sūrya's scarf is another detail that reveals the unknown master sculptor's concern with infusing his composition with a sense of rhythmic movement.

PP

PROVENANCE:
Nasli and Alice Heeramaneck, 1971; Pan-Asian Collection, 1971–1980; Robert Hatfield Ellsworth, 1980–1981?.

EXHIBITIONS:
Los Angeles County Museum of Art (circulated), *The Sensuous Immortals,* 1977–1979, pp. 38-39.

INDIAN, KOTAH, RAJASTHAN

Shiva, Ardhanārishvara, ca. 1750–1775
Tempera on paper or opaque watercolor on paper, 10 x 5 ¾ ″
Marion Stratton Gould Fund, 80.44

PROVENANCE:
Alan J. Abrams, San Geronimo, CA (dealer).

EXHIBITIONS:
Philadelphia Museum of Art, *Manifestations of Shiva,* 1981, no. P-7, p. 167, ill.

LITERATURE:
Diran Kavork Dohanian, "An Unusual Kotah Painting of Shiva, Ardhanārishvara," *Porticus* 4 (1981), pp. 31-34, ill.
Editor's note: Reprinted with the author's permission.

The Memorial Art Gallery has recently acquired an extraordinary Indian painting which has as its theme a festal celebration in honor of the Hindu God Shiva, Ardhanārishvara.[1] The painting is small in scale; it was commissioned by a noble patron, from the princely state of Kotah in eastern Rajasthan, as an album picture intended for private pleasure and edification. Yet, it treats a theme of enormous theological proportions and makes it cohere with an intimacy of scale and painterly touch.

The Great God, Shiva, according to Hindu mythology, manifests himself in a limitless variety of guises according to the needs of his devotees and the demands of his own fancy. In a rich multiplicity of appearances, he comprehends and resolves all of the dichotomies and contradictions of Being: Life/Death, Creation/Destruction, Male/Female, Ascetic/Erotic. His essential and fundamental image is the phallic column (Linga) in which he is comprehended as the axis of Existence and, through the form of the excited sexual organ, as the embodiment of the dynamic energies that determine and transcend Life. One of the most seductive of his enigmatic shapes is that of the primordial androgyne, Ardhanārishvara, The Lord Whose Half is Woman,[2] in which he embodies the pristine condition of Godhead before Creation. Male and female forms, conjoined in a single organism, enunciate the *original* integrity of creative power. Self-existent and potentially active, the bi-unity of the androgyne depicts that comprehensive and pure quality of God before, and apart from, Creation. Prior to the characterization of male and female and, through them, the whole of existence, God *is* Ardhanārishvara: Male and Female indivisibly united. The image of Ardhanārishvara is a perfect and complete epiphany.

The Gallery's painting represents Ardhanārishvara as the center of the Cosmos, celebrated by gods and men and, in fact, by all of Nature. He is seen seated at the summit of a mountain which rises from waters where elephants frolic. The god is four-armed and nimbate, and is seated beneath the spreading branches of a fig tree on a spread which is half tiger-skin and half lotus. In front of him is Nandin, the bull emblem of Shiva, and to one side, resting on the roots of the tree, is a white animal with a pointed muzzle, green wings, and a long spotted tail.[3] Birds and a monkey settle happily in the verdant branches of the fig, and in the lake below, lotuses grow and waterfowl swim in pairs. To the right, above a landscape of rolling hills luxuriant with trees of many kinds, the heavens are active. Beneath a canopy of churning clouds, the Great Gods appear: Vishnu (with blue skin), Brahma (with four faces), and Shiva, Vīnādhara (The Lord of Music). Above them, Garuda (Vishnu's eagle) and devas in aerial cars sprinkle flower petals and garlands in worship of Ardhanārishvara. On the ground below, acrobats perform to the accompaniment of horns, flute, and drum. The performers are garbed in courtly attire, except for two acrobats who have stripped to their shorts. The performance, moreover, is at its climax. A strong man is shown balancing, with the hilt in his mouth, a broad sword on the point of which his partner, formally dressed and with arms outstretched, strikes a theatrical pose. The celebration, in which all Creation takes part, is in wondrous response to the revelation (darshan) of God in Ardhanārishvara.

But that is not the whole story. The lake below, the columnar mountain, and the large tree beneath which the god sits, all carry generally understood symbolic references: the infra-cosmic waters, the World-mountain, the Cosmic tree. The natural setting has become the structured Universe, with Ardhanārishvara at its summit and center. In a characteristically Indian manner, symbolic references intermesh;

their meanings commingle and reinforce, as well as transmute, the essential significance of a common theme.

The same usage transforms the iconography of the god as well. Ardhanārishvara is conventionally represented as half-man, half-woman, with the body divided vertically.[4] On one side are the physical conformations, clothing, and jewelry of a male and, on the other, those of a female. In this example, the left side of the figure is male, dressed in a yellow dhoti and carrying the standard attributes of Shiva: the trident (trishula) held in the upper left hand and the tiger-skin on which the deity sits. The right half is female, dressed in a red sari and resting on a ground-cover of lotus-petals, a feature appropriate to the person of the goddess. The third eye, in the middle of the forehead, and the jatāmakuta (piled-up matted hair) are normally associated with Shiva, the Great Ascetic, and are shared, in this configuration, by male and female components. The same may be said for the serpent which is coiled around the jatāmakuta but which faces the male side.

But the left/right association of male/female, in this painting, is a departure from orthodox iconographic patterns in which the left side is, traditionally, female and the right, male. The goddess, when rendered as a separate symbolic form, is always placed to the left of the god of whom she is the counterpart, except in representations of the marriage of Shiva and Pārvatī (Kalyānasundara-mūrti), where the bride of Shiva is most frequently placed at his right.[5] What we have in the case of the Gallery's painting is evidence not so much of iconographic error as of the transformation and enrichment of the theme through the fusion of mythological incident. By reversing the relative placement of the male and female halves normal to the iconography of Ardhanārishvara, the painter has invested in its meaning (unity) the marriage (union) of Shiva and Pārvatī, taken from another myth. This may be the function, as well, of the gesture, patākāhasta, that the god makes with his hands held in front of his chest. In the language of dance,[6] in Orissa, this gesture signifies the Himalayas, of which Pārvatī, Daughter of the Mountain, is the offspring.[7]

In this painting, the theme of wonder and celebration is carried, as well, in its total visual effect. The rude vitality of the palette, in which reds, red-oranges, and mossy greens predominate, is softened by a consistent use of tonal gradation to modulate the broad definitions of shape. The imbrication of basic shapes to form effects of foliage and rock mass contributes to the whole painting a remarkable density of texture, and the regular magnification of significant detail invests it with the stunning lucidity of the super-real. It is in every way characteristic of the style and quality of Kotah painting in the third quarter of the eighteenth century, and it may have been produced in a workshop at court during the opening years of the reign of the child rajah, Maharao Umed Singh (1771–1819).

1. S. Kramrisch, *Manifestations of Shiva,* Philadelphia, 1981, p. 167. North Indian paintings of Shaiva themes are relatively rare, especially when compared with the production of pictures derived from the myth of Krishna.

2. T.A.G.Rao, *Elements of Hindu Iconography,* II, 1, p. 312f.

3. This fanciful beast is, apparently, a stand-in for the lion, the animal emblem normally associated with the goddess.

4. Rao, p. 323ff.

5. See, for example, H. Zimmer, *The Art of Indian Asia,* II, Kingsport, 1955, pl. 237.

6. E. Bhavnani, *The Dance in India,* Bombay, 1965, pp. 127, 129; Kramrisch, p. 167.

7. On the other hand, the fusion of the theme Ardhanārishvara with that of the union of Shiva/Pārvatī may simply be a reference to a version of the myth of Ardhanārishvara itself, in which Shiva manifests as the archetypal androgyne in response to the wish of Pārvatī for union in his body so that she might receive the worship of the sage, Bhringi, who had vowed to worship Shiva only. Cf. Rao, pp. 322–3.

Genzu Mandara: The Kongō-kai, ca. 1500
Ink and colors on paper, mounted on silk, 40⅞ x 32¾″
Marion Stratton Gould Fund, 79.51.1

Genzu Mandara: The Taizō-kai, ca. 1500
Ink and colors on paper, mounted on silk, 40⅞ x 32¾″
Marion Stratton Gould Fund, 79.51.2

The mandala is an image of comprehensive perfection. The strict order of its concentered patterns establishes its meanings within the range of human understanding. The complexity of its subdivisions implies universal reference and the geometric regularity of its composition defines a quality of being that is different from and beyond that of normal human experience. The mandala, originating in ancient India, is understood as a diagram of the ideal structure of the cosmos, and its essential association of concentered circles and squares forms the structural and symbolic basis for icon and shrine alike. Among Buddhists, it is one of the most ancient, and therefore one of the most hallowed, spiritually charged patterns; it is still in use today. As Buddhist doctrine and practice have spread beyond the boundaries of India, they have carried with them elemental forms of religious expression which have never been obscured, however much they have been transformed by local usage.

The mandala, as a system of order, is used to graph the relationships of component parts through reference to a common point or center, which integrates the whole. On the practical level, it helps to render the "true" nature of a component in the system by underscoring its relationship to all other components and to the coordinating center of the entire scheme. As a mathematically determined visual abstraction of the universe, it brings the infinity of the cosmos within the range of human understanding, and without distortion. It is useful, as a structured and comprehensive reference to the totality of existential phenomena, in defining the properly cosmic dimensions of existence as well as the specific finite character of any datum of it when perceived from the perspective of the whole. In practice, "mandala" almost always means "universe" and it is read as an image of the Absolute manifesting itself infinitely in the finite.

In Buddhist usage, the mandala interrelates the multiple phenomena and forces of existence through systematic reference to a central originating force, which is frequently imagined as a primordial Buddha, one who is distinct from the *historical* Buddha and from all other manifest beings. Though He is never manifest, He is constantly and continuously evident in every atom of the universe. This is the basic theme of every mandala with the image of Buddha at its center.

It is the principal theme of an extraordinary pair of Buddhist paintings, produced in Japan around the year 1500 A.D. and acquired by the Memorial Art Gallery in 1979. They were painted in gold and a full range of rich mineral color on silk[1] and constitute, together, a significant example of a type of religious painting that was introduced into Japan, along with the theologies and rituals of esoteric Buddhism, in the first decade of the ninth century. Though the paintings constitute a pair, the patterns of one do not mirror those of the other, however much they interact both formally and on the levels of meaning.

One of these is organized around a rectangular panel, centrally placed, which frames an eight-petalled lotus and is ornamented by an elaborate grid, painted in gold. In the precise center of the painting, set within the pollen-pad of the lotus, is the figure of a Buddha, seated on a lotus-throne in the posture of meditation. It is the largest figure in the painting. Around this Buddha is a circle of divinities, one within each of the eight petals of the lotus. At the cardinal points of the circle are the Dhyani Buddhas of the Four Directions: East, South, West, and North. The other petals hold images of four Great Bodhisattvas,[2] and from the intervals radiate eight vajras.[3] In each corner of the rectangle is a purna-ghata[4] capped by a vajra. This group of nine divinities and the eight-petalled lotus constitute a stan-

dard mandala in which the encircling figures are understood as projections of, or emanations from, the central one. It is the hub of the larger scheme of the panel.

Surrounding this system are the figures of hundreds of deities and mystical signs, each specifically characterized and of various stature. They are ranked in straight rows on either side of the central group, above and below, forming an intricate system of concentered rectangles and borders. Within this system, preeminent divinities are aligned along its major axes, vertical and diagonal, with the Buddha at its center. These are distinguished by measurement, or scale, and in some instances by the form of an arch, which sets the figures apart. All other figures are precisely scaled, in a descending order of size, according to their placement between center and periphery. The areas between the figures are filled with geometric patterns; the overall effect of the painting is one of an immense complexity of characterized form.

A mandala of this type is, perhaps, the most basic, as well as the most comprehensive, expression of esoteric Buddhist ideals. In the strict order of its concentered patterns and the harmony of its geometry, one can sense the equipoise and integrity the believer experiences as he approaches the psychological state of final enlightenment. The structured clarity of the mandala's composition serves to bring its theme, the absolute immanence of the Buddha in the cosmos, within the range of rational response. As a devotional instrument, its function is to coordinate the meditative or liturgical experience of the believer as he concentrates upon the theme in the pursuit of full enlightenment.[5]

The other painting in the pair is set out as a nine-part yantra,[6] with three rows of three rectangles each, culminating in the image of a Buddha in the central panel of the uppermost row. In this panel, the Buddha sits, within a circle of light, in the meditative posture upon a lotus-throne and gestures the distinctive esoteric mudrā, jnāna-mushti (wisdom-fist), in which the fingers and thumb of the right hand enclose the index finger of the left.[7] The Buddha-figure fills the panel; purna-ghatas in each corner, a geometric grid, and wide ornamental borders complete the representation.

Seven of the other panels hold mandalas, made up of quinary groupings of deities or mystical signs, and the last repeats the format of the nine-part yantra. The six panels in the two lower ranks each hold mandalas made up of mandalas in a systematic telescoping of the basic quinary structure. If "mandala," in practical terms, means "universe," then mandalas of mandalas establish a perspective of the universal that goes beyond the range of rational containment. This is the point of the painting, and in this it differs from its counterpart in the pair, for it posits, for the observer, not only an extraordinary point of view but also a qualitatively distinct sense of the theme of the Buddha's immanence in every atom of the universe. As it differs from its counterpart, it corrects and completes it (as esoteric theology corrects and completes revealed teaching), and it prompts the believer to see the companion painting in radically specified terms.

This pair of painted icons repeats, quite strictly, the appearance and format of a celebrated pair which was painted in China during the year 805 A.D. for the Japanese monk Kūkai (Kōbō Daishi), who had accompanied a diplomatic mission to the Chinese court and had remained to study, under the tutelage of the Chinese theologian, Hui-kuo (746–805), the secret doctrines of the esoteric Buddhist sect, Chen-yen. A year after Hui-kuo's death, Kūkai carried this double icon, together with the doctrines it expressed, to Japan and established there a community of Buddhists devoted to the new theology, Shingon.[8]

The icon became known in Japan as the Genzu Mandara, the Mandala of the Double-Realm. Its component parts are renderings of the Taizō-kai (Matrix or Womb field) and the Kongō-kai (Adamantine field) as laid down in the principal scriptures of the Shingon sect, the *Dainichi-kyō* and the *Kongō-cho-kyō*. The dominating motif in scripture and mandala is the figure of the primordial Buddha, identified by Shingon Buddhists as Dainichi (Mahāvairochana), the Great Light.

From Kūkai's time onward, the Genzu Mandara, as a type, was the principal icon of Shingon Buddhists and was repeated not only as painting, but also as sculpture and architecture whenever and wherever Shingon practice and ritual required its use. The Mandala brought to Japan by Kūkai rapidly acquired an extraordinary authority for all of the usual historical reasons. It was copied repeatedly[9] in a standard Buddhist effort to disseminate its authority, and it established a basis for the transformation of Buddhist painting in Japan. The copies were not, strictly speaking, reproductions of the original: some of the most celebrated of them were painted in fluid gold and silver on deep-blue or purple cloth, whereas Kūkai's pair was understood to have been painted in full color, as is the case with the Gallery's pair.

The Gallery's double-mandala, however, ought not to be regarded simply as a copy of an ancient work; it ought to be thought of as a reconstitution, at a later time, of a special iconic type whose origins go back to the hallowed example brought to Japan from China very early in the ninth century. It carries the authority of Kūkai's original through the inescapable historical references it makes, both in coloristic effect and in iconographic format.

The Genzu Mandara, as a distinct iconographical type, takes the theme of the relationship between manifest forms and originating energies and enhances it geometrically. In this scheme, two systems of order are defined: one, in which the component parts of a universal system are integrated by the central figure of Dainichi, the radiant source of every datum of Creation, and another, in which constellations of universes cohere within a grid of nine spaces. In this system, the dominant figure is also that of Dainichi, placed at its summit.

The diagram of the Taizō-kai is a mandala which comprises the realm of *manifest* beings, forces, and things. The Kongō-kai presents constellations of mandalas, understood to be infinite in number, which comprise the realm of *unmanifest* essential energies that are the causes of the manifest beings, forces, and things schematized in the other painting. One system of order and its meanings can be understood fully only in relation to the other; together, they underscore the all-pervasive presence, originally and ultimately, of Dainichi.

The Genzu Mandara elaborates, up to the limit of human comprehension, the essential Buddhist understanding that for every effect there is a cause and that spiritual liberation comes from the perfect realization of that fact. In ritual use, the double mandala aids the worshiper in the attainment of this goal.[10] Through the very *form* of art and by the direct appeal of its colors and shapes, abstruse and complex theologies are brought to bear upon the consciousness of the believer. Kūkai expressed this idea in the following comment ascribed to him:

> In truth, the esoteric doctrines are so profound as to defy their enunciation in words. With the help of painting, however, their obscurities may be understood. . . . the secrets of the sūtras and commentaries can be depicted in art, and the essential truths of the esoteric teaching are all set forth in it. Neither teachers nor students can dispense with it. Art is what reveals to us the state of perfection.[11]

In effect, the force of the Gallery's Mandala of the Double-Realm lies not so much in its capacity to reflect a complicated and abstruse theology as in its power to move even the unbelieving by the ravishing subtlety of its colors, the exquisite beauty of its patterns, and the contagious harmonies of its layout. It reveals to us the state and character of perfection.

1. The paintings, from a Buddhist temple, were purchased from Merlin and Mary Ann Dailey (East-West Shop, Victor, New York), who acquired them from an art dealer in Kyoto. The fabric for each painting is made up of two strips of silk, one twice as wide as the other, pieced together.

2. These represent the practices leading to full enlightenment.

3. The adamantine or immutable weapon. It is the preeminent emblem of esoteric Buddhism.

4. The overflowing vase. It is a symbol of vitality.

5. Monks were trained to know every detail of the mandala, the names and symbols of each deity shown, and the reasons for its inclusion and placement in the scheme. In public ceremonials, the mandala was among a large number of liturgical devices which would structure and modulate collective worship.

6. Literally "instrument," the yantra is a spiritually-charged diagrammatic schema, as ancient as the mandala whose concentered patterns it incorporates. As in the other banner, the original squares of the pattern have been transmuted into rectangles, probably in response to the habit of seeing as rectangles "pictures" mounted as hanging scrolls. It is a clear sign of the "late" date of these paintings.

7. This mudrā encompasses a wide range of specific meanings which coalesce within the understanding that the primordial Wisdom interacts with varied kinds of knowledge and subsumes them within its fundamental unity. It is the thematic key to the grand significance of the paintings taken together. It is also the identifying mudrā of Dainichi (Mahāvairochana).

8. "True Words."

9. Cf. L. Chandra, *The Esoteric Iconography of Japanese Mandalas,* New Delhi, 1971, pp. 11–14; T. Sawa, *Art in Esoteric Japanese Buddhism,* New York and Tokyo, 1972, p.94.

10. In worship halls, the two parts of the mandala were often hung facing one another on the eastern and western walls, or on either side of the principal icon, the Kongō-kai to the left and the Taizō-kai to the right. Before each painting was placed a large square platform, laid out, mandala-fashion, with the vast array of liturgical implements, flowers, and incense appropriate to the worship of the deities selected.

11. From the "Memorial on the Presentation of the List of Newly Imported Sūtras" as quoted in S. Moriyama, ed., *Kōbō Daishi Den,* Tokyo, 1934, p. 249; R. Tsunoda, *Sources of Japanese Tradition,* New York, 1960, p. 142. Kūkai is simply reaffirming, in a Buddhist context, a standard contemporary Chinese attitude toward *painting,* i.e., that painting makes things "appear real" with an immediacy that is beyond the range of verbal communication.

PROVENANCE:
Dealer in Kyoto, Japan; East-West Shop, Victor, NY.

LITERATURE:
Diran Kavork Dohanian, "Genzu Mandara: The Mandala of the Double-Realm," *Porticus* 4 (1981), pp. 24–30, ill.
Editor's note: Reprinted with the author's permission.

CENTRAL ASIA, ORDOS, 3RD–1ST CENTURY B.C.

Harness Ornament with Two Ibexes
Cast, pierced, and gilt bronze, 3⅞ x 3½"
Marion Stratton Gould Fund, 73.66

CHINESE, EARLY WESTERN ZHOU PERIOD,
CA. 1066–770 B.C.

Ceremonial Food Vessel (Gui), 11th–early 10th century B.C.
Bronze, 5⅝ x 10⅛ x 7½"
R. T. Miller Fund, 42.15

CHINESE, TANG DYNASTY (A.D. 618–907)

Horse and Rider, 8th century A.D.
Terracotta with polychrome, 11¾ x 14¾ x 5¼"
Gift of Ronni Solbert in memory of her mother, Mrs. Oscar Solbert, 73.22

CHA SHIBIAO
CHINESE, 1615–1698

Autumn Landscape
Ink on paper, mounted on a scroll, 50¾ x 25⅜″
Marion Stratton Gould Fund, 64.6

INDIAN, KASHMIR

The Bodhisattva Avalokitésvara, ca. A.D. 1000
Bronze, 7 x 3 x 1⅜″
Purchased through the Charles A. Dewey Fund and with the gift
of Diran Kavork Dohanian, 84.66

NORTH CENTRAL INDIAN, 10TH–12TH CENTURY

Nārāyana-Sūrya-Śhiva
Red sandstone, 22⅜ x 15¾ x 9⅜″
R. T. Miller Bequest, 61.12

INDIAN (BIHAR, NĀLANDĀ), PĀLA PERIOD,
CA. A.D. 750–1161

Tārā, 12th century
Black chlorite, 31½ x 17 x 9⅜″
R. T. Miller Fund, 61.13

INDIAN, PAHĀRI SCHOOL

Śhiva Accompanying Rāma and Sitā back to the Court of Ayodhya, ca. 1850–1900
Gouache on paper, 10⅜ x 16½″
Gift of Helen H. Reiff in memory of Robert F. Reiff, 83.55

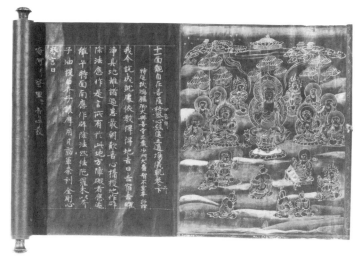

JAPANESE, EDO PERIOD, GENROKU ERA
(1688–1704)

Four-Tiered Imari Ware Food Container
Porcelain with overglaze enamels, diam. 9¼ x 8⅞ "
Mary Greer Potter Memorial Fund, 81.37

THAI, AYUDHYA PERIOD, 1350–1757

Head of a Buddha
Bronze, 12½ x 8¼ x 8½ "
Gift of James Sibley Watson, 30.33

ANDO HIROSHIGE

Japanese, 1797–1858
Evening Rain at Akabane, ca. 1839–1840
Colored woodcut, 9¾ x 14¹⁵⁄₁₆ "
Gift of Dr. James B. Austin, 87.34.2

THAI, BAN CHIENG, 4500–3000 B.C.

Vessel with Red Linear Decoration
Terracotta, diam. 8¾ x 6¾ "
Marion Stratton Gould Fund, 73.67

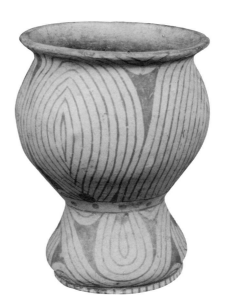

Manuscript of the "Khamsa" ("Quintet") by Nizam ad-Din Ilyas ben Yusuf, called Nizami, (1140/41–1209)
Tempera on gilt paper, 12⅛ x 7″
R. T. Miller Fund, 51.16

Plate
Painted and glazed terracotta, diam. 12″
Marion Stratton Gould Fund, 79.91

CONTENTS

AMERICAN ART

Contents

AMERICAN ART 1765–1900

American, 1738–1820
Study for Christ Rejected, 1811
Oil on paper mounted on panel, 30⅞ x 42⅛"
Signed and dated bottom center: *B. West July 15th 1811*
Marion Stratton Gould Fund, 64.59

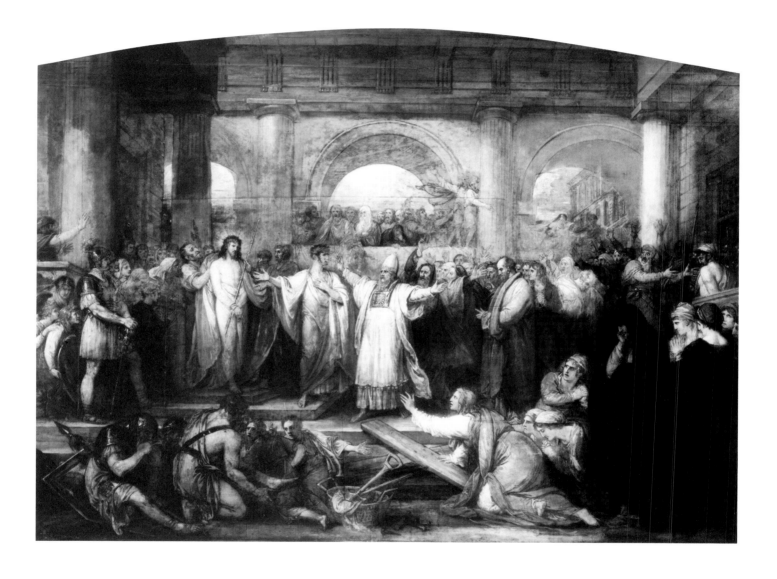

In September 1771 Benjamin West, having gone abroad to study at first hand art's great traditions, wrote from London to a friend in his native Philadelphia: "I have embarked in Historical painting—by which means I have removed that long received opinion that that was a department in the art that never would be encouraged in this Kingdom. But I can say I have been so far successful in it that I find my pictures sell for a price that no living artist ever received before."[1] Indeed, West's early efforts at large-scale paintings of classical and biblical scenes brought him immediate praise from London's leading painters and critics, a prominent place in a profession then dominated by the French, and the eventual patronage of the Anglican church and the British Crown. By 1792 West was a commanding force in the art world, serving as president of the Royal Academy of Arts and as master to two generations of aspiring history painters, British and American alike.

In a career marked by overwhelming successes in the realm of history painting—from his depiction of a contemporary subject, *The Death of General Wolfe,* painted in 1771 for George III, to his *Death on the Pale Horse,* from the Book of Revelation, painted more than forty years later—West's *Christ Rejected by the Jews* of 1814 stands out as one of his greatest public and commercial enterprises. It was produced in the last decade of the artist's life as one of a sequence of three monumental religious pictures, intended as elaborate "visual sermons" that might elevate both the moral estate and the aesthetic acumen of a large audience.[2] To that end, the finished picture (Pennsylvania Academy of the Fine Arts, Philadelphia) was put on public display in an elaborate installation in royal rooms in Pall Mall, where more than 240,000 paying visitors reportedly viewed it between June 1814 and November 1817.[3]

It was the promise of such commercial and popular success that led West in 1811 to make his ambitious plan of bringing together all of the events and characters of the last days of Christ in a single "Epic composition."[4] But the complexity of the subject required the artist first to lay out the design in detail, as he did in this oil sketch painted in July of that year. The highly finished study, comprised of sheets of paper pieced together, reveals how the composition was enlarged and altered, underscoring the important role that draftsmanship played in Neoclassical painting.

The subject, as it was described in the 1814 exhibition catalogue, is "Christ Rejected by the Jewish Priest, the Elders, and the People when brought to them by Pilate from the Judgement Hall."[5] West's image is a conflation of events related in the texts of the four Gospels. The setting was necessarily a great classical hall, according to the catalogue, representative of "Roman magnificence wherever they had established imperial sway."[6] Included in the composition are Roman soldiers, at left; Christ, Pilate, and a gesticulating Caiaphas, at center; the mournful Peter, to the right of the high priest; the Virgin Mary, supported by St. John, at lower right; and Mary Magdalene, who kneels upon the cross, at bottom center.

West had a high regard for his preparatory sketches for the late scriptural pictures and exhibited many of them alongside the large, finished canvases. This small *Study for Christ Rejected* was shown at least once, in 1815, at the Royal Academy, where it was critically acclaimed as "decidedly superior to the picture itself," then on view in Pall Mall.[7] Such a comment suggests the conceptual and technical differences that can be seen in the two works. Although West, a master draftsman, produced the beautifully drawn study, the finished painting was apparently sketched in by the artist's son Raphael, who left the rest of the canvas for his father "to fill up agreeably to His own ideas."[8]

West's skill in rendering the human figure and drapery through firm contour drawing and in creating clear but complex spatial relationships even on a small scale is certainly evident in the oil study. That compositional clarity, so impressive in the sketch, was to some degree compromised in the final painting. As one contemporary viewer noted of the additions to the large work, West "found it necessary to introduce more objects in order to fill up and give interest. Upon a small scale there did not seem to be want of them, but upon a large scale it was necessary."[9] A viewer in 1815 described this sketch as the one picture in the Academy's annual exhibition possessing "the true quality of art...that comprehensiveness and completeness which is found in the work of the great masters."[10]

PJ

1. West to John Green, Philadelphia, September 1771, quoted in Alberts, *Benjamin West,* p. 99.

2. Von Erffa and Staley, *Paintings,* p. 146.

3. Ibid., p. 359.

4. This description comes from the 1814 exhibition catalogue, quoted in ibid., p.359.

5. Quoted in ibid., p. 358.

6. Quoted in ibid.

7. Quoted in ibid., p. 361.

8. Quoted in ibid., p. 144.

9. Joseph Farrington to West, quoted in ibid., p. 360.

10. Sir George Beaumont, quoted by Joseph Farrington in his *Diary* for June 5, 1815; cited in ibid., p. 361.

PROVENANCE:
John Bligh (1767–1831), Fourth Earl of Darnley, Cobham Hall, Surrey, by 1824; by descent to the Eighth Earl, by whom sold through Christie's London, May 1, 1925, lot 90; Appleby Brothers, London, 1957; John Nicholson Gallery, New York, 1961–1963; to Vose Galleries of Boston, Inc., 1963.

LITERATURE:
Joseph Farrington, *The Diary of Joseph Farrington,* 16 vols., vols. 1-4, ed. Kenneth Garlick and Angus Macintyre, vols. 7-16, ed. Kathryn Cave, New Haven, 1978– , vol. 11, p. 4035 (November 21, 1811), vol. 12, p. 4161 (July 22, 1812), vol. 13, p. 4638 (June 5, 1815); John Galt, *The Life and Works of Benjamin West, Esq., President of the Royal Academy of London, Subsequent to his Arrival in this Country; Composed from Materials Furnished by Himself . . . Part 2,* London, 1820, p. 234; "Press Cuttings from English Newspapers on Matters of Artistic Interest, 1635–1835," scrapbook, Victoria and Albert Museum Library, London, vol. 4, pp. 924, 939, 949; *Burlington Magazine* 99 (December 1957), p. iv (advertisement); *Art Quarterly* 24 (winter 1961), n.p. (advertisement); John Dillenberger, *Benjamin West: The Context of His Life's Work, with Particular Attention to Paintings with Religious Subject Matter . . . ,* San Antonio, TX, 1977, p. 118, pl. 80; Robert C. Alberts, *Benjamin West: A Biography,* Boston, 1978, pp. 355, 359; Helmut von Erffa and Allen Staley, *The Paintings of Benjamin West,* New Haven, 1986, no. 354, pp. 142, 145, 360-361.

EXHIBITIONS:
Royal Academy of Arts, London, 1815, no. 110; British Institution, London, 1824, no. 161; Des Moines (IA) Art Center (extended loan), 1967; National Portrait Gallery, Smithsonian Institution, Washington, DC, and Pennsylvania Academy of the Fine Arts, Philadelphia, *Benjamin West and His American Students,* 1980, pp. 19, 21, 68, 98, 135, 163 (related work).

AMMI PHILLIPS

American, 1788–1865
Old Woman with a Bible, ca. 1834
Oil on linen, 33½ x 28″
Beatrice M. Padelford Trust, 84.22

Old Woman with a Bible by Ammi Phillips is a recent addition to the growing number of Phillips's works discovered since 1960, when the identity of this itinerant portraitist was first established by Barbara and Lawrence Holdridge.[1] Nothing is known of the painting's history, but attribution to Phillips is easily made on stylistic and technical grounds, and the painting can be placed securely within Phillips's career by comparison with his other works.[2] The portrait was found in western New York, but it clearly belongs to the body of work Phillips produced in a region along the New York-Connecticut border in the 1830s. There Phillips painted a large number of portraits, all distinctive for their abstraction and stylization, as seen in this example in the broad flat areas of highly contrasting color and the sharply defined contour of the sitter's profile.

Phillips worked in the so-called Border Country of New York, Connecticut, and Massachusetts throughout his long career. Although more than four hundred likenesses of many of that region's most prominent residents can now be attributed to Phillips, the artist slipped into obscurity after his death in 1865, as photography set a new standard for realism and rendered the itinerant portraitist's enterprise obsolete. Phillips was not rediscovered until the 1930s, when interest in the abstract and seemingly "modern" qualities of American naive painting was aroused by twentieth-century artists, scholars, and collectors.

Certain of the artist's conventions are evident in this portrait. The decorative embroidered braid, for instance, which outlines the woman's shawl, was one of his favorite devices after 1820, when he began to appropriate details from academic portraiture of the period. As in other examples of Phillips's work from the 1830s, sharp color contrasts draw attention to the subject's face and to beautiful details of her costume. The luminous pink of the woman's face and hands and the brilliant white of her day cap and collar are set off against a rich brown background and are highlighted, as one historian has written, "as jewels are displayed on dark velvet."[3] Among the most distinctive features of the portrait are the crisp pleats of the subject's bonnet and taut curl of the tie beneath her chin, elements painted with the precision and economy of means that are Phillips's hallmarks.

PJ

1. The Holdridges first published their research in "Ammi Phillips," *Art in America* 47, no. 2 (summer 1960), pp. 93-103. Subsequently they collaborated with Mary Black to provide what is the most extensive study of the artist to date, *Ammi Phillips: Portrait Painter, 1788–1865,* New York, 1969, published in conjunction with a retrospective exhibition at the Museum of American Folk Art, New York.

2. The painting was purchased from a Caledonia, NY, antiques dealer, who did not provide information on the portrait's history.

3. Black, *Ammi Phillips,* p. 14.

PROVENANCE:
Caledonia, NY, antiques dealer, 1983.

LITERATURE:
Patricia Anderson, "Ammi Phillips's *Old Woman with a Bible*: Expanding the Definition of American Naive Art," *Porticus* 8 (1985), pp. 26-35, ill. p. 26.

LILLY MARTIN SPENCER
(NÉE ANGÉLIQUE MARIE MARTIN)

American (b. England, of French parents), 1822–1902
Peeling Onions, ca. 1852
Oil on canvas, 36 x 29″
Gift of the Women's Council in celebration of the 75th anniversary of the
Memorial Art Gallery, 88.6

As a wife and a mother as well as an artist, Lilly Martin Spencer was particularly suited to painting the "maternal, infantine, and feminine expressions" so popular with the American art-buying public from the middle of the nineteenth century onward.[1] Her domestic genre scenes appealed to a wide audience, embodying many of the distinctive qualities embraced by the nineteenth century: the sweetness of family life, the beauty of humble things, and the joyful discovery of humor and vitality in the everyday world.

Peeling Onions represents a favorite subject of the artist: the young housewife carefully and agreeably tending to her daily domestic chores. In this example the young woman is preparing a stew. She works at a table laden with fruits, vegetables, a chicken, and kitchen utensils, slicing an onion so pungent it has brought tears to her eyes. She pauses in her work to wipe the tears away.

The appeal of the anecdotal kitchen picture to both the artist and her audience is suggested by the large number of similar scenes in Spencer's work at mid-century. They include *Shake Hands?*, of 1854 (Ohio Historical Society, Columbus), a picture of a young woman kneading bread who teases the viewer with her outstretched, flour-covered hand, and *Kiss Me and You'll Kiss the 'Lasses*, of 1856 (Brooklyn Museum), a humorous portrayal of a young wife stirring molasses on the stove and coyly avoiding the advances of her unseen husband. *Peeling Onions* is the subject of at least two other known works executed during this period, including a finished drawing of the same title (Munson-Williams-Proctor Institute, Museum of Art, Utica, NY) and *The Young Wife: The First Stew*, of 1856 (unlocated).[2]

Spencer's distinctive flair for combining expressive elements of still life and genre painting is revealed in these kitchen pictures. With *Peeling Onions*, for instance, the viewer comes to understand and appreciate the subject's action and emotion through the picture's telling details, all beautifully rendered. Contemporary critics hailed Spencer's obviously careful technique, demonstrated by her meticulously painted kitchen interiors, even when they derided the artist's popular subject matter. Accessibility and immediacy—values that middle class patrons cherished in their art—were served well by Spencer's highly illusionistic style, the effect of which has been described by art historian Joshua Taylor: "The wince of grief from the onion destroys artistic distance as surely as the illusionistic painted spoon projecting from the canvas.... [Spencer] gave vitality ... to commonly known American things, whether fashionable or humble. She helped to maintain the public's myth of its own humor and goodness, but to these she added her own strong belief in the simple pleasures of seeing and touching, and of inhabiting a world of people and personable things."[3]

Spencer's commercial success and artistic achievement in her own day attest to the unusual circumstances of the woman's life. The daughter of a progressive French émigré educator and utopian philosopher, the young Lilly Martin demonstrated remarkable natural talent at an early age and was encouraged in her artistic ambitions by enlightened parents. When she was just eighteen, her enterprising father took Lilly from the family's Marietta, Ohio, home to Cincinnati, where he devoted himself to guiding the girl's budding career as a portraitist and painter of decorative romantic "fancy pictures." Encouraged by early success, the self-taught painter moved in 1848 to the art capital of New York, where she received her only formal training in drawing, at the National Academy of Design. Without compromising her long and productive career, Spencer married in 1844 and eventually bore thirteen children, seven of whom lived to maturity. Indeed, the artist's large family and her busy household became the stuff of her art.

Spencer's anecdotal and descriptive painting style was influenced both by the artist's direct contact with examples of American and European genre art and by her era's general taste for story-telling pictures. Her first mentor was Cincinnati portrait and narrative painter James Beard, who must have imparted to the aspiring artist some of his own regard for the powers of observation and description. Spencer also studied paintings in the popular Düsseldorf Gallery in New York, a collection of nineteenth-century German genre and still-life pictures brought to this country by the German consul and purchased in 1857 by the Cosmopolitan Art Association, of which Lilly Martin Spencer was a member. Also in New York the developing painter was exposed to the first exhibitions of the English Pre-Raphaelites, whose highly realistic narrative style found particular support in this country among figurative painters and among advocates of a democratic art—an art that was both accessible and didactic, celebrating the virtues of the commonplace. Finally, Spencer was encouraged by the commercialization of American art at the middle of the nineteenth century, evidenced in the Art Union Movement, through which she sold many canvases, and by the rise of reproductive prints, which popularized many of her most widely appealing images. PJ

1. A description of the artist's most popular subjects, offered by a Cincinnati friend in 1848; quoted in *Lilly Martin Spencer (1822–1902): The Joys of Sentiment*, 1973, p. 30.

2. All related examples are recorded in ibid., pp. 110-111, 148-149, 166-167, 174-175.

3. Joshua Taylor, in his introduction to ibid., p. 9.

PROVENANCE:
Possibly W. M. Park, by 1868; Mr. and Mrs. William Postar, Boston, by 1973; to private collection, Massachusetts; to private collection, Michigan; (sold Richard York Gallery, New York).

LITERATURE:
Richard York Gallery, *An American Gallery*, vol. 3, New York, 1987, no. 1.

EXHIBITIONS:
Brooklyn Art Association, New York, 1868, no. 252 (title *Peeling Onions*, owned by W. P. Clark, may refer to this or another painting); National Collection of Fine Arts, Washington, DC, and Jewett Art Center, Wellesley College, Wellesley, MA, *Lilly Martin Spencer (1822–1902): The Joys of Sentiment*, 1973, pp. 35, 38, 111, 160, ill. fig. 19; National Collection of Fine Arts, Washington, DC, 1974–1980 (extended loan); Taft Museum, Cincinnati, OH, *Nicholas Longworth: Art Patron of Cincinnati*, 1988, no. 19, ill. back cover.

ASHER BROWN DURAND

American, 1796–1886
Genesee Oaks, 1860
Oil on canvas, 28 ¼ x 42″
Signed and dated lower left: *Pxt. A. B. Durand 1860*
Gift of the Women's Council in honor of Harris K. Prior, 74.5

sher Durand was one of the central, dominating figures of
the Hudson River School. He first achieved respect as an
engraver, but in the late 1820s he broadened his interests to
include oil portraits, landscapes, and occasional history or narrative
paintings. From about 1840, Durand painted landscapes almost exclu-
sively and was one of the first artists in America to paint and to exhibit
oil studies done directly from nature.

Durand visited the Genesee country but once, sketching in the
Geneseo area during late June and July of 1859. Of his trip he wrote
to his son in August: "With all my troubles I believe I have learnt
more about the management of colors in the painting of trees than by
all my previous practice, altho' I have never produced so little in the
same span of time, not having made but four studies in five weeks."[1]

During the following year, back in his studio, Durand painted
Genesee Oaks, based on the sketches he had made. The painting was
probably commissioned by James Samuel Wadsworth, a local squire,
who owned the work when it was exhibited at the National Academy
of Design in 1861. Seven oil studies done near Geneseo in 1859 are
recorded. One of them, *Oaks at Geneseo,* a source for this painting, was
photographed in Durand's studio after 1878. Shown in this photo-
graph are three small sculptures of cows—two standing, one
reclining—that may have served as models for the animals in the
painting.[2]

HSM

1. Asher B. Durand papers, New York Public Library, Archives of American Art,
microfilm N20: 1072-1073.

2. The photograph serves as the frontispiece for Lawall, *Asher B. Durand.*

PROVENANCE:
Descended in the family of James Samuel Wadsworth, Geneseo, NY; Dana
Tillou, Buffalo, New York; Lake View Gallery, Lake View, NY, 1974.

LITERATURE:
John Durand, *Life and Times of A. B. Durand,* New York, 1894, p. 177; David B.
Lawall, *Asher B. Durand: A Documentary Catalogue of the Narrative and Landscape
Paintings,* New York, 1978, no. 24, pp. 129-130, fig. 129; Carl Wiedemann,
"The Genesee Oaks," *The Conservationist,* September/October 1983, pp. 7-10,
ill. p. 7.

EXHIBITIONS:
National Academy of Design, New York, 1861, no. 184; MAG, *Genesee Country,*
1976, no. 35, ill. cover; The Genesee Valley Council on the Arts and Brodie
Fine Arts Center, State University of New York College of Arts and Sciences at
Geneseo, *Up and down the River,* 1977, pp. 68-69; Herbert F. Johnson Museum
of Art, Cornell University, Ithaca, NY (circulated), *Golden Day/Silver Night:
Perceptions of Nature in American Art, 1850–1910,* 1982–1983, no. 18, pp. 9,
41-43, ill. p. 43; MAG, *The Course of Empire: The Erie Canal and the New York
Landscape, 1825–1875,* 1984, no. 15, pp. 20, 52-53, ill. opp. p. 25.

American, 1816–1872
A Showery Day, Lake George, ca. 1860s
Oil on canvas, 14⅛ x 24⅛ "
Marion Stratton Gould Fund, 74.29

In eulogizing John Frederick Kensett, George W. Curtis, editor of *Harper's Magazine,* recalled, "There was no wall in New York so beautiful as that of his old studio . . . upon which [his sketches] were hung in a solid mass."[1] And, according to nineteenth-century critic Henry Tuckerman, from 1848 onward "all lovers of art and native scenery" regularly visited Kensett's quarters in Waverly House, at Broadway and Fourth Street, and delighted in the room's array of nature studies.[2] From his sketches and studies, Kensett worked up large, finished views of America's most popular vistas for an enthusiastic art-buying public. *A Showery Day, Lake George* is one of the personal studies, sold with the contents of the late artist's studio in 1873.

A painter who preferred the accessible landscapes of this country's well-known nineteenth-century vacation spots to the wilder scenery depicted by the first generation of American landscape painters, Kensett made frequent sketching trips throughout his career to the Berkshires, the Catskills, the Rhode Island shore, the White Mountains, and the Adirondacks. Lake George, a popular Adirondacks summer resort, was for Kensett "that sheet of water which has a name par excellence among our American inland seas."[3] He was drawn to it repeatedly after his first visit in 1853, and Lake George scenery inspired numerous canvases. Chief among them was his large-scale commission for New York businessman Morris Jessup, which was painted in 1869 (Metropolitan Museum of Art, New York) and is very similar in composition to this oil sketch. Indeed, this view of the entrance to the Narrows, which afforded magnificent vistas northward to Black Mountain and the Tongue Mountain Range, seems to have been one of Kensett's favorite sites on the lake.

Kensett began his career as an engraver but resolved by 1842 to devote himself "exclusively to the art of painting, especially in the department of landscape."[4] By 1849 he was well established in New York art circles and a member of the National Academy of Design. His skills as a draftsman contributed to the development of his mature painting style, which is characterized by an unusually spare and precise delineation of observed forms and surface textures. In this example, for instance, distant pine-covered slopes are rendered clearly, but briefly, through variations in the density of thinly applied blues and greens. The rough, wet surfaces of foreground rocks are fully described through distinct and bold strokes of gray and brown. Elsewhere the white of the canvas is allowed to show through to contribute other textures or to suggest silvery mist. The painting is a simple composition, reduced to expressive essentials, and reveals the facility and refinement that are Kensett's hallmarks. "His love of nature was as simple as it was deep," declared Kensett's friend Curtis, "and his interpretation was pure and reverend and beautiful."[5]

PJ

1. Quoted in Ellen Johnson, "Kensett Revisited," *Art Quarterly* 20, no. 1 (spring 1957), p. 71.

2. Ibid.

3. Quoted in Natalie Spassky, *American Paintings in the Metropolitan Museum of Art,* vol. 2, New York, 1985, p. 35.

4. Ibid., p. 31.

5. Quoted in *Executors' Sale,* p. 4.

PROVENANCE:
The estate of the artist (sold by Robert Somerville, New York, *Executors' Sale, The Collection of . . . Paintings and Studies, by the late John F. Kensett . . . ,* March 24–29, 1873, no. 296); Graham Blandy, CT, by 1974; to Vose Galleries of Boston, Inc.

LITERATURE:
"Photographs of Paintings by J. F. Kensett" (possibly compiled for Robert Somerville, ca. 1873), pl. 21, no. 296.

EXHIBITIONS:
MAG, "Harris K. Prior Memorial Exhibition," 1976; MAG, "Through the Looking Glass," 1980–1981; Herbert F. Johnson Museum of Art, Cornell University, Ithaca, NY (circulated), *Golden Day / Silver Night: Perceptions of Nature in American Art, 1850–1910,* 1982–1983, no. 36, pp. 70-71, ill.

MARTIN JOHNSON HEADE

American, 1819–1904
Newbury Hayfield at Sunset, 1862
Oil on canvas, 11 ¼ x 25 ³/₁₆"
Signed and dated lower left: *M J Heade 1862*
Gift of Jacqueline Stemmler Adams in memory of
Mr. and Mrs. Frederick M. Stemmler, 75.21

In his efforts to find subjects that suited him personally and artistically, Martin Johnson Heade looked beyond America's wilderness and pastoral landscapes—subjects favored by his contemporaries—and ranged widely. In South America and Florida, he studied exotic flora and hummingbirds. On both the East and West coasts of this country, he painted the sea in its various moods. But it was in the coastal lowlands of Massachusetts and Rhode Island that Heade found, in the 1860s, a subject that would fascinate him for the rest of his life: the anonymous salt marsh.

The year 1862, when this view was painted, marks Heade's first visit to the marshes around Newburyport, Massachusetts, a locale with which the artist is now closely identified. Yet, remarkably, the subject of the salt marsh imparts no clear sense of place, and the artist himself in his more than one hundred marsh paintings rarely identified the location. Such disregard for the specificity of a view ran counter to the native landscape school in the nineteenth century, which made a convention of the recognizable and distinctly American vista. Essentially the same salt marsh landscape was found all along the East coast, and Heade painted similar views from the Northeast to Florida. The flat, expansive marsh, fed by tidewaters and a web of winding streams, is characteristically lush with grasses. In Heade's day, the salt marsh was populated by great conical haystacks—the fruits of the harvest of this wild crop—which stood on raised stakes in the swampy fields for months at a time, until the cut grass could be hauled away to nearby farms for use as fodder and straw.

As art historian Theodore Stebbins has pointed out, the fascination that this distinctive landscape held for Heade is suggested by the character of the salt marsh itself. Pictorially, the ever-present haystacks were static elements in an otherwise changing landscape and thus functioned as convenient focal points in Heade's studies of the dynamics of sunlight and atmosphere. In *Newbury Hayfield at Sunset,* for example, these sculptural elements—the only solid forms in an extremely spare landscape—render evening light palpable through the play of color and light around them. The drama of sunset, to which Heade was repeatedly drawn, is heightened by contrast with the dark, still haystacks silhouetted against a broad sky.

The salt marsh may have held another level of meaning for Heade. Just as his floral still lifes may have personal and sexual references, Heade's numerous marsh studies, produced over more than forty years, may signal an enduring mystical vision.[1] Perhaps Heade, a naturalist whose writings on birds appeared from time to time in *Field and Stream,* appreciated the salt marsh as a distinct productive habitat, rich in fish, game, and wildflowers. By extension, then, the subject may have represented to him the pure, life-giving force of nature, offering the artist comfort and inspiration.

PJ

1. Stebbins has suggested that Heade's subjects may contain deliberate sexual references; see *Life and Works,* esp. pp. 55-56, regarding sexual meaning in the marsh paintings.

PROVENANCE:
Mr. and Mrs. Andrew Kulin, Boston, by 1975; Vose Galleries of Boston, Inc., 1975.

LITERATURE:
Theodore E. Stebbins, Jr., *The Life and Works of Martin Johnson Heade,* New Haven, 1975, no. 46, p. 220, ill.; Bruce Johnson, "Martin Johnson Heade's Salt Marshes and the American Sublime," *Porticus* 3 (1980), pp. 34-40, ill. p. 34.

EXHIBITIONS:
Herbert F. Johnson Museum of Art, Cornell University, Ithaca, NY (circulated), *Golden Day / Silver Night: Perceptions of Nature in American Art, 1850-1910,* 1982–1983, no. 27, pp. 58-59, ill. p. 58.

THOMAS RIDGEWAY GOULD

American, 1818–1881
The West Wind, 1876
Marble, h. 70½", w. 23", d. 33¼"
Signed on base: *The West Wind. T.R. Gould. Inv. et Fecit Florence 1876.*
Gift of the Isaac Gordon Estate through the Lincoln Rochester Trust
Company, 66.18

The West Wind is the most celebrated work of the American Neoclassical sculptor Thomas Ridgeway Gould. Born in Boston in 1818, Gould, who started out as a dry-goods merchant, produced sculpture in his free time, in the studio of the portraitist Seth Cheney. When Gould's business collapsed during the Civil War, he turned to sculpture as a profession, and, in 1868, he moved to Italy, following the footsteps of two previous generations of American artists. He established his studio in Florence, returning to the United States only twice, in 1878 and then in 1881, the year of his death.

Gould created The West Wind in 1870, and the work proved to be so popular that seven replicas were eventually produced,[1] providing Gould with a comfortable income for several years.[2] This marble replica, dated 1876, was purchased by Daniel W. Powers, of Rochester. It was shown in the Centennial Exhibition in Philadelphia before being brought to Rochester for display in Powers's renowned art gallery.[3]

Created during the later years of the American westward expansion, The West Wind embodies a uniquely American spirit.[4] The band of stars encircling the figure's waist makes Gould's patriotic meaning clear. The symbolic implications of the piece were not wasted on one observer at the Centennial who wrote: "Careless and American in aspect, her pulse-beats throbbing through a belt of Western stars, the glad incarnation seems to have just cooled in the Pacific the light foot she sets on the shore of an untamed continent."[5]

This evocatively emotional aspect of The West Wind is balanced, as was typical for work of its period, by a certain academic or historical feeling, derived from the Neoclassical and Classical sources of the work. The closest antecedent of The West Wind is the sculpture Hebe, 1796, (Nationalgalerie, East Berlin) by the Italian Neoclassical sculptor, Antonio Canova, which was based in turn on Classical and Hellenistic models, such as the well-known Victory of Samothrace (Louvre, Paris).

Despite Gould's use of these sources, the pose of The West Wind is original in the drama of its implied movement, which is effective from every angle. The figure balances against the force of the wind, which sweeps back her gown. As she strides forward, she turns her head to the left, countering the clockwise spiral of the arms. These opposing forces provide an internal balance, maintaining a sense of controlled motion.

Appropriately for a personification of the wind, the figure seems light and airy, an illusion consistent throughout the piece, with its narrow base, tiptoe stance, and fluttering drapery. The idealized features and anatomy as well tell us that this is no flesh-and-blood woman but an airy spirit. It was probably these qualities that helped The West Wind achieve its acceptance as a symbolic work, expressing the concept of America's manifest destiny.

PK

1. The original (h. 71″) is in the Mercantile Library in St. Louis. A reduced version (h. 48″), signed and dated 1874, is in the JoAnn and Julian Ganz, Jr., Collection (Wilmerding et al., American Perspective, ill. p. 134).

2. Craven, Sculpture, p. 205.

3. The Powers Art Gallery (1875–1897), located on the top floors of the Powers Building at State and Main streets, was considered by one contemporary as the "finest gallery formed by a single individual and open to the public to be found in America, and I think I can safely assert, in the world." In its heyday, the collection consisted of 574 modern oils, 127 copies of famous original masterpieces, 71 watercolors, 18 pieces of sculpture, plus tapestries, Oriental rugs, Japanese vases, engravings, books, 2,400 stereoscopic views of old-world scenery, several hundred stuffed birds, and an orchestrion, all works that were sold or dispersed following Powers's death in 1897. Perhaps because it was too heavy to move, The West Wind remained in the building until it was rediscovered in the 1960s by Isabel Herdle, curator of MAG, and its ownership was transferred to the Gallery. See Jean Merrell Dinse, "Private Art Collections in Rochester," Rochester History 7, no. 2 (April 1945), pp. 8-24.

4. A comparable allegorical figure appears in John Gast's painting entitled variously Westward Ho, Manifest Destiny, and American Progress, dated 1872, in the collection of Harry T. Peters, Orange, VA (reproduced in J. Gray Sweeney, Themes in American Painting, Grand Rapids, MI, 1977, pl. 7).

5. Strahan, Masterpieces, p. 296.

PROVENANCE:
Daniel W. Powers 1876–1897; remained in Powers Building, Rochester, NY, through 1966; Lincoln Rochester Trust Company, Isaac Gordon Estate.

LITERATURE:
James Jackson Jarves, Art Thoughts, New York, 1871, p. 318; James Jackson Jarves, Art Journal, London, January 1, 1871, pp. 7-8; Edward Strahan (pseud. Earl Shinn), The Masterpieces of the Centennial International Exhibition, Vol. 1, Fine Art, Philadelphia, n.d., pp. 294-296; William J. Clark, Jr., Great American Sculptures, Philadelphia, 1878, pp. 122-124; Samuel G. W. Benjamin, "Sculpture in America," Harper's New Monthly 58 (1879), pp. 667-668; Samuel G. W. Benjamin, Art in America: A Critical and Historical Sketch, New York, 1880, p. 154; Alphonso A. Hopkins, The Powers Fire-proof Commercial and Fine Arts Buildings, Rochester, NY, 1883, p. 114; A Catalogue of the Paintings in the Art Gallery of D. W. Powers, Rochester, NY, 1884, p. 8; A Descriptive Catalogue of the Powers Art Gallery, intro. James Delafield Trenor, Rochester, NY, 1890, no. 2; Lorado Taft, The History of American Sculpture, New York, 1903, pp. 189-190; Margaret Farrand Thorp, The Literary Sculptors, Durham, NC, 1965, p. 175; Wayne Craven, Sculpture in America, New York, 1968, p. 205; William Gerdts, American Neoclassical Sculpture: The Marble Resurrection, New York, 1973, fig. 62, pp. 84-85; John Wilmerding et al, An American Perspective: Nineteenth-Century Art from the Collection of JoAnn and Julian Ganz, Jr., Hanover, NH, 1981, pp. 134-135.

EXHIBITIONS:
Centennial Exhibition, Philadelphia, 1876; Powers Art Gallery, Rochester, NY, 1881–1897.

WINSLOW HOMER

American, 1838–1910
The Artist's Studio in an Afternoon Fog, 1894
Oil on canvas, 24 x 30¼"
Signed and dated lower right: *Winslow Homer 1894*
R. T. Miller Fund, 41.32

WInslow Homer withdrew from the established art circles of New York City and settled at Prout's Neck, Maine, in 1883. There he made a home and studio from a small stable that stood behind his family's house isolated at the end of a narrow spit of land extending into Saco Bay. The studio commanded an unimpeded view of the sea from an open piazza on the second floor, and here Homer studied and painted this familiar stretch of the North Atlantic Coast in every season, in all weather, and at each hour of the day.

The artist's move to these rugged and remote surroundings was deliberate, precipitated by his experience two years earlier at Cullercoats, a fishing village on the coast of England. There, among the strong-willed men and women who made their living from the sea, Homer reached a new understanding of the profound physical, emotional, and spiritual struggles that characterize human confrontations with the forces of nature. After his return from England in 1882, the pleasant seaside resort towns of Homer's native New England—once favorite subjects for his oils and watercolors—no longer satisfied his artistic needs. But the social and climatic conditions of Prout's Neck were different, more like those of Cullercoats. It was a place perfectly suited to his growing preoccupation with exploring the raw powers of nature, and he eagerly helped his brother secure land there for use as a Homer family retreat. Alone, except for the occasional company of family members, Homer's concentration at Prout's Neck was complete; by 1895, he could comment to his brother Charles, "The life that I have chosen gives me full hours of enjoyment for the balance of my life. The Sun will not rise or set without my notice and thanks."[1]

Homer's interest in the transitory effects of light and atmosphere is easily seen in *The Artist's Studio in an Afternoon Fog*. Silhouetted against the diffused sunlight and shrouded in a veil of brown mist, the cliffs, the house, and the studio are reduced to simple forms and pure design. Yet the overall effect is one of extreme fidelity to nature. As one commentator has written of Homer's late marine paintings, "One scarcely misses the lacking detail in the completeness of the 'impression.'"[2]

In 1901 Homer presented this canvas to John Calvin Stevens of Portland, Maine, a builder who had designed a cottage for the artist at nearby Kettle Cove. In submitting his bill for services, Stevens suggested as payment "any production of Winslow Homer."[3] *The Artist's Studio in an Afternoon Fog* was his reward.

PJ

1. Beam, *Winslow Homer,* p. 126.

2. Ibid., p. 121.

3. Ibid., p. 218.

PROVENANCE:
The artist, to John Calvin Stevens, Portland, ME, 1901; descended in the Stevens family.

LITERATURE:
Albert Ten Eyck Gardner, *Winslow Homer, American Artist: His World and His Work,* New York, 1961, pp. 206-207; James Thomas Flexner, *The World of Winslow Homer, 1836–1910,* New York, 1966, pp. 174-175, ill.; Philip Beam, *Winslow Homer at Prout's Neck,* Boston, 1966, pp. 217-218, ill. p. 123; Gordon Hendricks, *The Life and Work of Winslow Homer,* New York, 1979, pp. 222, 317, ill. pl. 57, checklist no. 539; Gordon Fairburn, "Winslow Homer at Prout's Neck," *Horizon,* April 1979, pp. 60-61, ill.; Joseph S. Czestochowski, *The American Landscape Tradition: A Study and Gallery of Paintings,* New York, 1982, pp. 126-127, ill.; Lois Dinnerstein, "Artists in Their Studios," *American Heritage* 34, no. 2 (February/March 1983), p. 82, ill.

EXHIBITIONS:
"Panama-Pacific International Exposition," San Francisco, 1915; Whitney Museum of American Art, New York, "Winslow Homer," 1944; Museum of Fine Arts, Boston, National Gallery of Art, Washington, DC, and Metropolitan Museum of Art, New York, *Winslow Homer,* 1959, no. 59, p. 78, ill.; Munson-Williams-Proctor Institute, Museum of Art, Utica, NY, and MAG, *Masters of Landscape: East and West,* 1963, no. 69, p. 73, ill.; Bowdoin College Museum of Art, Brunswick, ME, *Winslow Homer at Prout's Neck,* 1966, no. 30, ill.; Des Moines (IA) Art Center, 1967 (extended loan); Indiana University Art Museum, Bloomington, *The American Scene, 1820–1900,* 1970, no. 5, pp. 31-32, ill.; Whitney Museum of American Art, New York, Los Angeles County Museum of Art, and The Art Institute of Chicago, *Winslow Homer,* 1973, no. 55, p. 107, ill.; The National Museum of Western Art, Tokyo, and The Kyoto National Museum, Kyoto, Japan, *Masterpieces of World Art from American Museums,* 1976, no. 58, ill.; Wildenstein Galleries, New York, *Treasures from Rochester,* 1977, p. 62, ill.; National Gallery of Art, Washington, DC, *American Light: The Luminist Movement, 1850–1875,* 1980, pp. 249, 307, fig. 348; MAG, "Through the Looking Glass," 1980–1981; Herbert F. Johnson Museum of Art, Cornell University, Ithaca, NY (circulated), *Golden Day/Silver Night: Perceptions of Nature in American Art, 1850–1910,* 1982–1983, no. 30, pp. 11, 62-63, ill. p. 63; Whitney Museum of American Art, Fairfield County, Stamford, CT, *Winslow Homer and the New England Coast,* 1984–1985, p. 10, ill. cover.

JOHN HENRY TWACHTMAN

American, 1853–1902
The White Bridge, ca. 1900
Oil on canvas, 30 ¼ x 25 ⅛ "
Signed lower right: *J. H. Twachtman*
Gift of Emily Sibley Watson (Mrs. James Sibley Watson), 16.9

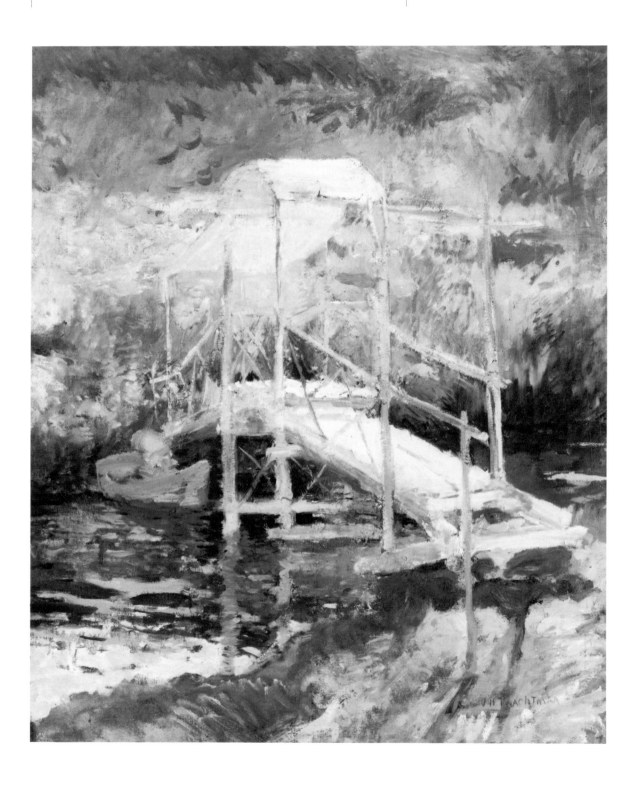

John Henry Twachtman was born in Cincinnati in 1853 and began his painting career as a decorator of window shades. He studied drawing at the Ohio Mechanics Institute and, in 1871, at Cincinnati's McMicken School of Design, where Frank Duveneck was one of his teachers. From 1875 to 1877 Twachtman worked at the Royal Academy in Munich, after which he spent a year in Venice with Duveneck and William Merritt Chase. Attempting to rid himself of Munich's dark palette, Twachtman enrolled in the Académie Julian in Paris in 1883. He lived in Paris for two years, often painting in the French countryside with his new friends Childe Hassam, Theodore Robinson, and Willard Metcalf. The paintings of this French period are cool and silvery in tone and tend toward the abstraction of Oriental art and the work of the American expatriate James McNeill Whistler. Twachtman did not develop his mature style until he settled in Greenwich, Connecticut, in the late 1880s and adopted a brighter palette influenced by Theodore Robinson's Impressionist experience.

The Connecticut landscape inspired some of Twachtman's finest paintings. *The White Bridge,* for example, was painted about 1900, five years after Twachtman had built a white lattice bridge on his property on Round Hill Road. In the painting one glimpses Horseneck Brook in the distance and imagines its course as it gently flows beneath the bridge. By spotlighting the bridge and eliminating the horizon, Twachtman arrests the eye of the viewer on the structure itself.

Working directly from nature, Twachtman applied the paint in broad, broken strokes with a quick and sure hand. The bravura brushstroke inspired by his Munich days was used with exhilarating force in his last years. When the painter Emil Carlsen, commenting on Twachtman's elusive and subtle style, told him he was a great technician, Twachtman said, "Technique, I don't know anything about it!"[1]

The White Bridge illustrates what his painter friend Childe Hassam called Twachtman's "virile" and "rhythmic" use of line. His selective use of the Impressionist style is seen in the prismatic reflection of sunlight on water. The painting's vibrant colors and its many diagonals create a sense of excitement within the composition. Yet there is a subtle quality that is almost dreamlike in its lyricism.

Like other American Impressionists trained abroad, Twachtman found subject matter in the New England landscape, where he painted familiar motifs to explore their visual poetry. There are several known versions of *The White Bridge,* including one now in the Art Institute of Chicago, another in the Minneapolis Institute of Arts, and a third in the Georgia Museum of Fine Arts, the University of Georgia.

One commentator has written of Twachtman's work, "Of all the American Impressionists, Twachtman was the most poetic temperament, and his paintings in series—of the pools and cascades on his Connecticut farm—often approach in form and feeling a level of abstraction nearly musical in tone."[2]

JBM

1. Eliot Clark, "John Henry Twachtman," *Art in America* 7, no. 3 (April 1919), p. 137.

2. Harold Spencer, "Reflections on Impressionism, Its Genesis and American Phase," *Connecticut and American Impressionism,* Storrs, CT, 1980, pp. 50-51.

PROVENANCE:
Mrs. John E. (Gertrude) Cowdin, by 1907; sold with Mrs. Cowdin's estate, American Art Association, New York, May 9-10, 1916, lot 168; to Macbeth Galleries, New York, for Emily Sibley Watson (Mrs. James Sibley Watson), Rochester, NY.

LITERATURE:
John Douglas Hale, "The Life and Creative Development of John H. Twachtman," Ph.D. diss., Ohio State University, 2 vols., 1957, no. 90, ill.; Richard J. Boyle, *John Twachtman,* New York, 1979, p. 78, pl. 29; William H. Gerdts, *American Impressionism,* New York, 1984, p. 159, ill. p. 158.

EXHIBITIONS:
Lotos Club, New York, "Twachtman," 1907, no. 5; MAG, "In Focus: A Look at Realism in Art," 1964, no. 74; Cincinnati (OH) Art Museum, *John Henry Twachtman: A Retrospective Exhibition,* 1966, p. 15, no. 56; Wildenstein Galleries, New York, *Treasures from Rochester,* 1977, p. 70, ill.; Nassau County Museum of Fine Art, Roslyn, NY, *William Cullen Bryant, the Weirs, and American Impressionism,* 1983, p. 35, pl. 8; The Cummer Gallery of Art, Jacksonville, FL, *Artistic Transitions: From the Academy to Impressionism in American Art,* 1986–1987, no. 46, ill.

JOHN SINGLETON COPLEY

American, 1737–1815
Nathaniel Hurd (1729–1777), ca. 1765
Oil on canvas, 29⅜ x 24⅝"
Marion Stratton Gould Fund, 44.2

RALPH EARL

American, 1751–1801
Mary Smith Booth (1744–1824), 1790
Oil on canvas, 38 x 31"
Marion Stratton Gould Fund, 57.13

THOMAS COLE

American, 1801–1848
Landscape Composition: Italian Scenery, 1831–1832
Oil on canvas, 40¾ x 61½"
Purchased through the Marion Stratton Gould Fund and with the gift of
Mr. and Mrs. Thomas H. Hawks, 71.37

ATTRIBUTED TO NOAH NORTH

American, 1809–1880
Pierrepont Edward Lacey and His Dog, Gun,
ca. 1835–1836
Oil on canvas, 42 x 30⅛"
Gift of Mr. and Mrs. Robert H. Dunn, 78.189

M. M. MANCHESTER

American, active ca. 1840s
Judge and Mrs. Arthur Yates, 1840
Oil on canvas, 36 x 58¾"
Gallery Purchase, 41.30

DEWITT CLINTON BOUTELLE

American, 1820–1884
The Indian Hunter, 1846
Oil on canvas, 32⅝ x 47⅛"
Marion Stratton Gould Fund, 84.47

RUBENS PEALE

American, 1784–1865
Still Life Number 26: Silver Basket of Fruit, 1857–1858
Oil on tin, 13 x 19"
Gift of Helen C. Ellwanger, 64.40

JASPER FRANCIS CROPSEY

American, 1823–1900
Chenango River, New York, 1858
Oil on canvas, 10⅜ x 16⅞"
Marion Stratton Gould Fund, 73.40

JASPER FRANCIS CROPSEY

American, 1823–1900
The Hudson River, New York, 1858
Oil on canvas, 10⅜ x 16⅞"
Marion Stratton Gould Fund, 73.39

DAVID GILMOUR BLYTHE

American, 1815–1865
Trial Scene, ca. 1860-1863
Oil on canvas, 22¼ x 27"
Marion Stratton Gould Fund, 41.24

JAMES HENRY BEARD

American, 1814–1893
The Night before the Battle, 1865
Oil on canvas, 30½ x 44½"
Gift of Dr. Ronald M. Lawrence, 78.15

MORTIMER SMITH

American, 1840–1896
Home Late, 1866
Oil on canvas, 40 x 46"
Marion Stratton Gould Fund, 75.139

EASTMAN JOHNSON

American, 1824–1906
Back from the Orchard, ca. 1876
Oil on board, 10⅜ x 6⅝"
Marion Stratton Gould Fund, 75.138

JOHN FRANCIS

American, 1808–1886
Still Life with Fruit, 1865
Oil on canvas, 25 3/16 x 30⅜"
Marion Stratton Gould Fund, 71.7

ATTRIBUTED TO THOMAS V. BROOKS

American, 1828–1895
Cigar Store Indian, ca. 1870
Painted wood, 85 x 24⅜ x 26½"
Marion Stratton Gould Fund, 63.8

AMERICAN (POSSIBLY LONG ISLAND
OR NEW JERSEY), 19TH CENTURY

Decoys: A Pair of Blue Herons
Wood, painted, l. 42⅝" and 38¾"
R. T. Miller Fund, 54.31.1-.2

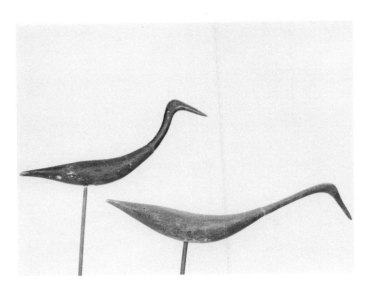

AMERICAN, 19TH CENTURY

Tramp Art Shrine, ca. 1865–1900
Painted wood, 43½ x 26¼ x 19"
Lillian Utz Fund, Florence Berg Fund, and Tribute Fund, 87.4

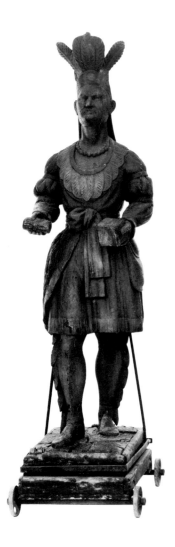

198

MARTIN JOHNSON HEADE

American, 1819–1904
Hummingbird with Cattleya and Dendrobium Orchids, ca. 1885–1895
Oil on canvas, 22¼ x 14⅜"
Harris K. Prior Memorial Fund, 76.3

DAVID JOHNSON

American, 1827–1908
Genesee River, 1888
Oil on canvas, 15⅝ x 22½"
Marion Stratton Gould Fund, 69.64

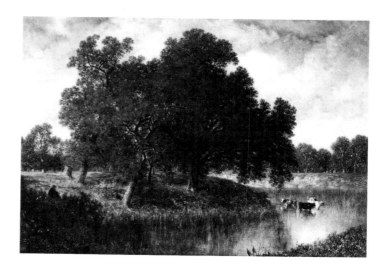

JOHN HABERLE

American, 1856–1933
Torn in Transit, ca. 1888–1889
Oil on canvas, 14 x 12⅛"
Marion Stratton Gould Fund, 65.6

FREDERICK W. MACMONNIES

American, 1863–1937
Nathan Hale, 1890
Bronze, 28⅜ x 9½ x 5¹³⁄₁₆"
Marion Stratton Gould Fund, 86.4

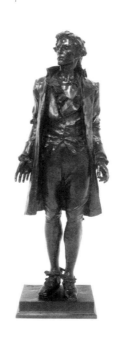

WINSLOW HOMER

American, 1836–1910
Paddling at Dusk, 1892
Watercolor on paper, 15⅛ x 21⅜″
Anonymous gift, 84.51

WILLIAM MERRITT CHASE

American, 1849–1916
A Summer Day, ca. 1892
Pastel on canvas, 16⅛ x 20″
Gift of the estate of Emily and James Sibley Watson, 51.42

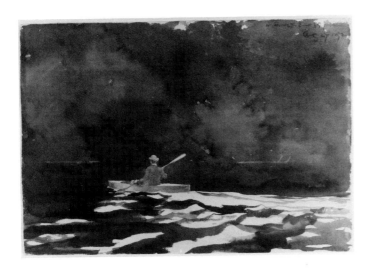

THOMAS WILMER DEWING

American, 1851–1938
Head of a Young Woman, ca. 1895
Silverpoint on gesso-coated wood-pulp paper board, 10¼ x 8¼″
Bertha Buswell Bequest, 55.79

MAURICE PRENDERGAST

American, 1858–1924
The Ships, ca. 1895–1897
Monotype on paper, 11 x 9⁹⁄₁₆″
Gift of Emily Sibley Watson (Mrs. James Sibley Watson), 19.29

AMERICAN ART 1900–

American, 1844–1916
William H. Macdowell, ca. 1904
Oil on canvas, 24 x 20″
Signed on reverse: *T. E.*
Marion Stratton Gould Fund, 41.26

As Thomas Eakins worked to capture on canvas the physical presence of men and women he knew and admired, he increasingly found satisfaction in the art of portraiture. During the last two decades of his life, the portrait became his principal means of artistic expression, despite the fact that the artist's uncompromising realism discouraged all but an occasional commission. His inspiration came instead from family members and friends, individuals with whom Eakins empathized and who were natural subjects for his probing character studies. Eakins's father-in-law, William Macdowell, was a favorite sitter. Over a period of fifteen years, Eakins made studies of the old gentleman in oil, in watercolor, and in photographs—studies that culminated in this powerful portrayal, dated about 1904.[1]

Typical of Eakins's late work, the portrait has been reduced to its expressive essentials—head and face. Set against a dark and broadly painted, objectless background, Macdowell's wiry, tousled hair and distinctive rugged features are, by contrast, illuminated and carefully described through a fine, deliberate brushwork well suited to delineating facial structure. No individualizing attribute, it seems, has been overlooked or idealized.

Eakins's frank description of Macdowell's aged features represents more than fidelity to nature, however. Through his probing of Macdowell's outer appearance, Eakins studies the inner man and, one suspects, addresses the broader issues of human vulnerability and endurance in old age. Thus Eakins created, in his own words, "a fine piece of work as a work of art and not a likeness."[2]

The strength of this portrait comes both from Macdowell's character and from Eakins's rapport with his subject. An engraver by trade, Macdowell was admired by his contemporaries for his philosophical bent. According to one source, Macdowell once served as a model for his friend Samuel Murray's marble bust of Jeremiah because the young sculptor considered the free-thinking old gentleman as something of a modern-day prophet. Murray himself recalled a time when Macdowell's theoretical turn of mind led him unselfconsciously to challenge a street cleaner's ineffectual practice of sweeping uphill rather than down.[3]

Shortly after his marriage to Susan Hannah Macdowell in 1884, Eakins began to photograph his father-in-law and subsequently also asked him to pose for his classes at the Philadelphia Art Students' League.[4] Sitters who held Eakins's interest beyond one portrait were rare but the artist painted Macdowell seven times. The apparent willingness with which Macdowell accepted the tedious task of sitting for Eakins is indicative of their friendship, and the relentlessness with which Eakins studied Macdowell's face suggests the expressive power that the painter found there.

PJ

1. Scholars generally agree that the portrait compares stylistically with the bust-length studies of 1903–1904, the years of Eakins's greatest portrait activity. Only Gordon Hendricks has proposed a date of ca. 1891 for this Macdowell portrait, citing its relation to photographs of the subject made at that time.

2. Goodrich, *Thomas Eakins,* vol. 2, p. 59.

3. Margaret McHenry, *Thomas Eakins Who Painted,* Oreland, PA, 1945, p. 128.

4. Hendricks, *Life and Work,* p. 188.

PROVENANCE:
Susan Macdowell Eakins (the artist's wife), Philadelphia, through 1938?; Babcock Galleries, New York; Robert C. Vose Galleries, Boston, 1941.

LITERATURE:
Lloyd Goodrich, *Thomas Eakins: His Life and Work,* New York, 1933, no. 416, p. 200, pl. 64; Roland McKinney, *Thomas Eakins,* New York, 1942, p. 71, ill.; "A Gift of American Painting," *Gallery Notes,* November 1942, p. 2, ill.; "Rochester Collects the American Nineteenth Century," *Art News* 42, no. 1 (February 15, 1943), p. 12, ill.; Sylvan Schendler, *Eakins,* Boston, 1967, pp. 104, 165, 171, fig. 80; Gordon Hendricks, *The Life and Work of Thomas Eakins,* New York, 1974, pp. 188, 190-191, fig. 186; Lloyd Goodrich, *Thomas Eakins,* vol. 2, Cambridge, MA, 1982, p. 217, fig. 251.

EXHIBITIONS:
Staedelsches Kunstinstitut, Frankfurt and Kunsthaus, Munich (organized by the American Federation of the Arts), "Nineteenth-Century American Paintings," 1953, Whitney Museum of American Art, New York, *Thomas Eakins Retrospective Exhibition,* 1970, no. 93, p. 71; Wildenstein Galleries, New York, *Treasures from Rochester,* 1977, p. 67, ill.; Philadelphia Museum of Art and Museum of Fine Arts, Boston, *Thomas Eakins: Artist of Philadelphia,* 1982, no. 119, p. 111, ill.

American (b. Germany), 1827–1916
Crested Swans, ca. 1910
Wood, paint, h. 84¼", w. 33", d. 30½"
Marion Stratton Gould Fund, 70.25

John Scholl, carpenter, farmer, and self-trained sculptor, immigrated to the United States from the Kingdom of Wurttemberg in 1853, according to family records. He, his wife, Augusta Kuhsmahl, and their growing family spent the years between 1855 and 1865 in Schuylkill County, Pennsylvania, where Scholl was employed as a coal-mine carpenter. By 1870 the Scholl family had moved to the village of Germania, Potter County, in Pennsylvania's Northern Tier.

Germania, an ethnic settlement of landowning working people founded in 1855, was intended as an ideal, although not communitarian, community that would preserve the German language and cultural life. In this socially cohesive setting, John Scholl worked as a subsistence farmer and carpenter, eventually acquiring over one hundred acres of land, where he constructed a large and impressive frame farmhouse that may have been his "masterpiece." Beginning in the 1890s, Scholl focused his creative energies on his house, and his unique decorative scheme, adapted from ordinary architectural "gingerbread," may have encouraged the later sculpture.

Sometime after 1900 John Scholl began to make elaborate wooden assemblages, ranging in size from a few inches to seven feet in height; approximately forty examples of this work survive. The sculpture can be categorized into four general types: whittler's puzzles (objects with moving parts carved from a single block of wood); articulated toys that operate with hand cranks; flat geometric "snowflakes" that hang from the ceiling or on the wall; and large, freestanding assemblages composed of table or pedestal bases surmounted by large "snowflakes," mechanical toys, or miniature buildings. This fourth type has been dubbed "celebrations," a term Scholl did not use but well suits the works' whimsical qualities.

Crested Swans is one of Scholl's celebrations, and it is photographically documented in the Scholl parlor, which served as a gallery and was visited by local residents between 1910 and the 1930s. Although many of Scholl's assemblages were repaired and repainted during the 1930s, *Crested Swans* appears to have its original coat of paint and has not been structurally altered. The only change the piece seems to have undergone is at the top of the wooden "fan": the carved fleur-de-lis and dove with spread wings were replaced by a wingless dove on a perch.

With the exception of the whittler's puzzles, which may only be fragments of lost work, each sculpture is an assemblage of cutout and carved elements. These include scrolls, diamonds, and other geometric shapes; applied wooden balls, stars, and German crosses; and carved men and birds. A number of pieces feature miniature buildings, and most incorporate architectural elements derived from fretsawn "gingerbread." *Crested Swans* and many of the larger pieces include bases derived from such common Victorian furniture as lamp tables and plant stands.

Little is known about Scholl's working methods. Fragments of biographical information and examination of the surviving work combined with knowledge of the working processes of other artisans and other folk artists, suggests that Scholl's working process has its basis in his carpenter's craft, as well as the casual whittling that was a common masculine pastime in rural communities.

No drawings survive, and none seem to have been made. Scholl apparently visualized his assemblages in their finished form. He told one neighbor that as he began each piece, he had "in his mind" what he was going to make.[1] His working method apparently involved the nonverbal thinking about design problems that artisans have employed for centuries.[2]

Many of Scholl's assemblages incorporate images and symbols that have not been deciphered completely. Some, for example, the small German crosses applied to many of the works, refer to Scholl's heritage. Other symbols may relate to Scholl's community, including its fraternal orders: *Song of Victory,* in the collections of the New York State Historical Association, contains cutout versions of symbols used by the Grand Army of the Republic. Except for the anchors and stars beneath the paired swans and the now-wingless "dove of peace" (a common Scholl motif), *Crested Swans* contains no apparent personal references. It remains one of the most striking, even mysterious examples of John Scholl's work.

KCG

1. Author's interview with Stanley Welfling, Jr., Germania, PA, March 1978.

2. See Eugene S. Ferguson, "The Mind's Eye: Nonverbal Thought in Technology," *Science,* August 26, 1977, pp. 827-836.

PROVENANCE:
Adele Earnest, Stony Point Folk Art Gallery, Stony Point, NY.

LITERATURE:
David G. Lowe, "Wooden Delights," *American Heritage* 20, no. 1 (December 1968), p. 20, ill; Robert Bishop, *American Folk Sculpture,* New York, 1974, pp. 212-213, ill.; Herbert W. Hemphill, Jr., and Julia Weissmann, *Twentieth-Century American Folk Art and Artists,* New York, 1974, p. 31, no. 28; Katherine C. Grier, *Celebrations in Wood: The Sculpture of John Scholl (1827–1916),* Harrisburg, PA, 1979, no. 19, ill.; Katherine C. Grier, "John Scholl's Wooden Wonders," *New York-Pennsylvania Collector,* August 1986, pp. 11-13, ill.; Charlotte Emans, "In Celebration of a Sunburst," *The Clarion,* fall 1983, p. 56, ill.

EXHIBITIONS:
Willard Gallery, New York, "John Scholl," 1967; Museum of American Folk Art, New York, "Twentieth Century American Folk Art and Artists," 1970; MAG, "Harris K. Prior Memorial Exhibition," 1976; William Penn Memorial Museum, Harrisburg, PA, *Celebrations in Wood: the Sculpture of John Scholl (1827–1916),* 1979–1980, no. 19.

MARY CASSATT

American, 1844–1926
Young Mother, Daughter, and Son (Mother and Son on a Chaise Longue, Daughter Leaning over Them), 1913
Pastel on paper, 43 ¼ x 33 ¼ "
Signed lower right: *Mary Cassatt*
Marion Stratton Gould Fund, 59.16

American by birth, Mary Cassatt spent most of her adult life in Europe. During her years of study she traveled widely in Europe and then settled in Paris. Her works were accepted at the official Salon, but in 1877, at the invitation of Degas, she exhibited with the group of independent artists who were already called the Impressionists. She continued to show with the group and to pursue her own direction in art rather than work in the official mode. Like Degas, who was a close friend and influence, she concentrated on the figure. Like him also, she frequently worked in pastel.

Many of her paintings and works on paper have women and children as their subject. Critics of the time saw her style and her content as feminine, yet forceful. Some interpreted her involvement with the theme of mother and child as a sublimation of her domestic impulses, for Cassatt never married. Her subject matter does reflect, to a degree, the realities of middle-class life at the end of the nineteenth century. Although as a member of a wealthy Philadelphia family Cassatt was free of the acute financial worries that plagued her colleagues, she was, nevertheless, circumscribed by the social conventions that restricted the activities of any woman, and particularly a single woman.

This pastel was made during Cassatt's final period of activity. Bereaved and discouraged by poor health and failing eyesight, she had not painted in 1912, but in 1913 she produced a number of large pastels. She wrote to her friend Louisine Havemeyer, who would later buy this work, on December 4, 1913: "I brought seven pastels to town, four were large; a nude boy and his Mother. They were in many respects the best I have done, more freely handled & more brilliant in color."[1] The loose handling of pastel and the intense colors in this work, which have been explained as the result of Cassatt's failing vision, may also be seen as vital and economic stylistic devices.

GS

1. Mary Cassatt to Louisine Havemeyer, December 4, 1913, in Mathews, ed., *Cassatt and Her Circle*, p. 311.

PROVENANCE:
Durand-Ruel, Paris, 1913 (10760-L10435); to Mr. and Mrs. H. O. Havemeyer, New York; Havemeyer Collection sale, American Art Association, New York, April 10-19, 1930, lot 86; Mrs. Albert Kahn, Detroit; Wildenstein Galleries, New York, from 1947 to 1952?; Walter Chrysler, 1959; Caesar R. Diorio, New York (dealer), 1959.

LITERATURE:
"Sale of the Havemeyer Collection Set for April 10-19," *Art News* 28, no. 25 (March 22, 1930), pp. 23, 30, ill.; John Palmer Leeper, Jr., "Two Worlds Seen in Two Shows at Pasadena," *Art Digest* 26, no. 2 (October 15, 1951), p. 8, ill.; Adelyn Dohme Breeskin, *Mary Cassatt: A Catalogue Raisonné of the Oils, Pastels, Watercolors, and Drawings,* Washington, DC, 1970, no. 579, ill.; E. John Bullard, *Mary Cassatt: Oils and Pastels,* New York, 1972, p. 84, pl. 32; Buffalo (NY) Fine Arts Academy, *American Art in Upstate New York,* 1974, p. 31; Haruki Yaegashi and Takeshi Kashiwa, *Les Peintres impressionnistes: 9: Cassatt,* Tokyo, 1978, no. 32, ill.; Frank Getlein, *Mary Cassatt: Paintings and Prints,* New York, 1980, pp. 154-155, ill.; Nancy Mowll Mathews, ed., *Cassatt and Her Circle: Selected Letters,* New York, 1984, p. 312, ill.

EXHIBITIONS:
M. Knoedler and Co., New York, *Masterpieces by Old and Modern Painters,* 1915, no. 42; Wildenstein Galleries, New York, *A Loan Exhibition of Mary Cassatt,* 1947, no. 21, ill.; Pasadena Art Institute, *Mary Cassatt,* 1951, no. 2; Wildenstein Galleries, New York, *Treasures from Rochester,* 1977, p. 68, ill.

GASTON LACHAISE

American, 1882–1935
Portrait Statuette of Mrs. J. Sibley Watson, Jr., 1925
Bronze, nickel-plated, h. 15¾", w. 8⅛", d. 6¼"
Signed and dated top of base, proper left: *G Lachaise © 1925*
Inscribed back edge of base, proper right: *Roman Bronze Works N.Y.*
Gift of a Friend of the Gallery, 67.11

Although the French-born sculptor Gaston Lachaise is probably best known for his monumental, idealized female nudes, portraiture represents an important facet of his work. While it offered Lachaise a practical means of financial support, portraiture also gave form to the strong and nurturing friendships that the sculptor enjoyed with some of the most progressive artists and intellectuals of his day.

Hildegarde Lasell Watson (1888–1976) was one of several close friends and patrons Lachaise knew through his association with *The Dial*, the American avant-garde art and literary journal. *The Dial* during the 1920s was published and edited by Mrs. Watson's husband, Dr. James Sibley Watson, Jr., and Scofield Thayer. During this decade, until it ceased publication in 1929, *The Dial* regularly featured Lachaise's work, along with the poetry of T. S. Eliot, E. E. Cummings, and Marianne Moore, and the criticism of Henry McBride and Roger Fry, to name but a few of the magazine's notable contributors. Hildegarde Watson was, however, a force in her own right among the creative minds of that enterprise. She earned poetic tributes from both Cummings and Moore, inspired a photographic portrait by Man Ray, and was honored with private performances by renowned musicians and composers, including Darius Milhaud and Virgil Thomson.[1] She was both an artist (one of her drawings was reproduced in *The Dial*) and an accomplished soprano, and acted in two art films made by her husband in his Rochester, New York, studio in the late 1920s and early 1930s.

That Mrs. Watson was also a woman of beauty and sophistication is evidenced by this statuette. With an air of dignity, she is posed in a Lanvin-designed dressing gown that, according to Mrs. Watson, Lachaise especially liked for its inherent sculptural qualities. Not only did the tight bodice emphasize the fluid contours of the subject's lithe body, but, Mrs. Watson recalled, the robe "was gathered in heavy fluted folds at the hips reminding him he said of organ pipes."[2] Elegance and sensuality are heightened by Lachaise's choice of surface treatment: highly polished bronze for the flesh and nickel plating for the satiny robe.

A photograph taken by Dr. Watson in Lachaise's studio shows that the sculptor made a second, larger version of this figure in clay or plaster, perhaps as a preparatory study to assist him in realizing anatomical detail on a small scale.[3] Although Lachaise dated the statuette 1925, the work must have been nearing completion in 1924, for it was included in the comprehensive list of Lachaise sculpture published that year in Albert Gallatin's monograph.

PJ

1. Cummings dedicated to Mrs. Watson a portion of *Poems, 1923–1954,* and Moore's "The Wood Weasel" includes an upside-down acrostic on Hildegarde Watson's name; both references are cited in Cyrus Hoy, ed., "Marianne Moore: Letters to Hildegarde Watson (1933–1964)," *University of Rochester Library Bulletin* 29, no. 2 (summer 1976), pp. 96, 134. The Man Ray photograph is in the collection of the MAG. The Milhaud and Thomson performances are described in Watson, *Edge of the Woods,* pp. 98-99, 119.

2. Quoted in Carolyn Kinder Carr and Margaret C. S. Christman, *Gaston Lachaise: Portrait Sculpture,* Washington, DC, 1985, p. 90.

3. The photograph is in the Watson Archive, Berg Collection, New York Public Library, New York.

PROVENANCE:
Mrs. James Sibley Watson, Jr. (née Hildegarde Lasell), Rochester, NY.

LITERATURE:
Albert E. Gallatin, *Gaston Lachaise,* New York, 1924, p. [53]; MAG, *Gallery Notes* 32, no. 9 (May 1967), p. 1, ill.; Gerald Nordland, *Gaston Lachaise: The Man and His Work,* New York, 1974, p. 35; Hildegarde Lasell Watson, *The Edge of the Woods: A Memoir,* Rochester, NY, 1979, p. 101, ill.

EXHIBITIONS:
Los Angeles County Museum of Art, and Whitney Museum of American Art, New York, *Gaston Lachaise, 1882–1935: Sculpture and Drawings,* 1964, no. 51, ill.; Albright-Knox Art Gallery, Buffalo, NY (circulated), *American Art in Upstate New York,* 1974–1975, p. 31; Wildenstein Galleries, New York, *Treasures from Rochester,* 1977, p. 86, ill.; MAG, *Gaston Lachaise: Sculpture and Drawings,* 1979, no. 23, pp. 13-15, 30, ill. p. 22; Bevier Gallery, Rochester (NY) Institute of Technology, "Selected Work from the Art Collection of Dr. James Sibley Watson, Jr.," 1985, no. 28; National Portrait Gallery, Smithsonian Institution, Washington, DC, *Gaston Lachaise: Portrait Sculpture,* 1985, pp. 90-91, ill. p. 91.

THOMAS HART BENTON

American, 1889–1975
Boomtown, 1927–1928
Oil on canvas, 46⅛ x 54¼″
Signed lower right: *Benton*
Marion Stratton Gould Fund, 51.1

Thomas Hart Benton was born in Missouri, the son and grandnephew of famous politicians. Benton's art and aesthetic ideals were profoundly influenced by the landscape, the culture, and the values of rural America, even though he spent many of his formative years as an artist outside of the region.

Benton studied painting first at the Corcoran Gallery of Art (from 1896 to 1904, during his father's four terms in the U.S. House of Representatives) and subsequently (1907–1908) at the Art Institute of Chicago. From 1908 to 1911 Benton worked in Paris, and for a brief time fell under the influence of European modernism. But after World War I, when he served in the U.S. Navy as an architectural draftsman, Benton abandoned what he called "the art-for-art's sake world" of the avant-garde for "the world of America," and ultimately established his reputation as a painter devoted to celebrating American rural life on canvas, in murals, and in the graphic arts.[1] By the early 1930s Benton was at the forefront of the Regionalist movement, championing the American scene, real and mythic, as a fitting subject for a democratic art.

Benton described *Boomtown* as one of his "best-known Regionalist pictures."[2] It was inspired, he wrote, by that distinctive phenomenon of the American West, exemplified by the town of Borger, Texas, as Benton experienced it in 1927.[3] Benton visited Borger in February of that year, finding a town "in the middle of its rise from a road crossing to an oil city."[4] He stayed in a second-floor apartment in the Dilley Building, above the American Beauty Bakery, and had a clear view of Main Street, with its colorful array of raucous oil and cattle men, "buxom, wide-faced, brightly painted Texas whores," and haphazard buildings, including the Midway dance hall and an assortment of hotels and rooming houses.[5] He sketched Borger's street life and the oil fields and incorporated these vignettes into the complex composition *Boomtown.*

In Benton's recollection of Borger he describes the qualities of a boomtown which fascinated him and to which he gave form in his painting:

> It was a town then of rough shacks, oil rigs, pungent stinks from gas pockets, and broad-faced, big-boned Texas oil speculators, cowmen, wheatmen, etc.
> The Texas rangers had charge of Borger when I was there. It was too tough for local government.... The day before I arrived in Borger there had been a cleanup of the town. Several hundred whores, bootleggers, gamblers, and rough characters had been chased out on the plains.
> The hotels that had bathtubs advertised the fact. They charged as much for a bath as for a room. Most of the people around Borger didn't take baths. It was useless anyhow, for the wind was liable to come up at any minute and blow all the dust of the unpaved rutty streets down your neck.
> Out on the open plain beyond the town a great thick column of black smoke rose in a volcanic eruption from the earth to the middle of the sky. There was a carbon mill out there that burnt thousands of cubic feet of gas every minute, a great, wasteful, extravagant burning of resources for momentary profit. All the mighty anarchic carelessness of our country was revealed in Borger.[6]

Like Borger itself, everything in *Boomtown* is alive with energy. Animated figures and buildings seem to dance to a fast-paced rhythm established by the swirling patterns of rapid brushstrokes that give form to the scene. Bright colors convey an unmistakable air of excitement, which even the ominous black smoke of the carbon mill and the large dark forms of oil derricks cannot dispel. The implicit irony of the Western industrial boomtown—the sacrifice of prairie land and the demise of rural values—was, Benton knew, lost on its inhab-

itants. Foreboding was easily dismissed in the expansive Texas Panhandle and quickly subdued by the spirit of the moment. In this quintessential "mushroom town," as Benton wrote,

> there was a belief, written in men's faces, that all would find a share in the gifts.... What if evil and brutal things were being done—people forgot them quickly and laughed in an easy tolerant way as if they were simply unavoidable and natural hazards of life, as inescapable as a dust storm. Borger on the boom was a big party—an exploitative whoopee party where capital, its guard down in exultant discovery, joined hands with everybody in a great democratic dance.[7]

PJ

1. Benton, *Artist in America,* pp. 44-45.

2. Benton, *American in Art,* pp. 58-59.

3. The date of Benton's visit to Borger is uncertain. In *An Artist in America,* Benton recalled the year as 1926, but a resident of Borger has described meeting Benton there sometime after February 1927, when the building that housed the American Beauty Bakery was completed; see "Carol Dilley Watched Benton." Karal Ann Marling, in her extensive study of this painting, accepts 1927 as the year of Benton's trip to Borger and has given the February date to related sketches of Borger's Main Street; see Marling, "Benton's *Boomtown,*" pp. 73-137 and *Tom Benton,* pp. 68, 144.

4. Benton quoted in Pagano, ed., *Encyclopaedia Britannica,* n.p.

5. Benton, *Artist in America,* p. 202.

6. Ibid., pp. 201-202.

7. Ibid., p. 203.

PROVENANCE:
Ferargil Galleries, New York, by 1935; Senator William Benton Encyclopaedia Britannica Collection of Contemporary American Painting, 1945-1951.

LITERATURE:
Arthur Strawn, "An American Epic," *Outlook and Independent* 54, no. 13 (March 26, 1930), p. 515, ill.; Ruth Pickering, "Thomas Hart Benton: On His Way Back to Missouri," *Arts and Decoration* 42, no. 4 (February 1935), p. 20, ill.; Thomas Hart Benton, *An Artist in America,* 1937, rev. fourth edition, Columbia, MO, 1983, pp. 201-204; Grace Pagano, ed., *The Encyclopaedia Britannica Collection of Contemporary American Painting,* Chicago, 1946, no. 6, ill.; Thomas Hart Benton, *An American in Art: A Professional and Technical Autobiography,* Lawrence, KS, 1969, pp. 58-59, ill. p. 92; Matthew Baigell, "Thomas Hart Benton in the 1920s," *Art Journal* 29, no. 4 (summer 1970), p. 428, fig. 11; Matthew Baigell, *Thomas Hart Benton,* New York, 1977, pp. 76, 89, pl. 45; "Carol Dilley Watched Benton Sketch Painting," *Borger* [TX] *News-Herald,* October 5, 1976, p. 3; John Diffily, "An American Regionalist: Thomas Hart Benton (1889–1975)," *Southwest Art* 9, no. 12 (May 1980), p. 11, ill.; Karal Ann Marling, "Thomas Hart Benton's *Boomtown*: Regionalism Redefined," in Jack Salzman, ed., *Prospects: The Annual of American Material Cultural Studies,* New York, 1981, vol. 6, pp. 73-137; Karal Ann Marling, *Tom Benton and His Drawings,* Columbia, MO, 1985, preface and pp. 68, 144.

EXHIBITIONS:
Delphic Galleries, New York, 1929; The Art Institute of Chicago (circulated), *The Encyclopaedia Britannica Collection of Contemporary American Painting,* 1945-1950, no. 6; Sokolniki Park, Moscow, Whitney Museum of American Art, New York, San Francisco Museum of Art (under the auspices of the United States Information Agency), *American National Exhibition,* 1959, p. 9; Dallas Museum of Fine Arts, "Directions in Twentieth-Century American Painting," 1961; Indiana University Art Museum, Bloomington, "American Painting, 1910-1960," 1964; The Gallery of Modern Art, New York, *The Twenties Revisited,* 1965, n.p.; Des Moines (IA) Art Center, *Mid-America in the Thirties: The Regionalist Art of Thomas Hart Benton, John Steuart Curry, and Grant Wood,* 1965-1966, no. 2, n.p.; Philbrook Art Center, Tulsa, OK, and Oklahoma Art Center, Oklahoma City, *The American Sense of Reality,* 1969, p. 20; Accademia Ligustica di Belle Arti, Palazzo dell Accademia, Palazzo Reale, Genoa, *Imagine per la città,* 1972, p. 369, ill. p. 166; Spokane (WA) World Exposition, "Our Land, Our Sky, Our Water," 1974; New Jersey State Museum, Trenton, "This Land Is Your Land," 1976; Grand Rapids (MI) Art Museum, *Themes in American Painting,* 1977, pp. 186-188, ill. p. 186; Akademie der Kunste, Berlin, and Dunstverein, Hamburg, *America: Traum und Depression 1920–1940,* 1981, no. 14, p. 527, ill. p. 269; Archer M. Huntington Art Gallery, The University of Texas at Austin, *Texas Images and Visions,* 1983, pp. 34, 82, ill. p. 83; The Museum of Fine Arts, Houston, TX, *The Texas Landscape, 1900–1986,* 1986, pp. 28-29, ill. p. 29.

American, 1883–1965
Ballet Mechanique, 1931
Conté crayon on paper, 10¼ x 10″
Signed and dated lower right: *Sheeler—1931*
Gift of Peter Iselin and his sister, Emilie Iselin Wiggin, 74.96

B
allet Mechanique is the most complex and arguably the most beautiful of the three conté crayon drawings that Charles Sheeler made in 1931 of the Ford Motor Company's River Rouge plant outside of Detroit.[1] It was one of at least six such exquisite drawings Sheeler completed that year, in a burst of creative activity inspired perhaps by his new, exclusive relationship with the Downtown Gallery, then the most lively showcase in New York for modern American art. The gallery's director, Edith Halpert, had advised Sheeler to give up his lucrative career as a commercial photographer and to concentrate solely on his paintings and drawings. Photography would continue to provide inspiration for Sheeler, however, and in his conté crayon drawings, the artist came closest to reproducing the visual effects of his finest photographic prints.

This drawing is one of a series of works inspired by a photographic commission Sheeler had undertaken in 1927. Working for the advertising agency N. W. Ayer and Son, Sheeler spent about six weeks photographing the River Rouge plant. It was part of Ford's first major advertising campaign to introduce the new Model A. As intended, Sheeler's photographs are an artistic interpretation of industry, focusing not on the new car or even the famous assembly line, but instead on the mammoth machinery and industrial architecture of the Rouge. Designed by architect Albert Kahn, the plant incorporated every phase of automobile-making, from refining raw ore to steel and glass manufacture, parts production, and finally the car's assembly. In *Ballet Mechanique,* Sheeler depicts a complex network of pipes that carried compressed air and excess gases between one of the power houses and the blast furnace.[2] Another of the Rouge drawings, *Smokestacks,* shows the upper portion of the same structure; both compositions may have had their source in a photograph, although no such print has been discovered.

Sheeler's interest in the Rouge works of the 1930s is not in description, but in aesthetics—the inherent beauty of objects designed for their utility.[3] In *Ballet Mechanique,* he creates a visual tension between the heavy pipes and their thin, delicate supports. By closely cropping the image and showing none of the apparatus in its entirety, Sheeler allows the whole system to seem suspended in mid-air. He isolates the pipes and struts from their context, creating an environment of ambiguous scale and space—distances from one object to another and their relative sizes cannot be determined. The composition becomes an abstract pattern of lacy complexity, energized by the diagonal motion of the pipes and by the artist's precise technique.

Sheeler characteristically selected a title that could add deeper meaning to his work. Here, the notion of a mechanical ballet adds a grace and elegance to the subtly modeled, delicately turned pipes. The title also recalls Fernand Léger's avant-garde film *Ballet mécanique,* which premiered in New York in 1924. The nonnarrative film also isolates mechanical objects and displays them spinning and flickering in quick succession. Sheeler appropriated not only the film's title but also its associations of clashing energy, adding a sense of motion and excitement to his own seemingly subdued vision of the Rouge.
EEH

1. The others are *Smokestacks* (The Lane Collection) and *Industrial Architecture* (private collection).

2. The sites and processes Sheeler depicted have been carefully identified by Mary Jane Jacob and Linda Downs in *The Rouge: The Image of Industry in the Art of Charles Sheeler and Diego Rivera,* Detroit, 1978.

3. Sheeler was not interested in social commentary. His work, however, was sometimes enlisted to support the theories of others. In 1932 this drawing was used to illustrate the short feature entitled "Order in the Machine Age" by Florence Loeb Kellogg in *Survey Graphic.*

PROVENANCE:
The Downtown Gallery, New York, 1931; O'Donnell Iselin, New York, by 1939; Peter Iselin and Emilie Iselin Wiggin, 1972–1974.

LITERATURE:
F.L.K. [Florence Loeb Kellogg], "Order in the Machine Age," *Survey Graphic* 20, no. 6 (March 1932) pp. 589-591, ill. p. 589; Constance Rourke, *Charles Sheeler: Artist in the American Tradition,* New York, 1938, pp. 84, 147, ill. p. 84; Robert Froman, "Charles Sheeler: 'Super Realist' with a Paintbrush," *Pageant* 3, no. 5 (1947), p. 66; Lillian Dochterman, "The Stylistic Development of the Work of Charles Sheeler," Ph.D. diss., University of Iowa, 1963, cat. no. 31.151, pp. 50, 60; Mark Savitt, "Shapes of Industry," *Arts Magazine* 50, no. 3 (November 1975), p. 9; Martin Friedman, *Charles Sheeler,* New York, 1975, p. 80, ill.; John P. Driscoll, "Charles Sheeler," *Art Journal* 36, no. 1 (1976), p. 92; Susan Fillin Yeh, "Charles Sheeler: Industry, Fashion, and the Vanguard," *Arts Magazine* 54, no. 1 (February 1980), pp. 154-158, ill. p. 155; Barbara Zabel, "The Machine as Metaphor, Model, and Microcosm: Technology in American Art," *Arts Magazine* 57, no.4 (December 1982), ill. p. 105; Susan Strickler et al., *American Traditions in Watercolor: The Worcester Art Museum Collection,* Worcester, MA, 1987, p. 100, ill.

EXHIBITIONS:
The Arts Club of Chicago, "Exhibition of Paintings and Drawings by Charles Sheeler," 1932, no. 13; Fogg Art Museum, Cambridge, MA, "Watercolors and Drawings by Burchfield, Hopper, and Sheeler," 1934; Detroit Society of Arts and Crafts, "An Exhibition of Paintings by Charles Burchfield and Charles Sheeler," 1935, no. 35; Museum of Modern Art, New York, *Charles Sheeler, Paintings, Drawings, Photographs,* 1939, no. 82, p. 51; National Collection of Fine Arts, Washington, DC, *Charles Sheeler,* 1968, no. 64, pp. 21, 120, ill. p. 120; Terry Dintenfass Gallery, New York, *Shapes of Industry: First Images in American Art,* 1975, no. 25, n. p.; Detroit Institute of Arts, *The Rouge: The Image of Industry on the Art of Charles Sheeler and Diego Rivera,* 1978, no. 29, pp. 9, 15, 16, 36, ill. p. 36; Hirshhorn Museum and Sculpture Garden, Washington, DC, *Dreams and Nightmares: Utopian Visions in Modern Art,* 1983–1984, no. 76, pp. 110, 182, ill. p. 113; Museum of Fine Arts, Boston, *Charles Sheeler: Paintings, Drawings, Photographs,* 1987–1988, vol. 1, no. 38, p. 124, ill.

STUART DAVIS

American, 1894–1964
Landscape with Garage Lights, 1932
Oil on canvas, 32 x 41⅞″
Signed lower right: *Stuart Davis*
Inscribed on reverse, on top stretcher member: *LANDSCAPE WITH GARAGE LIGHTS*; on vertical cross member: *STUART DAVIS*
Marion Stratton Gould Fund, 51.3

Stuart Davis was one of the most important American modernist artists of the thirties, a period dominated by the realism of the more numerous Regionalist, or American Scene, painters. For Davis realism was more than the telling of stories or the replication of people and places; it was the expression of a subject's spirit through the arrangement of colors and shapes.[1] In *Landscape with Garage Lights*, Davis struck a balance between an American vernacular and a modernist abstract aesthetic.

Begun in the summer of 1931 and completed in time for his exhibition in March 1932 at the Downtown Gallery in New York City,[2] *Landscape with Garage Lights* demonstrates Davis's evolving cubist-surrealist style. In these works, Davis mixed an arbitrarily composed geometry, with its freedom of forms and colors, and the vernacular architecture and schooners found in Gloucester, Massachusetts, where he spent most of his summers between 1915 and 1934. *Landscape with Garage Lights,* and indeed all of the Gloucester pictures from the summer of 1931, forcefully states that the American scene was more than the Midwestern farm; America was also a modern culture influenced by automobiles, motion pictures, and jazz.

Davis's study of the Gloucester waterfront alternated between abstraction and realism. After the somewhat abstract 1928 study *Gasoline Tank* (The Newark Museum, Newark, NJ), he shifted to a more realist scene-painting type with his 1930 *Summer Landscape* (Museum of Modern Art, New York). This concern for the factual is also shown in the photographs of the Gloucester waterfront (Stuart Davis Estate) he made at this time. Two drawings for *Landscape with Garage Lights* (Stuart Davis Estate) also demonstrate the important role that the purely formal elements of angles and flat planes of color played in the creation of this composition. Reality was the basis of the picture, but as the painting evolved, reality became secondary to the picture's compositional demands.

In his 1935 essay "Abstract Painting in America," written for the Whitney Museum of American Art, Davis asks, "What is abstract art?" He answers: "Art is not and never was a mirror reflection of nature. All efforts at imitation of nature are foredoomed to failure. Art is an understanding and interpretation of nature in various media. Our pictures will be expressions which are parallel to nature and parallel lines never meet."[3]

One of the most interesting aspects of Davis's amalgam of the actual and abstract is his use of words in this painting. The words "COAL" and "FISH" mean what they say, but their importance is chiefly pictorial. Moreover, many of the seemingly meaningless scribbles become script or calligraphically rendered forms of something actual—the rigging of schooners and fishing boats, reflections in the water, ropes on the dock, and gas pump hoses.

Landscape with Garage Lights and his 1932 exhibition represent a turning point in Davis's aesthetics, one that resulted in increasingly large paintings in which colors nearly explode and forms freely move through the pictorial space. Based on the ideas he explored in these paintings of Gloucester, Davis started to create an overall pictorial scheme to which the viewer has one response rather than discrete reactions to each part of the composition. But he always began with observations of the natural world and then abstracted from them. In this way, Davis remained true to his realist roots.

DDK

1. On July 6, 1938, Davis wrote in his "Day Books": "Reality in art is composed of shapes and colors." Quoted in *Stuart Davis,* ed. Diane Kelder, New York, 1971, p. 23.

2. Other Gloucester subjects exhibited in this show were *Landscape with Drying Sails* (Columbus Museum of Art, Columbus, OH) and *Red Cart* (Addison Gallery of American Art, Phillips Academy, Andover, MA). The notices and reviews of this exhibition are listed in *Stuart Davis Memorial Exhibition,* 1965, p. 92.

3. Quoted in Kelder, ed., *Stuart Davis,* p. 113. See also Davis's essay in the catalogue for his 1931 exhibition at the Downtown Gallery, quoted in Kelder, p. 111, and his 1927 letter.

PROVENANCE:
The artist; The Downtown Gallery, New York; Senator William Benton Encyclopaedia Britannica Collection of Contemporary American Painting, 1945–1951.

LITERATURE:
Stuart Davis, *Stuart Davis,* New York, 1945, n.p.; "Contrasts: Paintings by Lucioni and Davis," *American Artist* 10 (April 1946), pp. 34-35, ill. p. 35; Grace Pagano, ed., *The Encyclopaedia Britannica Collection of Contemporary American Painting,* Chicago, 1946, no. 33, n.p.; Edgar P. Richardson, *Painting in America: The Story of 450 Years,* New York, 1956, p. 388, fig. 164, and rev. ed., 1961, p. 344, fig. 164; Rudi Blesh, *Stuart Davis,* New York, 1960, no. 26; *The World Book Encyclopedia,* Chicago, 1969, vol. 4, p. 44, ill.; Vincent Price, *The Vincent Price Treasury of American Art,* Waukesha, WS, 1972, ill. p. 225; Roberta Smith, "Stuart Davis, Picture Builder," *Art in America* 64, no. 5 (September/October 1976), p. 85; John R. Lane, *Stuart Davis: Art and Art Theory,* New York, 1978, p. 107; Thomas Somma, "Thomas Hart Benton and Stuart Davis: Abstraction versus Realism in American Scene Painting," *Rutgers Art Review* 5 (spring 1984), pp. 51-52, fig. 4; Donald D. Keyes, "Stuart Davis: Snow on the Hills," Georgia Museum of Art *Bulletin* 12, no. 2 (winter 1987), p. 11, ill. p. 13, no. 9.

EXHIBITIONS:
The Downtown Gallery, New York, "Stuart Davis: American Scene," 1932; Arts Club of Chicago, "Three Contemporary Americans," 1945; Santa Barbara (CA) Museum of Art, *Stuart Davis, Yasuo Kuniyoshi, Franklin Watkins: Thirty Paintings,* 1949; MAG, "New Accessions of American Paintings from the Encyclopaedia Britannica Collection," 1951; Wildenstein Galleries, New York, *American and French Modern Masters,* 1955, no. 5, n.p.; The Detroit Institute of Arts and M. H. De Young Memorial Museum, San Francisco, "Painting in America: The History of 450 Years," 1957; Munson-Williams-Proctor Institute, Museum of Art, Utica, NY, and MAG, *Masters of Landscape: East and West,* 1963; National Collection of Fine Arts, Smithsonian Institution, Washington, DC, The Art Institute of Chicago, Whitney Museum of American Art, New York, The Art Galleries, University of California at Los Angeles, *Stuart Davis Memorial Exhibition,* 1965, no. 52, ill. p. 70; Museum of Fine Arts, St. Petersburg, FL, Loch Haven Art Center, Orlando, FL, Climmer Gallery of Art, Jacksonville, FL, *The City and the Machine: Their Influence on Art between the Two World Wars,* 1973, no. 28, ill. p. 42; The Brooklyn Museum, *Stuart Davis: Art and Art Theory,* 1978, no. 18, ill. p. 107; Grace Borgenicht Gallery, New York, "Stuart Davis: Paintings and Drawings from Gloucester," 1986.

ALEXANDER CALDER

American, 1898–1976
Untitled Mobile, 1935
Iron and steel, painted, h. 105½″, w. 72″, d. 41″, irregular
Gift of Charlotte Whitney Allen, 64.27

216

Alexander Calder and Charlotte Whitney Allen enjoyed a close friendship for years after they were first introduced in the 1920s. Calder would occasionally make gifts of his small sculptures and jewelry to Mrs. Allen, and she, reportedly, hosted two showings of the artist's famous *Circus* (Whitney Museum of American Art, New York) at her Rochester, New York, home.[1] It was Mrs. Allen who inspired *Untitled Mobile,* Calder's first foray into outdoor sculpture, an area of activity that later dominated the sculptor's work.

Calder described the Allen commission in his autobiography: "Mrs. Allen wanted a mobile for her garden which Fletcher Steele had designed—this was the first object I made for out of doors. As I remember, it consisted of some quite heavy iron discs that I found in a blacksmith's shop in Rochester and had then welded to rods progressively getting heavier and heavier."[2]

The idea of an outdoor mobile must have had special appeal for the sculptor in these formative years. It was a natural development of Calder's fascination with kinetic sculpture in general and, particularly, his experiments at that time with mobiles powered by air currents. The catalyst for the artist's move into mechanical abstract wire constructions had been a visit to the Paris studio of Piet Mondrian in 1930, where the sight of gridlike canvases of primary colors set against stark white walls moved Calder to tell the painter, "I would like to make them oscillate."[3] Calder's first mobile sculptures, constructed in 1930 and 1931, were motorized and akin to Mondrian's precisely engineered forms. His efforts after 1932, however, were directed toward making sculpture that moved naturally—sculptures that conveyed the elements of chance, nuance, and spontaneity which distinguish organic forms from the mechanical.

Reflecting on the role of nature in the evolution of his mobiles in the early 1930s, Calder wrote that "at the time and practically ever since, the underlying sense of form in my work has been the system of the Universe, or part thereof."[4] As a result, while the forms of his mobiles might be purely abstract, their structure represented to Calder fundamental life forces. Thus the artist, the patron, and the landscape architect could all find this mobile—with its otherwise unnatural geometric shapes and industrial materials—perfectly at home in the garden. A decade later the philosopher Jean-Paul Sartre wrote about another of Calder's sculptures and its relation to nature: "It is a little jazz tune, evanescent as the sky or the morning; if you miss it, you have lost it forever. . . . A mobile is in this way like the sea, and is equally enchanting: forever rebeginning, forever new."[5]

PJ

1. Several sculptures that Mrs. Allen remembered receiving as gifts are in the collection of the MAG. Mrs. Allen recalled the *Circus* exhibitions to Gallery curator Robert Henning (Henning note, MAG archives).

2. Calder, *Autobiography,* pp. 153-154.

3. Alexander Calder, "What Abstract Art Means to Me," in John W. McCoubrey, ed., *American Art, 1700–1960: Sources and Documents,* Englewood Cliffs, NJ, 1965, p. 209.

4. Ibid.

5. Quoted in Jean Lipman, *Calder's Universe,* New York, 1976, p. 261.

PROVENANCE:
Commissioned by Charlotte Whitney Allen, Rochester, NY.

LITERATURE:
Alexander Calder, *An Autobiography with Pictures,* New York, 1966, pp. 153-154; "Gift of Charlotte Whitney Allen: Gallery Receives Large Calder Mobile," *Brighton-Pittsford Post,* June 29, 1978, ill.

DAVID SMITH

American, 1906–1965
Big Diamond, 1952
Painted steel, h. 28⅛", w. 27⅝", d. 8⅞"
Signed, dated, and inscribed on back member (with blind stamp):
David Smith / 1952 / G2
Gift of the Charles Rand Penney Foundation, 75.300
(Top)

Untitled, 1952
Ink and tempera on paper, 15⅝ x 20⅛"
Signed and dated lower right: *DS 1/29/52*
General Acquisitions Fund, 80.52
(Bottom)

218

For David Smith the 1950s were a highly productive period of experimentation and refinement. During these years, working away from New York City at his Adirondack home near Bolton Landing (where he settled permanently in 1940), Smith turned inward for inspiration. The emotionally charged figural work of the previous decade—pieces that took form and content from the sculptor's world—gave way to increasingly intuitive and abstract sculpture. Smith's work of the 1950s, though often anthropomorphic, includes studies that explore formalism for its own sake. One such sculpture is *Big Diamond* of 1952, which is an exercise in pure line, shape, and color, revealing the sculptor's enduring interest in Cubist ideas as well as his characteristic affinity for the expressive language of the draftsman and the painter.

Smith's interest in an abstract art created from distinct images and materials of the modern age was inspired in the late 1920s by the pictorial experiments of European modernists, especially by the constructions of Picasso and Julio Gonzalez. While studying painting with modernist Jan Matulka at the Art Students League in New York, Smith produced his first steel sculptures in 1933. Reductive, flat, Cubist-derived representations of the human face, they were made—as were their direct antecedents—from found objects. These simple constructions appealed to Smith because they emphasized the clear expressive line and shape of Cubist design and encouraged his natural predilection for welding and machine assembly. Revealed in these first sculptures were formal and technical issues that Smith would champion throughout his career. From the 1930s onward, Smith's aesthetic was defined by his fascination with modern industrial materials and methods and his preference for a linear and planar mode of sculptural representation.

Big Diamond invokes Cubist design principles in several ways. Like the Cubist collage, it is an assemblage of found metal fragments and simple, prefabricated steel shapes—a playful and decorative arrangement that places industrial materials in a new context. Moreover, like painting or collage, the sculpture is strictly frontal, deriving its vitality not from the interplay of sculptural masses, but from the graphic silhouettes of colored geometric shapes seen against a backdrop or overlapping one another. As in expressionist painting, the arrangement of shapes and colors in the sculpture seems unstudied, automatic, and transitory in this piece, despite its realization in welded steel. The intuitive composition and the linear and two-dimensional character of the whole are conceits Smith developed from the modernist aesthetic to create an ambiguous and transcendent art form—a work that is less sculpture than it is, in Smith's words, a "drawing in space."[1]

Indeed, drawing is the underpinning of Smith's art. A consummate draftsman, he moved freely from one linear medium to another, and he regarded painting, drawing, and assemblage all as "segments of [his] work life."[2] "If you prefer one work over another, it is your privilege," he told his critics, "but it does not interest me. The work is a statement of identity, it comes from a stream, it is related to my past works, the three or four works in process, and the work yet to come."[3] Frequently these related works were drawings and paintings.

Paintings and drawings play an important, if not wholly understood, role in the genesis and progress of Smith's pictorial ideas.

There are several color drawings that clearly relate to *Big Diamond,* including one in the Gallery's collection (80.52).[4] These cannot be taken, however, simply as preparatory studies.[5] Rather, they are more correctly regarded as interdependent parts of a single vision, as Smith worked through an idea over and over again in a variety of media.[6]

PJ

1. Rosalind E. Krauss, *Terminal Iron Works: The Sculpture of David Smith,* Cambridge, MA, 1971, p. 161.

2. Miranda McClintic, "David Smith: Painter, Sculptor, Draftsman," in Edward F. Fry and Miranda McClintic, *David Smith: Painter, Sculptor, Draftsman,* New York, 1983, p. 24.

3. Ibid.

4. See Paul Cummings, *David Smith: The Drawings,* New York, 1979, nos. 28 and 33 for related examples dated as early as 1950.

5. Krauss, *Sculpture,* p. 125.

6. This is McClintic's thesis; see Fry and McClintic, *David Smith,* pp. 24-39.

PROVENANCE:
Estate of the artist; donor, Olcott, NY, 1967 (through Marlborough-Gerson Gallery, Inc., New York).

LITERATURE:
Rosalind E. Krauss, *The Sculpture of David Smith: A Catalogue Raisonné,* New York, 1977, no. 247 (incorrectly dated 1951), fig. 247.

HANS HOFMANN

American (b. Germany), 1880–1966
Ruby Gold, 1959
Oil on canvas, 55 ³⁄₁₆ x 40½″
Signed and dated lower right: *Hans Hofmann '59*
Marion Stratton Gould Fund, 60.37

As teacher and painter, Hans Hofmann played an influential role in American art of the post-World War II period. Although older and more experienced, Hofmann is considered a pioneering member of the first generation of Abstract Expressionists and is linked with Jackson Pollock, Willem De Kooning, Franz Kline, and others who transformed American painting in the 1940s and 1950s. His work, however, differed from that of the younger American artists. Unlike their often monochromatic canvases, Hofmann's paintings are suffused with color, and radiate a hedonistic enjoyment of life rather than a sense of anguish or personal crisis. They are neither environmental in scale nor confessional in intent. Remaining true to his European training, Hofmann pursued a self-referential style of painting that had metaphysical meaning for him.

Hofmann was born in 1880 in Weissenberg, Bavaria. He received some academic training in Munich in his youth but was sent to Paris by a wealthy patron in 1903. There he studied alongside Matisse, met Picasso, Braque, Gris, and the Delaunays, and was exposed to Fauvism and Cubism. When World War I erupted, Hofmann returned to Munich and there, to support himself, started his first art school, teaching the new methods of pictorial construction he had learned in Paris.

In 1930 one of his American students, the artist Worth Ryder, invited him to teach for a summer at the University of California, Berkeley, and three years later Hofmann moved permanently to the United States, where he established first his famous art school on 8th Street in New York City, and then, in 1935, the summer school in Provincetown, Massachusetts. At these schools he taught two generations of artists, including Robert Goodnough (67.34, 86.139), Helen Frankenthaler (81.13, p. 235), Ida Kohlmeyer (63.19), and Wolf Kahn (85.59, p. 235), artists whose paintings are also represented in the Gallery's collection.

Because Hofmann was known primarily as a teacher during these years, the experimental character of his own painting was not revealed until 1944 when Peggy Guggenheim offered him a one-man show at her Art of This Century Gallery. Hofmann found it difficult, however, to pursue both careers simultaneously, because, as he said, "when I paint, I want not to think; when I teach I must explain everything." [1] So in 1958, at the age of seventy-eight, he gave up teaching and devoted himself full-time to painting.

Ruby Gold, painted the following year, was part of a new body of work that was exhibited at the Samuel M. Kootz Gallery early in 1960. New in these works are the floating rectangles of flat color. [2] A counterpoint to the more painterly and varied recessive elements, these enlarged color planes give a classic structure to the composition while allowing Hofmann to create dynamic spatial effects. As one critic described it, Hofmann had at last achieved a balance between "what you would call his Apollonian and Dionysian sides: his penchant for structure and high voltage impasto." [3]

The paintings, executed during these last eight years of his life, are considered his signature works. Although they are characteristically varied in the range of effects achieved with pure color and exuberant brushwork, the best works, like *Ruby Gold,* incorporate oppositions between sharply defined rectangles and looser swatches of color, between warm and cool colors, and between smoothly plastered and erupted surfaces. Particularly in *Ruby Gold,* the color is intensified to a fever pitch. While the vermilions and magentas dominate and are closely keyed in value, they appear even more intense because they are juxtaposed with their complementaries, the greens and the blue, in the center.

Hofmann delighted in what he called "the push-pull effect" created by these color oppositions, the tendency of colors to expand or contract, creating the illusion of the three dimensions while affirming through the tactility of the paint the integrity of the painting as a two-dimensional surface. The spatial effect thus created is not a cavity as in Renaissance perspective, nor is it necessarily descriptive of a given volume; it is the dynamic sensation of space in the abstract.

Hofmann's concern with formal problems and their metaphysical implications stems from Paul Cézanne. Like Cézanne, Hofmann always painted from a subject, however transformed it might become in the painting process. And like Cézanne, Hofmann believed that color and form were synonymous, the only difference being that "in nature, light creates the color; in the picture, color creates light." [4] Thus in painting, the luminous quality of a color is the result of color relationships.

This realization—that a painting was about relationships, and that through those relationships a painting acquired a life of its own—had metaphysical significance for Hofmann. In his essay "The Search for the Real," he wrote: "The relative meaning of two physical facts in an emotionally controlled relation always creates the phenomenon of a third set of a higher order, just as two musical sounds, heard simultaneously create the phenomenon of a third, fourth, or fifth. The nature of this higher order is nonphysical. In a sense it is magic." [5]

Ruby Gold is the perfect embodiment of Hofmann's aspiration to synthesize his European heritage with the moral imperative of postwar America. Because of his preoccupation with the plastic and psychological power of pure color and its spiritual meaning, Hofmann may be seen as a bridge between the gestural abstractionists, Pollock, De Kooning and Kline, and the color-field painters, Mark Rothko, Barnett Newman and Ad Reinhardt.

PK

1. Erle Loran, *Recent Gifts and Loans of Paintings by Hans Hofmann,* Berkeley, 1964, p. 15.

2. Coates, *New Yorker,* January 23, 1960, p. 84.

3. Hoene, "Balanced Collection," p. 32.

4. Hans Hofmann, "The Color Problem in Pure Painting—Its Creative Origin," in *Hans Hofmann,* ed. Frederick S. Wight, Berkeley, CA, 1957, p. 51.

5. Hans Hofmann, *The Search for the Real and Other Essays,* ed. Sarah T. Weeks and Bartlett H. Hayes, Jr., Andover, MA, 1948, p. 47.

PROVENANCE:
Purchased from Samuel M. Kootz Gallery, New York, 1960.

LITERATURE:
Robert M. Coates, *The New Yorker,* January 23, 1960, p. 84; Hans Hofmann, *Hans Hofmann,* New York, 1963, fig. 115; Anne Hoene, "A Balanced Collection," *The Art Gallery* 11, no. 10 (summer 1968), ill. p. 32; Vincent Price, *The Vincent Price Treasury of American Art,* Waukesha, WS, 1972, ill. p. 260.

EXHIBITIONS:
State University of New York College of Education at Oswego, *Centennial Exhibition,* 1961, ill.; Minneapolis Institute of Arts, *Four Centuries of American Art,* 1963, n.p.; New York State Exposition, Syracuse, *Five Distinguished American Artists: Dickinson, Hofmann, Hopper, Shahn, Soyer,* 1965, no. 19; The Art Center, South Bend (IN), *Twentieth-Century American Masters,* 1978, pp. 30-31, ill.

BEVERLY PEPPER

American, (b. 1924)
Vertical Ventaglio, ca. 1967–1969
Stainless and carbon steel with automotive paint,
h. 104⅜″, w. 43½″, d. 86″
Gift of Charles Rand Penney, 78.195

Trained first as a commercial artist in New York City and then as a painter in Paris, Beverly Pepper did not turn seriously to sculpture until she was in her mid-thirties. As a sculptor, however, she quickly earned an international reputation. In 1961, after only a few years of working three-dimensionally, she was invited with nine other sculptors—among them David Smith, Alexander Calder, and Lynn Chadwick—to create work to be included in Italy's 1962 Festival dei due mondi at Spoleto. The pieces in the Spoleto festival that year were all made in Italian factories, where Pepper first worked extensively with industrial techniques and materials that would become critical elements in her later work. The Spoleto festival was a turning point in her career. Not only did she learn that the factory was an ideal creative environment for her, but she also established herself professionally alongside internationally known sculptors.

Vertical Ventaglio is one of a series of highly polished stainless steel sculptures made between 1967 and 1969.[1] In this series, Pepper explored precipitously balanced arrangements of rectangular and trapezoidal shapes. These open-ended boxlike forms all have reflective chromelike exteriors and colored enamel interiors. With its three cascading rectangles, cantilevered from a diagonal base, *Vertical Ventaglio* suggests a stop-frame diagram of an object falling through space. Implied movement, as in this piece, is an essential element throughout the series. Occasionally, Pepper even implied a sequence of movements from sculpture to sculpture. A sheet of drawings from one of Pepper's notebooks shows preliminary sketches for both *Vertical Ventaglio* and a closely related variant.[2] The tension of arrested movement is obviously important in both of these pieces individually, but when the drawings and sculpture are considered together, the suggestion of implied motion is confirmed and the tension is heightened.

Through the materials Pepper chose for this series—gleaming steel and richly enameled interiors—she refers to the contemporary industrial world. The interior of *Vertical Ventaglio* is coated with "Fiat Blue," a color and type of paint designed by the Italian automobile industry. There is also a secretive, metaphorical quality to Pepper's use of color in this series. Painted on the inside of the mirrorlike surfaces, the colors are not immediately noticed but gradually reveal themselves. Enclosing blue within these boxes is particularly effective in this piece when the blue of the sky is reflected on the exterior.

Critic and historian of twentieth-century sculpture Rosalind E. Krauss wrote that Pepper "mastered abstraction" in this series.[3] Intrigued with the conceptual issues raised in these pieces, particularly the paradoxical allusions to painting, Krauss wrote: "it is the frame that carries the image, while the space inside the bounding surface is empty."[4] Of this series, Pepper herself has said, "the idea is that from whatever angle you view it, the voids seem filled and the solids seem empty."[5]

Although she did not consciously recognize it until later, in the stainless steel series Pepper began to integrate the environment into her work. Writing in the mid-1970s, she explained, "I am using the environment in such a way that people are able to experience it. I realize that even in the polished steel, illusory sculptures where I was interested in capturing the illusion of sky and in the differences between the grass and the sculpture, I was trying to do exactly what I am trying to do now, to make the environment a part of the work.... [The steel sculptures] had to do with absorbing and disappearing in the landscape. At certain times of day, you couldn't even see the pieces because they became invisible against the sky."[6]

Beverly Pepper has lived principally in Italy since the 1950s, but she considers herself an American artist. "The thing that has kept me an American artist and not an Italian artist has been the simple fact that virtually every year since 1963 I have worked in a factory in America."[7] The greatest influences on her work are also American. David Smith's importance is clear, as is that of the Minimalist sculptor Donald Judd and such environmental sculptors as Robert Smithson and Richard Serra. After the illusory sculptures of the 1960s, Pepper began a series of site-specific environmental pieces. During the late seventies and early eighties, she began a series of late twentieth-century monuments derived from familiar toollike shapes. Underlying these wide-ranging visual explorations, however, is a constant instinct: "The abstract language of form that I have chosen has become a way to explore an interior life of feeling.... I wish to make an object that has a powerful presence, but is at the same time inwardly turned, seeming capable of intense self-absorption."[8]

SDP

1. Beverly Pepper described *Vertical Ventaglio* as one of her favorite pieces, in the Charles Rand Penney Lecture, Wilson Arts Center, Rochester, NY, March 13, 1988. In this lecture, she also said that the title of the piece comes from the Italian word *ventaglio*, meaning fan.

2. See illustration of pages from Pepper's sketchbooks in Rosalind E. Krauss, *Beverly Pepper: Sculpture in Place*, Buffalo, NY, 1986, p. 64.

3. Ibid., p. 59.

4. Ibid., p. 55.

5. Ibid., p. 62.

6. Jan Butterfield and Beverly Pepper, "Beverly Pepper: 'A Space Has Many Aspects,'" *Arts Magazine* 50, no. 1 (September 1975), p. 92.

7. Ibid., p. 92.

8. Krauss, *Beverly Pepper*, p. 13.

PROVENANCE:
Marlborough-Gerson Gallery, New York; Charles Rand Penney, Olcott, NY.

EXHIBITIONS:
Marlborough-Gerson Gallery, New York (circulated), *Beverly Pepper: Recent Sculpture*, 1969, no. 24, ill.

American, 1907–1975
The Beginning of the Fields, 1973
Oil on canvas, 52 x 76⅛"
Signed and dated lower right: *Fairfield Porter '73;*
inscribed on stretcher: *The Beginning of the Fields '73 Fairfield Porter*
Marion Stratton Gould Fund, 86.132

Although Fairfield Porter has long been known for his rather intimate depiction of still life, figure, and interior, he is perhaps best appreciated for his landscapes, which comprise more than half his oeuvre and are for the most part views of Maine and Long Island.

In *The Beginning of the Fields,* Porter achieves a subtle balance between vastness and intimacy. The scene is an intersection of a road near immense potato fields on eastern Long Island. The desired effect, however, is not the depiction of scenic grandeur, but rendering familiar, almost intimate, the potentially limitless and vacant fields. It is achieved first through a keen sense of composition. Porter's use of strong diagonal thrusts helps to define and to limit the potential empty vastness of the scene. Second, Porter has populated the landscape with ordinary objects: property and street signs, a car, distant houses. Ultimately he renders a scene that, for all its seemingly empty expanse, is almost as familiar as a room in his home.

Light, the single most important element in Porter's paintings, is the principal transcending force that orders his and, therefore, the viewer's perceptual experience. As Porter's work matures from the late 1940s onward, and light becomes increasingly his primary interest, his paintings become more confident, light-filled, and paler in tone.

Rarely was light so successfully used as subject matter as in *The Beginning of the Fields,* one of Porter's late masterpieces. In Porter's paintings of the 1970s, the images become increasingly understated and his canvases more spare, soft, and luminous. In *The Beginning of the Fields,* he began moving beyond the natural light-soaked effects of Impressionism to a more profoundly subjective approach.
PDS

PROVENANCE:
Hirschl and Adler Galleries, Inc., New York; Private collection, NC; sold Sotheby's, New York, December 4, 1986, lot 312.

LITERATURE:
John Ashbery and Kenworth Moffett, *Fairfield Porter (1907–1975): Realist Painter in An Age of Abstraction,* Boston, 1983, p. 38; Hilton Kramer, *New York Times,* March 9, 1974; Paul Cummings, "Interview with Fairfield Porter," *American Artist,* April 1975, p. 37, ill.; Michael Brenson, "Art: Porter on Display," *New York Times,* September 13, 1985, sec. C, p. 24.

EXHIBITIONS:
Hirschl and Adler Galleries, Inc., New York, *Fairfield Porter,* 1974, no. 31, ill.; Hirschl and Adler Modern, New York, *Fairfield Porter,* 1985, no. 34, ill.

JACQUES SICARD
(FOR WELLER POTTERY, ZANESVILLE, OH)

French, 1865–1923 (active in America 1901–1907)
Gourd Form Vase, ca. 1902
Ceramic with iridescent glaze, 16⅞ x diam. 11″
Gift of E. Martin and Angeline Guzzetta Jones in memory
of John W. Guzzetta, 86.136

JOHN SINGER SARGENT

American, 1856–1925
Mrs. Charles Hunter, ca. 1904
Charcoal on paper, 23¾ x 18⅜″
Gift of James O. Belden in memory of Evelyn Berry Belden, 70.52

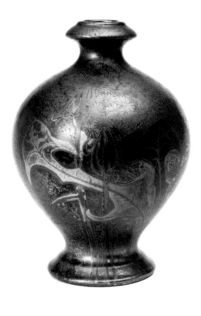

FREDERICK CHILDE HASSAM

American, 1859–1935
The Bathers, 1904
Oil on canvas, 48³⁄₁₆ x 148¼″
Gift of Mr. and Mrs. Ogden Phipps, 63.27

JOHN SLOAN

American, 1871–1951
Election Night, 1907
Oil on canvas, 26⅜ x 32¼"
Marion Stratton Gould Fund, 41.33

JOHN SLOAN

American, 1871–1951
Chinese Restaurant, 1909
Oil on canvas, 26 x 32¼"
Marion Stratton Gould Fund, 51.12

EVERETT SHINN

American, 1876–1953
Sullivan Street, 1905
Oil on canvas, 8 x 10"
Marion Stratton Gould Fund, 45.45

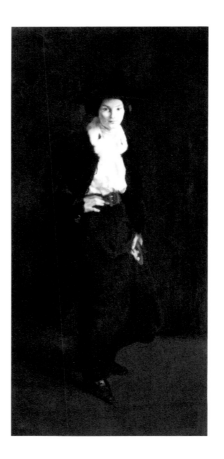

GEORGE BELLOWS

American, 1882–1925
Evening Group, 1914
Oil on composition board, 25 x 30″
Marion Stratton Gould Fund, 47.13

WILLIAM GLACKENS

American, 1870–1938
Beach at Blue Point, ca. 1915
Oil on canvas, 25 ¼ x 30 ⅛ ″
Elizabeth R. Grauwiller Bequest, 73.12

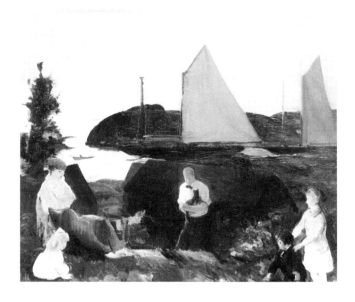

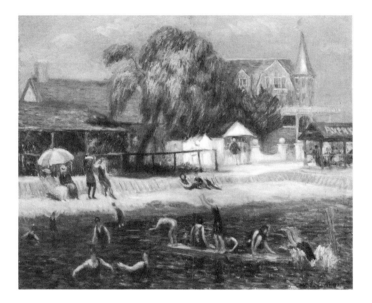

ELIE NADELMAN

American, 1882–1946
Head of a Woman, ca. 1916–1932
Polished bronze, 18 ¾ x 10 x 15 ½ ″
Anonymous gift in honor of Gertrude Herdle Moore, 62.7

CHARLES DEMUTH

American, 1883–1935
Zinnias, 1915
Watercolor on paper, 8 ⅝ x 10 ⅞ ″
Gift of Gertrude Herdle Moore and Isabel C. Herdle in memory of their father, George L. Herdle, 64.86

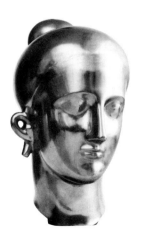

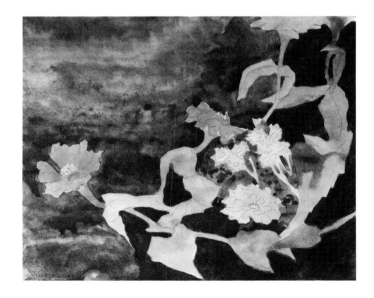

GEORGE GREY BARNARD

American, 1863–1938
Abraham Lincoln, ca. 1918
Marble, 21 x 11 7/8 x 14 7/16"
Marion Stratton Gould Fund, 86.5

GEORGE BELLOWS

American, 1882–1925
Stag at Sharkey's, 1917
Lithograph, 21 x 26 1/4"
Gift of Charlotte Whitney Allen, 64.31

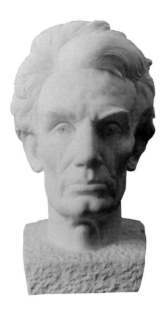

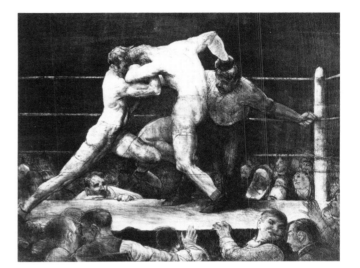

WARREN WHEELOCK

American, 1880–1960
*Le coq d'or: Chanticleer Greeting the Sun, From Chanticleer's Point of View,
Causing the Sun to Rise,* ca. 1923
Polished bronze with marble base, 28 3/4 x diam. 12"
Marion Stratton Gould Fund, 77.105

CHARLES BURCHFIELD

American, 1893–1967
Cat-Eyed House (*Snow-lit House*), 1918
Watercolor and pencil on paper, 18 1/4 x 22 1/4"
Marion Stratton Gould Fund, 44.53

ARTHUR DOVE

American, 1880–1946
Cars in a Sleet Storm, 1938
Oil on canvas, 15 x 21"
Marion Stratton Gould Fund, 51.4

REGINALD MARSH

American, 1898–1954
People's Follies No. 3, 1938
Egg tempera on composition board, 25 ⅞ x 39"
Marion Stratton Gould Fund, 43.1

RALSTON CRAWFORD

American, 1906–1978
Whitestone Bridge, 1939
Oil on canvas, 40 ¼ x 32"
Marion Stratton Gould Fund, 51.2

MARSDEN HARTLEY

American, 1877–1943
Waterfall, Morse Pond, 1940
Oil on board, 22 x 28"
Marion Stratton Gould Fund, 65.59

JOHN KOCH

American, 1909–1978
Interlude, 1963
Oil on canvas, 50⅛ x 39⅞"
Gift of Mr. and Mrs. Thomas H. Hawks, 65.12

WILLIAM GROPPER

American, 1897–1977
The Opposition, 1942
Oil on canvas, 28 x 38"
Marion Stratton Gould Fund, 51.5

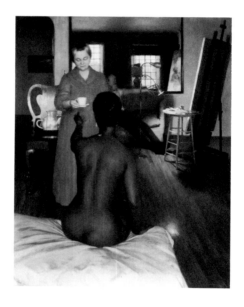

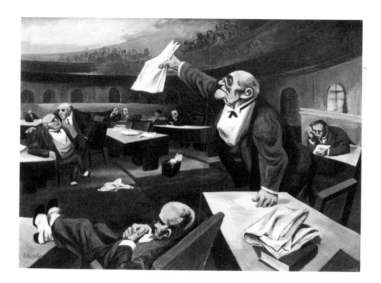

MILTON AVERY

American, 1893–1965
Haircut by the Sea, 1943
Oil on canvas, 44 x 32"
Gift of Roy R. Neuberger, 63.21

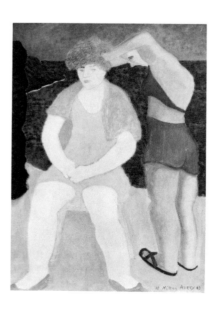

ISAMU NOGUCHI

American, (b. 1904)
Calligraphics, 1957
Cast iron, wood, and rope, 70⅝ x 18 x 18″
R. T. Miller Bequest, 60.2

MARK TOBEY

American, 1890–1976
Prairie Red, 1964
Tempera on paper, 55⅝ x 27¾″
Marion Stratton Gould Fund, 69.43

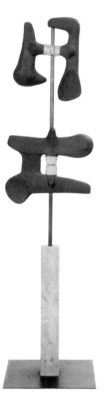

RUFINO TAMAYO

Mexican, (b. 1899)
Quetzalcoatl, 1979
Mixograph on handmade paper, 27 x 51½″
Hilda Coates Fund, 86.8

HELEN FRANKENTHALER

American, (b. 1928)
Seer, 1980
Acrylic on canvas, 93½ x 85⅛ "
Gift of the Women's Council on the occasion of
the Council's 40th anniversary, 81.13

ALFRED LESLIE

American, (b. 1927)
Untitled, 1960–1961
Oil on canvas, mounted on board, 80 x 100½ "
Marion Stratton Gould Fund, 67.9

WAYNE THIEBAUD

American, (b. 1920)
River Pond, 1967–1975
Acrylic on canvas, 74⅛ x 76¹/₁₆ "
Joseph C. Wilson Memorial Fund, 75.421

WOLF KAHN

American, (b. 1927)
Evening Glow, 1982
Oil on canvas, 52¼ x 76¼ "
Gift of Mr. and Mrs. Julius G. Kayser, 85.59

JOYCE TREIMAN

American, (b. 1922)
The Parting, 1983
Oil on canvas, 80 x 60"
Marion Stratton Gould Fund, 86.15

JEROME WITKIN

American, (b. 1939)
Breaking the Pose (The Art Class), 1986
Oil on canvas, 88 x 71"
Marion Stratton Gould Fund, 86.16

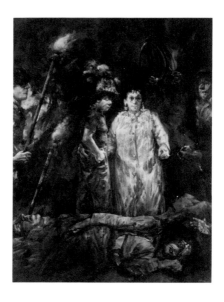

ROY DE FOREST

American, (b. 1930)
The Dipolar Girls Take a Voyage on the St. Lawrence, 1970
Acrylic, polymer, and charcoal on canvas, 70¾ x 64½"
Gift of Charles and Setta Odoroff in honor of
Maurice and Minnie Odoroff, 86.134

WENDELL CASTLE

American, (b. 1932)
Dr. Caligari, 1984
Curly cherry veneer, ebony, gold-plated brass,
92½ x 31½ x 26½"
Gift in honor of Joan M. Vanden Brul
by Her Family, 88.1

ALBERT PALEY

American, (b. 1944)
Convergence, 1987
Forged steel, polychromed, 107 x 77½ x 16½"
Gift in honor of Herbert W. Vanden Brul made possible by Harris
Corporation-RF Communications Division, Vanden Brul family
members and friends, and the artist, 87.61

238

CONTENTS

ART OF AFRICA, OCEANIA & THE AMERICAS

Door Lock, 20th century
Wood, metal, h. 26″, w. 16⅜″, d. 3¼″
Marion Stratton Gould Fund, 69.71

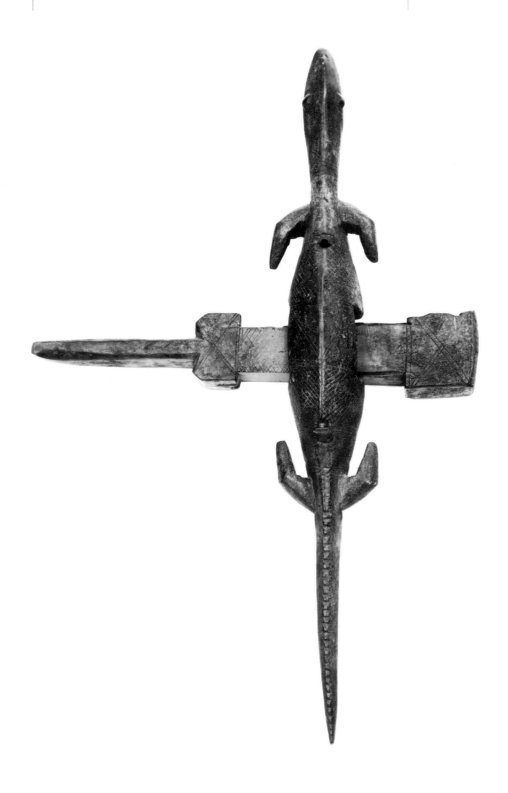

The Bamana are sedentary agriculturalists who raise millet, corn, and rice. They live in southeastern Mali along the Niger River. The arts of the Bamana are diverse and include ceremonial wooden masks and figures and secular objects such as the wooden doors and locks found on individual rooms and family granaries. Bamana locks are composed of a horizontal wood and metal bar that slides back and forth into a hole in the door jamb; vertical metal pins fit into holes in the horizontal bar. Once the lock is engaged, a wooden or metal key is used to release the pins and unlock the door.

The mechanics of the Bamana door locks are derived from Moslem locks, their decorative motifs from human and animal forms. The crocodile that decorates this lock plays an important role in the mythology of several ethnic groups in sub-Saharan Africa. In these myths, the crocodile often transports a clan's ancestor-founders to the group's present location. On a lock, the crocodile serves in his role as protector and clan totem by safeguarding the inhabitants or contents of the room. Locks with human forms evoke ancestral guidance and protection.

The elongated, angular, stylized body of the crocodile is characteristic of Bamana carving, particularly the conventions and style of the Western Sudanic ethnic complex. Elaborate surface decoration embellishes the carving: incised cross-hatchings cover the body, and deep notches ornament the ridge of the tail. Parallel and intersecting lines on the crocodile's face reflect scarification patterns found also on carvings of Bamana men and women.

CMK

PROVENANCE:
Afrantique Arts, Wyckoff, NJ.

EXHIBITIONS:
Harnett Gallery, University of Rochester, NY, "African Art: Changing Traditions in Mali," 1980, no. 9.

Female Figure, 19th–20th century
Wood, h. 17¼", w. 3¼", d. 3"
Marion Stratton Gould Fund, 69.33

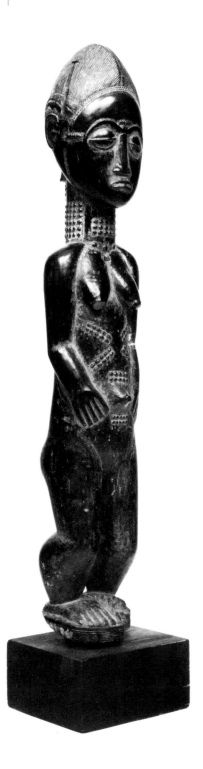

The Baule are agriculturalists who inhabit the forest zone of central Ivory Coast. They are part of the large Akan culture complex, which stretches from south central Ivory Coast eastward to the western border of Nigeria. Among the Akan, the Baule are renowned for their leadership, ritual, and household arts.

Baule woodcarvers produce two types of figures, spirit spouses and nature spirits. In Baule traditional belief, each person is paired with a spirit spouse from the other world: a man has a spirit wife (*Blolo Bla*), and a woman has a spirit husband (*Blolo Bian*). The presence of one's spirit spouse is made known through divination, usually in response to a problem that has been plaguing an individual or a member of a family. The diviner, a soothsayer and traditional medical practitioner, reveals that the spirit spouse is the source of the problem and advises his client to commission a carving, the image for which is revealed to the individual through dreams and interpreted during divination sessions. The carving is placed in a prominent and secure place in the owner's sleeping room; it is frequently handled and anointed with oil, giving the figure a lustrous patina and ensuring the spirit's protection and good will.

Nature spirits (*Asie Usu*) are also placated by the carving of wooden figures, which are placed in shrines and given periodic libations and offerings of eggs and the blood of sacrificial animals. These figures are identical in form to those carved to represent spirit spouses. Only the grimy, encrusted patina that results from their ritual use distinguishes nature spirits from spirit spouses. Since many Baule carvings are cleaned before sale on the tourist market, it is impossible to determine with certainty which type of figure is represented here.

This female figure exemplifies the highly sophisticated Baule woodcarving style, which is distinguished by refinement in technique and form and a predilection for surface embellishment. Raised linear patterns are clustered around the figure's neck, abdomen, and navel and along the back. These decorative cicatrices reflect traditional styles of feminine beauty, as does the elaborate coiffure composed of closely spaced parallel grooves. The contained posture, introspective expression, and traditional forms of body decoration represent fundamental Baule social virtues, which stress adherence to tradition and proper decorum. The carving also represents youthfulness, vigor, balance, and proportion, which are ideal qualities for the Baule.
CMK

PROVENANCE:
Ludwig Bretschneider, Munich (dealer).

DYIMINI (JIMINI), IVORY COAST

Face Mask, 20th century
Wood, pigment, h. 13¼″, w. 4¾″, d. 4¼″
Marion Stratton Gould Fund, 70.21

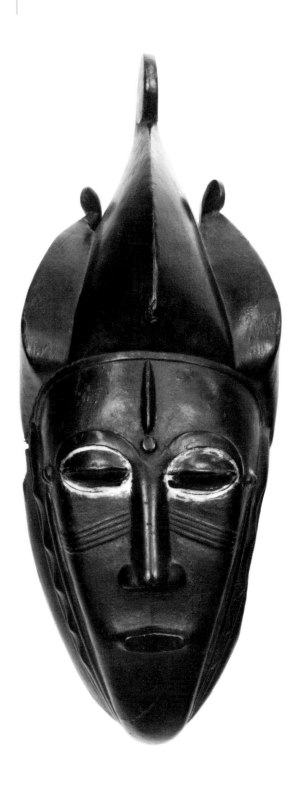

The Dyimini (Jimini) live in northern Ivory Coast. Although they are culturally and linguistically related to the Senufo, a large ethnic complex, there are specific characteristics that distinguish the Dyimini as a distinct people.

Illustrations of Dyimini masks have appeared in the literature devoted to the arts of sub-Saharan Africa, but there is little specific information on the types, styles, and functions of this art form. Limited though the scholarship is, characteristics specific to Dyimini face masks have been identified, and the Gallery's is recognizably in the Dyimini style.

The mask typically has a lustrous black surface and carefully modeled features that project from the elongated, flattened facial plane. The protruding oval eyes and pursed lips are emphasized with pigments, usually white, red, or blue. The linear scarification patterns that adorn the mask's forehead and cheeks and the elaborate tripartite coiffure that curves gracefully above the head and terminates in forward-curling spirals are expressions of Dyimini ideals of beauty.

Throughout Africa, the visualization of idealized notions of beauty often illustrates what a society considers to be admirable qualities and moral values. The incised linear patterns and raised serrated edge that frame the face may depict a stylized beard, a symbol common in much of the art of West Africa, denoting wisdom and authority achieved with age and experience.

Dyimini face masks probably function, as Senufo masks do, within *Poro,* the men's secret association that provides the traditional educational, religious, and social training for adolescent males. Masks and figures used in Poro are restricted to men; for the most part, women are forbidden to see and use these carvings and to learn the secrets of this powerful society. Different masks are worn for different ceremonies. A variety are worn in dances during stages of initiation training and in performances that mark the conclusion of the initiation cycle. Other masks are worn at mortuary rituals to honor deceased members of Poro.

Poro masks depict the terrifying and the ferocious, the serene and the beautiful, and represent both male and female qualities to instruct and unify the community. On this mask in the center of the forehead, as in virtually all Senufo masks, there is an elliptical mark that may be a symbol of the female genitalia. It represents, for at least one Senufo group, the Poro initiate's union with the earth and emphasizes the importance of female sexuality and fertility in Senufo society.[1]
CMK

1. Anita J. Glaze, "Dialectics of Gender in Senufo Masquerades," *African Arts* 19 (1986), p. 32.

PROVENANCE:
Afrantique Arts, Wyckoff, NJ.

Yoruba (Southern Ekiti), Nigeria, d. 1938
Veranda Post, ca. 1910
Wood, pigment, h. 56″, w. 11″, d. 10″
Marion Stratton Gould Fund, 71.13

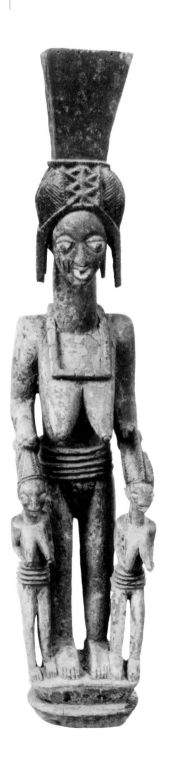

Africa's most populous nation, Nigeria, is home to the Yoruba, a large ethnic group who live in the southwestern portion of the country. They are prolific artists with a well-developed aesthetic vocabulary. The Yoruba pantheon is the focus of numerous wooden, iron, and bronze figures and staffs that adorn shrines and are carried by cult devotees. Wooden masks and figures manifest the power and status of local political rulers, old women, and twins.

Yoruba artisans also produce an impressive array of handsomely carved and decorated domestic objects and architectural sculpture. This decorative veranda post was carved about 1910 by Olowe of Ise, a renowned carver from southern Ekiti who died in 1938. The post is one of three that adorned the palace of the Ogoga of Ikere. Olowe also produced a number of doors and lidded vessels for Yoruba palaces; the carvings are remarkable for their complicated high-relief ensembles of figures depicting palace and local genre scenes.

William Fagg, noted authority on the arts of sub-Saharan Africa, photographed the Ikere palace veranda posts in situ in the early 1960s. The arrangement of the three posts reflected the hierarchy of the Ogoga's court. The central post depicted the ruler seated on a throne and dressed in full royal regalia, including a beaded crown, a traditional insignia of political authority for the Yoruba. He is supported by his senior wife, who stands behind him; smaller figures in front signify palace retainers. The king was flanked by the other two posts, a mounted warrior on the left and, on the right, this one of the king's second wife with attendants. Her high rank within the court is indicated by her elaborate dress and coiffure and the authoritative gesture of resting her hands on the heads of royal attendants. The importance of motherhood and continuity of the lineage is emphasized in the figure's pendulous breasts. The gestures of the two smaller females reinforce this symbol. Traces of pigment suggest that these veranda posts were once brightly painted and traditionally would have been regularly refurbished.

Olowe of Ise has been called "perhaps the best and most original Yoruba carver of this century," and his skill is evident in the craftsmanship of this veranda post.[1] The rounded female figures and the high relief of surface embellishment effectively balance the massive architectural bulk of the post. A series of parallel grooves and deeply cut triangular motifs define the central figure's four-lobed coiffure. Elaborate scarification patterns, which ornament her neck and back, are composed of linear, cross-hatched, and stippled designs placed in vertical registers and within triangular and rectangular perimeters. These embellishments demonstrate the artist's technical mastery and exemplify Yoruba aesthetic notions that reflect ideal physical and moral qualities.

CMK

1. Fagg and Plass, *African Sculpture,* p. 90.

PROVENANCE:
From the palace of the Ogoga of Ikere; Everett Rassiga, Inc., New York.

LITERATURE:
William Fagg and Margaret Plass, *African Sculpture, An Anthology,* London, 1964, p. 90, ill.; Linda Q. Green, "The Yoruba Housepost," M.A. thesis, University of Rochester, 1973; William A. Fagaly, "African Art at the New Orleans Museum of Art," *African Arts* 11, no. 4 (1978), p. 23.

AFRICAN (CENTRAL GUINEA COAST STYLE ZONE, ASANTE CULTURE, GHANA), 20TH CENTURY

Female Figure with Child
Wood and iron, 11¼ x 3¾ x 3⅞"
Marion Stratton Gould Fund, 70.62

AFRICAN (CENTRAL GUINEA COAST STYLE ZONE, ASANTE CULTURE, GHANA), 20TH CENTURY

Stool
Wood, 10¾ x 18 x 9"
Anonymous gift, 62.24

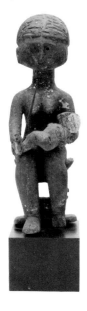

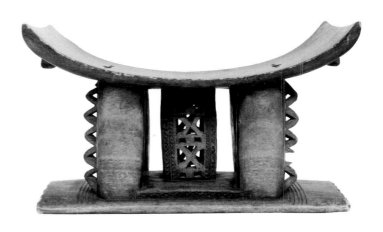

AFRICAN (EASTERN GUINEA COAST/EQUATORIAL FOREST STYLE ZONES, UNDETERMINED CULTURE [BAMUM/BAMILEKE?], GRASSLANDS REGION, CAMEROON), 20TH CENTURY

Crest Mask
Wood, 15⁵⁄₁₆ x 13¾ x 14⅝"
Marion Stratton Gould Fund, 71.20

AFRICAN (WESTERN GUINEA COAST STYLE ZONE, MENDE CULTURE, SIERRA LEONE), 20TH CENTURY

Helmet Mask (Sowei) for the Sande Society
Wood, 15½ x diam. 8⅞"
Marion Stratton Gould Fund, 72.52

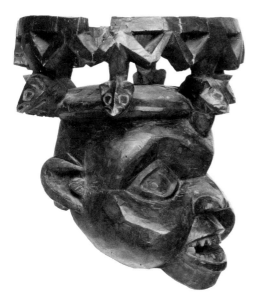

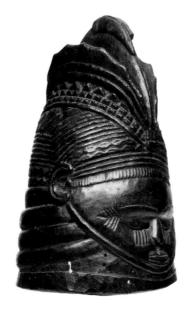

AFRICAN (CENTRAL GUINEA COAST style zone, OGONI CULTURE, NIGERIA), 20TH CENTURY

Articulated Face Mask (Elu)
Wood, pigment, and fiber, 7 ½ x 4 ¾ x 4 ⅝ "
Marion Stratton Gould Fund, 72.53

AFRICAN (WESTERN SUDAN style zone, SENUFO CULTURE, IVORY COAST), 20TH CENTURY

Horizontal Helmet Mask (Kponyungo)
Wood, 14 ⅜ x 25 ¾ x 13"
Marion Stratton Gould Fund, 70.22

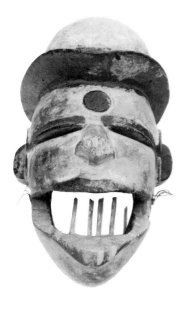

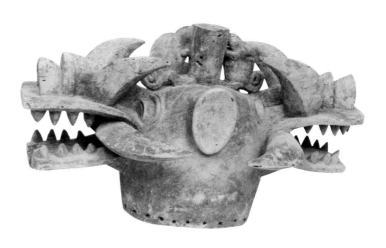

AFRICAN (WESTERN SUDAN style zone, SENUFO CULTURE, IVORY COAST), 20TH CENTURY

Attendant Figure or Rhythm Pounder (Deble)
Wood, 44 ⅛ x 9 ⅛ x 6 ¹¹/₁₆"
Marion Stratton Gould Fund, 69.72

AFRICAN (CENTRAL GUINEA COAST style zone, YORUBA CULTURE, NIGERIA), 20TH CENTURY

Twin Figures (Ere Ibeji)
Wood, pigment, beads, cowrie shells, and fiber,
9 ⅜ x 2 ⅝ x 2 ¾ " and 9 ¼ x 2 ⅜ x 2 ⅝ "
Marion Stratton Gould Fund, 65.9.1-.2

KARARAU REGION,
MIDDLE SEPIK RIVER
NEW GUINEA, MELANESIA (OCEANIA)

Clan Mask, 20th century
Cane fibers, shells, feathers, pigment, h. 96″
Marion Stratton Gould Fund, 73.138

The island of New Guinea is at the western end of the Melanesian archipelago in the South Pacific. It is home to a diverse people whose prolific artistic traditions have produced some of the world's most powerful and visually striking art. New Guinea's Sepik River, which stretches approximately seven hundred miles northeastward from the central highlands to near the center of the island's north coast, is a major trade and communication artery. The artistic production of the people who live along the Sepik River and its tributaries exhibits the broad range of forms, styles, media, and functions which characterizes the art of Oceania.

The art of the Sepik River region has been classified as belonging to one of three zones according to stylistic characteristics shared by cultural groups clustered along the river's lower, middle, and upper regions. Sepik River art in general is distinguished by expressive human and animal forms and a predilection for elaborate surface embellishment of bold curvilinear patterns that often imitate the complex painted designs of traditional body decoration. Gable masks, canoe prows, clay food bowls, suspension hooks, woven basketry masks, and ceremonial boards ornamented with human, animal, and abstract designs are among the many creations of Sepik River artists, most of whom are men.

Men's societies and the complex ceremonies associated with them are the focus of traditional Sepik River ritual life and the impetus for many of the region's art objects. This large clan mask is from the Kararau region of the Middle Sepik. Characteristically, the upper part of the mask is a hollow construction of plaited cane basketry ornamented with two masks, here made of basketry, but often of clay. Cowrie, conus, and nassa shells, cassowary bird feathers, curvilinear painted designs, and expressive facial features embellish the human images. Holes along the lower portion of the basketry frame allow the dancer's arms to protrude; a thick fringe of dyed bark fibers conceals the wearer's body. The mask represents a founding ancestor of the clan, and its use is restricted to male initiation ceremonies.

CMK

PROVENANCE:
East-West Shop, Victor, NY.

VERACRUZ, MEXICO

Remojadas Culture
Head, A.D. 300–900
Clay with traces of red and black pigment, h. 7¼″, w. 6¼″, d. 4½″
R. T. Miller Fund, 44.61
(Upper left)

Rio Blanco Culture
Bowl with Four Figures, ca. A.D. 700
Terracotta with traces of polychrome, h. 2¾″, diam. 4⅛″
R. T. Miller Fund, 45.65
(Lower left)

Classic Veracruz style
Palma, A.D. 300–900
Limestone, h. 10½″, w. 5″, d. 7⅛″
R. T. Miller Fund, 44.66
(Upper right)

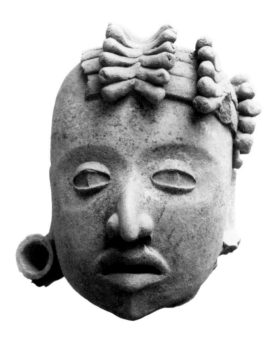

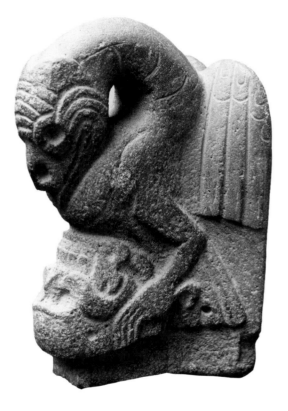

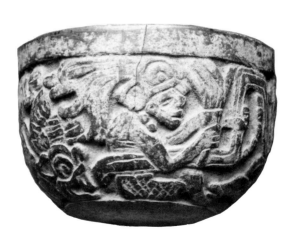

Veracruz, the eastern Gulf Coast region of Mexico, is rich in archaeological sites, which suggests a large population in ancient times. A great quantity of ceramic and stone sculptures reveals the important role of Veracruz in Mesoamerican civilization. The culture of Las Remojadas, a site west of the city of Veracruz, is particularly distinguished by its skillfully constructed and fired clay figures. There are influences from Teotihuacan and the Maya in these figures, deities in very humanlike form. The *Head* (44.61) from the Classic period (ca. A.D. 300–900) was made by pressing clay into a three-quarter round mold. The open back was later filled in by hand, and details, such as earspools and the coiffure adorned with bows, were added. The now missing body might have measured (including the head) 18 to 20 inches high if seated or 25 to 30 inches if standing.[1]

The terracotta *Bowl with Four Figures* (45.65) was made in two molds. It is in the style of the Rio Blanco culture centered in the Huachin region of south central Veracruz.[2] The four seated figures appear to be ritual performers, perhaps related to the ball court ceremony. One figure seems to wear a yoke, as ball players do, and clutches an encased cluster of feathers, a symbol in Maya iconography associated with inheritance of the throne.[3]

During the classic period in central Veracruz, especially at El Tajin, the great center, outstanding small stone sculptures were produced in the form of yokes, *hachas* (axes), *palmas* (palmate stones), and carved architectural ornaments. The yokes, hachas, and palmas are now identified as part of the paraphernalia of a rubber-ball game, a ritual religious activity that was an important feature of Mesoamerican life. The palma's curved base was fitted over the yoke and held in front by the player.[4]

This limestone *Palma* (44.66) shows an unusual image of an eagle attacking a skull and is skillfully carved in a somewhat stylized form. Too heavy for use in the actual game, the stone objects appear to have been ceremonial.

SES

1. Hodik and Jacobi, "A Remojadas Head," p. 16.

2. Letters to author from Hasso von Winning, July 19, 1986, and October 14, 1986.

3. Elizabeth P. Benson, "Symbolic Objects in Maya Art," *Mexicon* 4, no. 3 (July 1982), p. 46.

4. Gordon F. Ekholm, "Palmate Stones and Thin Stone Heads: Suggestions on Their Possible Use," *American Antiquity* 15, no. 1 (July 1949), pp. 2-3. Tatiana Proskouriakoff considers the hachas and palmas possibly ball-court markers; see "Varieties of Classic Central Veracruz Sculpture," *Contributions to American Anthropology and History,* no. 58, Carnegie Institution of Washington, 606 (1960), p. 67.

PROVENANCE:
Head, Bowl with Four Figures, Palma: Brummer Gallery, New York.

LITERATURE:
General references: George Kubler, *The Art and Architecture of Ancient America,* Baltimore, 1962, pp. 76-80; Elizabeth K. Easby and John F. Scott, *Before Cortés: Sculpture of Middle America,* New York, 1970, pp. 162-169; Gordon F. Ekholm, "The Eastern Gulf Coast," *The Iconography of Middle American Sculpture,* New York, 1973; Hasso von Winning, "A Procession of God-Bearers: Notes on the Iconography of Classic Veracruz Mold-impressed Pottery," *Pre-Columbian Art History: Selected Readings,* Palo Alto, CA, 1982, pp. 109-118.

Head: Barbara J. Hodik and H. John Jacobi, "A Remojadas Head and a Jaina Figurine Whistle," *Porticus* 3 (1980), pp. 13-21, ill.

EXHIBITION:
Palma: Lowe Art Museum, University of Miami, Coral Gables, FL, "A Pre-Columbian Synthesis? . . . Mexican Atlantic Gulf Coast," 1973, no. 21.

Oxkintok, Yucatan, Mexico
Stela No. 9, A.D. 859
Stone, h. 52″, w. 37½″, d 5½″
Marion Stratton Gould Fund, 67.30

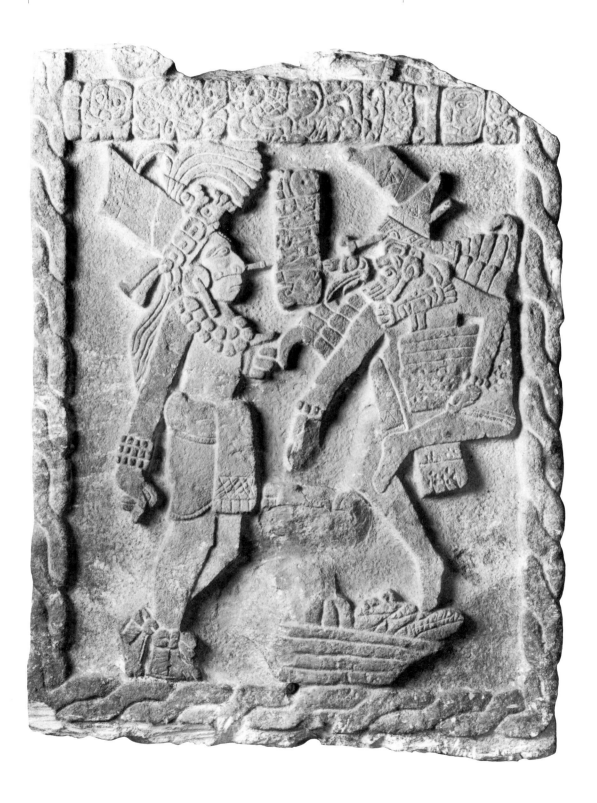

The hieroglyphs of the ancient Maya, the only pre-Spanish peoples of the Americas known to have developed a system of writing, have given us dates and some idea of their social, political, and religious life. A number of such clues are found in this piece. *Stela No. 9* from Oxkintok is dated on the left in the upper panel of glyphs—A.D. 859 by our calendar—and belongs to the late Classic period of Maya civilization, which flourished from A.D. 300 to 900 in such great centers as Copan, Tikal, and Palenque. Oxkintok was an important and extensive Maya site in the Puuc Hills of western Yucatan near the well-known site of Uxmal.

Carved on this stela are two elaborately dressed dancing figures who face each other but are separated by a vertical row of glyphs and by a horizontal band, now badly abraded. The figure on the right has been identified as the God N (Pauahtun), one of the principal lords of the underworld or region of the dead. He wears feathers on his arms and carries a codex, or folding-screen book, of bark paper with a jaguar-pelt cover. Below God N is a bowl or basket containing stylized but unidentifiable objects, possibly fruits or vegetables. God N's companion is a youthful noble or lord, perhaps representing one of the legendary "Hero-Twins," who, in Maya mythology, traveled to the underworld to overcome its lords. He is adorned with a nose plug, ear ornament, feathered headdress, and jade necklace.

The twisted rope border, frequently used in the Puuc, once surrounded an upper panel of about equal size and connected it with this stela. The lower part of another dancing figure was attached until about 1940 and depicted an Oxkintok ruler in the "real" world, the world of the living.

Effectively contrasted in this piece are the graceful rhythms of the adorned figure on the left with the frenzied God N. The flat, blocky style of this piece is typical of the late Classic period, and the skill of the Maya sculptor, working only with stone tools, is well manifested here.

SES

PROVENANCE:
Jean Louis Sonnery, Paris, ca. 1940; Everett Rassiga, Inc., New York.

LITERATURE:
Edwin M. Shook, "Explorations in the Ruins of Oxkintok, Yucatan," *Revista Mexicana de estudios antropologicos* 4, no. 3 (1940), pp. 165-171, fig. 9; Sylvanus G. Morley, *The Ancient Maya,* Stanford University, CA, 1946; Tatiana Proskouriakoff, *A Study of Classic Maya Sculpture,* Carnegie Institution of Washington, no. 593 (1950, reprint 1980), p. 161, fig. 87d, J. Eric S. Thompson, *The Rise and Fall of Maya Civilization,* Norman, OK, 1967, pl. 15a; Michael D. Coe, "The Maya God N in the Memorial Art Gallery," *Porticus* 4 (1981), pp. 9-13.

Peru, South Coast
Burial Mantle, ca. 200 B.C.
Cotton and wool, 50¼ x 115"
R. T. Miller Fund, 44.52
(Detail)

From very early times textiles were important in the life of ancient Peru, and thanks to the dry climate of the country's coastal region many of these textiles, revealing sophisticated techniques and a complex iconography, have been preserved. Hundreds of mummy bundles, many composed of fine fabrics, were found in 1925 by the Peruvian archaeologist Julio Tello, in his major discovery of a burial site on the Paracas peninsula.

Cotton growing developed on the coast about 2500 B.C. and loom technology about 1800 B.C. Wool from the highland animals, the llama and alpaca, is also found in woven materials of this coastal region, suggesting trade among the country's various regions. Spinning, dyeing, weaving—mostly on back-strap looms—and embroidery were the work of specialists, who produced elaborate cloths, robes, and mantles for ceremonial occasions and for burial of the elite.

This burial mantle comes from the Paracas region of Peru's south coast. It is made of two loomwide pieces of woven cotton joined in the middle by a tubular knitted red band decorated with small animal figures. A similar tubular band separates the wide embroidered band from the fringe. An embroidered wool band six inches wide almost surrounds the mantle. Two stylized animals, one within the other, decorate this band. The major figure is a monkey, and within its mazelike tail is a small feline figure. At the monkey's chin is a large pendent trophy head. Smaller trophy heads are at the end of its tail and in its paw. The monkey motif is repeated around the border, alternating, reversing, and repeating itself in vibrant colors—red, yellow, dark blue—creating rich patterns. Between the elaborate border and the plain cotton center section of the mantle, there is a reduced and simplified version of this monkey design.

A complex religious iconography underlies these magnificent textile designs. The monkey symbolizes the human spirit of the dead, and the trophy head represents the life or soul force of conquered enemies.[1]

SES

1. Telephone conversation with Alan R. Sawyer, July 19, 1986.

PROVENANCE:
Paracas necropolis, A. G. Nickstadt, Peru; Walram von Schoeler, New York.

LITERATURE:
Alan R. Sawyer, *Ancient Peruvian Ceramics,* New York, 1966; Alan R. Sawyer, *Ancient Andean Arts in the Collections of the Krannert Art Museum,* Urbana-Champaign, IL, 1975.

EARLY NAZCA

Peru, South Coast
Double Spout Jar, 200 B.C.–A.D. 100
Terracotta with polychrome, h. 7″, w. 5⅜″, d. 5½″
R. T. Miller Fund, 47.23
(Top)

Peru, South Coast
Bowl, 200 B.C.–A.D. 100
Terracotta with polychrome, h. 4⅛″, diam. 8¼″
R. T. Miller Fund, 45.43
(Bottom)

The Nazcas of the south coast of Peru are famous for the monumental earth drawings made in the desert between the Ingenio and the Nazca river valleys. No writing system by these Indians survives to interpret their meaning, but various clues suggest that the drawings were connected with rituals of irrigation and planting, as well as with aspects of astronomy and the calendar. The Nazcas' distinctive ceramics are decorated with motifs of agricultural fertility and abundance—fish, animals, birds, fruits, and vegetables. These natural forms, represented as semiabstractions, were painted on the vessels with colored slips (fine clay pastes).

The double-spouted vessel (47.23), skillfully modeled without a potter's wheel, is decorated with two felinelike figures, each having a spotted back and tail, upswept otter-whiskers, and a typical Nazca mouth mask. This mythical creature, a hybrid of the local ocelot and otter, both of which live near water, was looked upon as a benign guardian of agriculture.

Like the double-spouted vessel, the low bowl (45.43) shows the Nazcas' mastery of colored-slip decoration and the subtle relation between ornament and form. Human, animal, and bird attributes combine to represent a fertility deity, possibly the trophy-head cult monkey deity. The whiskers here are arranged horizontally, the forehead is decorated with a winged ornament, and beside the head hang strings of disks.

SES

PROVENANCE:
Bowl: A. G. Nickstadt, Peru; Walram von Schoeler, New York; *Double Spout Jar:* Walram von Schoeler, New York.

LITERATURE:
General references: Alan R. Sawyer, *Ancient Peruvian Ceramics,* New York, 1966; Alan R. Sawyer, *Ancient Andean Arts in the Collection of the Krannert Art Museum,* Urbana-Champaign, IL, 1975; G. Bawden and G. W. Conrad, *The Andean Heritage,* Cambridge, MA, 1982.

EXHIBITIONS:
Bowl: Hartnett Gallery, University of Rochester, NY, 1981.

Peru, North Coast
Blind Man Stirrup Jar, A.D. 450–600
Terracotta with white and red-brown slip, h. 7⅝ ", w. 4", d. 7 ⁷/₁₆"
R. T. Miller Fund, 44.65
(Left)

Peru, North Coast
Warrior Stirrup Jar, A.D. 450–600
Terracotta with white and red-brown slip, h. 11", d. 5"
Gift of Susan and Bernard Schilling in memory of Lucy P. Eisenhart, 82.17
(Right)

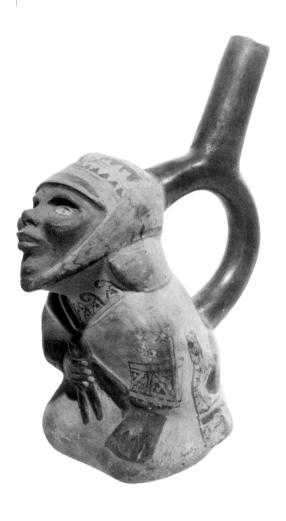

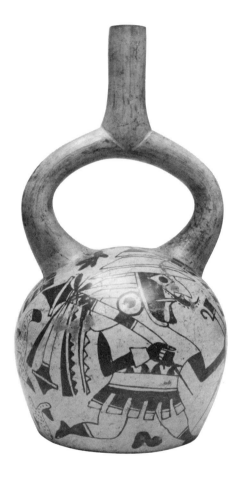

The arts of the Moche, who dominated the northern coastal region of Peru from about 300 B.C. to A.D. 700, evolved from earlier styles of the region. Today, essentially only their ceramics survive as testaments to their achievements. The Moche are also known, however, to have been builders of large-scale monuments such as the Huaca del Sol, a solid pyramid of sun-dried adobe blocks. They were also mural painters, metalworkers, and weavers. The wide variety of subjects treated in their ceramics shows the Moche to have been keen observers of humanity and the environment and also suggests that the work often had symbolic and religious significance. The techniques used in their ceramics include direct modeling, coiling, stamping, and two-part mold making.

The *Blind Man Stirrup Jar* (44.65), sensitively modeled with an expressive face, wears a belt that passes through the stirrup handle of another vessel. On the cream-colored slip, the painted decoration of the man's headdress and poncho suggests elaborate embroidered or woven material. The *Warrior Stirrup Jar's* (82.17) smooth cream slip is decorated with red line drawings of two running warriors. They wear conical helmets with knife-shaped ornaments at the top, earspools, and nose ornaments and they carry war clubs and bundles of weapons. Many similar pots were made specifically for burial and had a sacred function of representing events from Moche mythology.

SES

PROVENANCE:
Blind Man Stirrup Jar: Mrs. Olga Epstein, Lima, Peru, and Vienna, from 1906 to 1909; L. C. Collins, New York; Paul Drey, New York (dealer); *Warrior Stirrup Jar:* Luis Dalmau, Lima, Peru; Susan E. Schilling, Rochester, NY.

LITERATURE:
General references: Alan R. Sawyer, *Ancient Peruvian Ceramics,* New York, 1966; Christopher B. Donnan, *Moche Art of Peru,* Los Angeles, 1978; G. Bawden and G. W. Conrad, *The Andean Heritage,* Cambridge, MA, 1982.

Peru, South Coast
Tapestry Panel from a Shirt, ca. A.D. 800–900
Wool and cotton, 33½ x 11½"
R. T. Miller Fund, 44.62

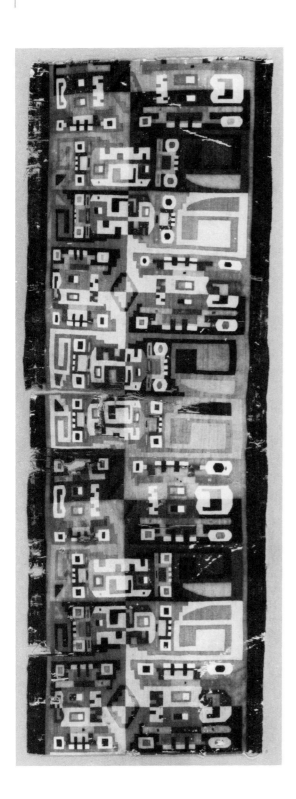

The Wari culture developed in the Montaro River basin about A.D. 600 under influences of the Tiahuanaco civilization, which had flourished around Lake Titicaca in the southern highlands of Peru and Bolivia. Militant and expansionist, the Wari exerted control through ceremonial centers and a powerful priesthood that directed craftsmen.

Weaving on the south coast had a long history of high quality production. To this the Wari added the important technical achievement of interlocking tapestry, which they learned from the Tiahuanaco people. On a strong cotton warp, the wool weft threads of each color area interlock with those of adjoining color areas, forming a tight fabric. With a few basic dyes, cochineal (red), saffron (yellow), and indigo (blue), a wide color range was obtained. Although rigid iconographical requirements dictated the motifs used in the shirts and ponchos of officials of certain rank, the master craftsmen creatively distorted, expanded, and compressed the forms to achieve variations in design and rich color harmonies.

The panel has five units, two of which are repeated: numbers one and four are the same, as are numbers two and five. Each unit contains four elements of design based on stylized animal motifs rendered as geometric patterns.

SES

PROVENANCE:
Brummer Gallery, New York.

LITERATURE:
Walter Lehmann and Heinrich Doering, *The Art of Old Peru,* London, 1924, pl. 112; Alan R. Sawyer, *Ancient Andean Arts in the Collection of the Krannert Art Museum,* Urbana-Champaign, IL, 1975; "Tiahuanaco Tapestry Design," *Textile Museum Journal* 1, no. 2 (1963), pp. 27-38.

CHIMU

Peru, Chicama Valley, North Coast
Burial Mask, 1100–1470
Gold, hammered, 17 ¼ x 9 ³/₁₆"
R. T. Miller Fund, 47.9

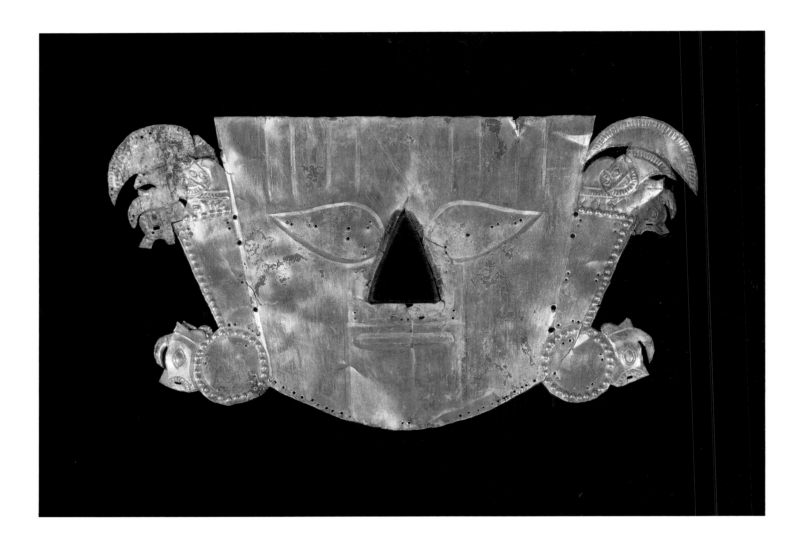

Metallurgy was among the technological achievements of the Chavin period in Peru, about or before 500 B.C. The skills were handed down through the Moche to the Chimu civilization and were much admired by the Incas, who learned from the earlier craftsmen.

Gold was the first metal to be worked in Peru and was likely obtained as nuggets from rivers and streams of the highlands. For the Indians of ancient Peru, gold symbolized the brilliance of the sun and was a reflection of the gods. Gold objects that had been worn by the living of high rank accompanied the deceased to the grave to delight that person's spirit in the next world. Mummies wrapped in elaborate fabrics were often topped with an artificial head that was covered with a mask made of thin hammered sheets of gold, silver, or copper.

On this burial mask, the ornate circular earspools with puma heads are like sleeves and may have held actual feathers. Puma heads also decorate the upper portion of the mask as do bent, stylized figures of warriors wearing feathered headdresses. The original decoration on the left is missing, but it has been replaced with another of similar design. Originally, separate ornaments may have been attached to the mask near the eyes, around the nose, and along the side of the face. Now only holes suggest where these ornaments may have been. The nose, which was raised in relief, has been lost. The holes around the edge of the head show where the mask was sewn to the mantle.
SES

PROVENANCE:
Walram von Schoeler, New York.

LITERATURE:
William M. Milliken, "Exhibition of Gold," *Bulletin of the Cleveland Museum of Art* 34, no. 9 (November 1947), pp. 211-212, ill. p. 234; Bruce H. Evans, "A Peruvian Gold Funerary Mask," *Dayton Art Institute Bulletin* 26, no. 1 (September 1967), p. 9, fig. 10; A. D. Tushingham, *Gold for the Gods,* Toronto, 1976.

EXHIBITIONS:
Cleveland [OH] Museum of Art, *Exhibition of Gold,* 1947–1948.

Northwest Coast, British Columbia, Canada
Raven Mask, mid-19th century
Wood, pigment, cedar bark, h. 9¼", w. 55½", d. 11¼"
Marion Stratton Gould Fund, 64.111

The Kwakiutl are Northwest Coast Indians who live in what is now British Columbia, Canada. Their traditional culture flourished until the early twentieth century. Economic livelihood depended on fishing. Abundant cedar forests provided ample wood for homes, canoes, and ritual and secular carvings. Inherited status and prestige were essential to the Kwakiutl's social structure. In this society, new titles of rank and changes in social relationships (e.g., births, marriages) were announced at potlatches, elaborate celebrations that enabled the display of individual and family wealth.

During the Kwakiutl potlatches dramatic presentations recreated the fantastic legends of the family's history. The stories were enacted by animal totems, such as the whale, eagle, and raven, using polychromed, articulated wooden masks with vibrant colors and bold forms characteristic of Kwakiutl style. Man's close link with these totemic animals is emphasized in some Kwakiutl masks with articulated jaws that open to reveal a human face within. This raven dance mask may have been used in a performance of the *Hamatsa* initiation society masquerades.[1] The secret society honored the courageous exploits of its members by recounting the legend of their acquisition of secret powers through the subjugation of their neighbors, the Heiltsuk. These dramatic performances emphasized the aggressive nature of the society in stylized enactments of cannibalistic ritual. In Hamatsa ritual, the principal mask is half man, half bird; the raven mask serves as his attendant. Some masks had wooden carvings of human skulls suspended from cedar bark strands attached to the back of the mask, powerful signs of the fierceness of Hamatsa.

Kwakiutl Hamatsa raven masks are generally painted in red, white, black, orange, and green pigments to accentuate the bird's bold eyes and flaring nostrils. A close-cropped fringe of red-dyed cedar bark and projecting feathers usually adorned the head, and longer bark strands were suspended from the mask to cover the wearer completely. Although commercial pigments were available at the end of the nineteenth century, the red, black, and white pigments used on this raven mask were made from locally available materials: black from charcoal; white from burnt, crushed clam shells; and red ocher from the earth. The mask was worn on the forehead and attached to the dancer with ropes tied through the mask, under the dancer's arms, and around his waist. The hinged lower jaw was manipulated with a cord that linked upper and lower sections of the mask. When the cord was pulled, the mask responded with a loud clacking sound, which no doubt heightened the dramatic effect of the performance.

CMK

1. Franz Boas, "The Social Organization and the Secret Societies of the Kwakiutl Indians," *Report of the U.S. National Museum,* under the direction of the Smithsonian Institution, Washington, DC, Government Printing Office, 1897, p. 447.

PROVENANCE:
Everett Rassiga, Inc., New York.

267

MEXICO (TEOTITLAN DEL CAMINO, OAXACA), POSTCLASSIC PERIOD, CA. 1300–1500

Incense Burner: Xantil Figure of Macuilxochitl
Ceramic, 19⅞ x 9⅝ x 5¾"
Marion Stratton Gould Fund, 69.22

COSTA RICA (GUAPILES, CENTRAL HIGHLANDS OR ATLANTIC WATERSHED ZONE), PERIOD VI, CA. 1200–1550

Flying Panel Metate (Ceremonial Grinding Stone)
Volcanic stone, 13⅞ x 26½ x 21⅜"
Marion Stratton Gould Fund, 72.10

WESTERN MEXICO (NAYARIT), CA. 200 B.C.–A.D. 500

Standing Female Figure
Ceramic, 21 x 11 x 5⅜"
R. T. Miller Fund, 54.41

Bella Coola culture, British Columbia, Canada,
19th century
Face Mask
Wood and pigment, 28 ½ x 17 ¾ x 10 ¾ "
Gift of Isabel C. Herdle, 84.45

David Piungftung, (b. 1938)
Inuit culture, Clude River, Alaska, 20th century
Polar Bear with Shaman
Stone, 2 ½ x 5 ¾ x 12 ¼ "
Gift of Mrs. Harmar Brereton, 83.82